The Indecent Screen

The Indecent Screen

Regulating Television in the Twenty-First Century

CYNTHIA CHRIS

Rutgers University Press

New Brunswick, Camden, and Newark, New Jersey, and London

Library of Congress Cataloging-in-Publication Data

Names: Chris, Cynthia, 1961– author.
Title: The indecent screen: regulating television in the twenty-first century / Cynthia Chris.
Description: New Brunswick: Rutgers University Press, 2018. | Includes bibliographical
 references and index.
Identifiers: LCCN 2018007357| ISBN 9780813594071 (cloth) | ISBN 9780813594064 (pbk.)
Subjects: LCSH: Television—Law and legislation—United States. | Television broadcasting—
 Censorship—United States. | Obscenity (Law)—United States.
Classification: LCC KF2840 .C48 2018 | DDC 343.7309/946—dc23
LC record available at https://lccn.loc.gov/2018007357

A British Cataloging-in-Publication record for this book is available from the British Library.

♾ The paper used in this publication meets the requirements of the American National
Standard for Information Sciences—Permanence of Paper for Printed Library Materials, ANSI
Z39.48-1992.

www.rutgersuniversitypress.org

Manufactured in the United States of America

Contents

Chronology

This chronology lists key actions by the Federal Communications Commission, the U.S. Congress, federal courts, and the broadcast television industry in regard to indecency. Focusing on select events discussed in this book, this list is not comprehensive.

1948 Congress passes a law establishing penalties for broadcasts of "obscene, indecent, or profane language," entered into the Code of Laws of the United States of America as Title 18, Part I, Chapter 71, Section 1464: Broadcasting Obscene Language.

1951 The National Association of Radio and Television Broadcasters issues a Code of Television Standards.

1975 On September 8, major broadcast networks launch the Family Viewing Hour.

1976 *WGA West, Inc. v. FCC*, 423 F. Supp. 1064 (C.D. Cal.), rules that the Family Viewing Hour is an unconstitutional burden on broadcasters.

1978 *Federal Communications Commission v. Pacifica Foundation*, 438 U.S. 726, affirms the FCC's authority to regulate indecent broadcasts, especially when children are likely to be watching; the case involved a 1973 broadcast of a recording of the comedy routine "Filthy Words" by George Carlin on Pacifica's WBAI in New York.

1987 The FCC issues a public notice (New Indecency Enforcement Standards to Be Applied to All Broadcast and Amateur Radio Licenses, 2 F.C.C.R. 2726) declaring its authority to take action

against indecency even when none of the "seven dirty words" are present, reversing longstanding policy.

1988 On June 23, the FCC fines KZKC-TV in Kansas City, Missouri, $2,000, following a complaint regarding the station's broadcast of an unedited R-rated movie, *Private Lessons* (1981), during prime-time on May 26, 1987. Later, the fine, the first ever levied on a TV station for indecency, is canceled.

1988 After the FCC attempts to shorten the safe harbor to the hours of midnight to 6:00 A.M., *Action for Children's Television v. FCC*, 852 F.2d 1332 (D.C. Cir.), rules that the commission has not given evidence that there is a "reasonable risk" that significant numbers of children are in the audience after 10:00 P.M.

1992 The Cable Television Consumer Protection and Competition Act allows cable systems to refuse programs containing "indecent" material and requires that such programs are segregated onto a single channel to be blocked or scrambled unless subscribers request access in writing.

1993 After several further attempts by the FCC and Congress to shorten the safe harbor, *Action for Children's Television v. FCC*, 11 F.3d 170 (D.C. Cir.), reaffirms that the commission must not apply anything but the "least restrictive measure" required to safeguard children from "constitutionally protected 'indecent' speech." The safe harbor returns to the hours of 10:00 P.M. through 6:00 A.M.

1996 The Telecommunications Act of 1996 establishes the TV ratings system and mandates that all television receivers measuring 13 inches or more, and manufactured after 2000, contain the V-chip.

1997 The FCC fines Grant Broadcasting, Inc., owner of WJPR-TV in Lynchburg, Virginia, and WFXR-TV in Roanoke, Virginia, $2,000 (later rescinded) for airing a science-fiction film in 1993 that contained several instances of indecent language.

2000 The Supreme Court overturns portions of the Cable Act of 1992, allowing indecent programming on cable channels to air unscrambled and preventing cable systems from demanding written requests for this programming.

2001 The FCC fines Telemundo $21,000 following complaints about three sexually suggestive scenes in episodes of *No Te Duermas* on WKAQ-TV in San Juan, Puerto Rico. Payment of the fine marks

the first indecency forfeiture involving television rather than a radio station.

2001 The FCC issues a policy statement (Industry Guidance on the Commissions Case Law Interpreting 18 U.S.C. §1464 and Enforcement Policies Regarding Broadcast Indecency) attempting to clarify the conditions that lead to a determination of indecency.

2003 The FCC fines KRON in San Francisco $27,500 following complaints about an instance of male frontal nudity during a morning newscast.

2004 The FCC issues a consent decree declaring that all Viacom-related indecency cases (except the 2004 Super Bowl halftime show case) would be resolved by payment of $3.5 million. Resolved cases included complaints about "Our Sons and Daughters," a 2003 episode of *Without a Trace*.

2004 In response to Bono's 2003 utterance "fucking brilliant" during a live broadcast of the *Golden Globe Awards*, the FCC issues the so-called Golden Globes Order, which renders every use of the "F-word" indecent regardless of context, and in a marked policy shift, declares that punitive measures can be taken against "fleeting, isolated" indecent or profane utterances.

2004 The FCC fines 20 CBS-owned stations the maximum $27,500 each, following a record-setting number of complaints (over half a million). The complaints were in response to an instance of partial nudity at the conclusion of the Super Bowl halftime show earlier in the year. CBS appealed. In 2008, the U.S. Court of Appeals for the Third Circuit vacated the fines.

2004 The FCC fines 169 TV stations $7,000 each, following complaints about an episode of Fox's *Married by America*, which aired in 2003; in 2008, fines levied on stations in markets not associated with complaints were rescinded; in 2012, attempts to collect remaining fines ceased.

2004 The FCC raises the maximum fine for broadcast indecency to $32,500.

2004 The FCC fines 111 CBS stations a record $3.6 million in response to complaints regarding a rerun of the *Without a Trace* episode "Our Sons and Daughters." The fine went unpaid.

2005 The FCC denies complaints about ABC's broadcast of *Saving Private Ryan*, despite numerous audible and unbleeped profanities.

2006 Congress passes and President George W. Bush signs into law the
Broadcast Indecency Enforcement Act, raising the maximum fine
for broadcast indecency to $325,000 per incident, per station.

2007 In *Fox et al. v. FCC,* the U.S. Court of Appeals for the Second
Circuit strikes down the Golden Globes Order as "arbitrary and
capricious under the Administrative Procedures Act," and it
overturns determinations of indecency involving utterances by
Cher and Nicole Richie on the *Billboard Music Awards* broadcasts.

2008 The FCC fines 52 ABC stations $27,500 each, following com-
plaints about the "Nude Awakening" episode of *NYPD Blue* aired
in 2003.

2009 In *Fox et al. v. FCC,* the Supreme Court overturns the Second
Circuit's 2007 ruling and sends the case back to the lower court for
reconsideration.

2010 The Second Circuit issues a new ruling in *Fox et al. v. FCC,*
declaring the indecency policy "impermissibly vague" in constitu-
tional terms.

2011 The Second Circuit Court of Appeals vacates the $1.43 million fine
the FCC levied on ABC in accordance with its ruling in *Fox et al.
v. FCC* (2010).

2012 The Supreme Court issues a decision in *Fox et al. v. FCC* affirming
that fines pertaining to the *Billboard Music Awards* broadcasts in
2002 and 2003, and to the 2003 *NYPD Blue* episode, are dismissed
because of failure to satisfy due-process concerns found in the Fifth
Amendment to the Constitution.

2013 The FCC raises the maximum fine for broadcast indecency to
$350,000 per incident, per station.

2013 The FCC issues a consent decree resolving complaints about *Jose
Luis Sin Censura,* aired by Liberman Broadcasting's Estrella
network, pending a $100,000 forfeiture.

2015 The FCC fines Schurz Communications' WDBJ-TV in Roanoke,
Virginia, a record $325,000 following complaints about a 2012
newscast that inadvertently included a small sexually explicit
image.

Abbreviations

ACLU	American Civil Liberties Union
ACA	American Communication Association
ACM	Alliance for Community Media
ACT	Action for Children's Television
APA	Administrative Procedures Act
ART	Americans for Responsible Television
BMA	Billboard Music Awards
CATV	community antenna television
CFA	Consumer Federation of America
CLeaR-TV	Christian Leaders for Responsible Television
CU	Consumers Union
DBS	direct broadcast satellite TV service
DMA	Designated Market Area
DTH	direct-to-home satellite TV service
DVR	digital video recorder
EB	Enforcement Bureau
ESRB	Entertainment Software Ratings Board
FCC	Federal Communications Commission
FoIA	Freedom of Information Act
FRC	Federal Radio Commission or Family Research Council, depending on context
GAO	General Accounting Office (since 2004, Government Accountability Office)

ISP	Internet Service Provider
LGBTQI	lesbian, gay, bisexual, transgender, queer, or intersex
MIM	Morality in Media (since 2015, National Center on Sexual Exploitation)
MPAA	Motion Picture Association of America
MPPDA	Motion Picture Producers and Distributors of America
MSO	multi-system operator (of cable or DBS systems)
MRC	Media Research Council
MVPD	multichannel video programming distributor
NAB	National Association of Broadcasters
NAL	Notice of Apparent Liability
NARTB	National Association of Radio and Television Broadcasters
NCTA	National Cable & Television Association (since 2016, NCTA—The Internet & Television Association)
NHMC	National Hispanic Media Coalition
OTT	"over the top" services
PCA	Production Code Administration
PEG	public, educational, or government channels
PSA	public service announcement
PTC	Parents Television Council
PTO	Patent and Trademark Office
TWC	Time Warner Cable
UHF	ultra-high frequency
VCR	videocassette recorder
VFX	visual effects
VHF	very high frequency
VOD	video on demand

The Indecent Screen

Introduction

What We Talk About
When We Talk About
Television and Indecency

Congress shall make no law respecting an establishment of religion, or prohibiting the free exercise thereof; or abridging the freedom of speech, or of the press; or the right of the people peaceably to assemble, and to petition the government for a redress of grievances.
—First Amendment to the U.S. Constitution, 1791

Whoever utters any obscene, indecent, or profane language by means of radio communication shall be fined under this title or imprisoned not more than two years, or both.
—U.S. Code Title 18, Part I, Chapter 71, Section 1464: Broadcasting Obscene Language (1948, revised 1994)

1

On November 6, 2005, the Fox television network aired an episode of the animated series *Family Guy* called "PTV." Early in the episode, Lois Griffin reminds her husband, Peter, that he must attend their daughter's school play that evening instead of staying home to watch television.[1] The next day, Peter hears local TV news anchor Tom Tucker announce that a "wardrobe malfunction" involving actor David Hyde Pierce's testicles occurred during the prior evening's live Emmy broadcast, and Peter is outraged that he missed this historic event. The fictionalized version of the Federal Communications Commission (FCC) receives such an astronomical number of complaints that the agency is unable to provide an exact count. In response, the FCC's leader, who takes the form of the *G. I. Joe* villain Commander Cobra, decides to "censor television."

The censors go wild, leaving no provocation or pun unbleeped or unblocked. New dialogue is dubbed into *The Honeymooners* (1955–1956) reruns so that audiences are protected from outbursts by Ralph Kramden (played by Jackie Gleason), which typically threatened his wife with "One of these days, *pow*, right in the kisser!"); and black rectangular "censor bars" cover most of the title of *The Dick Van Dyke Show* (1961–1966) as well as parts of Suzanne Somers, appearing on *Three's Company* (1977–1984) in short shorts and a bikini top. Disgusted by what he perceives as regulatory overreach that sanitizes his favorite TV classics, Peter decides to start his own television station. With help from Super Friend Apache Chief, he installs a huge satellite dish on the roof of the Griffin home.[2] Questioned by his wife, Peter declares proudly, "I'm saving television, Lois."

Peter's idea of "saving television" is to create more television. He foregoes the license application that would be required in the real world and starts broadcasting. He calls the station PTV, and the television programs that Peter creates for it, from *Dogs Humping* to *Cheeky Bastards*, are resolutely obsessed with the very subject matter—"sexual and excretory material"— that the Enforcement Bureau at the real-world FCC is charged with regulating.[3] The fictional FCC shuts down PTV and then begins to censor daily life. Government agents greet Peter when he emerges from a shower, insuring that his genitals are covered. They force him to wear a device that converts farts into jokes. They blow air horns over expletives that pepper a conversation between Peter and Lois, and join them in the bedroom to ensure that their sexual activity doesn't break any rules. Enraged, the Griffins make a trip to Washington, DC, where Peter addresses Congress. Pointing out how much various Washington landmarks look like sexual organs (the

FIG. 1 An employee of the Federal Communications Commission censors Peter and Lois Griffin's conversation in "PTV," *Family Guy*, Fox, November 6, 2005.

Capital Building, a breast; the Washington Monument, a penis; and so on), he convinces legislators to make the FCC lighten up. Peter's efforts defeat the puritanical repression of sexual expression and the hypocritical forces of selective enforcement, striking a heroic blow for free speech everywhere—especially, on television.

There are undeniable similarities between the 2005 *Family Guy* episode "PTV" and a chain of incidents involving live, celebrity-laden broadcasts that started in 2002 when Cher used an expletive during the *Billboard Music Awards*. In 2003, Bono and Nicole did the same, also on live awards shows. Then, on February 1, 2004, the Super Bowl halftime show culminated in a "wardrobe malfunction," when Justin Timberlake's tug on Janet Jackson's top provided viewers with a brief glimpse of her bejeweled breast. After the last incident, FCC Chairman Michael Powell moved to strengthen the commission's policy against indecency. Both the FCC and Congress moved to raise fines. The number of complaints received by the FCC skyrocketed as conservative media-watchdog organizations shepherded members toward electronic complaint forms. The networks claimed that the FCC's actions

threatened to dampen innovative and popular entertainment, and the creative community bristled at new restrictions. The FCC's policy and attempts to enforce it were taken to court by the networks, which kept the matter of broadcast indecency in the news for years.

The Indecent Screen explores these clashes among U.S.-based media advocates, television professionals, and federal regulators. This book is a work of history and analysis, focusing on very recent history and a particular national context. In many ways, the U.S. broadcast industry has an anomalous history, given its foundation in commercialism. Most other national radio and television markets originated as state-run or public broadcasting systems and operate under distinct social expectations and legal frameworks. These distinctions persist in varying degrees, despite significant globalization across media industries that provide for transnational circulation of capital, labor, and intellectual property—albeit a flow that sloshes unevenly with a few dominant media-producing nations, including the United States.[4] One of the hallmarks of the U.S. context is its ostensibly strong constitutional protection of free speech (including mediated speech). But, in fact, there are many limitations placed on free-speech rights, including regulations pertaining to broadcast indecency. Clashes over the what is allowable and what is prohibited in broadcasting are, in many regards, continuations of long-running squabbles over decency and indecency not only in television but also in radio, motion pictures, and other mass media. These clashes are taking new forms in the early twenty-first century in response to continuously changing conditions in the TV industry that affect how, when, why, if, and even where we watch TV, not to mention our expectations of the medium when we do watch it.

Those changing conditions involve, among other things, media and regulatory environments shaped by the liberal push and conservative pull of various cultural, social, and political agendas. Those agendas may be influenced by constituent demands and corporate lobbyists; by an executive branch that sets administrative priorities; by Congress, which passes legislation governing telecommunications industries; by the FCC, which develops policy in this area; by the judiciary, which interprets laws and policies when they are challenged; and by the media industries themselves, through their economic and technical imperatives and their programmatic components, however innovative—or regressive. As Imani Perry, Kimberlé Williams Crenshaw, and others have shown, public policy and the range of narratives available at any given time, in any given place, are mutually

constitutive.[5] Regulatory agents don't simply scurry to govern atomized speech events; they shape the playing fields in which speech takes place. "Structural, political, and representational" conditions and discourses work together to maintain social hierarchies, patterns of dominance and subjugation, and the possibilities of liberty or constraint.[6]

There are then, to be sure, many stakeholders in the media environment. Some of them coalesce from a variety of perspectives to advocate for media reform, challenging the boundaries of what is allowable on television and what is not. Some have argued that the FCC's indecency policy is too weak, the agency too slow and hesitant to enforce it, and the punishments inadequate. Others argue that the policy is too strict, too vague, and too arbitrary to pass First Amendment muster or to be implemented in a fair and precise manner. Throughout the history of U.S. media regulation, context has been key: public opinion, press coverage, and regulatory responses to incidents of indecency have depended on factors such as the genre of the program; the time of day that the program airs; and the race, ethnicity, gender, and sexual orientation of the speaker who voices or enacts the potentially controversial material. (As I will show, programming that nonjudgmentally represents LGBTQI characters has provoked a disproportionate share of the ire of some of the most conservative media advocacy groups.) Some utterances offend more than others, for reasons that correspond quite closely to the socially constructed expectations that varying audiences have for different kinds of speakers in different places.

I am interested in what motivates the persistent sparring among those on all sides of the decency debate and what their battles accomplish. I explore the history of efforts to regulate broadcast television content and the many challenges to those efforts, with an emphasis on the two decades following the Telecommunications Act of 1996. I argue that the degree to which a society can tolerate unregulated speech, and the extent to which we can use that freedom effectively, has an impact on the quality of public discourse, which goes beyond whether this word or that word is broadcastable or whether this or that amount of flesh is permissible. A media unfettered by puritanical controls—yet diverse enough to meet a wide range of needs and desires, and rich enough in options to provide for age-appropriate children's programming—is integral to our capacity as citizens to comprehend this twenty-first-century information environment—an environment that has never before been so rife with contradictions and so volatilely divided on questions of what constitutes truth and fact and the proper balance between

the rights of individuals and the common good. In "PTV," *Family Guy* creator Seth McFarlane might amusingly satirize both free speech (as practiced by a blowhard like Peter Griffin) and incursions, even modest ones, upon it. But First Amendment rights are no joke. Practicing free speech and defending it are never small responsibilities.

What's So Special about Broadcasting?

Ever since the earliest days of radio broadcasting, federal regulators and industry watchdogs alike have placed on radio and television broadcasters an expectation of acting in the "public interest, convenience, and necessity."[7] No other mass medium shares this obligation. What's so special about broadcasting, if anything, that justifies the federal government's unusual demand on it? The public-interest obligation derives from the long prevailing "scarcity principle," which holds that the electromagnetic spectrum is a finite public resource. The basic tenets of this principle were first articulated in the Federal Radio Act of 1927 and restated in the Federal Communications Act of 1934. The rationale for these pieces of legislation is that since the electromagnetic spectrum is a public resource, those licensed to use it could be required to act in the "public interest." However ill-defined this public-interest expectation, it is the backbone of congressional acts establishing the right of government agencies to license stations and to place limitations on the extent to which the First Amendment protects broadcast speech. In exchange for the privilege of using frequencies that belong to the public, broadcasters are obliged to air only programming that respects commonplace standards of decency (however difficult it might be to pinpoint those standards)—at least when there is a reasonable chance that children are in the audience. That is, given the scarcity of available frequencies, broadcasters are expected to act as public trustees of those precious airwaves.

But in the earliest years of the medium, most viewers were lucky to find even a handful of channels scattered across the VHF (very high frequency) portion of the electromagnetic spectrum on channels designated 2 to 13. Television has not been so scarce to most viewers since the proliferation of alternative delivery systems that have added exponential channel capacity. The "pioneers" of cable TV were rigging up wired systems as early as 1948 or 1949, but their bread-and-butter business was retransmitting broadcast signals to communities unreached by local stations.[8] The All Channel

Receiver Act of 1962 promoted access to broadcast channels 14 to 83—the UHF (ultra-high frequency) portion of the spectrum. A decade later, starting with the launch of HBO in 1972, new cable-only channels rapidly attracted millions of new subscribers to wired cable systems. In the 1990s, the growth of direct-to-home satellite TV gave consumers access to yet another delivery system. On-demand streaming services, led by Amazon (launched in 2006), Netflix (2007), and Hulu (2007), offered still another option for bringing TV programming (mostly *sans* live TV) into homes. It has been a technological and legal fiction to pretend that non-broadcast television systems do not also exploit public resources in an infrastructure that includes countless miles of under- and above-ground cable—an infrastructure in which communications satellites and microwave transmission also utilize portions of the electromagnetic spectrum. But the easy, no-cost accessibility of the broadcast signal girds its unique status. After all, broadcast channels, both VHF and UHF, are freely available over the air to any home equipped with a TV set or screen.

The distinction between broadcasting and cable has also depended on the recognition that the free-to-air broadcast signal is so ubiquitous as to be unavoidable. In 1978, the Supreme Court affirmed this distinction in a famous indecency case that had erupted five years earlier when a listener complained about WBAI in New York playing a recording of George Carlin's comedy routine "Filthy Words," a monologue exploring what the comedian called "the seven words you can never say on the airwaves." The court described broadcasting as not only "uniquely pervasive" but also "uniquely accessible to children," compared to other media.[9] In contrast, cable and direct-broadcast satellite television as well as online streaming services require subscription and nontrivial monthly payments, thus constituting invited guests to the home for which the subscriber, not the provider, is primarily responsible. Therefore, many regulations pertinent to broadcasting, including the rules regulating indecency and profanity—have never applied to cable or any other form of pay-TV.

The special status of broadcasting has been tested in a number of legal challenges that sought in one way or another to void broadcasting's unique obligations. In fact, the federal courts have been key protectors of broadcasting's character as a public trustee. For example, *Red Lion Broadcasting Co., Inc. v. FCC*, 385 U.S. 367 (1969), affirmed the constitutionality of the Fairness Doctrine, an FCC policy that had, since 1949, required broadcasters to provide some news or public affairs programming and to cover issues

fairly—that is, to represent multiple views on topics of public interest. In *Red Lion*, the Supreme Court determined that the policy is in the public interest, because it is the First Amendment rights of "the viewing and listening public, and not the right of the broadcasters, which is paramount."[10] That is, it is *the public's* right to have access to what the court called in another context a diverse "marketplace of ideas."[11] Balancing broadcasters' rights against those of viewers and listeners, the court found that protecting the latter justified minor incursions on the former. Nevertheless, the FCC, in a shift that was part and parcel of the Reagan-era deregulatory turn under the commission's Chair Mark S. Fowler, took a different view. Under Fowler, the FCC jettisoned the Fairness Doctrine in 1987, largely citing the *broadcasters'* right to First Amendment protections (not the public's), which opened the door to broadcast editorializing without rebuttal and a more partisan news culture generally.

Other cases affirming the special status of broadcasting followed. For example, in a 1985 case involving the FCC's "must carry" rules—which require cable systems to provide subscribers with local broadcast channels—a Quincy, Washington, cable provider and Turner Broadcasting System challenged "must carry" as an infringement of their First Amendment rights. The court agreed, recognizing that cable TV is more like "traditional [print] media" than broadcasting and therefore more broadly protected by the First Amendment.[12]

In cases where legislators sought to prevent indecency on cable TV, the courts were forced to reckon with differences between broadcasting and cable TV and generally drew similar conclusions. For example, when the State of Utah passed the Cable Television Programming Decency Act in 1983, several cable systems promptly challenged the law. In 1985, U.S. District Court of Utah agreed with the FCC, which had filed an *amicus curiae* ("friend of the court") brief in the case, stating that cable and broadcasting are fundamentally different: "cable television is not an uninvited intruder" (inferring that broadcast signals *are*, in contrast, intrusive, even inescapable).[13] For this and other reasons, the District Court overturned the Utah decency act, and federal protection for cable prevailed.[14] Given the status of broadcasters as trustees of a scarce public resource (the airwaves on which their signals travel), they continue to shoulder special public-interest obligations. Accordingly, the FCC regulates programming originating from broadcast networks and stations for the purpose of suppressing three categories of broadcast speech: obscenity, indecency, and profanity. While these regula-

tions have been sustained, the manner in which indecency and profanity are regulated has not always been consistent, and regulated parties have argued that these terms have been far from clearly or consistently defined.

Defining Indecency

This is a book about indecency, and as such, it must provide a definition of this term. Indecency, at least as the term is used in broadcast regulation, is difficult to understand without comparison to other categories of speech—obscenity and profanity.

Obscenity is a more settled legal category than indecency. But it is difficult enough to define that the FCC's 2016 fact sheet on "Obscene, Indecent, and Profane Broadcasts" quotes Supreme Court Justice Potter Stewart's famous line, "I know it when I see it."[15] Stewart, participating in a decision that overturned conviction of a theater manager who had screened Louis Malle's *The Lovers* (1958), which had been banned by the State of Ohio, agreed that the film was not obscene but demurred from offering a definition of obscenity.[16] In other cases, federal courts have tried to define the term more specifically, and the legal definition of obscenity has changed over time. Late twentieth-century law treats obscenity as a label for material that is sexually explicit: graphically unambiguous, intended to titillate or arouse, and otherwise lacking in aesthetic or social value.[17] It can be found in visual media (those that *depict*) or in written or oral forms (those that *describe*). A medical textbook containing images of genitals is never obscene; neither is a work of art depicting nude figures or a novel containing descriptions of sexual encounters—or an R- or NC-17-rated film, for that matter. The term *obscene* is generally reserved in the law for so-called hard-core pornography.[18] Non-sexual violence, no matter how gory or gratuitous, does not qualify as obscenity under the law.

Indecency is often defined in contrast to obscenity. According to the FCC's own website,

> Indecent material contains sexual or excretory material that does not rise to the level of obscenity. For this reason, the courts have held that indecent material is protected by the First Amendment and cannot be banned entirely. It may, however, be restricted to avoid its broadcast during times of the day when there is a reasonable risk that children may be in the audience . . . from 6 a.m. to 10 p.m.[19]

The remaining overnight hours are known as the "safe harbor." The definition continues as follows:

> Material is indecent if, in context, it depicts or describes sexual or excretory organs or activities in terms patently offensive as measured by contemporary community standards for the broadcast medium. . . . [C]ontext is critical. The FCC looks at three primary factors when analyzing broadcast material: (1) whether the description or depiction is explicit or graphic; (2) whether the material dwells on or repeats at length descriptions or depictions of sexual or excretory organs; and (3) whether the material appears to pander or is used to titillate or shock.[20]

As in the legal definition of obscenity, indecency can be found in depictions or descriptions. In the case of broadcasting, that means visual or spoken, prerecorded or live material. A key difference between obscenity and indecency is that obscenity can be found only in a work "taken as a whole"—a potentially obscene excerpt is not enough—whereas a single broadcast image (a scene, a shot, even a single frame) or an utterance within a program can be found indecent. Indecency encompasses only sexual or excretory material; again, violence is excluded.

Profanity is a separate category, defined by the FCC as "'grossly offensive' language that is considered a public nuisance."[21] The term *profanity*, in use as far back as the late fifteenth century, originally indicated anything that was not sacred; not simply the secular but the unholy or blasphemous. In contemporary usage, profanity has a more general definition, as one of many synonyms for what may also be called four-letter words (even though not all of them have four letters), swearing or cursing (terms which have roots in taking oaths or wishing ill on others), dirty words (by those who don't think too highly of this kind of language), or expletives (meaning words that add little meaning but may perform emphatic functions).[22] Most FCC actions in response to complaints about offensive programming have pertained to *indecent* speech, and before 2004, the commission largely avoided applying the label "profanity." Since 2004, the commission has opted at times to declare broadcasts profane as well as indecent, but not without some controversy.[23] Any uncertainty about the constitutionality of regulating profanity is a reminder that while these definitions—of not only profanity but also obscenity and indecency—are the ones in use by U.S. federal regulators in 2018, as I write, they have been altered many times and remain under

debate. Meanwhile, the regulated media have also changed in several significant ways.[24]

Television after the Telecommunications Act of 1996

In the roughly twenty years since the Telecommunications Act of 1996, the medium of television has been subject to rapid innovation. Among those innovations, the Telecommunications Act of 1996 ushered in a new phase of *decency regulation* through the introduction of a TV ratings system, "V-chips" in all newly manufactured TVs, and a cable channel-blocking option. These tools put greater responsibility for avoiding unwanted content into the hands of viewers, especially parents interested in managing their children's viewing. Little-used, they did not quell longstanding concerns among some observers and interest groups about indecent content. In fact, their implementation coincided with a paradoxical surge in complaints and regulatory action against televised indecency.

Previously, concerns had been focused on media other than television. In 1985, a group of women who were spouses of prominent politicians, including Vice President Al Gore's wife Tipper Gore, founded the Parents' Music Resource Center. They led a successful campaign to urge the Recording Industry Association of America to affix "Parental Advisory" labels to record albums and compact disks containing lyrics with profanity or explicit references to sex acts, extreme violence, or substance abuse.[25] In the 1990s, Republican opposition within Congress for federal support for artists whose work some found offensive led to alterations in funding practices at the National Endowment for the Arts.[26] In 1994, after congressional hearings on violence in videogames, game developers formed a trade association, the Entertainment Software Ratings Board (ESRB), which began using an age-based classification system.[27] Complaints to the FCC about radio "shock jocks" led to dozens of fines against radio stations in the 1990s and early 2000s. Then, decency advocates turned their attention almost entirely to television after several high-profile incidents of blurted expletives and partial nudity, on both live and prerecorded programming, in the early 2000s.

The FCC, guided by then-Chair Michael K. Powell, issued a memo known as the Golden Globes Order (2004), specifically in response to Bono's use of the phrase "fucking brilliant" during a live broadcast of the *Golden Globe Awards* in 2003. This order reversed nearly two decades of

policy allowing a hands-off approach to "fleeting, isolated" profanities. Powell's toughened approach was short-lived. In 2007, a federal appeals court struck down the Golden Globes Order, finding the FCC's actions excessively arbitrary. Still, the commission continued to take punitive measures against broadcasters, re-concentrating on prerecorded rather than live programming. In some of the most high-profile cases, the FCC issued a fine in 2006 against a 2004 episode of CBS's *Without a Trace*; it also issued fines in 2008 against a 2003 episode of Fox's *Married by America* and a 2003 episode of NBC's *NYPD Blue*, each of which involved partial nudity and sexual situations. Networks and stations protested in the form of protracted court cases that pitted conservative media-advocacy groups against free-speech proponents and broadcasters against the FCC. Their conflicts played out in orchestrated email campaigns, in congressional hearings, and in mainstream media coverage. The cycle of making and remaking, revising and undoing the indecency policy is one of the conditions of change structuring the medium of television in this period.

The television environment is characterized not only by contention over regulatory goals and procedures but also by changes in the industry. One of the most dramatic changes involves the growth of *choice* in the television marketplace. Regulatory support for new UHF channels and experiments in pay-TV in the 1960s may have only incrementally changed the menu of choices available to most TV-owning homes, but the cable boom that began in the late 1970s constituted a sea change, as channel capacity and the sheer quantity of programming grew exponentially, fragmenting audiences that had once clustered around a handful of channels. The vast majority of viewers of free-to-air broadcasting became subscribers to pay-TV, cable, satellite, and streaming services. It seemed that there would be a niche for every age group, demographic profile, and interest. If audiences could diffuse over dozens (and eventually hundreds) of channels, it would seemingly follow that viewers attracted to edgier fare as well as those committed to more wholesome themes could watch their preferred programs, change channels to avoid unwanted programming, and have little call to complain about what others were watching. But, as I will show, it didn't exactly work out that way. Why hasn't the proliferation of choice—in channels, programs, and providers alike—ameliorated viewers' concerns regarding indecency?

Further transformations took place in the realm of televisual *technologies*. Around 1997, with the introduction and widespread embrace of flat-screen televisions, consumers brought larger and larger screens into their homes.

The transition from analog to digital broadcasting in 2009 pushed more consumers to newer equipment. The replacement and displacement of Cathode-ray sets ensured that most homes, if inadvertently, acquired televisions equipped with the V-chip, mandated for sets built in 2000 or later, to allow consumers to prevent children from watching programming with violent or sexual content. But complaints to the FCC about indecent television skyrocketed in the middle of the first decade of the twentieth century. Why didn't these innovations satisfy advocacy groups and their constituents who were seeking to avoid unwanted programming?

Still other changes in the television environment involved *temporal* qualities of the medium. While the VCR had been around since the 1970s, more recent forms of time-shifting (such as the DVR and burgeoning on-demand video-streaming services) further divorced viewing experience from established broadcast schedules, underscoring the relative rarity of live TV. Internet-based "over-the-top" (OTT) services, such as Hulu or HBOGo allowed "cord-cutting" television audiences to eschew antenna-based broadcasting and subscription-driven cable and satellite contracts entirely. Meanwhile, video-ready smartphones and tablets miniaturized and mobilized access to television and other entertainment. Untethered from predetermined schedules, viewing practices exacerbate the paucity of live programming (with the notable exception of sports), and the use of time-delay equipment mitigates the instantaneity of even those relatively few live genres. Yet, many of the incidents that the FCC's Enforcement Bureau has found indecent took place during live broadcasts. What role does *liveness*, however infrequent, play in the decency debates, as its unpredictability remains a core concern of policymakers and watchdog groups?

In short, TV viewers have access to more channels, more sophisticated delivery systems, and more ways to control when and how we watch than in the medium's first half-century. Television has become bigger *and* smaller—more abundant, more mobile, more time-delayed, and available on more platforms. It is equipped with more surveillance and blocking technologies to help us avoid unwanted programming than ever before. But these new tools and these new ways of distributing and receiving television programming have not staunched complaints that broadcast TV in particular, and pay-TV channels too, contain excessive sexual content, profane language, and other material inappropriate for children.

To be sure, this wave of attention to television and indecency in the early twenty-first century did not unfold singularly; rather, it unfolded

concurrently with wide-ranging campaigns to delimit or surveil all manner of communications, which developed both within and from outside the state. These initiatives range from the National Security Agency's broad authority to intercept electronic communications (established in 2005) to the growth of "big data" industries that mine online activity with increasingly relaxed privacy protections for individual users.[28] They include students' demands for "trigger warnings" on potentially controversial course material and clashes on college campuses over controversial speakers.[29] While these important subjects are beyond the scope of this book, they are, like the debates over decency in media, evidence of an intensely—sometimes, even violently—contested information environment in which some are empowered to speak, others are silenced, and many are tracked and traced. And they are evidence of the urgent need to understand how speech in any form is regulated—by federal law, by voluntary self-censorship, by the chilling effect of bullying, or by any other means.

The Culture Wars and the Decency Debates

It is often assumed that American "culture wars" are fought across generation gaps or along clear left/right, Democratic/Republican axes. In truth, political perspectives that motivate intervention in broadcast regulation are far more complex and sometimes contradictory. For example, an array of stakeholders, including members of both major U.S. political parties, embrace a purported "family values" discourse that legitimates considerable speech restrictions. Debates over "family values"—debates that rage over attempts to define the proper shape and purpose of family and to police its belief systems and practices—are often lumped together under the umbrella term *culture wars* Typically, the term encompasses controversies over the extension of basic civil rights, especially reproductive rights and LGBTQI rights. These culture wars also encompass public-school-centered debates over the veracity of particular scientific teachings in the face of the competing non-scientific ideologies of intelligent design and creationism. Culture-war constitutional debates deal with the meaning of the Second Amendment, the separation of Church and State, and, most relevant to this book, the absoluteness of the First Amendment. For example, is flag-burning permissible? In *Texas v. Johnson*, 491 U.S. 397 (1989), the Supreme Court said that it is. Can a journalist be compelled to reveal her sources? Yes, at times:

the U.S. Court of Appeals for the Fourth Circuit ruled against reporter's privilege in *U.S. v. Jeffrey Alexander Sterling*, 724 F. (2013). Is hate speech protected by the First Amendment? The Supreme Court has ruled, in cases such as *R.A.V. v. City of St. Paul*, 505 U.S. 377 (1992), and *Snyder v. Phelps*, 562 U.S. 443 (2011), that it is. (In many other nation-states, it is not.)[30] Despite these high-court rulings, each of these types of speech remains controversial.

Media watchdog groups such as the Parents Television Council have played important roles in keeping indecency in mass media, among other issues, on the culture-war agenda. Obscenity may be banned, but is indecent speech permissible in mass media? The answer to that question depends on criteria that does not satisfy all stakeholders and has not been applied consistently over time. For example, until the Supreme Court ruled otherwise in *Joseph Burstyn, Inc. v. Wilson*, 343 U.S. 495 (1952), motion pictures were denied First Amendment protections and were vulnerable to *a priori* censorship by local and state censor boards. Not only obscenity, but also indecency and profanity, are still regulated in both broadcast radio and television. However, what might pass for indecency and profanity in broadcasting is legally permissible via satellite radio and cable television. And the internet? An attempt to ban online indecency, which was written into the Communications Decency Act, a component of the Telecommunications Act of 1996, didn't pass constitutional muster and was struck down in *Reno v. ACLU*, 521 U.S. 844 (1997).

I frame the term "culture wars" as so-called, or surround it in scare quotes, to suggest that while it may be a handy hook, it underestimates the complexity of public opinion on an array of issues. It may trivialize the real, material stakes in these issues by falsely cordoning them away from supposedly *non*-cultural issues, presumptively, the state of the economy, national security, and public health and safety. Yet we don't have to dig too deep to find connections between "cultural" and "non-cultural" issues: for example, connections between civil rights and security in employment and housing for LGBTQI people; between the undermining of science education and the hastening of environmental degradation due to climate change denial; between movements to define the United States as a Christian nation and a rising tide of homo- and transphobic, anti-Semitic, and Islamophobic hate crimes in the twenty-first century.[31] As James Davison Hunter writes in his *Culture Wars*, battles, legal and otherwise, over these kinds of issues are not only sectarian conflicts over social mores; they are also bellicose "struggles

for power," or struggles for the control of public discourse and private action: "what seems to be a myriad of self-contained cultural disputes actually amounts to a fairly comprehensive and momentous struggle to define the meaning of America—of how and on what terms Americans live together, of what comprises the good society."[32] In other words, culture matters—and "culture wars" are just politics that some stakeholders try to mask as non-political.

These stakeholders include the elected and appointed officials who make and enforce laws and policy, professionals in impacted industries (for this book's purposes, the media industries), and an array of nonprofit, non-governmental organizations invested in social and cultural issues. Some of these organizations are well known, such as the American Civil Liberties Union (ACLU), founded in 1920. The ACLU is the venerable defender of civil liberties, including free speech, which has frequently chimed in on legal proceedings via friend-of-the-court briefs when First Amendment concerns are at stake.[33] Among organizations that focus more narrowly on media, perhaps the best known are the Media Research Center (MRC) and the Parents Television Council (PTC), both founded by conservative Catholic activist L. Brent Bozell III, in 1987 and 1995 respectively, to conduct research and advocate against indecency in media.[34]

Similarly, the Family Research Council (FRC), founded in 1981 by psychologist and evangelical leader James Dobson, and the National Federation for Decency, founded in 1977 by United Methodist minister Donald Wildmon (later renamed the American Family Association and led by Tim Wildmon), have advocated for media consonant with the values of Christian conservative movements and against programming that it perceives as "attacking traditional family values."[35] Wildmon was also involved in two short-lived organizations, the Coalition for Better Television (cofounded with the Reverend Jerry Falwell and active from 1980 to 1982) and Christian Leaders for Responsible Television. Notably, "family values," as defined by these groups, usually excludes those families whose members include same-sex couples, and some of these groups have campaigned vigorously against marriage equality, the rights of gay parents, and legislation to protect LGBTQI people from discrimination.[36] Their interest in—and criticism of—television are part of these campaigns to scrub the medium of content they object to and to incentivize networks and advertisers to support programming aligned with their own values. Consider FRC president Tony Per-

kins's lament that "lovable" queer TV characters had swayed public opinion toward legalization of same-sex marriage:

> Television shows are full of lovable gay characters, whose dangerous lifestyle is just another funny footnote. Unfortunately for America, those make-believe people are having a real-life impact.[37]

To Perkins, it would seem, TV poses a danger not only to impressionable children but also to adults. Among its dangers is the possibility that it might model acceptance of public diversity instead of prejudice against targeted groups. In this view, a singular vantage point is valued over a diverse marketplace of ideas; ideological speech is favored over free speech.

The First Amendment: Testing the Limits

Although the First Amendment may seem absolute ("Congress shall make no law . . . abridging the freedom of speech"), the prohibition of broadcast indecency is a reminder that there are several kinds of speech that are not protected. It should also serve as a reminder that, with respect to the Constitution, "speech" is broadly defined: it is not confined to the spoken word but encompasses all manner of symbolic communication, including the written word, works of art, and actions of largely symbolic value, such as flag-burning. Electronic media of all kinds, too, are forms of speech. Film, television, web-based video, and other motion-picture technologies may capture images of actions, but obscenity and broadcast indecency laws are generally concerned with the circulation of these images and the contexts in which they are circulated, not with the acts represented. Constraints on various types of speech are not exactly rare, and the definitions of unprotected categories are constantly in flux.

Among landmark First Amendment cases of the early twentieth century were a string of cases in which the Supreme Court took up the task of determining the extent to which subversive speech, in the form of dissent from government interests, is protected. Immediately following the First World War, the Supreme Court heard a string of cases challenging the Espionage Act of 1917. The court held, consistently, that freedom of speech and freedom of the press could be curtailed if they presented a "clear and present

danger." In *Schenck v. United States*, 249 U.S. 47 (1919), for example, the "clear and present danger" to the war effort was the U.S. Socialist Party's distribution of fliers urging men to resist the draft. Another one of these cases, *Abrams v. United States*, 250 U.S. 616 (1919), considered the cases of five men convicted of violating the Espionage Act when they printed and distributed leaflets criticizing U.S. involvement in the First World War. The Supreme Court upheld their convictions, but in an influential dissent, Justices Louis Brandeis and Oliver Wendell Holmes, Jr., preached caution to those who would place limitations on the First Amendment, arguing that only the greatest "emergency . . . warrants making any exception to the sweeping command, 'Congress shall make no law . . . abridging the freedom of speech.'"[38]

Pivotal mid-twentieth century cases took up some of the same issues. In these cases, the courts began to move away from the "clear and present danger" test, applying instead a "balancing test" that weighs the cost of restraining speech (or other rights) against potential harm. Still, the scales often tipped in favor of permitting some limits on the First Amendment, when harm appeared to outweigh the costs of those limits. Here, during the peak of the "red scare" that flourished during the early years of the Cold War, the McCarthy-era judiciary frequently found that perceived threats to the nation trumped the rights of individual speakers to say what they wanted to say—or the rights of those speakers to refuse to speak, in some instances. The Supreme Court's decision in *American Communications Association (ACA) v. Douds*, 339 U.S. 382 (1950), sustained a requirement in the 1947 Labor Management Relations Act (known as the Taft-Hartley bill) that union leaders take an oath declaring their opposition to Communism. Likewise, in *Dennis v. United States*, 341 U.S. 494 (1951), the U.S. Court of Appeals for the Second Circuit upheld the conviction of several members of the U.S. Communist Party for plotting to overthrow the federal government. Writing the decision in *Dennis*, Judge Learned Hand appeared to favor a balancing test, arguing that the "gravity of the 'evil'" must be significant enough to warrant any "invasion of free speech as is necessary to avoid the danger."[39] Clearly, in this case and others, the judiciary saw the threat of Communism as sufficient cause to curtail speech rights.[40]

Almost two decades later, in *Brandenberg v. Ohio*, 395 U.S. 444 (1969), the Supreme Court took a different tack, specifying that to ban speech, the threat posed by it must not only be "clear and present" but "imminent."[41] The ruling struck down Ohio's criminal syndicalism statute barring advocacy of violence, under which a Ku Klux Klan leader had been arrested. In

this case, the court found the Klan's rhetoric insufficiently threatening to justify limiting the speaker's rights. If the decisions in *Schenck*, *ACA*, and *Dennis* suppressed dissent by restricting speech, the *Brandenberg* ruling had its own ominously reactionary overtones (i.e., granting protected status for the kind of subversion promoted by the white supremacist KKK but not for the criticisms of U.S. policy levied by the American Communist Party or anti-draft pacifists). The decision leaned toward First Amendment absolutism, a position typically associated with both right- and left-wing civil libertarianism, in allowing speech that is disturbing or hateful. No one ever said that robust free speech would be comfortable.

While the evolution of "clear and present danger" and "balancing tests" are a logical place to observe judicial thinking about the extent of free speech, there are other categories of speech that are routinely excluded from First Amendment protection. For example, commercial speech (such as tobacco, alcohol, or pharmaceutical advertising) has limited First Amendment protection.[42] Nor is defamation, which involves false statements about an individual or group by means of the spoken word (slander) or in publication (libel), protected.[43] Historically, it has been difficult for individuals to press libel suits against publishers because the courts have given the press wide latitude under the First Amendment to publish information that may be unflattering or embarrassing to public figures, so long as it is factually accurate. However, some recent cases, including one involving the celebrity and media news blog Gawker, which released a sex tape involving Terry Gene Bollea (who is more commonly known as the professional wrestler Hulk Hogan) and Heather Clem, who was then married to radio personality Bubba the Love Sponge (Todd Alan Clem), suggest that some courts may be willing to subordinate freedom of the press to the right to privacy under certain conditions.[44]

Another type of speech that is not protected by the First Amendment is obscenity, and it has been subject to legislative efforts to define and contain it since the eighteenth century. Under the influence of English common law, Massachusetts (both as a colony and a post-independence commonwealth) and Pennsylvania (in the early nineteenth century) sought to ban obscenity in art and literature for the purpose of protecting the morals of their citizens, especially "youth."[45] At the federal level, the U.S. Congress first legislated against obscenity in 1842, but the law was weakly enforced.[46] It was strengthened in 1865 to quash the fad for sending erotic materials to Union soldiers during the Civil War, criminalizing use of the postal service to mail

"obscene, lewd, or lascivious" publications.[47] The Comstock Act of 1873, which essentially reiterated the 1865 law, energized a movement to enforce obscenity prohibitions and was applied so broadly that some dealers in well-known works of art and literature were subject to obscenity charges.[48] The act also prevented shipments of birth control devices and information about birth control or abortion.[49] The Comstock Act was named for its author Anthony Comstock, a dedicated (one might say obsessed) anti-obscenity campaigner and the founder of the New York Society for the Suppression of Vice, who became a U.S. postal inspector. Before the nineteenth century came to a close, federal courts affirmed the constitutionality of the Comstock Act in rulings that upheld the convictions of individuals who had sent supposedly obscene material through the postal service, borrowing a method for defining obscenity, known as the Hicklin test, from English law. According to that test, if *any portion* of the material in question may "deprave and corrupt those whose minds are open to such immoral influences," then it is indeed obscene—and therefore a kind of unlawful speech unprotected by the U.S. Constitution.[50]

The courts began to abandon the Hicklin test, and parts of the Comstock Act began to fall in the 1930s.[51] Then *United States v. One Book Called Ulysses*, 5 F. Supp. 182 (S.D.N.Y. 1933), in the U.S. District Court for the Southern District of New York, determined that for content to be found obscene, an entire work must be obscene, not simply isolated passages. The case began when, in 1933, Bennett Cerf of Random House, having recently secured the rights to publish an American edition of *Ulysses* by James Joyce, tried to bring a copy of the first edition of the book into the United States. Customs confiscated the book. The publisher challenged. Judge John M. Woolsey, writing the decision for the court, declared that the book was not obscene because it was not obscene *as a whole*.[52] The decision set a new standard for determinations of obscenity, influencing subsequent cases to consider works in their entirety and not only decontextualized fragments. It freed Random House to publish the first U.S. edition of *Ulysses* in 1934.

Still, it would take until after the middle of the twentieth century for the courts to take significant further action to remake the parameters of what could be found obscene. First, in 1957, *Roth v. United States*, 354 U.S. 476, the Supreme Court upheld convictions of booksellers in both New York and California who had sent materials believed to be obscene through the mail, but following *One Book Called Ulysses* and other similar cases, it definitively jettisoned the Hicklin test. Justice William J. Brennan, Jr., authored the deci-

sion, which defined obscenity as occurring only if "to the average person, applying contemporary community standards, the dominant theme of the material, *taken as a whole*, appeals to prurient interest" (emphasis added). At the same time, *Roth* affirmed that such a work—one that is obscene in its entirety—is not protected by the First Amendment:

> All ideas having even the slightest redeeming social importance—unorthodox ideas, controversial ideas, even ideas hateful to the prevailing climate of opinion—have the full protection of the guaranties, unless excludable because they encroach upon the limited area of more important interests; but implicit in the history of the First Amendment is the rejection of obscenity as utterly without redeeming social importance.[53]

In *Roth*, the majority of the court's justices may have held that obscene materials are "utterly without redeeming social importance," but they would soon begin to elevate the individual's (at least, the adult individual's) right to privacy—in terms of the private enjoyment of such unredeeming works—over the state's interest in banning obscenity entirely. Within a few months of *Roth*, the Supreme Court overturned a Michigan statute banning distribution of publications to *anyone* if that material is "obscene, immoral, lewd, or lascivious" on grounds that the law violated the Due Process Clause of the Fourteenth Amendment, which, among other things, prevents states from delimiting federally guaranteed rights. Since the purpose of the Michigan statute was the protection of minors, writing in *Butler v. Michigan*, 352 U.S. 380 (1957), for the majority, Justice Felix Frankfurter famously declared that such a law would "burn down the house to roast the pig," and "reduce[s] the adult population ... to reading only what is fit for children."[54] Importantly, then, the case allowed that material suitable for some audiences may not be suitable for all audiences. *Stanley v. Georgia*, 394 U.S. 557 (1969), continued to press obscenity law in this direction, striking down state laws that made it illegal to possess obscene materials in one's own home.

In 1973, in *Miller v. California*, 413 U.S. 15, the Supreme Court once again attempted a definition of obscenity, this time elaborating on the definition offered in *Roth*. The new definition depended on whether a work qualifies as obscene through application of a three-pronged test: "(a) whether 'the average person, applying contemporary community standards' would find that the work, taken as a whole, appeals to the prurient interest ... (b) whether the work depicts or describes, in a patently offensive way, sexual

conduct . . . and (c) whether the work, taken as a whole, lacks serious literary, artistic, political, or scientific value."[55] The court took the first prong directly from *Roth*; the third prong, which originated in the *Miller* decision, is often referred to, by acronym, as the SLAPS (serious literary, artistic, political, or scientific) test. This ruling set a relatively higher bar for labeling a work of art, a piece of literature, a film, or any other medium as obscene, while still maintaining that the First Amendment does not protect obscene materials. In doing so, the court left open the possibility that states or local jurisdictions could regulate obscenity without banning it entirely, typically through the use of zoning ordinances that either cluster businesses specializing in adult entertainment or through mandates that such businesses operate at specified distances from schools.[56] *Miller* also affirmed *Roth's* emphasis on the application of community standards so that such regulations may vary from place to place.

Because the court has ruled that obscenity is not protected speech, the FCC has the constitutional authority to ban it entirely. And when the medium involved is broadcast radio or TV, the courts have affirmed repeatedly that the FCC is within constitutional bounds to also regulate indecency. In the case involving WBAI's broadcast of a recording of George Carlin's "Filthy Words" one afternoon in 1973, the Supreme Court upheld the FCC ban on indecency because children would likely have been in the audience. The FCC declared the broadcast indecent, and WBAI's owner, the Pacifica Foundation, appealed the case all the way to the Supreme Court. *FCC v. Pacifica Foundation*, 438 U.S. 726 (1978), affirmed a definition of indecency that includes "language or material that, in context, depicts or describes, in terms patently offensive as measured by contemporary community standards for the broadcast medium, sexual or excretory organs or activities."[57] Ever since, the commission, Congress, watchdog groups, and broadcasters themselves have wrangled over the definition of indecency—and over the times when children could be expected to be in the audience. Nevertheless, the same definition was proffered more than two decades later, in an FCC policy statement intended to clarify its indecency policy in 2001, and the Supreme Court yet again declared the FCC's capacity to develop and enforce a broadcast indecency policy constitutional as recently as 2012.[58]

In cases addressing each of these kinds of incursions on First Amendment protections, courts have historically agreed that it is in the government's interest to favor its own interests. In the case of obscenity, one's right to avoid stumbling across obscenity *in public* is protected, and the state regards its

interest in protecting children from exposure to obscenity as paramount. The courts have considered these conditions to be so critical that they have made clear, again and again, that obscenity is a form of speech not protected by the First Amendment. In the case of indecency, likewise, the courts have found sufficient governmental interest in protecting individuals (especially but not only children) from indecent sexual or excretory material *not only in public, but also when it appears on TV screens in the privacy of our own homes,* so that the FCC's indecency policy stands. That is, the First Amendment is absolute, except when it isn't. Recall the text of the amendment, in its entirety:

> Congress shall make no law respecting an establishment of religion, or prohibiting the free exercise thereof; or abridging the freedom of speech, or of the press; or the right of the people peaceably to assemble, and to petition the Government for a redress of grievances.

About that freedom of speech clause? "Congress shall make no law . . . abridging the freedom of speech"—except for when it shall. Except for when speech may incite violence or subvert government interests. Except when speech is defamatory. Except when speech violates another's privacy. Except when speech is obscene, and sometimes when it is indecent.

This book enters an already substantial conversation on the regulation of broadcasting. A few closely related volumes have informed my own thinking. *Saturday Morning Censors* by Heather Hendershot (1998), which illuminates debates over regulating children's TV through the 1990s, is among them. While I am careful to distinguish, as needed, between prior-restraint ("*a priori*") censorship and other speech-regulating mechanisms, I recognize, alongside Hendershot, just how blurry the line is between censorship and the chilling effect of those regulations: "on a practical level, regulation and censorship are often indistinguishable."[59] Even in the absence of censorship *de jure* (that is, the legally permissible prior restraint of speech), regulatory policy can create conditions of *de facto* censorship, among them self-censorship and censorship resulting from market forces, such as advertisers' resistance to controversial material. As well, the networks strive to insulate themselves from legal quagmires and financial penalties. To that end, their "standards and practices" offices, known in early radio and TV as offices of "continuity acceptance," scour scripts for legal concerns, including indecency, and are referred to colloquially as the "censors."[60]

Hendershot opens her book with these lines:

> Censorship is usually understood as prohibition: censorship forbids, obstructs, denies vision. It functions like a blindfold or a pair of scissors. This concept of censorship is misleading. In actuality, censorship does not just cut out images, sounds or text whose politics censors object to. The act of censorship is a *social process* through which the politics of class, race, gender, violence, and other potentially "problematic" issues are deconstructed and reconstructed, articulated and scotomized.[61]

Censorship, then, creates as well as obliterates. It reveals the borders of the allowed and the disallowed, the liminal edges of sanctioned discourse. If the word *sanctioned,* in this context, brings ambiguity to the previous sentence, it should. After all, the verb *to sanction* means both to penalize and to approve; the noun *sanction* means both a deterrent and permission. The intrinsic paradox in this term calls up precisely the dual function of censorship as both productive and repressive, or, in Hendershot's words, both "forbidden and tolerated."[62]

Raiford Guins, in *Edited Clean Version* (2009), also makes clear that censorship by any other name still amounts to censorship. In his analysis of "control technologies" that track, block, filter, or edit content in markets for recorded music, home video, and video games, Guins shows how devices such as the V-chip and web filters are "layers of censorial practices and processes that transform the television [or other media] into a self-governing device and further a neoliberal investment in the self as a deregulatory political agent."[63] As such, incorporated into hegemonic systems of control, the subjects of power become its enforcers. Partners-in-censorship—be they government agencies, corporations, advocates, or consumers—assign not only regulatory discipline but also familial duties to control technologies, as so-called parental controls often offload decisions about what is appropriate for children to pre-packaged algorithms. Borrowing from Nikolas Rose's formation of "governing at a distance," Guins calls this function *"parenting* at a distance," a vivid descriptor of the diffusion and proliferation of mechanisms of control.[64]

That mechanisms of control—from ratings and warnings to V-chips, blocking, bleeping, and filtering devices—are integrated throughout electronic media systems is clear. But *why*? It may seem commonsensical that decency crusaders from Anthony Comstock in the late nineteenth century to Michael K. Powell and Kevin J. Martin, both FCC chairmen in the early

twenty-first century, would seek to protect children from inappropriate material. But what material is inappropriate, who makes that determination, and how is it enforced? Marjorie Heins's *Not in Front of the Children* considers the ideology of innocence in rationales for regulation of content in public-school sex-education curricula, art, literature, and mass media of all kinds. She demonstrates that battles over appropriate and inappropriate content are historically and culturally context-specific; moreover, they are frequently premised on evidence that is methodologically suspect or inconclusive, incorrectly interpreted, or otherwise sorely lacking. (Further, much of the data on media effects comes from studies of exposure to violent media, which does not necessarily illuminate the effects of exposure to sexual content.[65]) To give one far-from-unique example: Heins describes how the "preliminary and tentative" findings of the 1972 Surgeon General's report *Television and Growing Up* were erroneously touted by Senator John Pastore (D-RI) in Senate hearings as hard evidence of the dangers posed by television to children. Deliberate omission of opposing viewpoints in the 1982 follow-up report *Television and Behavior* by the National Institute of Mental Health produced similar distortions.[66] Heins reminds us that political winds can blow off nuanced, factual information and reasoned debate: "by the 1990s," she writes, "it was politically almost untenable to question the claim that media violence has been proven to have dire effects on youth."[67] The result? A new raft of parental controls mandated by the Telecommunications Act of 1996 and a brewing tempest over indecency in media that would peak early in the twentieth century.

I follow Heins's claims that the "harm to minors assumption" is widespread, that it is a strongly held belief across political spectra, and that it is inconsistently supported by scientific evidence.[68] I also recognize that the very notion of "media effects" is, as Heins says, "too often posed in 'either/or terms'": either media, everywhere and always, produces negative effects, or it does not.[69] The truth is, of course, far more complex. As Heins continues, "Rarely do the debaters note that the same work may induce imitation in some viewers and catharsis in others—or that the same person may respond differently to different violent or sexual content."[70] (Not to mention the vast amounts of media to which we are exposed that leave us indifferent.) These assumptions about the effects of media, which drive the actions of media advocates and regulators, are the subject of this book.

Chapter 1 explores historical attempts to regulate obscene or indecent content in media that preceded television as well as the foundational policies

of broadcast regulation that have pertained to both radio and television. The foundations of obscenity and indecency regulation date back to at least as far as the Comstock Act of 1873. Like proponents of the Comstock Act, the censor boards that policed early cinema presumed that indecent material in any medium could do great (if unspecified) harm to public morals, especially to children. To stave off the censors and other critics, the motion-picture industry developed mechanisms of self-regulation in the form of the Production Code, enforced starting in 1934. Similarly, by 1929, the National Association of Broadcasters issued a Code of Ethics for radio stations, followed by a Code of Television Standards in 1951 as the new medium became established. These codes governing movies, radio, and television may have eventually fallen by the wayside, but the concerns of federal regulators and media advocates would continue to encourage ways of promoting decency in programming, especially in broadcasting. Starting in the 1970s, the FCC would take action against radio broadcasts determined to be indecent with some regularity; against TV broadcasts, punitive regulatory action remained scant. Attempts to establish "family viewing hours" in the 1970s and 1990s failed, but a "safe harbor" settled into place. These developments established the terms of indecency policy and enforcement going forward, policy that would impact TV and radio broadcasters alike.

Chapter 2 takes up the history of indecency and broadcast-television regulation after 1996, recounting the key incidents, policy shifts, and court decisions that made broadcast indecency front-page news in the early 2000s and kept the matter on the agendas of free-speech groups, conservative media-advocacy groups, media-industry trade organizations and the trade press, and Congress for years to come. Key precedents took place in little known cases, the first involving episodes of a Spanish-language variety show called *No Te Duermas,* broadcast in 2000 from Telemundo's WKAQ in San Juan, Puerto Rico; the second, in 2002, involved an instant of partial nudity on KRON's morning newscast in San Francisco. Soon after, in 2003 and 2004, when celebrities blurted expletives on several live awards shows, media-advocacy groups, foremost among them the Parents Television Council, were poised to flood the FCC with complaints. The FCC and Congress moved to crack down on broadcast-TV indecency, and the networks rallied to protest that crackdown. This chapter tracks these cases, and others, as they proceed through the courts, as well as the revisions to the indecency policy that resulted.

In chapter 3, I consider the central problem of *choice* in the medium of television and its relationship to the decency debates. Since around 1980, the number of channels and available channels has skyrocketed. But the increasing ubiquity of choices in the television marketplace has not assuaged anxiety over the potential for viewers, especially children, to encounter unwanted content. Indeed, concerns over indecency and profanity have paved the way for *constriction* of media environments through channel-blocking, the V-chip, and proposed à la carte cable models. Do these tools serve or disserve the historic mission of broadcasting to operate as a "vibrant marketplace of ideas"? Do they protect consumer sovereignty and leave diversity to market forces? This chapter scrutinizes the rollout of these technologies and their effect on the availability of information and the diversity of programming, outlets, and viewpoints.

Chapter 4 explores indecent language in terms of television's *temporal* dimension. The pervasive liveness of TV's first decade has long been a thing of the past, with live broadcasting now reserved for sports and a few other event-oriented genres, phenomena that have been explored by television theorists from David Antin to John Thornton Caldwell. As well, viewers employ time-shifting television technologies—the VCR, the DVR, and on-demand streaming—to access programming that disregards network schedules. Even time delays of a few seconds unsuture putatively live TV from televised events. Nevertheless, broadcasting's occasional liveness continues to shape decency regulations. The chapter includes both a taxonomic schema of types of televised profanities, scripted and unscripted, bleeped and unbleeped, as well as a textual analysis of specific profane utterances that captured the attention of media watchdogs, the FCC's Enforcement Bureau, and mainstream media. I understand these expressions as a form of disavowal, taking place in what Sigmund Freud called "joke-work," and, in their repetition, I understand them to be what Herbert Marcuse referred to as "repressive desublimation." In each instance, transgression is partial, recoiled, and ultimately commodified. Some incidents seem to offend more than others, implicating contextual factors such as the genre of programming and the gender of the performer; this chapter explores (and the book is informed throughout by) the role of gender and sexuality in the definition and enforcement of decency policies.

Chapter 5 asks what happens when complaints about indecency are lodged against programming that is not governed by the FCC's indecency

policy. As it turns out, sometimes complainants and their allies find innovative means of taking action against programming they find offensive. In the year 2000, a district attorney charged a performer on Grand Rapids public-access cable with indecent exposure, the first time such a law had been applied to a televisual representation, tantamount to creating a kind of "shadow policy" to allow for punitive action when established policy is more lenient than members of a particular community might wish. Conviction of the performer in this case depended on the court's understanding of the television screen as a public place, even when viewed in one's own home. In part, conviction hinged on concerns that the sheer size of the screen image and the duration of the shot could render a televisual exposure more shocking and threatening than an incident of indecent exposure in a park or on a street corner. Rejection of Huffman's appeal also depended on the judiciary's exploitation of the concept of TV as a "window on the world," constituting a porous border between public and private spheres.

The conclusion of this book considers the future of broadcast indecency policy, in light of ever-shifting political winds, especially the results of the 2016 presidential election and new leadership at the FCC. Powerful conservative and libertarian movements may prove to have paradoxical impact and irreconcilable goals, as one calls for stricter indecency regulation and the other flaunts regulations of many kinds. How do we face a future in which some forms of news media must censor political speech in order to avoid potential fines from a federal agency whose leadership is appointed by those very speakers whose speech is, at times, unbroadcastable? More than ever, it is urgent for us, as media consumers and as citizens, not only to *tolerate* free speech when it is uncomfortable, not only to *defend* protections for free speech, but to *demand* them and to *respond* to speech that is hateful, false, abusive, or discriminatory. The frankness, veracity, and transparency of information in the media environment depends on it.

1

A Brief History of Indecency in Media in the Twentieth Century

> We cannot allow any single person or group to place themselves in a position where they can censor the material which shall be broadcast to the public, nor do I believe that the government should ever be placed in a position of censoring this material.
> —Herbert Hoover, 1924

On Tuesday, May 26, 1987, KZKC-TV showed a movie called *Private Lessons* (1981) in the prime 8:00 to 10:00 P.M. time slot. The film, a comedy directed by Alan Myerson, is about a blackmail plot that involves a housekeeper's seduction of her employer's fifteen-year-old son. When the movie was released theatrically, the Classification and Rating Administration (CARA) of the Motion Picture Association of America (MPAA) had rated *Private Lessons* "R—Restricted—Under 17 Requires Accompanying Parent or Adult Guardian." It wasn't the first time that KZKC, an

independent station in Kansas City, Missouri, had shown an unedited or lightly edited R-rated film, and it was not uncommon for the station to receive ten or twelve letters of complaint when one of these films contained sexual themes or a bit of partial nudity.[1] But this time, one complainant didn't simply notify the station that she found the film inappropriate for primetime. A member of the local chapter of the National Federation for Decency, she videotaped the film and submitted a complaint to the Federal Communications Commission (FCC).[2]

In January 1988, the FCC announced that it would investigate the broadcast. *Kansas City Star* television critic Barry Garron responded in a barbed column:

> Hallelujah and pass the hypocrisy!
>
> It should be a particularly interesting investigation, because other TV stations throughout the country have shown uncut R-rated films for years without any FCC interference, and because the FCC apparently has expressed no interest in the many other R-rated films Channel 62 has shown in the past.
>
> The FCC has a quaint idea of what is indecent. When a Dodge City, Kan., station broadcast racist and anti-Semitic diatribes, the commission found no indecency. When a Utah station last year devoted hours a day to a white supremacist, that, too, was not indecent, according to the FCC.
>
> Now the FCC is saying it is perfectly all right to expose children to the rantings of racists and bigots but downright harmful for them to catch a brief glimpse of a naked body. . . . Maybe it has come to believe that censorship of what a few may believe to be naughty is how best to serve the nation.
>
> Now isn't that indecent?[3]

Garron showed no mercy for a system that would take punitive action against a somewhat risqué movie while protecting niches in which hate speech could flourish unfettered. Apparently, officials at the federal agency charged with regulating indecency in broadcasting didn't see the irony. Even if they did, they were only empowered to take action against broadcasts that included, as per revised indecency enforcement standards issued by the FCC in 1987, "language or material that depicts or describes, in terms patently offensive as measured by contemporary community standards for the broadcast medium, sexual or excretory activities or organs."[4] On June 23, 1988, the FCC issued a notice indicating that it had found

KZKC responsible for broadcasting indecent material and would fine the station $2,000.

This case should raise questions for anyone interested in the extent to which the federal government can or should regulate speech. Among them: (1) Since the material in question was not actually obscene, how can the courts and Congress justify policies permitting the FCC to take punitive action against the station that aired it, given the broad protections of the First Amendment?[5] (2) Does one complaining viewer constitute an indication that the broadcasted film was "patently offensive"? Regarding the first question, the FCC's authority to restrict and take punitive actions against indecent broadcasts is derived from the legacy status of broadcasting as a public trustee of the airwaves with unusual obligations. Indecency law does not pertain to other media—not print, recorded music, cable TV, or internet-based content. As for the second question, the "community standards" component of the indecency policy is regularly criticized as vague, subjective, and abstract. After all, who is to say what "community standards" are? KZKC's program manager told the *Kansas City Star* that while it received a dozen phone calls complaining about its broadcast of *My Tutor* (1983), a film with themes similar to those of *Private Lessons* and aired the previous evening, two callers told the station they had over-edited the film: "They knew we had cut quite a bit out."[6] In a nation as diverse—and, in many regards, as divided—as the United States—it would be more accurate to say they we constitute *communities*, plural and comingled, and that, therefore, a single standard is elusive.

Further answers to these questions can be found by exploring the history of attempts to regulate television content. In this chapter, I examine a handful of key concepts, focusing on pre-1996 phases of decency regulation: the television industry's own codes of ethics and their key precedents in film and radio; self-regulation and the Family Viewing Hour; the impact of the *FCC v. Pacifica* ruling and the "safe harbor." These concepts are entangled, and their histories are overlapping. The history of television regulation is not entirely separable from the history of attempts to regulate radio programming, because the same FCC policy pertains to both forms of broadcasting. Accordingly, I will discuss some pertinent radio cases but keep my emphasis on TV.

While readers may hope for a tidy, linear history, making sense of these cases defies strict chronological impulses. Each case moves along a trajectory

marked occasionally by the fits and starts of flaring campaigns, at other times by recession into the background, and often by the slow grind of bureaucratic and corporate *pas de deux* that take place in courtrooms and offices largely off of the public radar.

The Television Code and Its Precedents

People have fretted about seeing human flesh and hearing unsavory dialogue on television as long as there has been television. And by no means was television the first medium to arouse such fears. By 1907, the then-new medium of cinema prompted enough concern from both non-secular (mainly Protestant) groups and secular organizations devoted to social reform to support the founding of censor boards in cities and states throughout the United States, beginning in Chicago.[7] The Supreme Court legitimated film censorship in 1915 in the landmark case *Mutual Film Corporation v. Industrial Commission of Ohio*, which essentially deprived the movies of full First Amendment protections. Writing for the majority of the court, Justice Joseph McKenna asserted that "moving pictures ... [are] capable of evil, having power for it, the greater because of their attractiveness and manner of exhibition," and that audiences for the movies, which were "not of adults alone, but of children, make them the more insidious."[8] Without hesitation, the Supreme Court affirmed that states and municipalities could operate censor boards empowered to exercise prior restraint (that is, to suppress entire films or demand excision of particular scenes within films before they were screened), a kind of *a priori* censorship that would have been unconstitutional if the medium in question were newspapers or magazines.

Censors were interested in preventing a range of behaviors from appearing in cinema and used a variety of means to do so. For example, boxing films became controversial, especially in the American South, when the outcomes of the fights offended white supremacists. The states of Arkansas and Tennessee banned films of the African American boxer Jack Johnson defeating white opponents, including *Johnson-Jeffries Fight* (1910). In 1912 Congress passed the Sims Act, named after its primary sponsor, Representative Thetus Willrette Sims (D-TN), which made it illegal to transport boxing films across state lines. The law was repealed only in 1940.[9] While the Sims Act impeded distribution of films that defied Jim Crow-era ideologies of white superiority and racial segregation, in many ways, the most

widespread and persistent concern about the movies was how they treated sexual subjects.

Time and time again, early films displaying the (usually female) body or addressing sexual subjects were vulnerable to censorship, morality campaigns, bans, even occasional arrests of theater operators. This was the case for films as different as *The Unwritten Law: A Thrilling Drama Based on the Thaw White Case* (1907), a true-crime drama based on a much-publicized sex scandal; Lois Weber's *Where Are My Children* (1916), a melodrama with themes including access to contraception, abortion, and the eugenics movement; and *Purity* (1916), in which Audrey Munson played an artists' model and posed in the gauzy nude.[10] As film scholar Lee Grieveson observes, the reason for this is not simple prudishness, but rather,

> Sexuality exists at the interface between the individual body and the social body; thus, individual sexual and reproductive conduct interconnects with issues of national policy and power. Legislation directed against prostitution, venereal disease, and "white slavery," the forced abduction of white women into prostitution, made this connection particularly clear.[11]

Then as now, controversies over glimpses of human flesh and treatments of sexual behaviors, whether salacious or sensitive, erupted as part and parcel of larger social debates over women's control over their own bodies—just as the ban on boxing films was part of the powerful and racist discourse on the control of black men's bodies.

The Supreme Court bolstered the authority of the censor boards to cut or ban such films in the 1915 *Mutual* decision. Seeking to ameliorate the power of the censor boards, the movie industry developed self-regulating strategies. Under Will H. Hays's leadership, the Motion Picture Producers and Distributors of America (MPPDA) launched a voluntary script-reviewing system called "The Formula" in 1924, followed in 1927 by Hays's "Don'ts and Be Carefuls" and by the Production Code in 1930, authored by film magazine publisher Martin Quigley and Jesuit priest Daniel A. Lord.[12] The Hollywood studios did not embrace these guidelines until 1934, when they agreed to strict enforcement of the Production Code in order to avert threatened boycotts by the Catholic Legion of Decency and other groups. The MPPDA established the Production Code Administration (PCA) and named Joseph I. Breen to enforce the code, which assigned (or denied) a seal of approval to each film before it went into distribution.

Eventually, the authority of the PCA and the local censor boards to approve, disapprove, or alter films began to wane in light of the 1952 Supreme Court case *Joseph Burstyn, Inc. v. Wilson*.[13] In what is often known as the "*Miracle* decision" after the 1948 film directed by Roberto Rossellini at the heart of the case, the court reversed the 1915 *Mutual* decision that had essentially denied motion pictures First Amendment protections.[14] The Supreme Court's decision in *Freedman v. Maryland* (1965), a case in which a film exhibitor challenged his state censor board's power to ban films, assured that any remaining censor boards would soon be dismantled.[15] Likewise, the movie industry's trade association, by now renamed the Motion Picture Association of America, eventually abandoned the Production Code. In place of the censors and the code, the MPAA launched an age-based classification system in 1968.[16]

Despite the censor boards, motion pictures remained a wildly popular form of entertainment even when radio broadcasting emerged in the 1920s. Secretary of Commerce (and later U.S. President) Herbert Hoover, who was instrumental in developing a regulatory apparatus for radio, opposed imposing potentially censorious forms of regulation on radio.[17] However, the then-new medium was not immune to legislation shaping not only the structure of the industry (in the form of licensing requirements and ownership rules) and its technical specifications (frequency allocations, for example), but also its programming. According to the Radio Act of 1927:

> Nothing in this Act shall be understood or construed to give the licensing authority the power of censorship over the radio communications or signals transmitted by any radio station, and no regulation or condition shall be promulgated or fixed by the licensing authority which shall interfere with the right of free speech by means of radio communications. No person within the jurisdiction of the United States shall utter any obscene, indecent, or profane language by means of radio communications.[18]

In other words, the Federal Radio Commission (FRC) couldn't prevent broadcasters from saying what they wanted to say over the airwaves. Except when it could. And in the case of "obscene, indecent, or profane language," the Radio Act of 1927 decreed that it could.

Radio networks and stations, the National Association of Broadcasters (NAB), free speech advocates including the American Civil Liberties Union (ACLU), and government agencies began to tangle over exactly what that

passage of the Radio Act of 1927 meant almost immediately. Industry leaders such as NBC founder David Sarnoff questioned the authority of the federal government to regulate radio at all and charged that regulation of any kind provides a platform, ultimately, for censorship: "I believe that a free radio and a free democracy are inseparable; that we cannot have a controlled radio and retain a democracy; that when a free radio goes, so also goes free speech, free press, freedom of worship, and freedom of education."[19]

Even though radio was not subject to the extreme measures of censor boards that previewed and frequently altered movies before they were shown in movie theaters, radio broadcasters, like the motion picture industry, adopted a code of self-regulating standards. In 1929, the NAB released its first Code of Ethics. The *New York Times* announced, "Putting a stop to broadcasting offensive matter and fraudulent advertising is the objective of the ethics code. It sets forth that no matter barred from the mails shall be broadcast."[20] In this way, the NAB echoed the Comstock Act of 1873, which banned the mailing of any "obscene, lewd, or lascivious" material.[21] If something couldn't be sent through the mail, decision-makers at the broadcasting trade organization reasoned, why should it be transmitted over the airwaves?

Nevertheless, many of the Comstock Act provisions did not survive the 1930s.[22] Mechanisms of regulation and self-regulation were adjusted accordingly. As Victorian-era prohibitions weakened, organizations such as the NAB re-articulated their standards. The Radio Code was revised several times. By the time the 1939 version, simply known as The Code of the National Association of Broadcasters, was released, most of its admonitions in regard to the moral content of broadcasts could be found in a section on children's programming, which reminded stations that such programming should model "respect for parents, adult authority, law and order, clean living, high morals, fair play and honorable behavior," and advised them to reject advertising not up to "Accepted Standards of Good Taste."[23] On the whole, the document is more concerned with avoiding partisanship in discussions of issues of public interest, limiting the number of advertisements per minute, and barring fraudulent ads than with indecency.[24]

When, during and immediately after the Second World War, the FCC grappled with complaints that indicated audiences were not uniformly satisfied with the ways in which broadcasters and advertisers addressed their concerns, the commission produced the report *Public Service Responsibility of Broadcast Licenses* (1946), commonly known as the Blue Book, to clarify public-interest obligations. In short, the Blue Book set policy requiring

license holders to produce local programming, to air sustaining (noncommercial) programs and programs on public affairs, and to limit the amount of advertising. While many observers greeted the report enthusiastically, some broadcast-industry representatives found it to be excessively proscriptive: the premiere trade publication *Broadcasting* started referring to the industry's regulatory agency as the "Federal *Censorship* Commission."[25] On the whole, however, the report has little to say about standards of decency and mechanisms for taking action against indecency.

Soon after, as the new medium of television started to become widely available, concerns about its potential to debauch surfaced quickly. As early as 1950, Senator Estes Kefauver (D-TN) and Representative Ezekiel Candler Gathers (D-AR) convened congressional hearings that excoriated broadcasters who aired game shows, variety shows, and talk shows featuring women in gowns with "plunging necklines."[26] In the early 1950s, the secular Parent-Teacher Association and an array of Roman Catholic groups—including the National Council of Catholic Women, the Legion of Decency, the National Catholic Welfare Conference, and the National Council of Catholic Men, along with leading figures such as Cardinal Francis Joseph Spellman of New York and Martin Quigley, co-author of the MPPDA's Production Code—considered how they might influence television content.[27] Although these groups did not succeed in setting up their own system for rating TV programming, as the Legion of Decency had with motion pictures, some did advocate for the television industry to develop its own self-regulating rules.[28] With so much negative attention focused on this new and growing medium, the trade organization now known as the National Association of Radio and Television Broadcasters (NARTB, though it would later revert to its original name, NAB) issued the Code of Television Standards in March 1951, setting professional guidelines intended to stave off governmental regulation. The TV Code encouraged "decency and decorum" and declared that "profanity, obscenity, smut and vulgarity are forbidden."[29] Still, it left these terms undefined.

In some ways, the TV Code seems to have taken its cue from the movie industry's Production Code, rather than from the Radio Code, in terms of the kinds of material cited as potentially problematic. This is, perhaps, because TV shares with the movies the risk of *showing* its audiences the particulars of, say, a lock being picked, or human nudity, while radio has only to grapple with the extent of its descriptions of controversial material.[30] In any case, the TV Code mandated that alcoholic beverage use, illicit drug use,

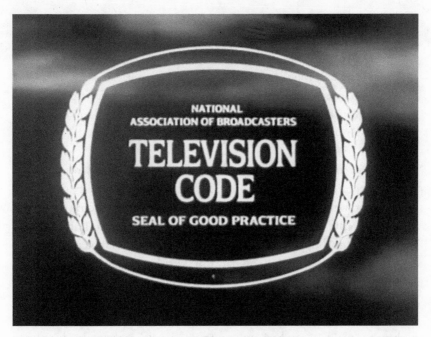

FIG. 2 One of several versions of the "seal of good practice" indicating that a program met criteria established in the National Association of Broadcasters' Television Code (c. 1967).

gambling, and divorce should be "deemphasized," "presented with discretion," and "not treated casually nor justified"; criminal acts should be condemned, and criminal techniques should never be shown "in such detail as to invite imitation"; costumes, choreography, and camera angles all had to respect "the bounds of propriety" and avoid revealing "anatomical details indecently."[31]

The NAB regularly revised the TV Code, tweaking some aspects while leaving much of the document intact. In the first (1951) version, a section on "acceptability of program material" promised to "maintain and issue . . . a continuing list of specific words and phrases, the use of which should not be used. . . . This list, however, shall not be considered as all-inclusive."[32] The list of banned words was not published as part of the TV Code, but was only made available to NAB member stations. Later versions of the code dropped the reference to a list of prohibited words, but continued to ban "profanity, obscenity, smut and vulgarity."[33] Both the 1951 and 1959 versions maintained that "Illicit sex relations are not treated as commendable. . . . Sex crimes and abnormalities are generally unacceptable as program material. . . . The costuming of all performers shall be within the bounds of propriety."[34]

The later edition added a passage with one warning against the casual use of epithets.

> Words (especially slang) derisive of any race, color, creed, nationality or national derivation, except wherein such usage would be for the specific purpose of effective dramatization such as combating prejudice, are forbidden, even when likely to be understood only by part of the audience.[35]

Over the course of the 1960s and 1970s, as cultural standards changed, what was considered acceptable on television also changed. Television in the 1970s acknowledged the so-called sexual revolution and, in some ways, celebrated it.[36] NBC's *Rowan and Martin's Laugh-In* (1968–1973) featured dancers in bikinis and body paint as well as jokes built on double entendre. But the broadcast networks, under the guidance of skittish personnel at the networks' standards and practices offices, remained cautious in many regards.[37] For example, throughout NBC's five seasons of *I Dream of Jeannie* (1965–1970), Barbara Eden's belly button was concealed despite a midriff-baring costume, perhaps to "avoid . . . emphasis on anatomical details," as the code advised.

Not all of that caution was expended on sexual matters or the body itself. Tommy and Dick Smothers, hosts of the variety show *The Smothers Brothers Comedy Hour* (1967–1970), battled with CBS executives over sexual references and political commentary, including criticism of U.S. involvement in the war in Vietnam that surfaced in comedy sketches or in the musical performances of guests like Pete Seeger and Harry Belafonte.[38] These battles eventually led to the show's abrupt cancelation. Writers and producers continued to tangle with the networks over scripts dealing with racism and the civil rights movement on ABC's *The FBI* (1965–1974) and premarital sex in an episode of CBS's *Phyllis* (1975–1977) called "Bess, Is You a Woman Now?"[39] Social issues, no matter how realistic, relevant, or intelligently handled, were red flags that required negotiation and frequent revisions or excisions before an episode could go into production.

Nevertheless, in the 1970s, new issue-oriented situation comedies, such as the CBS sitcoms *All in the Family* (1971–1983) and *M*A*S*H** (1972–1983), managed to address previously taboo subjects such as extramarital sex, homosexuality, racism, and anti-Semitism. Toward the end of the 1970s, screwball versions of the same genre, such as ABC's *Three's Company* (1977–1984), paired sexual innuendo with skimpy costumes for its female star, while action/adventure series with female protagonists such as *Charlie's Angels*

FIG. 3 In a segment that CBS refused to broadcast, Harry Belafonte performs "Don't Stop the Carnival" with a montage of footage of protests held outside the 1968 Democratic National Convention in Chicago. Excerpted in *Smothered: The Censorship Struggles of the Smothers Brothers Comedy Hour* (dir. Maureen Muldaur, 2002).

(ABC, 1976–1981) and *Wonder Woman* (ABC, 1975–1977; CBS, 1977–1979) also frequently put them in revealing clothing. Could audiences have their sex symbols and their (sometimes ambivalently) feminist heroines too?[40] These kinds of shows tried to appeal to both heterosexual male viewers who were comfortable with glamorously objectified female characters and to a new wave of feminist viewers who had been empowered by the women's liberation movement to demand that female protagonists play roles other than wife and mother, secretary or nurse. But if the networks sought to maximize their audiences by including a little something for everyone, not everyone was pleased.

Self-Regulation and Family Hour Feuds

In the 1970s, society and entertainment were changing hand in hand, but some of these changes alarmed individuals both inside and outside the

television industry. Arthur Taylor, then president of CBS, was disturbed by a 1971 report by the U.S. Surgeon General's Scientific Advisory Committee on Television and Social Behavior, which (albeit cautiously) drew some links between children's TV viewing and aggressive behavior.[41] Taylor, interviewed years later, said that "I didn't see how we could continue at CBS to make the hundreds of millions of dollars a year we were making without indicating our sensitivity to that."[42] He advocated publicly for a family hour, which put him at odds with producers of some of CBS's most successful shows, including *All in the Family* creator Norman Lear.[43] But Taylor wasn't alone. Federal regulators and industry organizations also championed the family hour. Some viewers, too, were voicing their concerns about a spate of made-for-TV movies with controversial themes involving "sexually endangered youth" which aired in early primetime.[44]

Advocates for a family hour were most concerned with programming during the "dayparts" that attracted the largest audiences: primetime (7:00 P.M. to 10:00 P.M. Central and Mountain Time, and 8:00 P.M. to 11:00 P.M. Eastern and Pacific Time) and what is known as the "early fringe," the two and a half hours immediately preceding primetime, which typically includes local and network news and, during its final hour, syndicated game shows or second-run sitcoms. Among those advocates was FCC Chairman Richard Wiley, who in 1974 urged the networks to limit sexual and violent content when children were likely to be in the audience. The commission never actually undertook formal rulemaking to mandate a family hour, but the NAB's Television Code Review Board took up the cause. On September 8, 1975, the networks put the Family Viewing Hour into effect, in a self-regulating move to stave off calls for more formal interventions.[45] (Whether the system was truly voluntary would be a matter of later debate.) The networks agreed to schedule programs suitable for audiences of all ages during the first hour of primetime. Adult-themed fare had to air after 9:00 P.M. Eastern or Pacific time, 8:00 P.M. Central or Mountain time. In effect, the practice was a form of "channeling," in which some kinds of programming are steered toward certain time slots, and other kinds of programs are corralled into other hours.

Establishing a primetime family hour meant that some very popular shows were shifted into later timeslots, including CBS's *All in the Family*, which had been the top-rated show for four seasons, from 1971 to 1975. When *All in the Family* moved from its Saturday night 8:00 P.M. leadoff spot to Monday nights at 9:00 P.M., it remained at the top of the ratings for the

1975–1976 season. (A short-lived variety show hosted by sportscaster Howard Cosell replaced *All in the Family* on Saturdays.) From 1976 to 1977, the show bounced again to Wednesdays and then back to Saturdays, dropping to number twelve in the season's rankings. Lower ratings for some rescheduled shows, for which the shifting schedule may have been partly to blame, translated into diminished earnings from advertising in the short run. In the long run, first-run shows airing after the family hour would be expected to earn less in syndication, since those shows would likely be off-limits in the lucrative hour preceding primetime, which most stations fill with syndicated product.

Rescheduling may have also diminished the capacity of some of these shows to act as what media scholars Horace Newcomb and Paul Hirsch later called "cultural forums." In an influential 1983 article, they argue that "almost any version of the television text functions as a forum in which important cultural topics may be considered."[46] Shows ranging from *Father Knows Best* to *All in the Family* stage ideological clashes (in the former, rather politely; in the latter, loudly and clearly), but "do not present firm ideological conclusions."[47] One viewer might identify with bigoted Archie, another with liberal Mike. Ideally, in some living rooms, watching the show might spur on frank discussions of the issues of the day. Moving a show to a later timeslot could diminish the number of even older children in the audience; in the case of *All in the Family*, that meant that a show largely about the generation gap might play to fewer generations.

In some ways presaging Newcomb and Hirsch, David Rintels, then president of the Writer's Guild of America West, was incensed by the family hour, as were many industry professionals. He argued in a 1976 *New York Times* op-ed that the uproar over sexual content on television overlooked the fact that:

> Sex on television means, to a large extent, talk. Talk about homosexuality, talk about abortion, talk about birth control and prostitution and pre-marital or extra-marital relationships. It means, essentially, a whole vast area of human concern. . . . I think you should be willing to hear and talk about all human concerns—but if you are not willing, turn the set off. You also don't have to let your children watch.[48]

"For the first time in American history," Rintels claimed, "an agency of the U.S. Government succeeded in telling some Americans what they couldn't say—and what all Americans couldn't see—on television."[49] (That the family

FIG. 4 Archie Bunker (Carroll O'Connor) and his son-in-law Mike Stivic (Rob Reiner) at the conclusion of one of their many arguments. "Meet the Bunkers," *All in the Family*, CBS, January 12, 1971.

hour was never *official* FCC policy didn't seem to matter, since Chair Richard Wiley had urged the networks to adopt the practice.) Unions representing "above the line" labor—not only the WGA but also the Screen Actors Guild and Directors Guild of America—sued the FCC and NAB, claiming that the TV Code did not make clear what would be considered inappropriate, was arbitrarily enforced, and amounted to censorship.[50] In November 1976, Judge Warren J. Ferguson of the U.S. District Court for the Central District of California issued a ruling that undermined the Family Viewing Hour as overreach in violation of both the First Amendment and the Administrative Procedures Act. According to the ruling, the family hour agreement stifled expression, and FCC Chairman Wiley had involved the commission in this policy without following procedural requirements.[51] By 1979, even though the U.S. Court of Appeals for the Ninth Circuit overturned Ferguson's decision, the family hour had fizzling out "in practice."[52] For a time, at least, this particular campaign was put to rest, and media advocates would try other tactics to influence broadcast television.

Likewise, the TV Code fell by the wayside. In 1982, the Department of Justice won an antitrust lawsuit brought against the NAB in regard to a portion of the TV Code that set caps on the number of minutes per hour that broadcasters could sell to advertisers. The NAB moved to abandon just that section and then the entire code.[53] In quick succession, then, both the Family Viewing Hour and the NAB's TV Code, which had urged decency standards since 1951, crumbled. Both were ostensibly attempts at self-regulation but smacked of censorship. The family hour imposed the values of those authorized by the networks to sign off on scripts in production. And the TV Code's pleas for "decorum" and "propriety" seemed archaically out of step during an era when audiences were keeping *Laugh In*, *All in the Family*, *M*A*S*H**, and other groundbreaking shows at or near the top of the ratings. If TV content were to be regulated to preserve decency, a different mechanism would have to be found to do so.

To that end, throughout the 1980s and 1990s, media advocacy groups, many of which were affiliated with conservative Christian movements, continued to campaign vigorously against what they identified as programming offending traditional values or criticizing conservatives. Foremost among these groups were Brent Bozell's Media Research Center and the Parents Television Council, James Dobson's Family Research Council, and Donald Wildmon's National Federation for Decency, as well as the Coalition for Better Television and Christian Leaders for Responsible Television. These groups' favored tactic was to threaten organized boycotts against companies buying advertising time on programs deemed indecent, gratuitously violent, or "anti-Christian," heightening the networks' wariness about supporting programs that might contain content that could offend some viewers.[54] These groups also successfully intimidated advertisers to move away from certain programs: even industry powerhouse Proctor & Gamble withdrew some ads to placate Wildmon in 1981.[55] Another organization, Americans for Responsible Television (ART), founded by Terry Lynn Rakolta in Michigan in 1989, persuaded Proctor & Gamble and other advertisers to pull their ads from Fox's *Married with Children*, at least temporarily.[56] These kinds of campaigns became such a regular part of the culture-war-shaped mediascape—and such a thorn in the media's side—that they inspired parody in the form of *The Simpsons* episode "Itchy & Scratchy & Marge," first aired on Fox on December 20, 1990. In the episode, Marge Simpson, upset by the violence in her children's favorite cartoon, launches Springfieldians for Nonviolence, Helping, and Understanding (SNUH) and stages protests

FIG. 5 Marge Simpson (Julie Kavner), founder of Springfieldians for Nonviolence, Under-standing, and Helping ("S.N.U.H."), leads a protest against violence in children's program-ming in "Itchy & Scratchy & Marge," *The Simpsons*, Fox, December 20, 1990.

against the show's producers; but in the end, she has to combat the over-reaching censorious impulses of the movement she has founded.

As the twentieth century began to draw to a close, some active partici-pants in the decency debates would step away. Others would redouble their efforts. The influential Action for Children's Television (ACT), led by Peggy Charren, had taken a moderate approach that differentiated the group from its Christian-conservative counterparts. After the NAB abandoned the TV Code in 1982, ACT announced that it would fight attempts by the networks to expand commercialism in children's programming.[57] ACT eschewed boycotts as a strategy and fought on a "freedom *from* censorship" platform against many of the restrictive regulatory measures that would have pleased those other groups.[58] But by the early 1990s, after successfully working toward passage of the Children's Television Act, which was intended to sup-port educational programming and limit the influence of advertising in children's programming, ACT had disbanded. In 1995, a new group was founded that began to dominate discussions of indecency on TV: the

Parents Television Coalition (PTC). A spin-off of Bozell's MRC, the PTC quickly became another very conservative and very vocal voice on these matters, campaigning to revive the deposed family hour, at least in part to counter the increasing visibility of gay and lesbian characters in primetime.[59]

Even that late in the twentieth century, the appearance of any gay, lesbian, bisexual or transgender character, however minor, in the role of something other than a sad outcast, a victim or perpetrator of a tawdry crime, or some other hoary stereotype, was cause for celebration among queer and allied communities.[60] Shows like *LA Law* (1986–1994), *Rosanne* (1988–1997), and *Northern Exposure* (1990–1995) were introducing gay, lesbian, or bisexual characters, not yet in leading roles but as recurrent members of ensemble casts. Each seemed a kind of breakthrough. But the PTC vilified the networks for including occasional queer characters on *Dawson's Creek* (1998–2003), a gay adoption storyline on *Melrose Place* (1992–1999), and other affirmations of queer humanity as assaults on the family.[61] (It didn't seem to matter to these conservative media advocates that LGBTQI people are members of families of their own. After all, their intention was not only to minimize the visibility of queer characters on TV but to pathologize and marginalize those of us who are queer and to undermine even incremental advances in civil rights for our communities.) In spite of the PTC and like-minded groups' efforts, a few gay characters gained prominence. Ellen DeGeneres used her sitcom *Ellen* (1994–1998) as a platform for coming out in "The Puppy Episode" (April 20, 1997), which drew an audience of some 42 million—two and half times the show's usual audience in its penultimate season. The popular *Will & Grace* (1998–2006) started off with an openly gay male character in a title role; it was frequently named in the PTC's annual list of the "Top 10 Worst" shows.[62] Some things had changed. Others, not so much.

Even though the PTC didn't win a new family hour, the 1990s were not a total loss for the organization. By now, it was clear that the PTC and similar groups not only demanded means to make better TV-related decisions for themselves and their children; they also wanted to play the role of gatekeeper, shaping what everyone can watch and allow their children to watch. Their constituents would eventually harness newer technologies—the internet and email—to become an ever more vocal force demanding restrictions on the "old" medium of television.

Indecency Law and the Battle over a Safe Harbor

The broadcasting-industry gatekeepers and media advocates acting as would-be gatekeepers were, of course, not the only sources of institutional limits on sexual expression or profane utterances. Legal measures and federal regulations developed simultaneously with the industry's practices of self-regulation. In 1948, Congress established penalties for obscene, indecent, or profane broadcasts by passing a law that became part of the United States Code, the published record of all federal laws.[63] Title 18, Part I of the U.S. Code contains federal criminal laws; Chapter 71 addresses obscenity in about a dozen separate sections; Section 1464 of Chapter 71 is titled "Broadcasting Obscene Language" and originally read as follows:

> Whoever utters any obscene, indecent, or profane language by means of radio communication shall be fined not more than $10,000 or imprisoned not more than two years, or both.[64]

Just as Section 1464 was becoming law in the late 1940s, commercial broadcast television was becoming well established. The networks were producing and distributing programs such as NBC's *Meet the Press* (1947–) and *Texaco Star Theater* (1948–1953), hosted by Milton Berle. Local stations were in operation, and more were being founded every year. (Even though the wording of Section 1464 mentions only "radio communication," not television specifically, the term *radio* applies broadly in this context to programming transmitted by radio waves, at frequencies lower than 300 megahertz and with wavelengths longer than 1 meter, over which both radio and TV programming is transmitted. In 1994 Congress voted to amend laws pertaining to the enforcement of Section 1464 to clarify that it pertains to both radio and television broadcasting.[65])

In 1960, Congress charged the FCC with enforcing Section 1464, but it took another ten years for the first indecency case on 1464's behalf to develop. That first indecency case didn't start with a listener complaint. In 1970, the FCC initiated its own case against WUHY-FM in Philadelphia for airing an interview with Jerry Garcia of the Grateful Dead on a show called *Cycle II*, in which Garcia used the word "shit" and variants of the word "fuck" repeatedly. The station chose not to contest the $100 fine.[66] In 1973, the FCC fined Sonderling Broadcasting's WGLD, based in Oak Park, IL, $2,000 following a discussion of fellatio on an afternoon call-in

show called *Femme Forum*.[67] The show was part of a fad known as "top-less radio," in which male hosts engaged in sexual banter with (mostly) female callers, sparking an uptick in the number of complaints sent to the FCC. According to a 1975 report in *The New York Times*, "there were 2,000 complaints sent to the F.C.C. in 1972; 25,000 in 1974."[68] That said, the article does not make clear how many of those complaints pertained to radio and how many to TV, or even if all of those complaints were about profanity or indecency.

While the WUHY and WGLD cases established that the FCC was willing to act against instances of indecency, one complaint made during this time period led to a series of events that had lasting impact on policy for years to come. That complaint came in response to a broadcast on the New York City-based radio station WBAI, an affiliate of the Pacifica Foundation. On October 30, 1973, at 2:00 P.M., WBAI aired a recording of George Carlin's routine "Filthy Words" from his comedy album *Operation: Foole* (1973).[69] In the routine, Carlin wonders aloud about why some words are considered so bad that one cannot say them on broadcast media. The routine includes repeated use of the seven words that Carlin claimed could not be said on "public airwaves":

> I was thinking one night about the words you couldn't say on the public, ah, airwaves, um, the ones you definitely wouldn't say, ever, [']cause I heard a lady say "bitch" one night on television . . . and, uh, "bastard" you can say, and "hell" and "damn," so I have to figure out which ones you couldn't . . . and it came down to seven, but the list is open to amendment. . . . The original seven words were, "shit," "piss," "fuck," "cunt," "cocksucker," "motherfucker," and "tits."[70]

One listener complained. That listener was a man named John Douglas, who was a member of the anti-pornography group then called Morality in Media (MIM, renamed the National Center on Sexual Exploitation in 2015). He had heard the broadcast in his car with his fifteen-year-old son. The FCC launched an investigation and eventually decided that the complaint had merit. According to the commission, the broadcast was "patently offensive by contemporary community standards" and was aired "at a time when children were undoubtedly in the audience."[71] While declining to issue a fine, the commission told the station that the decision would become part of its license file—in essence warning Pacifica that its license could be jeopardized by future additional complaints.[72]

Pacifica appealed, and in 1977 the D.C. Court of Appeals ruled that the FCC's action was tantamount to censorship, which is expressly prohibited in section 326 of the Communications Act of 1934.[73] Section 326 reads:

Nothing in this chapter shall be understood or construed to give the Commission the power of censorship over the radio communications or signals transmitted by any radio station, and no regulation or condition shall be promulgated or fixed by the Commission which shall interfere with the right of free speech by means of radio communication.[74]

Further, the Court of Appeals interpreted Section 1464 of the U.S. Code, which bans "any obscene, indecent, or profane language by means of radio communication," as applying narrowly to obscene speech and therefore not to the broadcast in question.[75] This interpretation treated the three categories of obscenity, indecency, and profanity as virtually synonymous rather than distinct.

In 1978, the Supreme Court reversed the Court of Appeals in *FCC v. Pacifica*. Justice John Paul Stevens wrote for the majority in a close 5 to 4 decision, allowing that the commission was within its rights to sanction a station for indecent broadcasts (but not to exercise prior restraint—that is, to censor content *prior* to broadcast). Further, the court's decision held that "indecency" is not necessarily "obscenity," permitting application of Section 1464 to the broadcast of Carlin's performance without having to declare it obscene. And importantly, the Supreme Court affirmed the federal government's right to take the unusual step of curtailing First Amendment protections in regard to broadcasting while sustaining them for print and other media. The decision rested on the beliefs that broadcasting is unusually ubiquitous, that media effects are powerful, and that children are especially vulnerable audiences (without citing much supporting evidence)—the same beliefs that informed prior discussions of indecency in early cinema:

First, the broadcast media have established a uniquely pervasive presence in the lives of all Americans. Patently offensive, indecent material presented over the airwaves confronts the citizen, not only in public, but also in the privacy of the home, where the individual's right to be left alone plainly outweighs the First Amendment rights of an intruder. . . . Second, broadcasting is uniquely accessible to children, even those too young to read. . . . Pacifica's broadcast could have enlarged a child's vocabulary in an instant.[76]

The *Pacifica* ruling made clear that the FCC should seek to regulate only indecency—which, unlike obscenity, remained a legal form of speech protected by the First Amendment—"at times of the day when there is a reasonable risk that children may be in the audience."[77] Seeking to recognize that children are more likely to form a portion of the TV audience during some parts of the day than others, the commission established a "safe harbor" for indecent broadcast speech. (The term *safe harbor* itself may invite confusion: it does not refer to the period that is safe for children to watch but rather to the period in which indecent programming is safe from regulatory action.) This provided airtime for programming with adult themes that may have contained profanity or otherwise indecent content, while guarding against the broadcasting of such material at times when there was a "reasonable risk" that children were the audience. The safe harbor, not unlike the failed family hour, "channeled" decent and potentially indecent programming into different timeslots: no indecency would be tolerated, without risk of punitive measures, when children were likely to be in the audience; some indecency (but never obscenity) could be tolerated when children were unlikely to be in the audience. The last hour of primetime (10:00 to 11:00 P.M. in Eastern and Pacific time zones, 9:00 to 10:00 P.M. in Central and Mountain time zones) became the commonsensical cutoff.

Importantly, from 1978 to 1987, which legal scholar (and later FCC advisor) Alison Nemeth calls the "post-*Pacifica* benign neglect period," the FCC required *repeated* use of one or more of the seven words identified by Carlin as those one couldn't say on television for a broadcast to qualify as indecent.[78] The commission would take action only in cases involving repeated or sustained profanity or indecency; single, fleeting, unscripted profanities uttered during live broadcasts would not trigger enforcement proceedings, even if they provoked complaints. In other words, the policy allowed for accidents to happen. In part, this measure of regulatory tolerance resulted from the fact that many saw WBAI's broadcast of Carlin's "Filthy Words" as an anomalous indiscretion, an oddity. Former FCC Chair Charles D. Ferris, for example, said that the case was "as likely to occur again as Halley's Comet."[79]

Ferris was wrong. More indecency cases were coming down the pike in the 1980s, 1990s, and beyond. Perhaps none were as extravagantly expletive-filled as Carlin's recording at the heart of the *Pacifica* case (1978), but some did nudge the commission to take action. Some cases involved recorded music with sexual references in the lyrics. For example, indecency fines were

assessed after complaints about broadcasts of Prince's "Erotic City" three times, first in 1986, and twice in 1996.[80] Many complaints cited the radio performers sometimes referred to as "shock jocks" (who in many ways, followed in the footsteps of the "topless radio" of the 1970s) as sources of crude or explicit talk about sex acts and body parts. Some of these shows racked up thousands of complaints and multiple indecency fines. Among the best-known targets for multiple complaints and fines, continuing into the twenty-first century, have been *The Howard Stern Show* (in broadcast syndication from 1986 to 2005), *The Opie and Anthony Show* (1995–2014), and *The Bubba the Love Sponge Show* (launched in local markets in 1985 and syndicated by Clear Channel from 2001 to 2004), as well as shows hosted by Tom Leykis (in the business since 1970 and syndicated from 1994 to 2009) and Mancow Muller (based, for most of his career, in various Chicago stations).

With these wildly popular forums for sometimes explicit sex talk proliferating, the policy laid out in the WBAI case involving Carlin's "Filthy Words" no longer seemed, to the FCC, broad enough to police the airwaves. On April 16, 1987, the commission changed course by adopting a series of memorandums, each addressing a separate case. When these memos were released two weeks later, on April 29, they constituted a notice to broadcasters about a major shift in how the decency policy would be enforced. The new approach abandoned the list of specific banned words, made more "creative" cursing and sexual or scatological talk equally actionable, and made all profanity subject to contextual analysis.

One of the memos responded to a complaint about a song played on KCSB-FM just after 10:00 P.M. on July 26, 1986. KCSB was (and still is) a college- and community-run radio station broadcasting from the University of California, Santa Barbara. The song, referred to by the FCC as "Makin' Bacon," contains unambiguous lyrics including the lines "Come here, baby, make it quick/Kneel down there and suck on my dick." (The song, whose title is usually written as "Making Bacon," was recorded by the Pork Dukes, a British punk band.) The commission did not fine KCSB but issued the memo to put stations on notice that such a broadcast could be found indecent even though it lacked any of the seven words that the *Pacifica* ruling had affirmed, per Carlin's routine, were too offensive to say over public airwaves. Assuring broadcasters that "Speech that is indecent must involve more than an isolated use of an offensive word," the memo continued by, in part, citing *Pacifica* and, in part, expanding on it:

Specific words, however, need not necessarily be repeated to the same degree as were the words involved in *Pacifica*, nor do the seven words at issue in *Pacifica* provide an exhaustive list. Further, what is indecent "is largely a function of context" and cannot be judged in the abstract.[81]

Another section of the memo suggested that indecency at any time could be actionable, essentially jettisoning the concept of the safe harbor, which had been in place since the Pacifica case.[82]

Another memo issued the same day addressed two separate complaints against Pacifica Foundation's station KPFK-FM in Los Angeles. The first involved a show called *Shocktime U.S.A.*, aired at 7:45 P.M. on July 10, 1986. During the live broadcast, a cast member blurted some unscripted profanities, among them, words from Carlin's list. The group producing the show "expelled" that person. The station canceled the show and reminded other producers about acceptable standards. In the absence of a recording or transcript that would allow for further analysis, the commission declined to take any action regarding this complaint.[83]

In the same decision, the commission also addressed a complaint from Reverend Larry Poland of the High Evangelical Free Church in Redlands, California. Poland had heard excerpts from the play *Jerker* by Robert Chesley while alone in his car. Nevertheless, his complaint and the response to it hinged on the premise that children *might* have been in the listening audience. KPFK aired excerpts from the play after 10:00 P.M. during the safe harbor period on September 8, 1986, during a show called *IMRU* (pronounced "I Am Are You," which, founded in 1974, remains the longest-running radio news show about LGBTQI issues). In the play, widely considered an important early work about the HIV/AIDS crisis, two gay men engage in sexually explicit conversation in a series of telephone calls. KPFK provided the FCC with a recording of the program, and the commission declared indecency without hesitation, in spite of the fact that the station had included a warning at the start of the broadcast. (The memo also raised the possibility that the play's same-sex content was actually obscene—without explaining why the also-explicit but ostensibly heterosexual content of "Makin' [*sic*] Bacon" was not—and referred the case to the Justice Department, which declined to pursue criminal prosecution.[84]) As in the KCSB case, no penalty was issued, but the memo provided a stern "warning... that this material would be actionable under the indecency standard as clarified today."[85]

In yet another decision issued the same day as the KCSB and KPFK memos, the FCC responded to complaints against Howard Stern's syndicated radio show, which was heard in syndication on WYSP-FM in Philadelphia while originating on Infinity Broadcasting Corporation's WKRK-FM in New York City. National Federation for Decency founder Donald E. Wildmon filed two of the complaints; a Philadelphia resident filed another. While finding some of the material cited in the complaints to be "innuendo and double entendre and therefore not actionable indecency," other content contained prolonged (not passing) and "explicit references" to sexual and excretory organs and activities.[86] A reference to bestiality seemed to play a key part in the analysis, though it should be noted that Stern did not claim to have been "sodomized" by an animal but rather by ventriloquist Shari Lewis's sock puppet, known as Lamb Chop.[87] As in the day's other memos, the commission demurred from levying a fine but concluded with a warning that similar material would be regarded as indecent in the future. (Later, stations airing Stern's show wouldn't get off so easy; various stations and Infinity itself paid well over $2 million in fines related to thirteen separate indecency cases between 1992 and 2004. Subsequently, Stern moved his show to Sirius Satellite Radio, which is not covered by broadcasting rules.)

Also on April 29, 1987, in addition to these three memos, the FCC released a public notice re-emphasizing that broadcasters should not assume that indecent material would be allowable after 10:00 P.M.—or anytime, really. Drawing on its ruling in the case involving Pacifica's WBAI, the commission would continue to define indecency as "language or material that depicts or describes, in terms patently offensive as measured by contemporary community standards for the broadcast medium, sexual or excretory activities or organs," but would abandon its cautious interpretation of that definition as requiring repeated use of at least one of the "seven dirty words" for a broadcast to rise to the level of indecency.[88] The public notice, combined with the three orders, signaled a significant change in the commission's stance toward indecency. In addition to stepping away from the safe harbor, the new policy also vastly expanded the kinds of utterances or images to be considered actionable.

Reactions were, predictably, mixed. Broadcasters and free-speech advocates understood the move as a crackdown. Mel A. Karamazin of Infinity Broadcasting Company, home to Howard Stern's show, objected immediately: "We took the seven dirty words and we said, 'Don't say these things,' and Howard Stern never said those things. . . . If they're saying, 'You can't

discuss sex on the radio,' we don't think we'll conform with that. We'll fight that on constitutional grounds."[89] Andrew Jay Schwartzman of the Media Access Project charged outgoing FCC Chairman Mark S. Fowler with leaving "a legacy of censorship."[90] (It was ironic, at the very least, that Fowler, who ran the FCC during a period of rapid deregulation, had once promised members of the NAB that he would fight for First Amendment protections to apply to broadcasting just as they do to print media.[91] Fowler saw the 1987 repeal of the Fairness Doctrine as a cornerstone of that promise but obviously took a different view of indecency.) In contrast, Donald Wildmon, whose National Federation for Decency had been fighting for stricter enforcement for a decade, held that the FCC was still too soft on indecency and "should have prosecuted" in these cases.[92] If this shift in policy, away from a narrow list of seven actionable words and away from a 10:00 P.M. to 6:00 A.M. safe harbor, was an attempt to placate the conservative watchdog groups, it didn't work. But there would be plenty of chances ahead for the commission to test out its new policy.

None of the seven words were present when, in 1988, the commission issued its first fine resulting from a complaint of indecency since the flurry of late-April 1987 rulings. That fine, in the amount of $2,000, which was then the maximum possible, was issued after the FCC's investigation of KZKC-TV in Kansas City's broadcast of the movie *Private Lessons* in May 1987. Initially, KZKC claimed that it edited *Private Lessons* for television and that it made a practice of advising "parental discretion" before and during such movies.[93] Later, it became clear that station employees had mistakenly aired an unedited version that included several scenes of above-the-waist female nudity and contained implied but unambiguous sexual activity involving an adult and a minor; those employees were terminated.[94] The UHF station, broadcasting as channel 62, had recently been acquired by the Chattanooga-based chain Media Central.[95] Morton Kent, chair of Media Central's board, defended the station's "firm policy of family entertainment."[96] Almost immediately after issuing the fine, the FCC put the matter on hold, and a year later, on September 6, 1989, rescinded the fine.[97]

Meanwhile, the moderate advocacy group Action for Children's Television (among others) took the revised policy to court, opposing the safe harbor entirely as an unjustifiable incursion on the First Amendment. Although the FCC had suggested that its "current thinking" was that midnight would be a "reasonable" cutoff point, Ruth Bader Ginsburg, then circuit judge for the U.S. Court of Appeals, D.C. Circuit, wrote a deciding

opinion that left the new definition of indecency in place but questioned the "more restrictive channeling approach" as "not adequately justified."[98] The commission had failed, the court ruled, to prove that there was "a reasonable risk" that children (especially those under 12) may be listening to broadcast radio or watching broadcast TV after 10:00 P.M.. In essence, the court sent the concept of the safe harbor back to the FCC for further consideration.

The commission and the courts continued to spar over the parameters of the safe harbor for years to come. Another Reconsideration Order, issued later in 1987, reinstated a safe harbor starting at midnight and ending at 6:00 A.M.[99] In 1988, Congress enacted a law requiring a 24-hour ban on indecency, eliminating the safe harbor entirely. Senator Jesse Helms (R-NC), who had been particularly upset about KPFK's broadcast of excerpts from *Jerker*, championed the legislation—not surprisingly, given his well-known opposition to any governmental appropriations for research and treatment efforts related to HIV/AIDS and his willingness to denounce works of art with controversial content.[100] All of the major broadcast networks, PBS, the ACLU, and other media-industry and free-speech organizations challenged the law; by 1991, it was declared unconstitutional.[101]

In 1992, Congress tried again, writing into the Public Telecommunications Act of that year a provision "to prohibit the broadcasting of indecent programming ... between 6 a.m. and 12 midnight" for most stations.[102] In 1993, yet again, the U.S. Court of Appeals for the DC Circuit overturned this portion of the 1992 Act, arguing that the commission had failed to demonstrate an urgent need to restrict "constitutionally protected 'indecent' speech" by any other than the "least restrictive measure."[103] In other words, the government may curtail speech rights in the interest of protecting children, but only through the most minimal limitations. To the Court of Appeals, the FCC had not justified its ban, which whittled away the First Amendment rights of both broadcasters and audiences, and had not proven that legions of vulnerable children were in the broadcast audience after 10:00 P.M.

In 1993, while the parameters of the safe harbor were still under contention, the FCC received a complaint about profanity in a movie aired at 2:00 P.M. July 24 by WJPR-TV in Lynchburg, Virginia and WFXR-TV in Roanoke, Virginia. It took four years for the commission to issue a notice of apparent liability for a forfeiture, fining the owner of these stations, Grant Broadcasting System II, Inc., $2,000. The notice does not refer to the

movie by name, and refers only to "an unidentified science fiction motion picture," but it appears to be *DeepStar Six* (1989).[104] Dialogue transcribed from a videotape of the latter portion of the movie sent to the FCC by the complaining viewer contains over a dozen uses of the word "fuck" and about five instances of "shit," which the commission's investigators determined to be "repetitious and gratuitous." Further, the NAL specifies that the movie was shown outside of the "safe harbor" and that "commercials promoting children's sporting events were aired throughout the broadcast of the movie."[105] Once again, within weeks, the FCC rescinded the fine. And it remained the case—at least for the rest of the 1990s—that the commission would not find indecency in any television broadcast or follow through with punitive measures.

Nevertheless, in 1995, during the period in which the WJPR/WFXR case was under deliberation, a compromise settled one component of this particular debate, at least for the time being. The FCC established a ban on indecency from 6:00 A.M. to 10:00 P.M., with the remaining eight overnight hours constituting the safe harbor. It had taken some eighteen years since the concept of the safe harbor was affirmed in *Pacifica* (1978), but finally, the policy stuck. At this writing, the same cutoff times have remained in place for over two decades.

Conclusion

Who won and who lost the battles over the broadcasts described in this chapter? Conservative media advocates experienced their failure to establish a family hour in the 1970s and again in the 1990s as losses. Likewise, their attempts to ban indecency throughout primetime hours, or even around the clock, stumbled. The establishment of the 10:00 P.M. to 6:00 A.M. safe harbor in 1995, after years of push and pull, was a compromise that both sides—broadcasters bucking for broader First Amendment protection and those seeking a 24-hour indecency ban—could, or would have to, live with. Still, like it or not, most decision-making entities (federal courts, Congress) repeatedly affirmed that indecency restrictions in broadcasting were a constitutional special case, enabling regulation of speech that would be protected anywhere else but in broadcasting.

The failed family hour and the shifting safe harbor were both forms of "channeling" meant to direct certain kinds of programming to designated

time zones, providing networks and stations with notice about when certain kinds of programming could be suitably scheduled and notifying viewers of times when certain kinds of programming would or wouldn't be available. All decency (however defined), all the time, would prevail in one set of hours; the possibility of occasional indecency in others. The networks and the courts generally resisted more restrictive versions of these measures; conservative media advocates and other stakeholders remained unsatisfied. But they were not dissuaded from continuing to campaign against indecency, particularly on television, and in the twenty-first century, they would find new ways to do so.

Did the watchdog groups represent widespread concerns about indecent TV? Were—and are—they a harbinger of massive discontent with programming "patently offensive as measured by contemporary community standards for the broadcast medium?" Complaints do indicate that some viewers have taken offense at a particular broadcast, even if theirs may be minority views. It has not mattered. In legal gymnastics designed to avoid setting up a system capable of proactively censoring broadcasting, federal legislators and regulators devised indecency laws and policies that asked broadcasters to designate their own censors. Network employees in standards and practices offices, foremost, would be left to duke it out with producers and writers, largely behind the scenes, over bits of scripts they found objectionable— even after a set of 1987 decisions by the FCC indicated that the agency would apply a more expansive definition of indecency. That definition would necessarily consider the "function of context" in determining whether any particular broadcast was indecent, but it was lacking in specificity regarding exactly what might lead to punitive measures.[106] At the same time, indecency policies were developed in such as way as to allow for input from the public, in the form of a complaint system that all but invited a particularly vocal fragment of the audience to speak for all, the popularity of some of the most complained-about programming notwithstanding. Still, it would take until the year 2001 for the FCC to actually collect a fine from a TV station in regard to indecency. The squeaky wheels might not get all the grease they called for, all the time, but they were in many ways poised to continue to control the terms of the decency debates.

2

Targeting Television in the Twenty-First Century

> I had to put my best version of outrage on. . . . They knew the rules and were flirting with them, and my job is to enforce the rules, but, you know, *really*? This is what we're gonna do?
> —Michael K. Powell, Chair, Federal Communications Commission, in 2014, concerning the 2004 Super Bowl halftime show indecency case

On July 12, 2012, at about 6:00 P.M., the WDBJ's local evening news program on Schurz Communications' WDBJ-TV in Roanoke, Virginia, aired a story on a controversy in a nearby town. Residents had discovered that a new recruit to the volunteer emergency response team was a former adult entertainer, and some demanded that she be relieved of duty. Footage from an adult film distributor's website was to appear as part of the segment. Due to an incorrect software setting on the computer used to prepare the footage for broadcast, the editors were unaware that at the very edge of the frame

was a thumbnail video showing what the FCC described as "a hand strok-
ing an erect penis" for 2.7 seconds.[1] At least five complaints from viewers
reached the FCC, and an investigation ensued.

Two and a half years later, on March 23, 2015, the FCC levied a fine of
$325,000 against the station. Tim Winter, president of the PTC, lauded the
fine as "a victory for families," while a representative of the NAB lambasted
the action as excessive and called it unfair treatment of a "family-owned
broadcaster."[2] WDBJ went on to formally protest the fine, with the support
of the NAB and other industry organizations. Since the image appeared in
a news context, they argued, the fine was excessive if not altogether uncon-
stitutional.[3] As well, WDBJ argued that the FCC had done nothing to clarify
its decency policy with respect to the First Amendment since a 2012
Supreme Court decision reversing several indecency decisions made by the
FCC.[4] On what grounds could the commission have issued such a large fine?

In the previous chapter, I established that Congress authorizes the FCC
to take action against radio or TV stations that have aired material deter-
mined to fit criteria established in commission policy as indecent. For this
purpose, the FCC defines indecency as "language or material that depicts
or describes, in terms patently offensive as measured by contemporary com-
munity standards for the broadcast medium, sexual or excretory activities
or organs."[5] It's easy enough to see, then, that WDBJ's newscast might have
attracted complaints and the scrutiny of regulators. But was the offending
image—however sexually explicit—excusable, given that it was part of a
news story, occupied a small fraction of the screen for less than three seconds,
and resulted from an honest mistake rather than an intention to air porno-
graphic material? And how did the amount of such a fine—once capped
at $2,000 per station, per incident, in the late 1980s—grow so large? Did
WDBJ's appeal stand a chance?

To answer these questions, and to put a case like this into context, I turn
to the twenty-first century regulatory environment. I examine a series of par-
ticular cases, from the first-ever determinations of indecency in television,
to high-profile incidents, to local newscasts like the WDBJ case that were
seen by relatively few but crossed the proverbial line for someone in the audi-
ence. Each incident and its legal aftermath contributed in some way to
ever-shifting definitions of indecency, uncertainty about governmental
capacity to regulate it, and industry motivation to resist regulation. Nearly
every time Congress or the FCC attempted to harshen policy or undertake
punitive measures, broadcasters and free-speech advocates would query not

only specific indecency findings and fines but the indecency policy itself, on First Amendment and due-process grounds. Exploring these cases reveals just how challenging it is to the industry and regulators alike to keep broadcast media accountable to an array of stake-holding constituents—viewers of all ages and viewpoints who approach the medium with different expectations, needs, and desires.

Desperately Seeking Indecency . . . and Finally Finding It

When the FCC first declared a television broadcast indecent and carried through to collect a fine, the broadcast in question did not involve either nudity or profanity but rather sexual situations and dialogue.[6] The case involved a Spanish-language talk-and-sketch comedy series called *No Te Duermas* that originated from WKAQ-TV, in San Juan, Puerto Rico, and aired between 8:30 and 10:00 P.M., prior to the by-now well-established safe harbor. In 2000, a viewer complained about a number of segments within three episodes, which had aired April 3, April 10, and May 29 of that year. One scene suggested that a heterosexual couple undertook sexual activity obscured by a bubble bath. Another featured a woman giving a lecture on female sexual pleasure, illustrated with images of "phallic symbols and sexual devices"; in another, actors playing military personnel engaged in sexually suggestive banter.[7] In the third episode, Spanish-language derogatory epithets referring to gay men were "bleeped"; the English word "motherfucker" was not.[8] Late in March 2001, FCC ruled that all three scenes qualified as indecent and levied the then-maximum fine of $7,000 per incident, a total of $21,000, on the station owner Telemundo.

Telemundo defended the broadcasts, saying they did not rise to the level of indecency and claiming that "Puerto Rican audiences are 'far less self-conscious about sexual matters and sexual programming'" than audiences in other FCC jurisdictions.[9] Nevertheless, the commission insisted on extending "a national community standard" to all U.S. territories and challenged the argument about cultural differences by referring to a petition it received "signed by approximately 200 Puerto Rican residents who believe the material at issue to be indecent" as evidence that the perceived offense was widespread.[10] In the end, Telemundo paid the fine, marking the first instance of a forfeiture secured from a TV station or network due to a broadcast being deemed indecent.

Table 1
Indecency Complaints and Notices of Apparent Liability Issued, 2000–2013

Year	Total Complaints	Radio Programs Named in Complaints	Broadcast TV Programs Named in Complaints	Cable TV Programs Named in Complaints	Other	NALs (Radio)	NALs (TV)
2013*	1,678	438	751	13	5	0	0
2012*	1,793	519	886	17	11	0	0
2011*	26,328	588	899	160	20	0	0
2010*	146,584	558	1,124	714	36	0	1
2009*	194,558	825	1,240	1,143	23	0	0
2008*	128,483	874	1,341	1,264	10	0	1
2007*	153,255	1,174	1,442	1,485	36	0	0
2006*	358,547	1,149	1,440	1,133	83	0	2
2005	233,531	488	707	355		0	0
2004	1,405,419	145	140	29		9	3
2003	202,032	122	217	36		3	0
2002	13,922	185	166	38		7	0
2001	346	113	33	6		6	1
2000	111	85	25	1		7	0

Sources: Federal Communications Commission, Indecency Complaints and NALs: 1993–2006, accessed March 5, 2017, https://transition.fcc.gov/eb/oip/ComplStatChart.pdf.
* 2007–2013 statistics provided by the FCC Enforcement Bureau.

The *No Te Duermas* complaint was one of just 111 complaints that the FCC recorded in 2000 (see Table 1). Each concerned a different program, 85 of which were heard on radio. Another 25 involved broadcast television programs, and just one, a cable channel. That same year, the FCC issued seven Notices of Liability (NALs), all of which involved radio broadcasts, and issued $48,000 in fines. A year later, in 2001, the number of complaints more than tripled, to 346; the FCC issued six NALs against radio programs, plus the one involving the *No Te Duermas* episodes. Complaints against cable TV programs also increased but were routinely denied, since the indecency rules apply only to over-the-air broadcasting. The number of NALs did not rise proportionately, and the FCC continued to find indecency on radio far more than on television, even if some audience members had intensified concerns about indecency on TV and were making their views known.

In 2001, while the *No Te Duermas* case was under review, the FCC was also preparing to respond to complaints from broadcasters about the lack of clarity in its criteria for determining indecency. In April of that year, the

commission issued an "Industry Guidance" policy statement acknowledg-
ing that only the most "compelling interest" could justify restrictions on
broadcasters' First Amendment-protected speech and that any limitations
on broadcast speech should be "the least restrictive means" possible.[11] That
"compelling interest" is the "welfare of children" who could presumably be
harmed by exposure to inappropriate material.[12] The statement goes on to
articulate its standard for determining indecency in some detail. First, the
material must "describe or depict sexual or excretory organs or activities,"
and it must be "patently offensive as measured by contemporary commu-
nity standards for the broadcast medium."[13] "Patently offensive" material is
to be judged according to its "explicitness or graphic nature," the degree to
which it "dwells on or repeats at length" indecent material, and "whether
the material appears to pander or is used to titillate, or whether the mate-
rial appears to have been presented for its shock value."[14] To find a broad-
caster guilty of indecency, a broadcast had to satisfy all, not just one or some,
of these criteria. In each of these criteria, the Industry Guidance statement
drew directly from FCC definitions of indecency that dated back to its 1975
decision in the WBAI case involving George Carlin's "Filthy Words."[15]

The next time the FCC declared a television broadcast indecent, the inci-
dent, like the *No Te Duermes* case, involved a live, local broadcast. When
Australian comedians Simon Morley and David Friend took their act "Pup-
petry of the Penis" to San Francisco in 2002, they appeared on the Octo-
ber 4 edition of KRON's *Morning News* show dressed only in capes. When
one of the men stood up, a full but fleeting view below the waist went live
to air for "less than a second."[16] A viewer complained, and the FCC launched
an investigation. Just under four months later, the FCC levied the maximum
$27,500 fine on the station. Young Broadcasting, KRON's parent company,
tried to claim a bona fide news exemption. And why not? In the Industry
Guidance policy statement of 2001, the commission had noted that "In
determining whether material is patently offensive, the full context in which
the material appeared is critically important. . . . Explicit language in the con-
text of a bona fide newscast might not be patently offensive."[17] The docu-
ment did not comment on whether a possible exception might apply to
visual sexual or excretory material as well as language.

In the KRON case, the FCC's Enforcement Bureau (EB) did not appear
to be in the mood to entertain the possibility of a legitimate exception for
partial nudity, at least not in the context of a "soft news" segment promot-
ing the act at a local theater. Two years after the broadcast, the EB concluded

that just having these performers on a live set, partially nude, established conditions in which nudity was likely enough to occur that its fleeting nature was irrelevant. Station managers apologized and paid the fee without protest. This was, according to FCC Commissioner Kevin Martin, "only the second time the commission has ever found a television broadcast to be indecent."[18] This wasn't precisely true: the FCC had also found indecency in WZKC-TV's airing of the movie *Private Lessons* in 1987 and in WJPR-TV's and WFXR's broadcast of *DeepStar Six* in 1993, but, in both cases, had canceled the fines.

While the WKAQ and KRON cases unfolded, complaints about TV incidents climbed. In 2002, the FCC recorded almost 14,000 complaints, 40 times the number recorded in 2001. Trends were clear: First, groups such as the PTC were successfully motivating constituents to complain. Second, using the FCC's online form and the PTC's email template, complaints now regularly targeted a program perceived to be indecent with multiple complaints, even though the FCC's process requires only one complaint to trigger an investigation. Third, while complaints about radio broadcasts also increased, television finally caught up to and surpassed radio as the most complained-about medium. Among the incidents drawing complaints and regulatory scrutiny in this period was Fox's live broadcast of the *Billboard Music Awards* on December 9, 2002. The singer and actor Cher used profanity when she accepted the Artist Achievement Award, a lifetime honor, joking about her detractors: "I've . . . had critics for the last forty years saying that I was on my way out every year. Right. So fuck 'em. I still have a job and they don't." A spate of similar incidents during live broadcasts—and occasional glimpses of nudity on both live and prerecorded programs—continued to drive up complaints in 2003 and 2004.

On January 19, 2003, just a few weeks after Cher's appearance on the *Billboard Music Awards*, NBC aired the *Golden Globe Awards*. Bono and The Edge, both members of the rock group U2, took the stage to accept the award for Best Original Song in a Motion Picture (the song was "The Hands That Built America," from Martin Scorsese's *Gangs of New York*). Bono lifted the statuette in the air and said, "That's really, really, fucking brilliant." Complaints about this segment of the show, including many originating with the PTC, were among the over 200,000 indecency complaints received by the FCC in the year 2003, more than fourteen times the number received in 2002. Initially, in October 2003, the FCC Enforcement Bureau ruled that Bono's use of the word "fucking" didn't qualify as indecent because the adjec-

tive did not "describe sexual or excretory organs or activities," which is essential to a finding of indecency.[19] NBC, in its defense, cited a 1991 edition of the *American Heritage Dictionary* that included a definition for the word in its role as an intensifying adverb not unlike "really" or "very."[20] Besides, Bono had used the word only once. It was, in the commission's terms, an inarguably "fleeting and isolated" utterance. The PTC challenged the ruling, and FCC Chairman Michael K. Powell advocated for reconsideration.

On December 10, 2003, two months after the EB's announcement that it would not take action against the use of the word "fucking" as a non-sexual intensifier, another celebrity followed in Cher's and Bono's recent footsteps when Fox again broadcast the *Golden Globe Awards* show live. At the podium to present an award, Paris Hilton and Nicole Richie mocked both the indecency rules and their reality TV show *The Simple Life*, which put these wealthy socialites to work at menial labor. Hilton warned her costar, "Now, Nicole, remember, this is a live show. Watch the bad language." In response, Richie mused, "Why do they even call it *The Simple Life*? Have you ever tried to get cow shit out of a Prada purse? It's not so fucking simple." (The script called for her to say "pig crap," and she improvised to intensify the excretory term and alter its animal source.[21])

Each of these cases—the live broadcasts of the 2002 and 2003 *Billboard Music Awards* and the 2003 *Golden Globe Awards*—captured the attention of news media, federal regulators, and watchdog groups. But not all new indecency cases involved indecent or profane language. The April 7, 2003 episode of Fox's *Married by America*, a short-lived reality TV show, prompted dozens of complaints.[22] In a bachelor party scene, women's bare breasts and buttocks were exposed but pixilated. The next major indecency case involving a broadcast reached exponentially more viewers and would cause an even greater hullabaloo. This one was live, like the awards shows that had been generating so much controversy, but as in the *Married by America* case, it would be the unclothed body that sparked complaints.

On February 1, 2004 (just a week after the FCC's ruling on the KRON case), at Super Bowl XXXVIII, a "costume reveal" became a "wardrobe malfunction" during Justin Timberlake's and Janet Jackson's halftime performance, exposing her right breast for less than half a second. Following numbers by Kid Rock, P. Diddy, Jessica Simpson, and Beyoncé, Jackson's performance began with a group of dancers in costumes seemingly inspired by *Clockwork Orange* with a touch of Bob Fosse, circa *All That Jazz*. Early

in the segment, the dancers wore mostly white, then shed those garments in favor of mostly black with accents of red and white, mixing men's hats, motorcycle jackets, and clunky boots with garter belts and short skirts. Jackson herself appeared in long sleeves, a snug corset, tall boots, and loose pants layered with thigh guards reminiscent of samurai amour. At the end of a medley of her songs "All For You," "Rhythm Nation," and "Knowledge," Timberlake joined her onstage, launching into his hit "Rock Your Body." While Jackson and the dancers were in carefully coordinated costumes, he appeared to have walked in off the street, in baggy khakis, a green t-shirt, a dark unstructured jacket, and sneakers. Jackson and Timberlake paced the stage, occasionally pairing up, sometimes touching one another's buttocks, sometimes strutting away from one another.

While some observers noted that there had been offensive material in other segments of the halftime show, it was the final few seconds that garnered most of the attention.[23] At the end of the song, Timberlake reached across Jackson's body to grasp the far corner of her bustier. When he pulled his hand away, he was holding a portion of her costume, and her right breast was fully exposed for some nine-thirty-seconds (9/32) of a second. The last few frames of the segment show Jackson moving her hands toward her breast. Both performers' facial expressions seemed to suggest that they were as taken aback as some of the viewers were by how much of the costume fell away.[24] The scene cut quickly to a long shot of the stage. CBS later claimed that the network, its then-parent company Viacom, and MTV (also Viacom-owned), which produced the halftime segment, were all unaware that Timberlake and Jackson had added this move to their act.[25]

Even if Jackson's breast was televised for less than a second, technologies other than live broadcast kept it on viewers' screens. The digital video recording company TiVO announced that the incident set a record (since eclipsed) as the most rewatched moment in the history of their device.[26] Interest in the event was persistent: Google counted the name "Janet Jackson" as the most-searched phrase during all of 2005.[27] Print newspapers and magazines covered the event and its aftermath, and their electronic counterparts sometimes included still or moving images of Jackson as, or immediately after, Timberlake removed a piece of her costume. The 2004 Super Bowl halftime show also became TV's most complained-about incident. (That record still stands.) The FCC claimed to have received over a half million complaints, the vast majority of which were generated by an online campaign launched immediately by the PTC. Within 24 hours, Michael K.

Powell, then chair of the FCC, deplored the gaffe as "a classless, crass, and deplorable stunt. Our nation's children, parents and citizens deserve better."[28]

After these incidents and the unprecedented waves of complaints, the regulatory tide was prepped to turn away from strictly contextual analysis and lenience toward "fleeting, isolated" profanities, to a much harsher approach. In March 2004, the commission issued a memo that would be known as the "Golden Globes Order" in response to the January 2003 broadcast in which Bono had used the gerund "fucking" as an intensifier. All five commissioners rejected the possibility that the "F-word" could be used without sexual connotation, dismissing the EB's 2003 agreement with NBC that the word has a legitimate alternative usage free of its sexual connotations.[29] In effect, the order overturned the EB's decision not to take action against NBC stations for the Golden Globes gaffe by Bono. However, to find indecency in this instance, the commission also had to find a way to sidestep its own practice, which it had used since 1987, of pursuing only cases against repeated profanities, since Bono had used the word only once. Noting that Section 1464 of the U.S. legal code does not *require* "repeated or sustained utterances," but only that a person "'utters any obscene, indecent, or profane language" in a broadcast medium, the commissioners jettisoned the restraint written into the Pacifica decision—and with it, years of precedent.[30] Since the memo constituted a new policy direction, the commission declined to fine NBC stations for airing Bono's exclamation, but Powell announced upon release of the order that "parties are on notice that they could now face significant penalties for similar violations."[31]

Under the new policy, the Enforcement Bureau handled the *Billboard Music Awards* cases in a 2006 Omnibus Order covering these incidents and several others. Cher's and Nicole Richie's utterances were among those declared indecent and profane.[32] The U.S. Court of Appeals for the Second Circuit overturned the ruling in 2007, stating that "the FCC has failed to articulate a reasoned basis for this change in policy," thus rendering it "arbitrary and capricious under the Administrative Procedure Act."[33] As for the *Married by America* bachelor party scene, the FCC's first response was severe: in 2004, 169 stations were fined $7,000 each, totaling over $1.18 million. But four years later, the commission rolled back most of the forfeiture order, maintaining fines against only those thirteen stations in markets that had originated complaints.[34] This was something of a newly restrained application of the concept of community standards. (After all, how could

the FCC declare that a community in which no one complained was as offended as one whose members did generate complaints?) Still, Fox refused to pay the remaining $91,000 fine, and eventually, in September 2012, the FCC abandoned the *Married by America* case altogether.

While there is some wrangling about how complaints are counted, by some accounts, the PTC may have generated as many as 99 percent of the 1.4 million complaints recorded in 2004, the year the number of complaints peaked.[35] Nearly half of those complaints targeted the 2004 Super Bowl halftime show. The Golden Globes Order was more specific about verbal indecency than indecent visual material, but it had pushed aside the standard of regulatory restraint in regard to "fleeting, isolated" indecency in general. And having ruled against KRON over the "Puppetry of the Penis" incident, despite the incident being unplanned and over in the blink of an eye, the FCC had established a precedent for taking action against a quick glimpse of partial nudity. The commission eventually fined CBS-owned stations $550,000, sparking a series of legal battles, not only over this particular fine but about the indecency policy generally.[36] CBS challenged, and in 2008 the U.S. Court of Appeals for the Third Circuit issued a decision that vacated the fines. In short, the court found the FCC's shift in policy "arbitrary and capricious" and determined that CBS could not be held responsible for the performances of Jackson and Timberlake, who were "independent contractors" rather than network or station employees.[37] In 2009, the Supreme Court declined to hear the FCC's appeal, letting the lower court's decision stand.

The FCC had indicated its willingness to take action in certain cases, but still, relative to the spike in complaints, very few cases were subject to fines. But with advocacy groups, FCC leadership, and members of Congress urging a crackdown, the impact of those fines would soon be intensified. At a congressional hearing early in 2004 on how the FCC enforced its indecency policies, David Solomon, then chief of the Enforcement Bureau, detailed ways that the FCC was strengthening its procedures, among them: informing stations that repeat or particularly egregious violations could lead to license revocation and notifying broadcasters that it could apply a fine to each indecent expression within a program rather than treating it as a single incident. Solomon also concurred with members of Congress and with PTC President Brent Bozell that a big hike in allowable fines would encourage broadcasters to avoid indecency more carefully. FCC commissioners, too, voiced bipartisan support for raising fines: both Republican Chair

Michael K. Powell and Democrat Michael K. Copps were quoted as commenting that broadcasters accepted fines as "the cost of doing business,"[38] and therefore were not deterred by the risk of indecency determinations. (Never mind, at least in TV, that evidence for this claim was scant, given how few fines had been levied to date and how vigorously most were fought.) At the time, the maximum fine was set at $27,500 per station, per incident. A few months later, the commission raised the cap to $32,500; any further increase would require an act of Congress.[39] An early version of a bill that hiked up fines stumbled, but when Congress did act, it did so with unusual unity. In 2006, then-President George W. Bush signed into law the Broadcast Indecency Enforcement Act, which passed the Senate unanimously, with 379 of 435 members of the House of Representatives also voting "yea." The measure raised the maximum fine per station, per incident tenfold, to $325,000.[40] In 2013, the FCC adjusted the cap again to account for inflation, lifting the maximum fine to $350,000 for a single incident.[41]

The hiked fines and the Enforcement Bureau's initial response to the Super Bowl halftime show demonstrated the commission's willingness to exercise its toughened stance on visual as well as verbal material containing indecency. Still, the vast majority of complaints did not lead to punitive measures against broadcasters. Early in 2005, the FCC cleared dozens of cases, issuing memorandums denying complaints, most of which had been generated by the PTC. One of these memos announced that 21 programs targeted by the PTC did not meet the standard of indecency. Twelve of those 21 complaints named the WB affiliate WBDC-TV in Washington, DC, as the source of the offending material, which included episodes of *Dawson's Creek* and *Gilmore Girls* that used the epithet "dick" and other mild profanities such as "ass," "bastard," and "bitch." The commission decided, in regard to utterances of these words, that "their use in this context was not sufficiently explicit or graphic and/or sustained to be patently offensive," thus failing one of the tests for finding indecency.[42] A similar memo denied another fifteen PTC complaints, three of which singled out episodes of *Friends* that used words such as "penis," "hell," and "son of a bitch"; another two denied sexual banter on episodes of *Scrubs,* none of which were found to be "patently offensive."[43]

As well, early in 2005, the commission denied the American Family Association's complaints regarding ABC's 2004 Veteran's Day broadcast of *Saving Private Ryan* (1998), Stephen Spielberg's World War II drama. About a third of ABC's affiliates had refused to air the film, fearing complaints and

FIG. 6 Medic Irwin Wade (Giovanni Ribisi) delivers one of the lines that led some ABC affiliates to refuse to air *Saving Private Ryan* (dir. Stephen Spielberg, 1998) on Veteran's Day in 2004.

fines.[44] While admitting that the film's use of expletives is "graphic and explicit, and . . . repeated" enough to meet two of the criteria for indecency, "contextual considerations" led the FCC to conclude that the language was "not gratuitous and could not have been deleted without materially altering the broadcast."[45] In making this determination, the commission relied in part on a precedent of its own ruling that denied complaints against nudity in *Schindler's List* (1993, aired by NBC in 1997), arguing that the gravity of the subject matter warranted content that might have been actionable in other contexts and articulating a kind of "artistic exception" that would be reserved for rare application.[46] The ruling lauded ABC for framing *Saving Private Ryan* with an introduction by both an elderly veteran of a World War II battle depicted in the film and by Senator and Vietnam War veteran John McCain, with a verbal warning about its "R-rated language and graphic content," and with prominent use of the rating TV MA LV, which alerts viewers that the broadcast is intended for mature audiences because of its language and violence.[47]

Previously, the commission had issued inconsistent guidance about the extent to which warnings may help insulate broadcasters from charges of indecency. In the landmark case of the George Carlin routine that led to the *Pacifica* decision of 1978, the FCC had acknowledged leeway for broadcasts after 10:00 P.M. when "preceded by a warning."[48] In contrast, a 1987

memo declaring indecent scenes from the play *Jerker* broadcast on KPFK made clear that "the fact that this program was broadcast at 10:00 P.M. with a warning does not render it permissible"; after all, the memo noted, channel-surfing listeners and viewers are likely to miss these warnings.[49] In essence, the *Saving Private Ryan* decision reasserted that the commission would continue to engage in contextual analysis of potentially indecent material, taking into account not only time of day and intent but also genre and subject matter. The strict Golden Globes Order may have been in effect during the broadcast, but the commission used its discretion to deny complaints. ABC may have been vindicated, but broad questions regarding the clarity of the indecency policy remained.

Scripted *Blue*

Early in 2003, while the FCC was still deliberating on fleeting frontal nudity in KRON's live "Puppetry of the Penis" newscast, ABC aired an episode of *NYPD Blue*, "Nude Awakening," that contained an instance of *scripted*, not-so-fleeting, but partial nudity. It became the focus of a huge FCC fine and a lengthy court case. The series, from its inception, had rankled advocacy groups with its edgy language and treatments of sexual themes. The American Family Association led a boycott; major advertisers and some 57 network affiliates (a quarter of ABC stations) initially shied away from the series, even if they "came around" once the show proved a hit.[50] Still, it was the "Nude Awakening" episode, which aired February 25, 2003, that bore the brunt of FCC action against the show.

The episode begins with a scene in which the character Detective Connie McDowell (Charlotte Ross), having spent the night with Detective Andy Sipowicz (Dennis Franz), enters a bathroom wearing a robe, which she sheds, preparing to shower. Two separate shots show Ross, as Connie, unclothed, in back and side views, with her arms strategically raised to cover her nipples when she turns sideways. Sipowicz's young son Theo (Austin Majors), unaware that she is there, opens the bathroom door. Connie turns around and gasps when she sees the boy. He has a full-frontal view of her, but the viewer does not; a close-up of the back of his head blocks our view of her naked chest. The next shot is of Ross in three-quarter view, one hand across her breasts, the other covering her pubic region, mouth agape. In a reverse shot, the camera peers between Connie's legs to frame an image of Theo,

staring dumbfounded at her for a moment before he leaves the room.[51] His voice muffled by the closed door, Theo offers, "I'm sorry!" and the camera lingers on Connie, still awkwardly contorted, still aghast, as she answers, "It's okay, no problem," in an unconvincing tone. Media scholar Jennifer Holt calculated that there was "roughly seven seconds of partial nudity" in a scene lasting forty seconds.[52]

Early in 2008, one month shy of five years later, the FCC announced that its investigation had found the scene indecent, warranting fines totaling $1.43 million, or $27,500 for each station that aired the episode before 10:00 P.M. (While the maximum fine had been raised in the interim, $27,500 was the cap at the time of the episode's first broadcast.) Fifty-two stations in Central and Mountain time zones, which started the show at 9:00 P.M., took the financial hit. Citing the "safe harbor" rule, the FCC declined to fine stations in Eastern and Pacific Standard Time Zones, which aired *NYPD Blue* at 10:00 P.M.[53]

To arrive at a determination of indecency, the FCC analyzed the scene according to its multipronged test. The test first requires that the contested material is sexual or excretory in nature. The Enforcement Bureau decided that, despite ABC's argument to the contrary, a woman's buttocks do qualify as "sexual organs and excretory organs," drawing on prior "case law and common sense."[54] In regard to the second prong of the test, which measures the "explicitness or graphic nature" of the material, the NAL contended that the nudity was indeed explicit, despite obscuring Ross's nipples and pubic region throughout.[55] Further, examining the extent to which the potentially indecent material is "dwel[t] on or repeat[ed] at length," the Enforcement Bureau found sufficient evidence that Ross's unclothed body appears in "multiple, close-range" shots, including one starting from "a full shot of her naked from the back, from the top of her head to her waist; the camera then pans down to a shot of her buttocks, then lingers for a moment, and then pans up her back."[56]

Finally, the scene had to satisfy another criteria: "whether the material panders to, titillates, or shocks the audience."[57] The NAL states more than once that the FCC received "numerous complaints . . . including thousands of letters from members of various citizen advocacy groups."[58] Given what was found to be "a reasonable risk that children may have been in the audience," at least in some time zones, "Nude Awakening" was, according to the Enforcement Bureau, "legally actionable." Despite prior cases in which a warning at the start of the program helped broadcasters avoid punishment,

such as in the *Saving Private Ryan* cases, a notice preceding the *NYPD Blue* episode that indicated "'Nude Awakening' contains adult language and partial nudity" made no difference. This particular NAL argued that "the audience is constantly changing stations" and can easily miss such warnings.[59] As a result, the Enforcement Bureau asserted that the scene met the four-part criteria of representing sexual or excretory organs; being explicit; having substantial duration; and pandering, titillating or shocking. Therefore, the broadcast was deemed "patently offensive as measured by contemporary community standards for the broadcast medium."[60]

Is any other reading of the scene imaginable? Of course it is. On one hand, the lingering shot of the character Connie's backside added little narratively. The camera angle and movement are curious, potentially akin to what Laura Mulvey once identified in Hollywood techniques of filming women's bodies as, "a curious and controlling gaze."[61] In this sense, the pan could be seen as indulgent. On the other hand, the scene could be perceived as more quotidian than pandering or titillating. Who doesn't undress before they shower? To find the scene indecent, the Enforcement Bureau would have to take the view that all nudity is sexually provocative, which is surely a decontextualized reading, one that the commission itself had previously rejected. In 2005, for instance, the commission rejected a complaint regarding a "rudimentary depiction of a cartoon boy's buttocks" when animated character Bobby Hill stepped into a shower during an episode of Fox's *King of the Hill* (1997–2009).[62] In this light, would the *NYPD Blue* scene hold up as shocking? The sight of his father's naked lover was shown to be shocking to the seven-year-old boy, but surely the scene is familiar, even banal, to anyone who has ever inadvertently opened the door to an occupied bathroom, such that the principle theme of the sequence is embarrassment—Theo's, Connie's—rather than erotics.

Despite the unequivocal tone of the NAL, in 2011, the Second Circuit Court of Appeals overturned *all* "Nude Awakening" fines, citing its previous finding in *Fox. v. FCC* (2010) that the FCC policy is "unconstitutionally vague," creating a chilling potential to intrude on First Amendment-protected speech.[63] Nevertheless, the torrent of complaints and the EB's initial determination of indecency insisted that the scene was a sexual expression. In making such a reading, the media advocacy groups and the federal regulator were occupying the role of protective, paternal arbiter: the same role that Justice McKenna supported on the early twentieth-century motion picture censor boards and the role assumed by the court itself in *Mutual v.*

Ohio (1915), as it became poised to protect audiences "not of adults alone, but of children," from the suspected "evils" found in alluring media sounds and images.[64]

The uproar over the February 2003 episode of ABC's *NYPD Blue* did not immediately squelch sexual subject matter on competing networks. On November 6, 2003, CBS aired an episode of the FBI procedural drama *Without a Trace* called "Our Sons and Daughters," involving a search for a missing teenage boy, a rape, and an epidemic of sexually transmitted disease among high school students. In a party scene, which is shown in two segments lasting a total of just over a minute, characters wearing only underwear move in and out of shadow, some in apparent sexual positions. Rather than taking targeted action in response to complaints about the episode, the FCC included the "Our Sons and Daughters" case when it settled a number of outstanding indecency cases involving Viacom-owned stations, most of which were part of Viacom's Infinity Broadcasting Corporation chain of radio stations. These included WNEW in New York, home to *The Opie and Anthony Show*, which had run a contest that urged listeners to submit evidence that they were having sex in a public place.[65] In a consent decree issued in November 2003, Viacom and the FCC agreed to terms that would close all active indecency cases involving Viacom properties—except the one pertaining to the 2004 Super Bowl halftime show. The agreement required Viacom to install delay equipment at all of its TV and radio stations, for use in avoiding indecency in live programming; to retrain employees on indecency law; and to make a "voluntary contribution" of $3.5 million to the U.S. Treasury.[66]

Viacom paid up and put to rest the *Opie and Anthony* case, the *Without a Trace* incident, and others. But on December 31, 2004, CBS reran "Our Sons and Daughters" without making any changes in the orgiastic scenes. The PTC complained to the FCC, and, since the broadcast occurred just weeks after the consent decree, also issued a statement that "questioned Viacom's sincerity to abide by federal indecency laws."[67] In a 2006 NAL, the commission agreed that the episode contained "no nudity" but declared the one scene "highly sexually charged and explicit . . . particularly egregious because it focuses on sex among children," and imposed a record fine totaling $3.6 million on 111 stations.[68] Andrew Jay Schwartzman, head of the Media Access Project, and *Without a Trace* creator Hank Steinberg issued statements protesting the ruling, since the scene did not display "sexual or excretory organs" and was intended to critically explore the consequences

of casual sex rather than titillate.[69] As in so many previous cases, the commission ultimately did not collect, even though in this case it was demanding the largest forfeiture related to an indecency case in its history. The Enforcement Bureau has confirmed that these fines were never paid.[70]

Complaints, the Courts, and the Constitution

In the 2000–2005 period, media advocacy groups had succeeded in drawing enough attention to televised indecency to practically force the FCC to take action against at least some incidents, but they were not able to sustain momentum, at least not in terms of raw numbers. Complaints never again neared 2004's record 1.4 million. In 2005, the number of complaints recorded dropped to just under a quarter million and then rose again, to just over 350,000, in 2006. From 2007 to 2010, complaints dropped below 200,000 each year. Still, the unprecedented torrents of complaints remained within the public imagination, as bellwether of more widespread discontent, or as prudish nitpicking ripe for parody. Matt Groening's *The Simpsons*, which had satirized the decency debates as early as 1990, in "Itchy & Scratchy & Marge," tackled the subject again in "You Kent Always Say What You Want," in which local TV news anchor Kent Brockman utters indecent language on live television when Homer Simpson accidentally dumps a cup of hot coffee into Kent's lap. Homer's neighbor Ned Flanders, who scrutinizes videotaped broadcasts for scenes to complain about, pounds out emails to launch a campaign against Brockman. When his children ask him what he's doing, he replies, "Imploring people I never met to pressure a government with better things to do to punish a man who meant no harm for something nobody even saw." Indeed.

While not everyone may have agreed that a crackdown was in order, in some of the cases adjudicated in this period, the FCC levied fines in record-setting amounts, thanks to the efforts of Bush-era commissioners and an enthusiastic bipartisan Congress (on this issue, if few others) to raise these fines exponentially in 2006. But as the first decade of the twenty-first century drew to a close, many of these cases remained in dispute in the courts. These challenges were not limited to particular incidents but questioned the very validity of the indecency policy itself.

One of several key rulings came June 4, 2007, from the U.S. Court of Appeals for the Second Circuit, in *Fox et al. v. FCC*, which sought review

FIG. 7 Ned Flanders (Harry Shearer) scrutinizes videotaped broadcasts for indecent material to complain about in "You Kent Always Say What You Want," *The Simpsons*, May 20, 2007.

of the 2006 orders declaring indecent utterances by Cher and Nicole Richie at the *Billboard Music Awards* in 2002 and 2003, respectively. A group of seven former FCC officials submitted a friend-of-the-court brief urging the court to throw out those decisions and even the indecency policy as a whole. They included former chairs Mark S. Fowler (who served 1981–1987) and Newton N. Minow (1961–1963), as well as former commissioners James H. Quello (1974–1997) and Glen O. Robinson (1974–1976), with three former members of the agency's legal staff also signing on.[71] Each had played some role in making an issue of indecency while at the commission. Minow had famously given a speech to the NAB in 1961 in which he accused broadcasters of turning the medium into "a vast wasteland." Fowler had been at the helm when the FCC expanded its indecency enforcement policy in 1987. Quello was an outspoken advocate of action on indecency, and is said to have played a key role in brokering a $1.7 million fine paid in 1995 by Infinity Broadcasting to settle outstanding cases, most of which involved *The Howard Stern Show*.[72] Robinson had been involved in the FCC's decision to declare WBAI's broadcast of George Carlin's "Filthy Words" indecent, but

even then he voiced concerned about the potential for censorious over-enforcement.[73] By 2006, they had all revised their stances and called for the Supreme Court to invalidate the FCC's indecency policy on the grounds that it violates the First Amendment.[74] (They continued to petition the courts in subsequent indecency cases, too.[75])

The Second District Court did not go as far as the former FCC officials suggested, but they did overturn the Golden Globes Order, the policy on which these indecency determinations were made, finding it "arbitrary and capricious under the Administrative Procedures Act (APA) for failing to articulate a reasoned bases for its change in policy."[76] (In short, the APA requires both that governmental agencies follow established guidelines in developing and enforcing policies and that these policies are public knowledge.) In the case of the Golden Globes Order, that would have meant reviewing the policy of taking no action against "fleeting, isolated" expletives, which had been in place since 1987, and offering an evidence-based rationale for any change of policy. The District Court went so far as to say that one of the fundamental bases for the Supreme Court's decision in *FCC v. Pacifica* (1978)—the potential harm to children exposed to indecent broadcasting—was overstated. Writing for the majority in *Pacifica*, Justice John Paul Stevens worried that "Pacifica's broadcast could have enlarged a child's vocabulary in an instant."[77] But the decision in *Fox v. FCC* (2007) parried that the harshened interpretation of policy in 2003, and its application to the *Billboard Music Awards* broadcasts,

> is devoid of any evidence that suggests a fleeting expletive is harmful, let alone established that this harm is serious enough to warrant government regulation. Such evidence would seem to be particularly relevant today when children likely hear this language far more often from other sources than they did in the 1970s when the commission first began sanctioning indecent speech.[78]

The Second District's ruling stopped there, without considering the networks challenges to the indecency policy on constitutional grounds.

If the rule change was unjustified, then so were the rulings that declared the *Billboard Music Awards* broadcasts indecent. But the Second Circuit's decision did not stand. The Supreme Court overturned the ruling in 2009, holding that neither was the policy too vague nor did the networks lack notice that the kinds of utterances in question could qualify as indecent.[79] The higher court asked the Court of Appeals for the Second District to

reconsider the constitutional questions that it had not addressed in its 2007 decision, in some ways upping the ante.

On July 13, 2010, the Second Circuit ruled that the FCC policy, *in constitutional terms*, is "impermissibly vague" and prone to "discriminatory" enforcement.[80] For example, the court observed that the commission applied a subjective notion of artistic necessity when it protected the use of the words "fuck" and "shit" in *Saving Private Ryan*, while denying this leniency when the same words were used in the documentary *Martin Scorsese Presents the Blues* (2004), aired on PBS affiliate KCSM-TV in San Mateo, CA.[81] The court held that policy vagueness—and vagaries—produced a chilling effect, citing the refusal of some CBS affiliates to air the documentary *9/11* (2002) and the efforts of several local stations to minimize live portions of newscasts.[82] Recognizing this significant incursion on the First Amendment, the Second Circuit "[struck] down the FCC indecency policy"—for the second time, but this time on constitutional grounds.[83]

With the indecency policy invalidated—at least for now—the FCC took steps to slow the barrage of complaints. In 2011, it closed an email inbox that had been set up to receive complaints, which made it easy for duplicates to be submitted by constituents who did little more than hit "forward" or "send" when they received an alert from an advocacy group asking for complaints to flood the FCC about a particular broadcast, even if they hadn't actually seen it. The newer system required complainants to fill out a form online, which requires some unique effort.[84] Not surprisingly, in 2011, complaints started to drop as rapidly as they had once climbed, from about 26,000 in 2011 to fewer than 2,000 in 2012 and 2013.

The FCC and the Department of Justice prepared to take still-unresolved cases to the next (and theoretically last) level. Late in 2011, they filed briefs asking the Supreme Court to overturn lower court decisions and to reinstate the indecency policy.[85] The Media Access Project, the Center for Creative Voices in Media, and the Future of Music Coalition had already given notice of their continued opposition to the policy, arguing that the Second Circuit Court was correct in deciding that indecency policy is unconstitutionally vague and that the "scarcity principle" that undergirds broadcast regulation is wildly out of date and unfairly burdens broadcasters in a market in which media compete across platforms.[86] On January 10, 2012, the Supreme Court heard arguments on both sides of the case. According to reports, justices seemed sympathetic to the networks' frustration with the vagaries of the policy. For example, Justice Elena Kagan noted that, given

the artistic exceptions made for broadcasts of *Private Ryan* and *Schindler's List*, it looks like "nobody can use dirty words or nudity, except Stephen Spielberg."[87]

Five months later, in June 2012, the high court released its opinion. Focusing on three cases (the 2002 and 2003 *Billboard Music Awards* incidents on Fox involving Nicole Richie and Cher and the "Nude Awakening" episode of ABC's *NYPD Blue*), the court concluded that "the commission failed to give Fox or ABC fair notice prior to the broadcasts in question that fleeting expletives and momentary nudity could be found actionably indecent. Therefore . . . the commission's orders must be set aside."[88] The ruling vacated determinations of indecency without an associated forfeiture in Fox's Billboard cases, as well as ABC's *NYPD Blue* fines. Finalizing the case on the basis of due-process concerns, the court sidestepped any First Amendment-related questions that had come up in the course of these long proceedings. But the due-process concerns were not insubstantial. The decision, authored by Justice Anthony Kennedy on behalf of a unanimous court (with Justice Sonia Sotomayor recused) noted that the Due Process Clause of the Fifth Amendment to the U.S. Constitution "requires the invalidation of laws that are impermissibly vague."[89] The Supreme Court did not, by any means, use this opportunity to strike down the federal law or FCC policy prohibiting broadcasts of "obscene, indecent, or profane language," but it did clearly seek to motivate the commission to give networks and stations unambiguous indecency standards and fair notice of changes in the policy.

In many ways, the ruling cleared the deck, letting the commission and the courts—and the TV stations and networks involved—put these lingering, nearly decade-old cases behind them. But what next? Although the ruling affirmed that the FCC could regulate indecency, the court made it clear that, in the words of media scholar Jennifer Holt, "they just need to work on the way they do so."[90] As the ruling states:

> . . . this opinion leaves the commission free to modify its current indecency policy in light of its determination of the public interest and applicable legal requirements And it leaves the courts free to review the current policy or any modified policy in light of its content and application.[91]

Only Justice Ruth Bader Ginsburg, who concurred with the majority decision but appended a short statement anyway, seemed ready to face simmering free-speech issues that, in so many prior cases, so many courts had

sidestepped. "In my view," she wrote, "the court's decision in *FCC v. Pacifica Foundation*, 438 U.S. 726 (1978), was wrong when it was issued. Time, technological advances, and the commission's untenable rulings in the cases now before the court shows why *Pacifica* bears reconsideration."[92] Her willingness to take this bold move was singular, and consideration of the constitutionality of indecency law and policy in terms of the First Amendment would once again be deferred.

Conclusion

After the June 2012 Supreme Court ruling, how would the commission handle future cases? In September of that year, Chairman Genachowski "directed the Enforcement Bureau to focus its indecency enforcement resources on egregious cases and to reduce the backlog of pending indecency complaints."[93] In doing so, the EB dismissed over a million complaints, some 70 percent of the backlog, in less than eight months.[94] Dismissed cases included Fox's 2003 *Married by America* episode; apparently, a few pixilated body parts from a nearly decade-old, short-lived reality TV show, constituted neither one of its strongest cases nor one of the most egregious violations in its backlog. Enforcement actions would be few and far between, demonstrating a more cautious approach. Similar restraint prevailed after Genachowski's term as FCC chairman ended in May 2013, during Mignon Clyburn's term as acting chair from May to November 2013, and when Tom Wheeler took over the chairmanship in November 2013.

By this time, even Michael K. Powell, chairman during the 2004 Super Bowl who had told Congress that the halftime show was "a new low for primetime television," had revised his once tough stance on indecency. In 2014, he told ESPN that his initial response to the Timberlake-Jackson performance was not outrage but rather "Wow, this is kind of a racy routine . . . not that I personally minded it"—but that when he realized that Jackson's breast was exposed, he lamented to the friend he was watching with that "My day is going to *suck* tomorrow."[95]

At the same time that Genachowski advised staff to dismiss all but the most egregious cases, the commission also called for public comment on the indecency policy. When the comment period ended, the commission said that it had received just over 100,000 responses, with "almost all of them in favor of keeping the existing rules," rather than reverting to the narrow

parameters maintained between the 1976 Pacifica decision and the 1987 expansion of what could qualify as indecent.[96] To put the number of comments into context, compare it with the reported 3.7 million comments received in 2014 when the FCC was considering reclassifying Internet Service Providers (ISPs) as common carriers (the "net neutrality" initiative toward the end of the Obama administration) and the reported 9 million in 2017, when the FCC, led by Trump-appointee Ajit Pai, was taking comments on reversing that ruling.[97] Clearly, watchdog groups on both the Right and the Left failed to rally comparative crowds to voice their views of indecency to the commission.

Wheeler's commission would take action in selected cases. Among them was one that had been open for over six years, since mid-2006, when the FCC started looking into complaints about a show called *Jose Luis Sin Censura* (2002–2012), which was then airing on the Liberman Broadcasting network Estrella TV. The National Hispanic Media Coalition and the Gay & Lesbian Alliance Against Defamation filed a joint formal complaint against the program in 2011, charging that the show's host exhorts audience members to utter Spanish-language expletives, vulgarities, racist slurs targeting Latino/Latina people, derogatory terms for gay men, and misogynistic language.[98] Resolution came in the form of a consent decree released November 14, 2013 citing Liberman-owned stations KRCA in Riverside, CA; KPNZ in Ogden, UT; KMPX in Decatur, TX; and KZJL in Houston. The decree ordered Liberman Broadcasting to forfeit $110,000 and retrain employees in indecency law.[99]

It wouldn't be long before the FCC had another chance to demonstrate just when an indecency complaint seemed, under Wheeler's leadership, worth pursuing. In 2012, WDBJ-TV in Roanoke, Virginia, for 2.7 seconds during a 6:00 P.M. newscast, aired an image that was declared indecent. I described the image in the introduction to this chapter. The station claimed that the broadcast was inadvertent. A software program, in need of upgrading, did not display the margins of the footage while it was being previewed, so station employees were unaware that it would appear within the frame when broadcast. It took almost three years for the FCC's Enforcement Bureau to declare the scene indecent and to levy the largest possible fine, $325,000, on WDBJ-TV, a CBS affiliate.

The FCC seemed to see little wiggle room in the WDBJ case, no matter how small or fleeting the image and no matter the role of human (or technical) error. The decision suggested that even in the post-Golden Globes

Order era, and even after courts overturned the commission's decisions in some of the most high-profile indecency cases ever (the 2004 Super Bowl halftime show and the 2003 *NYPD Blue* episode "Nude Awakening," among others), the FCC could respond harshly. The NAL made clear that "there is no exception for indecency laws for news broadcasts," reminding the station that the Enforcement Bureau had found indecency in KRON's "Puppetry of the Penis" even though the exposure was live, fleeting, inadvertent—and part of a newscast.[100] The Bureau treated the WDBJ incident as more egregious, because it was prerecorded and therefore could've been avoided, and because it not only showed a "sexual organ" but actual "sexual activity." That another instance of male frontal nudity in a newscast (a shot of a man being rescued from a river, used on NBC's *Today Show*) was *not* found indecent was dismissed as a defense. The EB had decided that the image was too "distant" to be "graphic and explicit."[101]

WDBJ appealed. Lawyers representing the station argued that that the image—an erect penis and a hand—occupied only 1.7 percent of screen space, and protested the finding that the segment was "graphic and explicit," prolonged, or purposefully titillating.[102] Moreover, they maintained that the broadcast did not meet the commission's criteria for willfulness; the station did not *intentionally* seek to shock viewers.[103] Not surprisingly, the appeal also reiterated longstanding concerns that the FCC does not give clear guidance about nudity in the context of bona fide newscasts. The appeal was particularly forceful in reminding the regulatory agency that just because in 2012 the Supreme Court had avoided addressing First Amendment concerns about the indecency policy, that didn't mean those concerns didn't persist. Lawyers for WDBJ argued that the kind of restraint established in the 1975 FCC Pacifica Order should be the model for a constitutional policy on broadcast indecency: indecency should be defined "narrowly," "actionable" incidents must be intentional, "repeated or extended."[104] Anything else, they maintained, was overreach that had never been fully tested in the courts. It looked like they were ready to take their challenge as far as they needed to, perhaps forcing the courts to take up the First Amendment questions that had been set aside in 2012.

WDBJ's appeal was filed halfway through 2015, but was later withdrawn and the fine paid, not because the station had a change of heart about its fault in the matter, nor because it suddenly saw the battle against the fine as unwinnable. Instead, WDBJ's parent company, Schurz Communications, closed the case to clear the way for the sale of a group of TV stations includ-

ing WDBJ to Gray Television Group in 2016. An outstanding indecency case might have jeopardized FCC approval of the sale.[105] In WDBJ's appeal, pursuing the First Amendment principles took a back seat to riding a wave of industry-wide consolidation. In this case, it would seem, the old Bush-era lament that indecency fines are just "the cost of doing business" in a hypercompetitive race for ratings seemed to gain new traction, but with a twist. Instead of only ratings, the race was now on for deep-pocketed station-owning chains to gobble up smaller station groups and accumulate more vast market shares.[106]

Even though the WDBJ case was resolved abruptly to help one of these mergers go forward, the harshness of the FCC's ruling, the approval of the PTC's leadership ("a victory for families"), and the vigor of WDBJ's appeal indicate that even after all the complaints, fines, and protracted court cases, regulators and regulated entities were still at odds. Conservative media advocates, through it all, remained fired up about perceived indecency.[107] What would it take to satisfy broadcasters and watchdogs, branches of government and audiences alike?

During the period discussed in this chapter—roughly 2000 to 2017—these debates over indecency raged despite changing conditions in the television industry that might have been expected to quell such concerns. Complaints to the FCC kept coming despite availability of the tools mandated by the Telecommunications Act of 1996 to help viewers avoid unwanted material and despite ever-increasing cable channel capacity and the rollout of new television-delivery systems. As audiences fragmented over new channels and new services, it might stand to reason that people would run into less unwanted programming and, therefore, would find less to complain about. It didn't always work out that way. I explore the proliferation of *TV choices* in relation to concerns about indecency in the next chapter.

3

Television

More or Less?

> The fundamental fact is that people love television. And if you can provide them with more television, they love it even more.
>
> —Ralph J. Roberts, founder and CEO of Comcast

On a 2005 episode of Fox's animated series *King of the Hill*, thirteen-year old Joseph Gribble tells his friend, twelve-year-old Bobby Hill, about a billboard advertising an upcoming broadcast of the Daytona 500. The sign features an attractive female model, a gushing bottle of champagne, and a car. More interested in the woman and the champagne than the car, they mistake the Daytona 500 for a reality TV show instead of a NASCAR race. They are eager to watch the show, but Bobby recalls that his father, Hank, has blocked the channel that is airing it. (That channel happens to be Fox, in an ironic and self-reflexive move.) Bobby asks his father to unblock the channel. Hank refuses. "Is it football season?" he asks his son. Bobby replies, "No," and Hank holds firm. "Then it's blocked."[1] Bobby figures out his father's

password to the television's parental controls and changes its settings. Now free to watch whatever they want, Bobby and Joseph check out a salacious reality TV show that offers breast enhancement to contestants who perform demeaning stunts and another involving cosmetic surgery and autophagia. If these fictional concepts sound unspeakably grotesque, they only parody actual reality TV competitions involving beautification and body-modifying practices such as *Extreme Makeover* on ABC (2002–2007) and Fox's *The Swan* (2004). The boys also get to watch the Daytona 500, even though it is not exactly what they expected.

Hank wants to protect his son from programming that is inappropriate. To make sure that Bobby does not watch these kinds of shows, he blocks Fox—a channel he is paying for with his monthly cable bill. The Hill household's cable subscription seems to provide too many choices, some unwanted, sometimes. So Hank turns to one of the tools mandated for all television with screens over thirteen inches by the Telecommunications Act of 1996, to help manage sprawling channel lineups and seemingly endless choices by making some of that programming inaccessible.[2] But that means he blocks *everything* aired on that channel, so when football season rolls around, he unblocks it and hopes for the best. Blocking lets less, not more, TV enter the household. That an appetite for football renders the tool useless for several months each year, and that its settings are so easily overcome by the child that it is meant to protect, are signs of their ineffectiveness in a television environment where so-called family-friendly entertainment appears next to adult-themed programming; where various members of a household approach television with different needs, desires, and expectations; and where we may not all agree about what is appropriate and inappropriate for our children and ourselves.

This chapter examines the problem of indecency and *choice* in a media environment in which the number of channels has skyrocketed and new delivery systems have proliferated. Television has never been so available or so abundant. So abundant, in fact, that at the end of the twentieth century, new technologies emerged to help consumers manage this plentitude, especially its potential indecency. These tools to help viewers avoid unwanted programming included the V-chip, a TV ratings system known as the Parental Guidelines, channel-blocking, "family-friendly" programming packages, and the à la carte option, which would depose the industry's prevalent business model in which cable systems sell bundled channels to consumers. That is, in various ways, these tools, instead of continuing the trend toward

greater channel capacity, more capacious subscriptions, and more ways to watch TV than ever before, deliver to us *less* TV. And some of these tools, as Raiford Guins argues in relation to the V-chip, in his adaptation of Nikolas Rose's concept of "governing at a distance," enable "parenting at a distance"—or, at least, the self-satisfying illusion of having done so.[3]

Are these tools effective ways to access wanted content and avoid unwanted content? It may seem counterintuitive that such mechanisms are even considered and, in some quarters, necessary. In a multichannel universe, there is a niche for every age group, and most homes have more screens than occupants, so why should anyone ever be subjected to age-inappropriate (or otherwise offensive) or unwanted programs?[4] It's not like we face the screen with only a handful of channels to choose from, as in the early decades of television. But all too often, purportedly innovative solutions have regressive results that do more to consolidate corporate power and less to promote the public good.

What is the public good, in terms of broadcasting and multichannel television? For starters, it would not be particularly controversial to argue that *competition* in the commercial marketplace for television channels of all kinds is useful. That is, consumers should be able to choose among multiple providers and products. Competition—in markets for both delivery systems and content—should keep choices abundant, prices reasonable, service dependable, and innovation steady. In broadcasting, the FCC assesses competition in terms of outlet diversity (meaning a variety of independent owners in media markets); source diversity (the availability of multiple content providers); program diversity (a variety of programming formats and content); and viewpoint diversity (a wide range of diverse and antagonistic opinions and interpretations).[5] In other words, media competition is healthy when there are lots of ways to get information and entertainment, from a lot of different owners, who air or publish a lot of distinctive material, representing many different voices and perspectives. In a media environment as abundant, pervasive, and even cacophonous as our own, these goals may seem within reach.

Yet, by many measures, competition in broadcasting is weak in a market dominated by a small handful of huge corporations.[6] In cable and satellite TV markets, the situation is not much better, given the extent of horizontal and vertical integration.[7] Still, some observers question the role of media consolidation in a perceived lack of viewpoint or channel diversity. For

example, Mara Einstein points out that the relationship between "media ownership and program content" is largely indeterminate; she has argued that, instead, it is the "reliance on advertising" that constricts concepts, formats, and forms.[8] But as it turns out, not all consumers or their advocates see the widest possible array of choices as best for most households. In other words, despite the late Comcast CEO Ralph J. Roberts's claim that the more television, the better, only if you provide some consumers with *less* television, "will they love it even more."[9] This is a trend, I argue, with foreboding implications for a televisual environment that is, by some measure, already lacking in diversity and overcommitted to the fetishized centrality of vaguely defined "family values."

The Domestic Medium Grows Up—and Grows

Almost immediately after World War II, television was promoted as a unifying force that would nurture relationships within families that were scarred by the war and were challenged by new postwar ways of life. One of those challenges was suburbanization, which distanced young couples and new parents from extended family networks and urban entertainments. Drawing on how TV was discussed in magazines and touted in advertisements in the late 1940s and 1950s, Lynn Spigel describes the high hopes for this new, glowing, chattering piece of furniture that took the place of a piano or fireplace in many homes:

> Television was the great family minstrel that promised to bring Mom, Dad, and the kids together; at the same time, it had to be carefully controlled so that it harmonized with the separate gender roles and social functions of individual family members. . . . Television was supposed to bring the family closer together but still allow for social and sexual divisions in the home.[10]

The belief that television would "bring the family even closer," Spigel continues, is "in itself a spatial metaphor," one that "was continuously repeated in a wide range of popular media."[11] Spigel's book includes an image from an RCA advertisement of 1949, in which the television, housed in a wooden console, occupies the focal center, while the family forms a cozy half-circle around the set. Mom is seated on a chair at left, with her arm resting on the

shoulder of a boy who sits on the floor next to her. Dad, at far right, shares a couch or loveseat with his daughter; his arm seems to encircle the girl. The family isn't just brought "together" by television, into a common space in which they are doing the same thing at the same time; they are brought "closer," literally and figuratively, as evidenced by cuddly caresses that the parents use to protectively flank, and hold tight to, their children. And they are all smiles, as is the performer on screen.

Such an idealized notion of television came with downsides. Television seemed to become for many children a "passive addiction" that posed an unhealthy alternative to playing outdoors, distracted kids from schoolwork, undermined parental authority, and exposed youth to the fantastical action of *Captain Video* or the mildly racy humor of Milton Berle's *Texaco Star Theater*.[12] By 1949 and 1950, the Parent-Teacher Association and the National Council of Catholic Women were warning parents to watch out for inappropriate programming and beginning to speculate about a TV ratings system.[13] (Their wish would take half a century to come to pass.) Other groups of Catholic clergy and laypeople also urged the new medium to show restraint.[14] Further, husbands and wives, parents and children, boys and girls, found that despite a small handful of channels to choose from, they often approached the set with different desires. Television *divided* families who couldn't agree on what to watch.

What of the many potential viewers who don't fit roles within the narrow nuclear family—single parents, same-sex couples, the childless, the elderly—and even the *televisionless*? Their desires were apparently of less concern to those invested in TV as a "family" medium. The "TV or Not to TV" episode of *The Honeymooners* (1955–1956) took on this problem, when Alice Kramden (Audrey Meadows) asks her husband Ralph (Jackie Gleason) to buy what would be their first television. Believing that he cannot afford such a significant purchase, he schemes with neighbor Ed Norton (Art Carney), whose TV is broken, to co-own a new set. But the men argue ferociously about where to put it and what to watch, nearly coming to blows. And what about Alice? She only wanted TV to alleviate the boredom of her long days of housework and evenings alone when Ralph went out to shoot pool, go bowling, or socialize at the Raccoon Lodge with his male buddies. Instead, Ralph takes the new device as his own, and instead of watching in the evening with his wife, he shares (and squabbles over) the set with his buddy Ed. Their situation is evidence of gendered division

not only in labor but also in access to entertainment and technology: Alice never seems to get a chance to take a seat near the screen, let alone pick a program.[15]

Household magazines and ads advised families to get more than one TV set to satisfy divided families without compromising the "domestic ideal" of family togetherness too much.[16] With more than one set in the home, tuned to different channels, more members of the family might be willing to spend their evenings at home, even if they could be watching different shows on different sets in different rooms.[17] But until households started buying the new color TVs in the 1960s, making the old black-and-white set a backup, few homes enjoyed the luxury of multiple screens. Even if they had more than one television, broadcast choices were not as abundant as they would be a couple of decades later.

In television's earliest years, until well into the 1980s, most of these sets used an antenna to pick up signals from a handful of local stations. Most of those stations carried the national broadcast networks: Dumont, until it ceased operations in 1956; NBC and CBS, which got into television early, with their first broadcasts dating to 1939 and 1941, respectively; and ABC, which launched in 1948. If programming on one channel didn't please a viewer, she could turn the dial to another station, and then another, and perhaps one or two more, but then she would likely find herself back where she started. Local stations and national networks alike knew that viewers had few choices. To maximize their audiences, they sought to appeal to broad cross-sections of the population, making what later came to be called "least objectionable" or "lowest common denominator" programming that would satisfy many and offend few, despite actual demographic heterogeneity in the audience, in terms of age, region, gender, race, and ethnicity. Apparently, early TV programmers weren't terribly interested in diversity within potential audiences. Most starkly, they failed almost entirely in imagining racial and ethnic difference, as demonstrated by the absence of people of color in leading roles throughout the 1950s and 1960s, with strikingly few exceptions.[18]

Manufacturers and industry observers alike emphasized aspects of television that would bolster the primacy of the home. Worried about teenagers slipping off to the movies—or the local lovers' lane? Dad spending too much time at the local tavern, watching baseball or boxing on TV, if there wasn't yet a set at home?[19] Not a problem; just get a set, or maybe two. The family,

in such a view, is the social tie *non pareil*, and spending time at home with family members is superior to outings with peers. There is a protectionist urge to all this closeness, as if the world outside poses unstated threats that could be avoided by hunkering down at home in front of a screen occupying center stage.

That center stage operated more like a circus, in which there may be acts taking place in all three rings, but the viewer can only focus on one at a time. If a parent found one program inappropriate for the kids, and a second member of the household was bored stiff by another, the choices narrowed even further. This paucity of options eventually began to change, slowly at times. In the All-Channel Receiver Act of 1962, Congress allowed the FCC to require all TV sets sold after 1964 to include UHF tuners so that they could receive channels 14 to 83 (in addition to VHF channels 2 to 13, favored by major broadcasters and their affiliates), but until the 1970s, there simply weren't VHF stations serving many localities.[20] Short-lived experiments in "pay-TV" cropped up throughout the decade, perhaps most notably, Subscription Television, Inc. (STV), which briefly, in 1964, cornered the market for televised Major Leagues Baseball games in Los Angeles and San Francisco.[21] But in many ways, the federal government did little to expand channel capacity and even worked toward maintaining a few-channel status quo.[22]

Regardless, the few broadcast channels available to most homes didn't remain the only options on the small screen for long. In the 1970s, the television industry began to diversify and expand considerably. In doing so, TV followed the film industry's example. Filmmakers in the 1950s and 1960s, fighting a Production Code that strived to make all films suitable for all audiences, developed adult-themed genres with films such as *The Moon Is Blue* (1953), *The Wild One* (1953), *The Man With the Golden Arm* (1955), *Tea and Sympathy* (1956), and *Baby Doll* (1956).[23] Likewise, in the 1970s, pay-TV in the form of wired, subscription-based cable systems began to offer alternatives to the free-to-air, advertising-supported broadcasters, augmenting the oligopolistic system of national networks and affiliated stations with new channels and numerous new choices for television households. These cable channels defined their audiences in more narrow demographic terms, or as more narrow interest groups, than ever before. Some offered programming that treated sexuality and violence more openly than in the industry's first two decades. That new openness proved both a ratings bonanza and a source of contention among some viewers.

Searching for the 500-Channel Universe

Although cable systems have existed for practically as long as free-to-air broadcast television, through the early 1970s, those systems tended to serve areas that were otherwise unable to pick up clear signals due to geographic features or other interference.[24] Their purpose was only to retransmit local broadcast signals to communities without their own stations. There were not, as of yet, cable channels with original content of their own. In localities where those stations came in loud and clear over the air, a subscription would have been redundant. In the 1970s, several services were founded around the core business of offering movies previously seen only in theaters, and these services became available nationally: Home Box Office (HBO), which also prominently featured live sporting events, was founded in 1972; Star Channel in 1973, to be rebranded as The Movie Channel in 1979; and Showtime, in 1976. By 1975, 14 percent of television-owning homes in the United States subscribed to cable.[25] But not all new channels focused on movies. Kids' programming dominated Pinwheel, which premiered on Warner Cable's experimental system QUBE in Columbus, Ohio, in 1977. It became Nickelodeon in 1979, which was also the year that all-sports channel ESPN launched. They were followed by the 24-hour news channel CNN and by BET, which focused on programming by and about African Americans, in 1980; MTV, then an outlet for music videos, founded in 1981; and dozens more. By 1980, 23 percent of homes had become cable subscribers.[26] In short, people began to become cable subscribers in large numbers because there was, more or less suddenly, new programming in circulation that could not be accessed otherwise.

The cable industry continued to grow in all directions, including the number of channels each cable system was capable of offering, the number of programming services that systems could choose from when filling those channels, and the number of subscribers. The FCC's *First Report* on the market, released in 1994, claimed that by 1990, there were some 70 channels available, with 67 percent of all cable systems having "the capacity for providing thirty or more channels," and 51.7 million subscribers (or 55.4 percent of U.S. TV households). By 1993, there were 106 channels, 77 percent of cable systems could provide 30 or more channels, and 57.4 million households (or about 60 percent of TV homes) subscribed to a cable service.[27]

This rate of growth continued robustly in most aspects. For one thing, cable was no longer the only competitor to broadcasting. Instead of counting

only cable subscribers, the FCC now had to account for other forms of delivery such as satellite services and internet-based TV, broadly grouped together as multichannel video programming distributors (MVPDs). By the FCC's *Twelfth Report*, released in 2006, "94.2 million TV households, or almost 86 percent of TV households subscribe to an MVPD service"; of those, 71.6 percent stuck to cable, with 27.7 percent opting for direct-to-home (DTH) or direct-broadcast satellite (DBS) services, and 1.5 percent using newly recognized broadband service providers.[28] The same report counted 531 networks available nationally via cable and/or satellite subscription and another 96 regional networks.[29] Some 96 percent of homes had the option to subscribe to digital tiers of channels.

The project of counting available channels grew more challenging. By 2013, the FCC's annual report could only say that, regarding the largest providers (Comcast, Time Warner Cable, and Charter), "these three cable MVPDs offer digital service with access to *hundreds of channels*" (emphasis added).[30] The report admitted that both MVPD subscriptions and TV-owning generally were declining slightly, as some viewers opted for internet-based video-streaming, but the FCC still counted 101 million subscribers, with 55.7 percent using cable; 33.1 percent DBS; and 6.9 percent broadband. Just over 5 percent had already signed on to "TV Everywhere" services that supplied pay-TV to computers, tablets, and smartphones.[31] Without a doubt, methods of delivery had multiplied and the quantity of deliverable content had grown exponentially. The sheer size of the market, measured in number of subscribers, seemed to indicate persistent, robust interest in television.

Or did it? Living in a proverbial 500-channel universe doesn't mean watching all 500 channels. According to a report issued by the U.S. General Accounting Office (GAO) in 2003, "In fact, a 2000 Nielsen Media Research Report indicated that households receiving more than 70 networks only watch, on average, about 17 of these networks."[32] Subsequent reports on the subject held fast to the number 17 as the behavioral norm. Early in 2006, the FCC cited the 17-channel-watching average household again.[33] In 2007, Nielsen released a new report, according to which U.S. TV-watching households only watch an average of 15.7 channels.[34]

Just as having hundreds of channels doesn't necessarily mean that consumers are using all of them, having hundreds of channels doesn't necessarily provide proportionate program diversity. A great deal of what airs on cable channels originates on the broadcast networks. Channels such as

TBS, AMC, and WE TV mix originals with post-network syndicated series; others, such as SOAPNet (defunct in 2013) and Ion Television have made daily marathons of broadcast network reruns the centerpieces of their lineups.[35] Likewise, Weigel Broadcasting's digital broadcast networks MeTV, Decades, and Heroes & Icons, which are also carried by some cable systems, fill their schedules with "classic" television sitcoms, Westerns, sci-fi, and dramas.

In other words, more channels may provide the convenience of multiple opportunities to catch certain shows or revisit old favorites, but they are far from a source for all-new programming. Although some of cable's original programming is innovative, admired, influential, and successful—cue *The Sopranos* (HBO, 1999–2007), *The Daily Show with Jon Stewart* (Comedy Central, 1999–2015), and *Pose* (FX, 2018–), among others—these series are highlights of schedules that contain, otherwise, a great deal of derivative material. The trend in television has been toward providing consumers with "more television," including more opportunities to revisit previously aired programming, presumably so that we can "love it even more," as Comcast's Ralph Roberts observed. Yet in the 1990s, not all stakeholders were pleased with much of the television they were getting. In response, an array of industry players began to offer tools for controlling access to unwanted programming. Some of these new tools were economically motivated: why pay for channels you don't watch? Others were designed specifically to help viewers avoid indecent programming. In various ways, they all, after decades of providing consumers with more and more channels, presented ways to have *less*, not more, TV.

The Ratings Game

Cable channel-blocking, the V-chip, and the TV Parental Guidelines (or ratings system) were products of the Telecommunications Act of 1996. These technologies were designed for use in conjunction with one another, to give subscribers greater control over what members of their households, specifically unsupervised children, could watch. Channel-blocking provisions require cable systems to scramble any channel in a customer's bundle if asked to do so. The V-chip allows users to adjust a television's settings so that programs with ratings that they choose to avoid cannot be accessed. The 1996 Act eased in the V-chip requirement, so that all televisions with screens

measuring 13 inches or more (diagonally) sold in the United States would contain this technology by the year 2000. The settings are passcode-protected. (It didn't seem to matter that, from 1990 to 1995, the FCC had found broadcasters liable for indecent programming about two dozen times—and each and every time, it involved a radio station, not television.) So how did these new parental controls on the supposed culprit of TV become key components of the 1996 Act?

Around 1990, Tim Collings, an engineer then working at Simon Fraser University in British Columbia, developed a system—not precisely a single microchip, despite the term that would become its popular name—that could identify and block coded television programming.[36] He presented the V-chip (which he called a viewer control device) to representatives of Canada, France, Germany, Italy, Japan, the United Kingdom, and the United States at a technology forum at the annual Group of 7 (G7) summit in 1995. In attendance was, according to industry legend, U.S. Vice President Al Gore, who was no stranger to decency debates. When Gore was still a U.S. Senator (D-TN), his wife Tipper was among the founders of the Parents Music Resource Center, which, in 1985, successfully lobbied the Recording Industry Association of America to affix warning labels to albums. Reportedly, Gore told President Bill Clinton about the V-chip and gave public demonstrations of a prototype, as did Senator Joe Lieberman (D-CT).[37] Another fan of the technology, then-Representative (later Senator) Ed Markey (D-MA), pushed for its adoption in his role as chair of the House Telecommunications Subcommittee. While Collings tried to dub his device "Vyou Control," stylizing a portmanteau of the words view and you, Markey's claim that the V in V-chip stands—or should stand—for violence, caught on more widely.[38]

Campaigns to control media content are often associated with the Christian Right, conservative watchdog groups, and Republican legislators and appointees, and there is plenty of evidence to suggest that this is often the case. Consider, for example, Senators Jesse Helms's (R-NC) and Alphonse D'Amato's (R-NY) late 1990s campaign to defund the National Endowment for the Arts; Senator Ted Stevens's (R-AK) unsuccessful efforts in 2005 to extend decency regulations to cable; Morality in the Media's influence on the 2012 Republican Party platform, which called for more aggressive action against "pornography and obscenity" on all media platforms; and harder-line enforcement by the FCC during the terms of Michael K. Powell (2001–2005) and Kevin J. Martin (2005–2009) as chair.[39] But to see decency reg-

ulation as a right-wing project would be to underestimate its political salience. Democratic leadership embraced the V-chip, promoted it to educators and others interested in children's well-being, and argued that rather than censorious, it was a tool of "empowerment" for concerned parents. In other words, it was a form of *re-regulation* (replacing old rules with new) that largely imposed *self-regulation* on both networks that would begin to apply ratings to their programs—and on viewers, who could choose to use the new tools or not. When Congress, in a rare instance of bipartisan near-consensus, voted overwhelmingly to pass the Telecommunications Act of 1996, the V-chip was part and parcel of its content-oriented provisions. Why didn't the V-chip quell complaints about indecent content? Then answer to that question calls for a brief review of how it works.

To make the V-chip effective, the act also legislated development of a ratings system to indicate age-appropriateness and particular content warnings. To develop this ratings system, the National Association of Broadcasters and the National Cable & Telecommunications Association (NCTA) worked with the Motion Picture Association of America (MPAA), which already had extensive experience with its own ratings system. The MPAA's system, which went into effect in 1968, and—despite criticism that it is inconsistently applied—is relatively simple and requires little prior knowledge of the codes.[40] Ratings appear on advertisements for films, on film posters used for promotion at movie theaters, on-screen prior to trailers, and elsewhere. The rating takes the form of a horizontal rectangle, with the rating in large font on the left-hand side, and a definition of the rating on the right. For example, a rating of G is paired with "General Audiences/All Ages Admitted." Below, another line or two of text indicates what prompted the rating. For example, *Guardians of the Galaxy* (2014) earned PG-13 "for intense sequences of sci-fi violence and action, and for some language." Three of the five current ratings (G, PG, and PG-13) allow for all-ages audiences but the PG and PG-13 ratings warn parents to "give parental guidance" and to "be cautious," respectively—presumably, in allowing children to attend. The R rating disallows anyone under 17 from attending a film unless "accompanied by a parent or guardian." NC-17 disallows audience members under 18 altogether.[41] Theaters are, ostensibly, responsible for enforcing age restrictions, but may have little legal or economic motivation to do so.[42]

By comparison, television's Parental Guidelines are relatively complex, and to make sense of the ratings, viewers need to have some familiarity with the codes. A square "bug" appears on the top right corner of the screen at

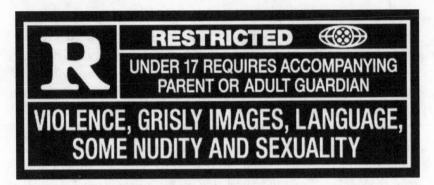

FIG. 8 An example of an R rating issued by the Classification and Rating Administration, a division of the Motion Picture Association of America, c. 2017.

the start of each program, displaying three lines of information. The top line simply—and perhaps needlessly—says "TV." The middle line, which uses larger type, indicates one of six age groups recommended for the program: Y (children under 6), Y7 (children 7 or older), G (general audiences), PG (parental guidance suggested), 14 (parents strongly cautioned), or MA (mature audiences only). On the lower line, one or more of five additional codes may appear to explain why the program has been given the age rating indicated: FV (fantasy violence), D (suggestive dialogue), L (language), S (sex), or V (violence). Some combinations of ratings indicate the intensity of the category of content that may be of concern. If L is used with PG, it indicates "infrequent coarse language"; with 14, "strong coarse language"; with MA, "crude indecent language." The thresholds are subjectively imprecise, with distinctions that are not immediately apparent. Likewise, S and V ratings, used in combination with PG, 14, or MA, are meant to indicate varying degrees of explicit sexual or violent activity, from "moderate" to "graphic."[43]

As with the MPAA ratings, use of the Parental Guidelines is voluntary but widespread, though rarely used for news and sports programming, much of which is live. Broadcasters and cable systems campaigned to educate viewers about these little-used technologies via information on company websites and public service announcements (PSAs). In March 2004, the NCTA launched a "media literacy" campaign, including PSAs on channel-blocking, the V-chip, and ratings, and a new website, ControlyourTV.org, to explain these technologies and point users to family-friendly fare.[44] The ads directed viewers to consult network websites, the FCC's website, and a toll-free num-

FIG. 9 An example of a rating issued by the TV Parental Guideline Monitoring Board, c. 2017, including MA for "mature audiences only," L for "coarse or crude language," S for "sexual situations," and V for violence. See the TV Parental Guidelines at http://www.tvguidelines.org/ratings.htm for a full key to the ratings.

ber at the commission for more information. One of these PSAs, made to air on the Fox network, starts by reaching out to troubled parents: "Lost all control of what your kids watch on TV? Have no fear, the V-chip is here." The narrator ads, *sotto voce* and with just a hint of snark, "And [it] has been for some time." Non-realistic animation depicts familial settings. "You wouldn't want this to happen," the narration warns, as cartooned children, staring at a TV set, suddenly scream in fear or shock. The V-chip is personified as a headless superhero with a puffed-out chest and flowing cape, assuring parents that if they use the ratings system and the V-chip, they won't need to worry about their kids' TV choices. Despite these efforts to promote the ratings and the V-chip, the tools remained little-used and

widely misunderstood.[45] In 2005, a Kaiser Family Foundation confirmed that only 15 percent of surveyed parents had actually used the V-chip, and nearly 40 percent didn't even know that their TVs included this device.[46]

The unpopularity of these technologies wasn't lost on media advocacy groups campaigning against indecency. As usual, the Parents Television Council led the way. In 2005, PTC founder L. Brent Bozell denounced the V-chip as a next-to-useless tool to control the "torrent of trash on the TV screen," since the ratings system was inconsistently applied by the networks and excessively confusing.[47] When a year later, another round of ads circulated to raise awareness of these tools, Bozell continued to criticize the television industry—for "the raw sewage it pumps into America's living rooms night after night"—and the inadequate parental control system.[48] Bozell may have been painting all of television programming with a prudishly broad brush, but he wasn't the only critic of the V-chip and the ratings system.

In 2016, an array of observers, including some 30 academic researchers, mostly in psychology and communications disciplines, came together to petition the FCC to revamp the ratings system. Officers of more than two dozen advocacy groups, including the American Family Association, Parents Television Council, Family Research Council, and Morality in Media, asked for independent monitoring and greater transparency in a system that has relied almost entirely on the promise of self-regulation: the networks rate their own programs, and representatives of broadcasting, the cable industry, and production studios hold 18 of 23 seats on the TV Parental Guidelines Oversight Monitoring Board.[49] They warned the FCC commissioners that the current system was a failure—inconsistent, opaque, and underutilized—citing studies showing that "media have important effects on children," which are all too often negative in terms of undermining academic performance, exacerbating aggression, and contributing to obesity and early sexual activity.[50] (The letter also noted that some media exposure can have *positive* effects, citing studies that have correlated *Sesame Street* viewership to preparedness for schooling.[51]) Clearly, after 20 years, the V-chip and ratings system had done little to staunch complaints, satisfy media watchdogs, or engage parents in using these tools to manage children's viewing.

The Telecommunications Act of 1996 also mandated channel-blocking, requiring cable systems to provide mechanisms that subscribers can use to make unwanted channels inaccessible. By manipulating PIN-code-protected settings, any unwanted channel can be blocked. When a channel is blocked,

none of its audio or video is available; the channel is still, however, technically part of the bundle or tier of channels that the household subscribes to (and, therefore, the blocked channel is among those receiving revenue from the subscriber's monthly fee). It might seem likely that as cable channels have grown increasingly niched, catering to specific age groups (as do the Nickelodeon and Disney channels), or interests (all news, all sports; golf, tennis, or food networks), that a household's interest—or lack of interest—in a particular channel would be clear. But the reality of scheduling practices proves otherwise.

Most television channels offer a range of programming, with different ratings, on different days of the week and different times of the day, and most viewers are likely to find only some portion of it offensive. CBS's 2014–2015 lineup, for example, included *Criminal Minds* and the *NCIS* franchise, which usually have TV-14 LV ratings, as well as shows with less restrictive ratings and genres not typically rated, such as the *CBS Evening News, 60 Minutes, Thursday Night Football*, and daytime fare like *The Price Is Right*. A household that blocks CBS because of one offending program blocks *all* of its programs. A subscriber who blocks all TV-14 shows may miss ABC's *Scandal* as well as episodes of *America's Funniest Home Videos* and *Modern Family*. Shows that one might find inappropriate for children in the afternoon (like ION TV's reruns of *Criminal Minds*) might be favorites of adults at another hour. Likewise, parents might find themselves in the same predicament as *King of the Hill*'s fictional Hank Hill, who wants to watch football on Fox but prevents his son Bobby from watching the network's reality TV shows. Such a desire for alternating access and non-access are too subtle for channel-blocking to fulfill. Furthermore, channel-blocking fails to satisfy those who not only want to avoid certain content but also want to avoid subsidizing that content. Why should anyone pay for services they are not using? This is a matter that the movement backing à la carte cable subscriptions has tried to redress, and one that the MVPDs themselves addressed via the creation of exclusively family-friendly tiers.

All in What Family? Family-Friendly Tiers

The V-chip, the ratings system, and channel-blocking technologies came about through the collaboration of industry players, including regulators, and were mandated by congressional action. Following the 2004 Super

Bowl, recognizing that these tools had failed to satisfy watchdogs and other viewers concerned about televised indecency, some elected officials scurried to mandate new paths to avoid unwelcome programming. Beginning in March 2005, Representatives Joe Barton (R-TX) and Fred Upton (R-MI), and Senators John Breaux (R-LA), Ted Stevens (R-AK), Jay Rockefeller (D-WV), and Kay Bailey Hutchison (R-TX) were among members of Congress who declared their interest in devising indecency rules for cable channels modeled after the broadcast policy.[52] Democratic FCC Commissioner Michael Copps also spoke out in support of such a measure.[53] Leaders of both the National Association of Broadcasters and the National Cable & Telecommunications associations made it clear that the industry would not stand for such a measure without a fight.[54] In March 2005, FCC Chairman Michael Powell, despite having raged about the 2004 Super Bowl halftime show and other recent incidents, admitted that expanding indecency regulations to cable would be "very likely unconstitutional."[55] But these were practically his parting words: Powell's term was ending, and President George W. Bush had appointed Kevin J. Martin to take his place. Martin kept open the possibility of tougher cable regulations open throughout his tenure.[56]

While a cable indecency policy never came to pass, Martin did support and encourage family-friendly cable tiers.[57] In April 2005, Senator Ron Wyden (D-OR), introduced the Kid-Friendly Programming Act, demanding that "each multichannel video programming distributor shall offer a child-friendly tier of programming consisting of no fewer than 15 channels" as part of a basic tier or as an expanded add-on.[58] The bill never got out of committee, but the industry quickly adopted the idea on a voluntary basis. In December 2005, Comcast, Time Warner Cable (TWC), and other systems announced that they would offer family-friendly tiers starting in 2006. FCC Chairman Kevin Martin applauded the move as one of several possible "tools to help address the increasing amount of coarse programming on television."[59] TWC's Family Choice Tier gathered the Disney Channel, Discovery Kids, Boomerang, Food Network, The Weather Channel, HGTV, and a few others into a family tier costing $12.99 more than a basic subscription.[60] Comcast's Family Tier was similar, at $14.95 over basic, and promised to include only "limited 'live' entertainment" with its risk of unscripted, uneditable indecency.[61] Comcast included many of the same channels as TWC and tacked on National Geographic and the religious broadcaster Trinity Broadcast Network (TBN, which targets Protestant, Catholic, and

Messianic Jewish audiences). Cox Family Service and Echostar's DISH Family packages comprised comparable offerings. None of these tiers included much in the way of sports channels (hence their affordability), which makes them far less appealing to subscribers for whom professional and college football and basketball, pro baseball, hockey, and other televised sports, are indispensable.[62]

Early on, cable operators promoted these packages as evidence of their own reliability, promising to provide only programming that any home could call "decent." In 2006, Time Warner Cable's webpage for Family Choice featured a photograph of a young girl, lying prone on what appears to be a bed, smiling and clutching the remote control, her gaze meeting the viewer's. This image is paired with a headline in the imperative: "Feel more secure with what your kids watch." Trust *us*, the webpage seems to say: we'll only give you content you'll be comfortable with; you can leave the kids alone to make their own safe choices. TWC's Family Choice promises consumers that TV can act *in loco parentis* as an electronic babysitter—and a dependable one, at that.

Later, TWC shifted responsibility for decency from the company to the subscriber. By 2014, the tier's motto was "It's in Your Hands." On its webpage, a white nuclear family of four walks through a forest. The man holds his son's hand and gazes in his direction, while the mother grips her daughter's hand, her gaze similarly cast toward the girl. Both children look away from their parents. The wooded setting might represent a wholesome break from screen time altogether, but in folklore and popular culture, forests have often been a site of danger, especially for children.[63] The 2014 version of TWC's Family Choice webpage reminds parents to hold their children close and do the work of monitoring children's viewing themselves. Like the V-chip, the family tier is a mechanism "meant to empower parents and relocate the source of censorial power," but it is also a discursive reframing of the relationship between the viewer and the medium as one part self-governing subject and one part market-faithful "*de*regulatory political agent."[64]

By offering family-friendly tiers, cable systems may have bought good will with members of Congress who were avidly pursuing new cable regulations, as well as with some disgruntled consumers, but these tiers did not ameliorate concerns about indecency. Tiering cannot assure that all programming will be family-friendly. Time Warner called the channels in this package "squeaky clean," even while pointing out that federal law (via "must carry") requires subscribers to receive local broadcasters, "which may air unsuitable

programming at various times."[65] To solve that problem, the webpage urges subscribers to learn to use channel-blocking technologies ("parental controls"). As well, the website warns, signing up for this package means that many popular cable channels will not be available. It is not possible to subscribe to Family Choice in one room and still get other channels elsewhere in the house: "Family Choice is a 'whole-home' solution."[66] In effect, parental controls are self-controls, too, which is why they don't work for many TV households.

Not all family packages came from already market-dominant providers. Robert W. Johnson founded the satellite TV and radio service SkyAngel in 1980 (though it didn't go on the air until 1996, when it secured carriage from Dish Network).[67] SkyAngel is part and parcel of a long history of Christian media-making, with a twist: instead of primarily producing televangelist content, SkyAngel put a Christian brand on a delivery system.[68] Its online presence sought to appeal directly to the dual impulse to protect both vulnerable children and one's own moral standing, and place blame for society's ills firmly outside the home and on television, as if it were a predatory intruder. In 2006, the SkyAngel website warned potential subscribers of the danger:

> Despite what you do to make sure your family is protected from any outside negative influences, did you know that there is a presence in your home that is slowly and surely influencing every member of your family no matter what you do as a Christian? It's the programming coming through your television set. Most Christians would probably agree that a lot of what mainstream television has to offer today is offensive. And, no matter how much we try to guard what's coming into our homes through television, it is nearly impossible to keep the bad out.
>
> If there is an absence of positive choices on TV, before long the line between good and evil becomes blurred, no matter what your age.

In other words, media effects are severe, and television invades the private sphere with dangerous, and even unavoidable, content. Therefore, the service attempts to lead viewers—both children and adults—away from what it points to as television's soul-stealing temptations, allowing access only to carefully vetted "positive" choices. In this phase of its history, SkyAngel offered about 30 channels of "Christian . . . family-friendly television and radio," providing Christian music videos, ministry, movies, and documentaries, as well as a few non-faith-based choices, such as HGTV, Hallmark,

and Fox News Channel. Early in 2014, the service was shut down after a failed experiment in streaming IPTV channels for iPad and Roku devices, leaving only three channels in operation via DISH subscriptions: KTV (Kids & Teen TV), Angel One's religious programming, and Angel Two's hunting, health, and fitness shows, which air alongside reruns of TV classics like *Lassie* and *Andy Griffith*, collectively branded as "TV for a Better You."

With the development of family-friendly tiers, the cable and satellite TV services attempted to placate advocacy groups, members of Congress, and others favoring new government regulations. In doing so, these companies showed their critics good-faith interest in responding to consumers' demanding ways to minimize indecent programming. But these tiers, lacking many popular channels, were too unappealing to quell concerns. Besides, the concept depends on agreement about what constitutes family-friendly—and on faith in the cable provider's competence as an arbiter of what is family-friendly and what is not. Given the well-known contempt that most consumers have for their cable companies, trust between cable system operators and subscribers seems to be in short supply.[69]

One from Column A . . . : The à la Carte Model

Despite decades of expansion, in terms of consumer access to more and more channels—more television to love even more—yet another proposal for helping consumers avoid unwanted content was based on the presumption that we would all be safer with less TV. "À la carte" (rather than bundled) channel selection would allow subscribers to check off desired channels on a list and pay only the fees assessed on those channels. Consumers would no longer pay for channels that they never watch, due to either innocuous disinterest or a fervid desire to avoid (and avoid subsidizing) unwanted content.

À la carte surfaced as the brainchild of politicians, policymakers, and other stakeholders. Some saw it as a matter of consumer sovereignty. According to L. Brent Bozell of the Parents Television Council, the point is to withhold one's money from companies that produce material that one finds offensive: "If you go to the 7-Eleven to buy a quart of milk, you are not forced to take a six pack of beer, too."[70] Financial rationales were a locus of much debate. Would à la carte really save consumers money? Would it produce unwanted externalities that would take their own tolls on the market?

Senator John McCain's (R-AZ) attempt to shepherd the issue through the Senate Committee on Commerce, Science, and Transportation was derailed, in part, by the 2003 GAO study. The committee, which was then chaired by McCain, had requested the report.[71] One of its goals was to explain why cable providers offer tiers of channels, rather than allowing customers to pick and choose.[72] In sum, the GAO found that à la carte cable would lead to higher costs to consumers and depleted program diversity. The study concluded:

> Greater subscriber choice might be provided if cable operators used an à la carte system, wherein subscribers would receive and pay for only the networks they want to watch. But, an à la carte system could impose additional costs on subscribers in the near term because additional equipment—which many subscribers do not currently have—will be required on every television attached to the cable system to unscramble networks the subscriber is authorized to receive. Moreover, an à la carte system could alter the current economics of the cable network industry, wherein cable networks derive significant revenues from advertising. In particular, cable networks experiencing a falloff in subscribers could also see an associated decline in advertising revenues, since the amount that companies are willing to pay for advertising spots is based on the number of potential viewers.[73]

Additional equipment might not be the only new expense under à la carte. Cable systems would also have to provide additional customer service to help manage churn, as subscribers change their minds about what channels they want to pay for, growing weary of those they no longer watch or are willing to pay for, and seeking access to appealing new programming on channels that they do not yet have.

In the spring of 2004, Representatives Nathan Deal (R-GA) and Joe L. Barton (R-TX), both then members of the House Commerce Committee, pressed the FCC to reconsider the matter.[74] Judging by the 2003 GAO report, their request should have been a non-starter. Hadn't independent investigators already found that à la carte would be risky business, for the industry and consumers alike? Still, some stakeholders were unwilling to take no for an answer. Conservative advocacy groups, led by Concerned Women of America, pushed for à la carte. Cable executives including Debra Lee from BET, Carole Black of Lifetime, Geraldine Laybourne of Oxygen Media, and Judith McGrath of MTV Networks, pushed back, reporting to Congress

that à la carte could chip away at advertising revenue, jeopardizing the viability of niched channels including those specifically targeting women. The Black Congressional Caucus made the same argument to the Commerce Committee on behalf of networks targeting racial and ethnic-minority audiences.[75]

These critics' concerns might have been enough to take à la carte off the front burner. But in August 2004, the FCC published jointly written remarks by the Consumers Union (CU) and The Consumer Federation of America (CFA) that vigorously defended à la carte cable. The report argues that à la carte "would enhance consumer sovereignty and invigorate competition without raising consumer costs."[76] Rather than advocating for across-the-board adoption of à la carte, they promoted the idea that cable providers give subscribers the option to either stick with bundles *or* order off a menu: "a mixed bundling environment."[77] In such an environment, consumers are "captives" who may be disgruntled by paying for channels they don't watch when the only choice is bundling. When à la carte becomes an option, those "captives" are "liberated" to become either "devotees" of particular channels they would choose via à la carte, or "grazers," who "really value the bundle with its wide range of choices" and continue to subscribe the traditional way.[78] The report also argues that the GAO overestimated the costs of new technologies required to offer à la carte, since many subscribers already had the kinds of cable boxes that an à la carte system would require, and that à la carte options could "lead to greater diversity," with niched channels safely finding carriage.[79]

With two studies drawing incompatible conclusions, the House Committee on Energy and Commerce asked the FCC for more information on cable programming, pricing, and markets. The commission responded in November 2006 with a report by its own Media Bureau that underscored many points previously raised in the GAO's analysis and added new concerns. If the GAO and the CU/CFA reports disagreed about the cost of adapting hardware to à la carte, the FCC pointed out that hardware is not the only cost of unbundling. À la carte channels, the report predicts, would have to spend more on advertising, noting that "existing networks sold on an a la carte basis [such as, presumably, HBO and Showtime] spend a significant amount of their revenue marketing themselves to consumers"— much more than their bundled counterparts.[80] The report is also unequivocal about the impact of à la carte on advertising revenue, calling it "a significant negative effect."[81] The report concludes that instead of saving

consumers money, monthly bills would *rise* "between 14% and 30%," even if those subscribers were settling for only their 17 (there's that number again) favorite channels and dropping the rest, which they never or rarely sampled.[82]

While the FCC's emphasis was on the economic factors of à la carte, the PTC and other conservative advocates reasserted the moral agenda. PTC Executive Director Tim Winter called the Media Bureau's report "hopelessly inadequate, as it barely mentioned the prime reason why so many people want cable choice: Cable is completely awash in raunch."[83] Over the next year, Concerned Women for America, Citizens for Community Values, Morality in Media, Focus on the Family, and the PTC continued to call for an à la carte option.[84] At a Senate hearing on broadcasting and "decency" in November 2005, Charles Dolan of Cablevision also testified in favor of à la carte, even as other cable companies and the National Cable & Telecommunications Association continued to oppose.[85] Eventually, proponents of à la carte got a hand from the new FCC chair, Kevin J. Martin. Martin told the Senate that à la carte could save consumers 2 percent on their monthly digital tier subscriptions.[86] The NCTA countered that à la carte's impact on program diversity—the risk to the most niched channels—would not be worth such paltry savings.[87] At this impasse, Martin asked the FCC's chief economist to revise the FCC's 2004 report on à la carte, to correct errors made by the consulting firm Booz Allen Hamilton and to reorient the report in favor of à la carte.

The revised study, released early in 2006, claimed that a subscriber could choose as many as 20 channels (six required broadcast networks and fourteen other choices) for what customers were then paying for bundled basic and expanded tiers: an average of $45 for 64 channels. That sum was hard to square with the same report's admission that per-channel costs, then an average of 71 cents, could rise to $5 to $10.[88] But economic facts seemed not to have mattered as much to Martin as bringing a pet project to fruition. As for the threat of decreased program diversity, he made his position clear in a speech to advertising professionals: "No consumer wants to be required to buy everything and no advertiser wants to advertise on channels that no one watches."[89] The channels that Martin said "no one" watches were those expected to be most vulnerable under à la carte, like TV One (which targets African American audiences and is jointly owned by Radio One and Comcast's NBCUniversal) and Sí TV (an English-language channel for

Latino/Latina audiences, rebranded in 2011 as NuVo TV, and shuttered in 2015), whose owners—and supporters, including the NAACP and the National Hispanic Media Coalition—oppose à la carte.[90] Having glibly erased the audiences for these channels as insignificant "no ones," and undeterred by progressive advocates' concerns about quashing racial and ethnic diversity on cable, Martin continued to push the issue.

Eventually, some industry players claimed that the FCC was playing favorites, punishing companies opposed to à la carte and granting favors to others.[91] A congressional report published in December 2008 charged that under Martin, the FCC was, in many ways, "broken," at least in part because "the Chairman manipulated, withheld, or suppressed data, reports, and information."[92] Drawing on analysis of FCC emails by the House Committee on Energy and Commerce, Congress excoriated Martin for ordering the 2006 Further Report's "predetermined" new findings despite a lack of new evidence, additional research, or public comment on à la carte.[93] Martin left the FCC in 2009 on the day of President Barack Obama's inauguration. He had not convinced most of the industry or Congress to adopt à la carte. Commissioner Michael Copps, who filled in as acting chair, did not press the matter during his short tenure.[94] Martin's successor, Julius Genachowski, who served as chair from June 29, 2009, to November 4, 2013, also seemed unlikely to prioritize à la carte.[95]

Ironically, halfway through Genachowski's term, cable and satellite system operators other than Cablevision seemed to suddenly embrace the à la carte that they had long opposed.[96] Their reasons were clear: they had become desperate to reverse the trend toward "cord-cutting," as millions of subscribers canceled subscriptions, in part as a result of the recession that began late in 2007 as the newly unemployed and underemployed sought to cut expenses, and in part as viewers decided they could get the TV they wanted in other, cheaper ways. Many households cut the cord permanently, getting their TV via new internet-based streaming or "over the top" (OTT) services.[97]

OTT services had proliferated and captured the attention of many consumers. Amazon.com started offering streamable film and television programming in 2006, calling the service Amazon Unbox (in 2011, it was renamed Amazon Instant Video). Netflix added video streaming to its DVD delivery service in 2008. Through Hulu, which had its full launch in 2008, three of the major broadcast networks (majority partners NBCUniversal,

Fox, and Disney-ABC) bypassed the cable systems. Younger viewers seemed increasingly disinterested in traditional television, even as they embraced YouTube, launched in 2005, and Vine, Twitter's app for sharing six-second videos, launched in 2012 and largely discontinued in 2016. DISH released Sling TV early in 2015, branding the OTT service as "The Best of Live TV" and including the coveted ESPN and ESPN 2 alongside CNN, Cartoon Network, Disney Channel, El Rey Network, and Galavision, for just $20 per month. If Time Warner, Comcast, DirecTV, DISH, and other cable providers were going to slow the shrinking of their customer bases, they would have to rethink the business plan they had been so vigorously defending, and they were now willing to do so.

It may have already been too late. In *Variety*, Andrew Wallenstein said the proposal had become irrelevant: "A la carte channel choice no longer makes a lick of sense in the age of on demand viewing . . . if a consumer is given the ability to cherry-pick, say, Bravo, but forgo Disney Channel and Nickelodeon, why would the same consumers be OK with paying for Bravo shows *Rachel Zoe Project* and *Watch What Happens Live* when all they want is *Top Chef?*"[98] Wallenstein had a point; all the cord-cutters (and the typically younger "cord-nevers") were already living in the age of on-demand viewing. Bundles or no bundles, cable and satellite subscriptions were, to some, looking like they would soon be joining the 8-track tape and the VCR in obsolescence. Nevertheless, some proponents of à la carte cable wouldn't waiver. John McCain introduced the Television Consumer Freedom Act to the Senate in May 2013 to force cable companies to offer unbundled subscription options. Representative Anna G. Eshoo (D-CA) offered similar legislation to the House. Both floundered.

While industry analysts continued to disagree about how à la carte would impact ad revenue and the viability of a great many channels, it would pay to consider how the à la carte experience would shape viewers' choices in an environment of less, not more, TV.[99] After all, access to an array of bundled channels allows consumers to respond to programming innovations on channels that may not have previously been on their radar. Bundling allows viewers to move around, building audiences for innovative new shows or new channels. Bravo's record-setting audiences for *Queer Eye for the Straight Guy* (2003–2007), for example, came largely from audiences not already hooked on Bravo, and many viewers flocked to Comedy Central for the first time with the launch of *Chappelle's Show* (2003–2006). AMC drew in new

viewers with *Mad Men* (2007–2015) and further expanded its audience base with *Breaking Bad* (2008–2013) and *The Walking Dead* (2010–present). Would any of these series have gotten off the ground in an à la carte universe? In a bundled subscription, these kinds of audience migrations require some combination of effective promotion, critical acclaim, positive word of mouth, and a handy remote control. Under à la carte, trying out a new series on a channel not previously on one's roster also requires subscribing to a new channel—contacting the cable provider, paying an additional fee—all before spoilers flood social media and interest wanes. In other words, rapid churn to catch new shows just might not be feasible.

Late in 2014, some broadcast networks and cable channels began to release plans to launch new services amounting to *de facto* à la carte. Time Warner was first, announcing that they would make HBO available via an OTT subscription.[100] CBS made a similar announcement, saying that "CBS All Access" would cost $5.99 per month, launching immediately with a combination of local station livestreams, a classic archive, and current one-day delayed shows with fewer commercials than when broadcast, with compatibility on various devices rolling out gradually.[101] Viacom followed by promising to launch a standalone stream of Nickelodeon in March 2015.[102] Others followed. OTT services weren't precisely à la carte, not as McCain and Martin and Bozell had imagined it, but they did constitute a transformation of the TV marketplace that consumers could use to pick and choose channels.

If viewers were no longer coming to TV, TV would make itself available to viewers on a multitude of screens. Previous efforts to offer conventional TV online had depended on the user's capacity to link cable or satellite subscriptions to internet-accessed video streams. A subscriber could watch ESPN, HBO, or any other channel on a smartphone, laptop, tablet, or gaming console—but only if their subscription to a cable or satellite provider could be verified. In other words, the "TV Everywhere" model was designed to allow subscribers to move content around their own array of devices; it was not a means of allowing non-subscribers to access content.[103]

Newer OTT plans no longer require viewers to have cable or satellite subscriptions. Skipping that step, viewers who want to watch TV via streaming media devices such as Roku or Apple TV—or their iPads or other devices, for that matter—can bypass the MVPDs and subscribe directly to the desired channel and only the desired channel. And starting in 2015, "smart TVs"

came preloaded with OTT apps (such as Netflix, Hulu, YouTube, and many others), allowing viewers to stream TV without an external device, a broadcast antenna, a cable subscription, or a satellite dish. A cord-cutting household with young children, for example, can still satisfy their desire for Nickelodeon for a few dollars a month, on any device in the home, many of them mobile. Ralph J. Roberts's claim that people love TV, and love more of it more, seems to have diminished in relevance as the industry has discovered ways to get people to pay for TV, even if only a little TV, just a channel or two or three, that they love just enough.

Conclusion: Policy, Politics, and *Postcards*

Tools for avoiding potentially offensive television programming, instituted in the Telecommunications Act of 1996, supported a kind of market-loving neoliberal discipline, assigning responsibility for notifying viewers of potential offense (via ratings) to program distributors (the networks that rate their own programs) and to viewers themselves.[104] As mechanisms of consumer responsibility, these technologies did not raise much in the way of serious First Amendment concerns, unlike attempts to apply broadcasting's decency regulations to cable TV, or unlike the Communications Decency Act of 1996, which imposed restrictions not only on obscene but also indecent internet-based communications, both of which fell to constitutional concerns[105].

Propping up each of these efforts to restrict indecent expression and quell complaints about indecent media is the icon family. It has often been the case that services labeled family-friendly are only those that are believed to be "appropriate for children." Those parties promoting kids' tiers, à la carte, stricter rules, and harsher penalties may fail to recognize a range of media needs and wants among adults of all ages, parents of young children or not, part of the growing number of solo householders or not, and the enormous and increasingly empty-nested baby boomer generation.

Who decides what is family- (or kid-) friendly? Sometimes it is not the television industry or the viewer in charge of these decisions. In 2005, an episode of the innocuous kids show *Postcards from Buster* went unaired by all but a few PBS affiliates, after a complaint from Secretary of Education Margaret Spellings whose agency had partially funded the series, which was meant to promote diversity in children's programming. Spellings demanded

FIG. 10 Buster, an animated rabbit, poses with families at a bonfire in "Sugartime! (Hinesburg, Vermont)," *Postcards from Buster*, PBS, February 2, 2005.

the return of any federal monies used to produce the episode "Sugartime!" in which Buster visits Vermont farms to learn how maple sugar is made. Buster's sin? Some of the children featured in the episode have two moms; a lesbian couple hosts Buster's visit to Vermont. Spellings could not abide that federal funds intended to advance diversity in children's programming were actually used to produce an episode that recognized that same-sex couples can and do parent. Apparently, some families are simply not family-friendly enough, and some forms of diversity are not as desirable as others.

In a 500-plus-channel universe, characterized by aggressively niched channels, finely targeted programming, and a proliferation of TV-ready screens, the notion of "family TV time" seems quaintly archaic. The idealized togetherness of mom, dad, and the kids huddled around a central set falls increasingly into a nostalgic wayside as viewers are diffused over innumerable devices, channels, and programs. The fetishized portrait of the family sharing a single screen may be a thing of the past—or a nostalgic rendering of a past that never really was. But it still looms large as an ideal, privileging the heterosexual, the married couple, and the reproductive nuclear family as the

television audience that matters most, at least to those, like Spellings, who take it upon themselves to effectively censor realistically inclusive content produced under a diversity mandate. Her homophobic, diversity-crushing attack on *Postcards from Buster* served as a reminder that despite the availability of mechanisms that, as Raiford Guins suggested, enable "*parenting at a distance*," governmental agencies and agents are still poised to *govern up close* to protect vested interests.

4

Bleeps and Other Obscenities

On April 21, 2013, novice news anchor A. J. Clemente made his first—and last—appearance on the television station KFYR, an NBC affiliate in Bismarck, North Dakota. Unaware that cameras were rolling, microphones were live, and the broadcast had begun, Clemente's first on-air words were "Fucking shit." The next day, he tweeted that he had been fired from the job. He later explained that he lost his composure when he found that he would be reading a report on the London Marathon without a chance to practice saying the name of the winner, Tsegaye Kebede.[1]

According to Nielsen Media Research, at the time, there were about 150,000 TV-owning households in the Designated Market Area (DMA), including Bismarck and nearby Minot, ranking the region 151st among U.S.-based DMAs in size.[2] In short, the potential audience for the offending broadcast—at 5:00 P.M. on a Sunday—could not have been more than modest. But this nervous new employee's mistake, witnessed firsthand by relatively few, was amplified exponentially by an entertainment industry that seemed tickled to poke a little fun at one of its own. Within a few days, Clemente was in New York, where he appeared on NBC's *Today Show*, ABC's *Live! With Kelly and Michael*, CBS's *Late Show with David Letterman*,

Morning Joe on MSNBC, and the syndicated *Inside Edition*. Cumulative audiences for these programs numbered well into the millions. Countless news outlets covered the story; *The Huffington Post* addressed the incident at least five times. A CBS-owned website in Seattle reported that KFYR's Facebook page was "flooded" with pleas for the station to give Clemente another chance. But news director Monica Hannan was adamant: "We train our reporters to always assume that any microphone is live at anytime. Unfortunately, that was not enough in this case."[3]

Online articles about Clemente's gaffe contained links to videos of the broadcast posted to YouTube, which garnered hundreds of thousands of views and were replayed on censor-free venues such as SiriusXM's *Opie and Anthony Show*. By May 5, 2013, an op-ed by Clay Jenkinson in *The Bismarck Tribune* lamented the "buzz" over Clemente's "rare double 'expletive deleted'" (*sic*: the expletive was *not* deleted, that was the problem). Jenkinson noted that when North Dakota maintained a remarkably robust economy even as much of the country staggered during the 2007–2009 recession, no one seemed to notice. It took a trivial, if comic, blunder by an individual ill-prepared for his professional debut for the state to make national headlines.[4]

Some outlets that covered Clemente's on-air outburst repeated his exact expression (YouTube and *Opie and Anthony*, for example), and others dropped obvious hints. *HuffPost* opted for "F—ing shi-t" or "F***ing S**t" in titles, but sometimes spelled out the words "fucking shit" in the body of an essay. *Entertainment Weekly*'s website used "fu—in' sh—."[5] Jenkinson's op-ed in the *Bismarck Tribune* referred to the "F-word" three times, including once in the title.[6] However briefly, Clemente was the affable face of unfettered expression—and a bit of a laughingstock, his anchorman-good looks squandered on a career that he kissed goodbye the first time he opened his mouth on air.

Print and online publications may substitute only slightly obscuring euphemisms for expletives, like "F-word," to avoid offending readers or advertisers, even though they enjoy First Amendment's free speech and free press protections. The equivalent, in more regulated broadcasting, is the "bleep," in which a short beep tone is inserted in the audio track in place of utterances with potential to attract viewer complaints and FCC fines. For live programming—which is often not really live but aired on a delay of about seven seconds—broadcast-delay systems allow a production team to "dump" audio and insert bleeps if they hear indecent or profane language.

(Broadcast-delay must not have been in use for the KFYR newscast that cost A. J. Clemente his job.) After much-publicized award-show profanities uttered by Bono, Cher, and Nicole Richie in 2002 and 2003, and the "wardrobe malfunction" during Justin Timberlake and Janet Jackson's 2004 Super Bowl halftime performance, use of broadcast-delay became more commonplace in live television—and the bleep itself, an increasingly scripted feature of prerecorded programming.

In the mid-2000s, the FCC put tougher rules in place (at least temporarily) to punish stations involved in indecency incidents, and Congress raised indecency fines tenfold. In response, broadcast networks found ways to obey the letter of the law while thumbing their collective nose at its spirit. The broadcasters, after all, compete for ratings against less-regulated cable channels and video-streaming services, where dexterous use of expletives and subject matter too risky for broadcast networks—explicit sexual behavior, illicit drugs, and unrepentant violence—are stock in trade of both the dramatic and comedic genres (cue AMC's *Breaking Bad*, 2008–2013, HBO's *Entourage, 2004–2011*, or Comedy Central's *South Park*, 1997–). Moreover, broadcasting's love affair with reality TV requires maintenance of the audience's faith in its "reality"—its unscripted and unstaged segments, its uncertain outcomes. How best to prove to audiences acclimated to the exclusion of certain expletives from broadcast scripts that footage is reality-based? Allow it to contain excludable expletives (also known as profanities, swearing, cursing, or—most frequently in regulatory discourse—indecent language), of course, because the aesthetics of reality draw, in part, on the possibility that television might be live. Might, but usually isn't.

Live broadcasts, after all, are incompletely containable. They are unpredictable, accident-prone. Among the most costly accidents in live broadcasting are those involving profanity or sexual representation understood under FCC policy as indecency. (Excretory representations can also qualify as indecent, but are much less often the subject of complaints.) The costs come in various forms. To certain media advocacy groups, individual well-being and social welfare are diminished when public figures mouth so-called dirty words.[7] To First Amendment absolutists, any effort to curtail utterances under any circumstance diminishes the constitutional guarantee of freedom of expression.[8] To television stations and station-owning networks, costs can be measured in legal fees and fines. But efforts to increase penalties have not eradicated occasional slips of the profane tongue from the airwaves. In fact, as I will show, regulatory efforts *increase* the reach of any

particular utterance, through the cascading repetitions that constitute legal dissection and media coverage of the matter. (Cf. the A. J. Clemente case.)

But there is profanity and then there is profanity. Indecent language may be shocking, offensive, expressive, hilarious, or banal, even tiresome. Expletives may be accidental, live, unscripted, bleeped, scripted, uncensored, or some combination of these attributes. The FCC's policy on obscenity, indecency, and profanity has pertained, at least since policy statements issued in 1987, to visual representations of sexual or excretory activities as well as to indecent language or profanity. But this chapter focuses closely on verbal material that may or may not, depending on its source and other contextual considerations, qualify as indecent. Those contextual considerations include the medium, delivery system, channel, genre, time of day, and social position of the speaker, in terms of factors including age and sex.[9]

To map distinctions between these various kinds of expressions, I provide a taxonomy of indecent televised language, beginning with its extravagant presence on premium cable channels as well as on rare, allowable broadcasts. Both depend on particular kinds of *privilege*: for the former, the exclusivity of advertising-free pay channels; for the latter, the caché of "artistic necessity." Turning to broadcasting, I explore the unscripted profanity that may occur during live programming and that may or may not get covered by a "bleep." Next, I consider the paradoxical case of the scripted expletive, which is frequently bleeped and which toys with a rule that it ultimately upholds. As the scripted bleep is often played for laughs, I draw on the work of the founder of psychoanalysis Sigmund Freud's work on the disinhibiting function of what he called "joke-work," as well as on philosopher and social theorist Herbert Marcuse's reflections on the transgressive use of "obscenities"—and their failure, in overuse, to transgress. I conclude the chapter by examining media coverage of blurted expletives in terms of another context: the gender of the speaker. Not all expletives, it seems, are treated equally.

Mythic Liveness

One of the fundamental paradoxes of televisual experience is the *apparent* liveness of *all* televisual transmissions and the relative scarcity of *actual* live television transmission. Whether liveness is pervasive or a televisual rarity, it is one of the medium's nearly mythic "distinctive features."[10] In an essay

first published in 1975, critic and poet David Antin refers to "the fabled instantaneity of television [as] essentially a rumor."[11] That is, just because television has a developed capacity for instantaneous transmission does not mean that most television transmissions consist of live broadcasts. They do not, at least not since the mid-1950s. Using the kinescope and, after 1956, videotape, the networks discovered that audiences would tune in for reruns, eliminating the necessity for 52 weeks of all-new programming, slashing production costs.[12] As Antin observes, "The money metric has … played a determining role in neutralizing what is usually considered the most markedly distinctive feature of the medium: the capacity for instantaneous transmission."[13] "Instantaneity," he reminds the reader, opens the door to "unpredictability," which is firmly disfavored by commercial interests.[14]

Of course, for some events to have unpredictable outcomes can be commodified. The classic cases are news, awards shows, and live sporting events. (There are, to be sure, exceptions. NBC's *Saturday Night Live*, for example, has been broadcast live to Eastern and Central time zones since its launch in 1975, and on tape delay for Mountain and Pacific time audiences. On April 15, 2017, *SNL* started broadcasting the show live in all time zones simultaneously.[15] Making primetime broadcasts a regular practice in the 2017–2018 season, NBC provoked the ire of the Parents Television Council.[16]) In most other television genres, unpredictability is disruptive. Paradigmatic cases of unpredicted disruptions are indecent language and flashes of nudity, but other kinds of speech are similarly disruptive and similarly elided. For example, on January 23, 1991, a few days after the start of Operation Desert Storm (in which a U.S.-led coalition of military forces attacked Iraqi troops that had invaded Kuwait in 1990), three members of the AIDS Coalition to Unleash Power (ACT UP) New York entered the *CBS Evening News with Dan Rather* studio. Bolting in front of Rather's desk, they called out "Fight AIDS, not Arabs" and "AIDS is news." Activist John Weir's face can be seen on screen briefly, before someone off-screen grabs him and pulls him out of the frame. Rather cut immediately to a commercial break. Afterward, he apologized for the "rude people" who "tried to stage a demonstration." He assured audiences that the demonstrators had been "ejected." They were also arrested.[17]

Broadcasting's gatekeepers reacted similarly when, on February 24, 2013, Bill Westenhofer accepted the Academy Award for Best Visual Effects (VFX) on behalf of Rhythm & Hues Studios, alongside corecipients Guillaume Rocheron, Erik-Jan DeBoer, and Donald R. Elliot, for *Life of Pi*

(2012). Barely a minute after the winners arrived on stage, the orchestra launched into the ominous theme from *Jaws*. Still, Westenhofer continued to speak: "Sadly, Rhythm & Hues is suffering severe financial difficulties . . ." (In fact, the company had filed for bankruptcy just twelve days earlier.) The music became increasingly loud, and his microphone was cut off. While it is not unusual for music to rise over award recipients who linger beyond the allotted time, in this case, the producers moved quickly to squash what might have become political speech. Just outside the theater where the ceremony was taking place, hundreds of VFX artists were holding a protest to draw attention to their arduous working conditions and the film studios' preference for cheaper off-shore labor.[18] Termination of Westenhofer's turn at the mic ensured that the demonstration went unmentioned during the broadcast.

In both examples, members of the production team made a snap decision to re-order programming conventions. A commercial break or musical cue comes early, rushing the disruption to a close and patching the broadcast back to the script. These diversions protect live TV, in such cases, from unpredictability that, unlike a football touchdown or the announcement of the next winner, does not play within broadcasting's rules.

Live television may be vulnerable to such gaffes, but liveness remains fundamental to the aesthetics of television and our expectations of it. Many media scholars have followed Antin in recognizing the *possibility* of liveness in broadcasting, while identifying in the trope of liveness some calculated duplicity. To John Ellis, televisual liveness is a form of "pretend. . . . The broadcast TV image has the effect of immediacy. It is *as though* the TV image is a "live" image, transmitted and received in the same moment that it is produced.[19] To Jane Feuer, liveness is an "ideological construction" that draws on the very term's "connotative richness."[20] Film always recalls the past, she argues, but the medium of television "postulate[s] an equivalence between the time of the event, time of television creation, and transmission-viewing time."[21] In suggesting such an equivalency, television presents itself as "alive . . . living, real, not dead," even if, according to Feuer, "current American network television is best described as a collage of film, video and 'live.'"[22]

To John Thornton Caldwell, one of the most pervasive presumptions about television is the "myth of liveness," which is, in television production, little more than nostalgic "artifact."[23] According to Caldwell, "liveness is a visual code and component of a broader stylistic operation. It is a look that

can be marshaled at will, feigned and knowingly exchanged with ontologically aware viewers."[24] To Mimi White, liveness is TV's "alibi," a "metonymic fallacy" in which a part of TV masquerades as its whole or is naturalized as its purpose.[25] Its "spatial pyrotechnics" operate as heir to the exhibitionism of the early cinema of attractions, as famously described by Thomas Gunning.[26]

The predominance of prerecorded programming and the use of seven-second (more or less) broadcast delays for ostensibly live programs have, arguably, all but evacuated liveness from the medium of television. But the TV we watch doesn't have to be live for us to read it through the lens of our knowledge that it *might* be live. Our willingness to see "liveness" when it is barely there is less deluded false consciousness than the viewer's ability to read television's stylistic codes—which include the use of expletives. Those codes are commonplace in reality TV and in single-camera situation comedies in mockumentary formats, such as *The Office* (2005–2013) and *Parks and Recreation* (2009–2015), both on NBC, or ABC's *Modern Family* (2009–); and they pop up in other genres, too. So liveness persists as myth, ideology, and aesthetic.

The real paucity of liveness is underscored when the rare (non-sporting) live broadcast is still rolled out, by industry and press alike, as the heart and soul of television. In these cases, liveness is hailed as both a "distinctive feature" and an endangered species, television's essence and barely recalled memory. Consider the hoopla over NBC's September 9, 2013, launch of *The Million Second Quiz*, which aired live nightly over a ten-day period, boasting a lucrative jackpot, a substantial online component, and network personality cameos.[27] The series harked back to the popular live quiz shows of TV's early years, such as CBS's *The $64,000 Question* (1955–1958) and NBC's *Twenty One* (1956–1968) but with more elaborate staging, a ridiculously complex scoring system, and a bizarre format resulting in sleep-deprived contestants. A heavy promotional campaign could not save the show from abysmal ratings.[28]

Likewise, a live *Sound of Music* remake aired on NBC on December 5, 2013, announced in headlines that emphasized the newsworthy unusualness of the event, while playing off the title song's familiar opening lyric, "The hills are alive," with lines such as "... the Show Is Live," "TV Is Live...."[29] The show was the top-rated broadcast of the evening, starting a trend. NBC launched plans to adapt more musicals for television (*Peter Pan Live!*, 2014;

The Wiz Live!, 2015; *Hairspray Live!*, 2016; *Jesus Christ Superstar Live in Concert*, 2018) and committed to a non-musical adaptation of Aaron Sorkin's *A Few Good Men* for 2019. Fox got in on the act with *Grease: Live* (2016) and *The Passion* (2016). Ironically, productions of *The Rocky Horror Picture Show: Let's Do the Time Warp Again* on Fox (2016) and *Dirty Dancing* on ABC (2017) were as spectacularly promoted and designed, using many of the aesthetics of a live broadcast of a stage show—but they were prerecorded. The flurry of attention to these programs is typical granted the occasional live episode of a situation comedy or TV drama, which critics often chide as ratings stunts or hail as homages to the early years of television.[30]

Premium Profanity

When the FCC investigates a complaint of televised indecency, context is key. Most important is a determination of what kind of channel or service aired the program that garnered a complaint. Complaints about programs on cable- and satellite-only channels, video-streaming services, or OTT applications, which deliver programming to consumers without cable or satellite subscriptions, are summarily dismissed. The FCC also considers time of day, routinely dismissing complaints about indecency in the safe harbor of 10:00 P.M. to 6:00 A.M., as well as whether the material was live or prerecorded, and other factors. Expletives that may be found indecent are pervasive in some sectors of the TV market and nearly absent in others, with rare exceptions for certain privileged broadcasts on the basis of "artistic necessity."

In the medium of television's most privileged corner, expletives are plentiful. Consider, as a particularly extreme example, a scene from HBO's *The Wire*. In the series' first season, episode 4, titled "Old Cases," which first aired June 23, 2002, Officer James McNulty (Dominic West) and Detective William "Bunk" Moreland (Wendell Pierce) revisit a crime scene. From the moment they enter an apartment where a woman was fatally shot, they conduct a conversation that lasts some four minutes, using only variations on one particular word, intermittent silences, and occasional grunts. Throughout the scene, they compare crime scene photographs to the actual space, laying out the images on the kitchen floor to determine the positions of the shooter and victim. Moreland holds a cigar in his mouth during much of the scene:

MORELAND: Aw, fuck.

MCNULTY: Motherfucker.

MORELAND: Fuck, fuck, fuck, fuck, fuck. Fuck. Fuck. Fuck, fuck, fuck. Fuck.

MCNULTY [establishes bullet trajectory using a tape measure and his own gun]: Wha' th' fuck.

MORELAND: Fuck . . .

MCNULTY [pinches a finger as his tape measure retracts]: Fuck!

The conversation continues in this manner, mostly at muttering tones, for nearly a minute as they continue their investigation, until Moreland recognizes a new clue. Dialogue resumes emphatically:

MORELAND: *Motherfuck*. Aw fuck, aw fuck.

MCNULTY: Fuckety fuck fuck fuck. Fucker. Aw, fuck. Fuck. Fuck. Fuck.

MORELAND [simultaneously]: Fuck, fuck, fuck.

MORELAND: Motherfucker!

MCNULTY [notices a damaged piece of the wall]: Fuckin' A. Uh huh. Fu-u-ck [with minor exertion as he pulls a bullet out of the wall with pliers]. Motherfucker [matter-of-factly, showing Moreland the bullet].

MORELAND: Fuck me.

Moreland and McNulty exit the apartment. The camera remains indoors. The detectives appear through a window pocked with a bullet hole. McNulty reenacts the shooting by pointing his gun into the kitchen and tapping it on the glass three times to demonstrate how the shooter might have gotten the victim's attention before firing. Satisfied, he breaks the dialogic stream by introducing a new word: "Pow."

In this scene, *The Wire* does considerable showing off. The actors flaunt how much they can do with simple inflections; the writers take full advantage of working in the premium cable tier where linguistic freedom is associated with upmarket financing and cultural capital. As such, the scene offers a kind of linguistic "pyrotechnics," an actorly spectacle that recalls White's and Gunning's remarks on televisual and cinematic spectacle, respectively. Subscription-dependent, without advertisers to appease, premium channels like HBO enjoy a relative lack of containment regarding what they distribute. Regulatory restraint is scant content-wise, and entry to this privileged space is by choice. HBO and other premium channels are invited guests, not free-to-air intruders, and not everyone invites these channels into their home.

According to Nielsen Media Research, there were about 116.4 million TV-owning households in the United States at the start of the 2015–2016 season, but only 31.4 million of them subscribed to HBO (and somewhat fewer to Showtime, Cinemax, and Starz).[31] Airing only to those subscribing households, and relatively unfettered, programming like HBO's *Sopranos* or *Deadwood*, or Showtime's *Weeds*, have used profanity to, among other things, remind viewers that they're not watching the staid old rule-bound broadcast channels anymore. Privilege derives from privilege.

Broadcasters, meanwhile, maintain their own conventional uses of profanity, even though they are beholden by the FCC, advertisers, and conservative watchdog groups to frame it through various devices. One of those devices, albeit rare, is "artistic necessity." On occasion, the networks have labored to legitimate particular uses of profanity, as ABC did for a broadcast of Stephen Spielberg's *Saving Private Ryan* (1998) scheduled for Veteran's Day, November 11, 2004. ABC had aired the film, which includes about 20 uses of forms of the word "fuck," in 2001 and 2002, unedited and uncensored, with little or no apparent concern from affiliates or audiences. But this time, with the FCC's Golden Globes Order in effect since March 2004, stations were wary of earning FCC fines. The order had declared all uses of the word "fuck" indecent, however fleeting and regardless of context.[32] Some 66 of ABC's 225 affiliate stations were scared off and preemptively aired something else in its place.[33] However, in the case of *Saving Private Ryan*, the FCC was willing to allow exception to its ruling that all uses of certain words are profane and indecent and did not fine ABC.

Two years later, the FCC took a different approach when handling a complaint about several expletives ("the 'F-word,' the 'S-word' and various derivatives of these words") in an episode of Martin Scorsese's seven-part documentary series *The Blues* (2003), first aired on PBS affiliates.[34] KCSM-TV, a station licensed by the San Mateo County Community College District in California, showed the episode "Godfathers and Sons" on March 11, 2004, before 10:00 P.M. The station defended airing the program without alteration as an "educational experience" about the people interviewed in a manner that "accurately reflected their viewpoints."[35] The FCC's decision noted that many of the expletives were uttered by commentators other than the blues musicians that the documentary is about, and that omitting them, unlike in the *Saving Private Ryan* case, would not have changed any of its meanings.[36] The FCC fined KCSM $15,000, but declined to fine stations from markets that did not produce complaints, in

a somewhat ironic effort to show the commission's "commitment to an appropriately restrained enforcement policy."[37] (Someone in San Mateo, it seemed, was the only offended viewer, and that viewer's discomfort cost the nonprofit station significantly.)

Fleeting Expletives, Fleeting Rules

The scripted, unbleeped utterance that is commonplace in some cable and streaming programming remains relatively rare on broadcast channels; the financial risk may be too great. But its complement, the unscripted, uncensored utterance occasionally slips through all proscriptive measures and appears on live broadcasts. From 1987 to 2004, the FCC had held that a "single, isolated, nonliteral expletive is not actionable."[38] The Golden Globes Order of 2004 reversed that policy on at least two counts. First, the commissioners declared that any profanity, however fleeting or accidental, can qualify as indecent and is therefore vulnerable to financial penalties; it would be "irrelevant" whether the utterance was intentional or unintentional.[39] Second, the commission rejected NBC's defense that Bono used the gerund "fucking" as an "intensifier" akin to "really" or "very."[40] Instead, the commission argued that any variant of the word fuck, "in any context, inherently has a sexual connotation."[41] (See chapter 2 for more on the Golden Globes Order.)

Not surprisingly, the networks contested the ruling. On June 4, 2007, the U.S. Court of Appeals for the Second Circuit struck down the Golden Globes Order. The court refused to accept the commission's finding that Bono's utterance had sexual connotations and reprimanded the FCC for implementing the new policy without adequate justification for jettisoning decades of precedent.[42] Citing the Administrative Procedure Act, which is intended, in part, to prevent government agencies from taking arbitrary action, the FCC's harshened approach to fleeting expletives was suspended.

Therefore, the FCC did not act when, in early 2008, actresses Diane Keaton and Jane Fonda used expletives on daily morning news programs. On January 15, on *Good Morning America*, Keaton complimented interviewer Diane Sawyer's looks, especially her full lips. "I'd like to have lips like that," Keaton offered. "Then I wouldn't have worked on my fucking personality. Or my—excuse me—my personality." Sawyer, laughing, interjected "Also a crime, also a crime," referring to an anecdote Keaton had told

earlier about shoplifting at a high-end department store. Keaton pressed on: "If I had lips like yours, I'd be better off. My life would be better. I would be married. I have these thin lips." Gently disciplining her guest, Sawyer rebutted: "My mother's going to work on your personality with soap in your mouth, is what she's going to do." Keaton acknowledged her error: "I know, excuse me, I shouldn't say anything like that." Sawyer referred to her guest as she signed off the interview, "This is Diane Keaton, who will be answering to the censors."[43]

A month later, on February 14, 2008, Jane Fonda and playwright Eve Ensler appeared on NBC's *The Today Show* to promote the tenth anniversary of Ensler's play *The Vagina Monologues*. Fonda, describing her befuddlement when asked to join the cast, told Meredith Viera, "I hadn't seen the play. I live in Georgia, okay? I was asked to do a monologue called '[Reclaiming] Cunt.' I said, 'I don't think so. I've got enough problems.' But then I came to New York to see Eve and it changed my life. It really did." After the interview, Viera acknowledged to viewers that Fonda had said "a word from the play that you don't say on television. She apologizes and so do we. We would do nothing to offend the audience." (Many viewers didn't hear what all the fuss was about, in either the Keaton or Fonda incidents. *Today* and *Good Morning America* go out live in the Eastern time zone since they are produced in New York City. Only Eastern Standard Time viewers heard the expletives live and unbleeped. For viewers in Central, Mountain, and Pacific time zones, the shows were prerecorded and bleeped.) Even though some viewers filed complaints with the FCC, encouraged to do so by the Parents' Television Council, which attacked NBC in a press release issued the same day as the broadcast, regulators took little recourse.[44] The expression was fleeting, isolated, and unscripted, and after the Second Circuit Court of Appeals 2007 ruling, the FCC's attempt to take punitive action against such utterances had been nullified.

Frequently, when profanities occur on live TV events, intentional broadcast delays give production teams a few seconds to catch and "dump" an unscripted and unwanted utterance. Although the technology is imperfectly reliant on quick reflexes and prone to human inattention or error, the networks have used the time delay with more consistency and frequency for live programming since the 2004 policy change.[45] An example of a profanity successfully covered up with a bleep was Melissa Leo's blurted expletive on the 83rd *Academy Awards* broadcast, on February 27, 2011. Leo won the Oscar for best supporting actress for her role in *The Fighter* (2010). She was

composed enough to flirt with presenter Kirk Douglas and to rattle off gracious thanks to the director David O. Russell, cast members, and family. She waved to onlookers in the balcony. Then, seemingly overcome by emotion, she remarked, "When I watched Kate [Winslet accept the award] two years ago, it seemed so [fucking] easy." The profanity was bleeped. As Leo realized what she had just said, she added, "Oops!" and briefly put her left hand over her mouth and then on her forehead while looking away for a moment before continuing her speech. The gesture performed a kind of immediate apology, an acknowledgement that a line, however arbitrary, had been crossed. Later, backstage, Leo issued a verbal version of the requisite apology.[46]

Leo's ostensibly transgressive speech act was repressed in the bleep, but it was not forgotten. Later in the broadcast, two other speakers referred to it. Both Leo's *Fighter* costar Christian Bale and *The King's Speech* writer David Seidler joked about her gaffe during their turns at the podium. Best Supporting Actor award winner Bale started his own acceptance speech with milder expletives ("Bloody hell. . . . What the hell am I doing here?") that were left intact. When he paid tribute to his fellow actors, he began with Leo, remarking not on her work in *The Fighter* but on her performance earlier in the evening: "Melissa. I'm not going to drop the F-bomb like she did, I've done that plenty before." Seidler accepted the award for Best Original Screenplay and ended his speech by referring to the scene in *The King's Speech,* in which a speech therapist, played by Geoffrey Rush, coaxes King George VI (Colin Firth) to curse, with thanks to "Her Majesty the Queen, for not putting me in the Tower of London for using the Melissa Leo F-word" in his screenplay. Through Bale's and Seidler's uses of the unambiguous euphemisms "F-bomb" and "F-word," the disallowed word surfaced again and again, reminding audiences of the earlier incident. The broadcast expletive, along with its aliases, the bleep and the euphemism, operate in tandem to transgress, disavow, and return the scene to order. The profanity may be disallowed, but it is also fully incorporated.

The Scripted Expletive

While unscripted expletives may occur in live broadcasts, sometimes profanity is quite purposefully placed within edited-for-broadcast reality-based programming. Examples abound. One expletive-heavy reality series on a broadcast channel is Fox's *Hell's Kitchen* (2005–), in which aspiring chefs

compete under the tutelage of celebrity chef Gordon Ramsey. The series employs multiple strategies that normalize the use of profanity on TV. Expletives, always bleeped, underscore the sense of urgency that the show attempts to portray as intrinsic to both fast-paced kitchen work and high-stakes competition. Under such pressure, who wouldn't let a few indelicate words fly? They are also are part of a reality-TV aesthetic that insists upon its own immediacy, even when its footage is prerecorded and edited long before broadcast. These utterances may not be scripted—in that Ramsey and the contestants may not be fed lines to deliver on camera—but they are treated as such in post-production as markers of authenticity.

During a 2013 episode of *Hell's Kitchen*, a contestant speaks directly to the camera: "Nobody seems to like my menu, and I don't [fucking] like that." The expletive is bleeped, and the lower portion of her face is blurred. Another competitor questions the competence of his teammates: "How the [fuck] did we get those two idiots on our team?" Yet another complains about how long a teammate is taking to finish a task, exclaiming, "It's [fucking] butter, dude!" Each of these utterances takes place away from the kitchen. In a space much like a confessional booth, a lone, seated contestant addresses the camera directly.[47] The speech that occurs in this space *could* be edited or restaged if the language were considered unacceptable, without interrupting the competition. Instead, profanity remains, obscured by bleeping and blurring, alongside terms that might be considered rude or vulgar without rising to the level of actionable indecency. "Asshole" is bleeped; "ass" is not. "Fuck" and "shit" are bleeped; "suck it" is not. As expletive attributives, the bleeped terms (and some of the unbleeped language) add little actual meaning, but connote the intensity of the speakers' emotions.

With some derring-do, broadcast programming in non-"reality" genres has occasionally incorporated expletives of this type: uttered and censored, displaced by a marker (the bleep) that irrefutably references the disallowed profanity.[48] For example, in an episode of *Seinfeld* (1989–1998, NBC) called "The Non-Fat Yogurt," first aired November 4, 1993, bleeps replace nine variant forms of the word "fuck" and at least one "shit." Jerry (Jerry Seinfeld) and Elaine (Julia Louis-Dreyfuss) experience unwanted weight gain soon after they begin frequenting a frozen yogurt shop that claims its product is fat-free. At the shop, declaring his fondness for the product, Jerry first utters a profanity, which is bleeped: "This is so [fuck]-ing good." (When the gerund is used, the ending is audible and it is easy to lip-read the utterances.) The shop owner's son Matthew (John Christian Graas) overhears him, and

he starts using the word on his own ("Where's my [fuck]-ing cupcake?"), which upsets his mother (Maryedith Burrell). Jerry implores the child to give up using the word: "Cursing is not something that most comedians do.... It was an accident, I haven't done it since, and I would never do it again. And if you continue cursing, you'll never become a comedian like me when you grow up." Later, when Jerry and his friends discover that the frozen yogurt is not fat-free and expose the deception, the boy confronts Jerry: "Thanks for ruining my daddy's business, you fat [fuck]." This time, his mother doesn't seem to mind his choice of words.

That a *Seinfeld* episode from the 1990s played with the bleep was unusual, though not unique. Fox's short-lived Hollywood satire *Action* (1999–2000), for example, used scripted, bleeped profanity regularly.[49] The animated series *Family Guy* uses the technique, perhaps most extravagantly in the 2005 episode "PTV," which is discussed in the introduction to this book. In the twenty-first century, the bleeped expletive has become almost commonplace in scripted primetime programming such as ABC's *The River*, created by Oren Peli and produced by Stephen Spielberg. In the first episode of the short-lived series, which premiered on February 7, 2012, Tess (Leslie Hope), her son Lincoln (Joe Anderson), a motley crew, and some documentary filmmakers head to Brazil to search for Tess's husband, Emmet Cole (Bruce Greenwood), a scientist and the host of a nature show who has been missing for six months in some exceedingly scary section of the Amazon River. A great deal of the show's footage is purported to come via the documentarians' cameras. The degree to which their footage is mottled with video grain, pale, and handheld, provides visual cues that help the viewer distinguish between the show's omniscient camera and the documentary-in-the-making's diegetic camera.

Another tactic used to mark the footage as a document of reality is the profanity, which erupts a half dozen times during the episode. In each case, the profanity is bleeped. Most of it is uttered by the missing explorer's son, Lincoln. In an early scene, he tells his mother why he doesn't want to join the voyage: "He missed my life to inspire a billion people I don't give a [bleep] about." Later, Lincoln tells the documentary producer, "Go [bleep] yourself." During chaotic actions scenes, other voices exclaim, "What the [bleep] was that? ... Watch out, it's here.... [Bleep], that was close." If the sound of the bleep doesn't quite convince us that the show is live (it doesn't), it does suggest that the scene derives from the techniques of televisual liveness. These spoken lines are *coded* as unscripted and immediate, as if there

were no possibility of second takes. The bleep operates as a kind of Band-Aid that patches potentially indecent footage, readying it for broadcast, even if the scrape that needs covered is self-inflicted by the script.

The scripted bleep surfaces not only in drama but also in live-action situation comedy, where it is just as resolutely bleeped. A particularly charming instance occurred on *Modern Family*, a popular, critically acclaimed domestic sitcom involving three related households. On January 18, 2013, the episode "Little Bo Bleep" toyed with profanity, in scenes featuring Mitchell Pritchett (Jesse Tyler Ferguson) and Cameron Tucker (Eric Stonestreet) with their daughter Lily Tucker-Pritchett (Aubrey Anderson-Emmons). Rehearsing for her role as the flower girl in an upcoming wedding, Lily suddenly exclaims, "Oh, [bleep]!" Her utterance is covered by a long bleep and the lower half of her face is broadly pixelated. Cameron fails to suppress laughter, and he later wonders if, perhaps, he and Mitchell had misheard her: "Maybe she said truck or duck or luck. She could've said yuck." His doubts are dismissed later when Lily asks for ice cream and is offered fruit. She retorts, "Fruit? [Bleep]." When her parents initiate a discussion about the word—"the one that starts with F"—she asks if they mean "flower" or "fruit" and then, finally, "Oh, you mean [bleep]." Later, at the wedding, seeing her sentimental father shed tears, Lily tries to make him laugh again by blurting the banned word. There's little mistaking what she is supposed to have said, given both the parental challenge that her new vocabulary poses and the rhyming and alliterative hints.[50]

Expletives had been kept out of broadcast program titles until CBS aired the situation comedy *$#*! My Dad Says* (2010–2011). The series was based on a Twitter feed launched in August 2009 by a writer named Jason Halpern. Amused by his cantankerous father's witticisms, he started tweeting quotes on August 3. Within weeks, Halpern had almost 800,000 followers, a book deal, and a sitcom in development.[51] *Shit My Dad Says* tweets featured uncensored profanity, as did the *Sh*t My Dad Says* book, even if on the cover, the word "shit" was spelled with an asterisk in place of the vowel. For television, a nonsense sign substituted for all four letters of the expletive in the title, and William Shatner took on the role of the dad, but his character lacked many of the attributes of the man after which it was modeled. In real life, Halpern's parents were still married; the character Ed Goodson was thrice divorced, devoid of his Jewishness and his expletives. Anglicized and linguistically chastened, the series lasted only 18 episodes.[52]

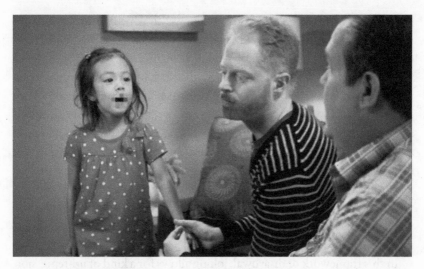

FIG. 11 Mitch (Jesse Tyler Ferguson, center) and Cam (Eric Stonestreet, at right) react when their daughter Lily (Aubrey Anderson-Emmons) says a "bad" word, which is both bleeped and pixelated, in "Little Bo Bleep," *Modern Family*, ABC, January 18, 2012.

If the provocative title of CBS's *$#*! My Dad Says* failed to guarantee success, the lesson was lost on ABC the following season. The network settled on the title *Don't Trust the B—in Apartment 23* (2012–2013) for a sitcom developed by former *American Dad!* producer Nahnatchka Khan. Was it necessary to blot out the word "bitch" in the title? Once a red (or at least cautionary yellow) flag for the networks' offices of standards and practices, the term is now routine in reality TV and other genres, as in the phrase "son of a bitch," as a generic reference to something difficult or annoying, as a derogatory reference to a strong woman character, and as an ironic term of endearment. (On *The Simple Life*, on Fox 2003–2007, Paris Hilton and Nicole Richie used the phrase "Goodnight, bitch.") And at least since HBO's prison drama *Oz* (1997–2003), "bitch" has become a more frequent insult hurled at male characters, as a slur indicating effeminacy or asserting the speaker's dominance, a usage that may have made its broadcast debut in the first episode of Fox's teen soap *The O.C.* (2003–2007).[53] In this context, the obliterated "bitch" in the title *Don't Trust the B—in Apartment 23* is both dependent on the increasingly acceptable uses of the word and on its continuing valence as a transgressive utterance. Thus domesticated with its "edge" well preserved, the word performs an unthreatening form of rebellion. Language once aggressively sexist becomes generalized, and strong expressions become banalities.

To what end? Considering the frequency with which scripted profanity is used to get a laugh, one could say that it performs what Sigmund Freud called "joke work." According to Freud, "the main characteristic of the joke-work" is clear: it is "that of liberating pleasure by getting rid of inhibitions."[54] That is, a joke breaks a rule. The inhibited becomes disinhibited. But that's not all there is to a joke. In the case of scripted profanity, the bleep acknowledges *and* refutes. It allows the speaker to appear to transgress even as the broadcaster marks the utterance as unacceptably transgressive; the bleep simultaneously embraces and disavows. A profane utterance may be a transgressive eruption that, when covered by the bleep, is both allowed (it is not entirely absented) and repudiated. When the disinhibited act or utterance takes place to get a laugh, the transgression is framed to the point that it is hardly a transgression at all.

In this framework of disavowal, joking allows for a kind of *un*-repression that may unleash aggressive or uncomfortable thoughts or feelings, while undermining those very expressions, softening their edges: *it's only a joke*. But Herbert Marcuse found that transgressive adoptions of forbidden expressions not only neutralize their force, rendering them banal, but also result in more insidious consequences. In his 1969 *An Essay on Liberation*, Marcuse recognized the "political potential" of profanity as one element of a "systematic linguistic rebellion"[55]:

> The methodical use of "obscenities" in the political language of the radicals is the elemental act of giving a new name to men [*sic*] and things, obliterating the false and hypocritical name which the renamed figures proudly bear in and for the system. And if the renaming invokes the sexual sphere, it falls in line with the great design of the desublimation of culture, which, to the radicals, is a vital aspect of liberation.[56]

Soon after, in 1972, Marcuse retracted this aspect of his argument regarding revolution and language, declaring that the "political potential" of verbal "obscenity" had already become "ineffective."[57] The utterance that once seemed counterhegemonic no longer defies repressive rule. It even performs the work of repression, in that the profanity marked as transgressive becomes, like broadcast liveness itself, a stylistic code, contained and commodified, at once disavowed and obligatory.

Indecent Language and Woman's Place

If the use of expletives is pleasurably disinhibiting, as Freud suggested, who gets to blow off such steam? If the use of "'obscenities' in the political language" is an attempt—albeit, according to Marcuse, a too-readily co-opted attempt—to overcome repression, who can use these fraught terms to challenge an oppressive social sphere? Linguistic liberation may not be within the reach of all speakers. When male and female speakers blurt roughly the same expletives during live broadcasts, they are often met with very different kinds of media coverage.

There can be little doubt that in many contexts, many words once deemed "unladylike" are now used by women without sanction.[58] Yet it is curious that so many of the most publicized instances of broadcast profanity involve female speakers. Is profanity more expected from men and therefore less offensive, less newsworthy? It isn't hard to find linguistic data that suggests that women's language is more policed, and self-policed, than that of men. Over four decades ago, Robin Tolmach Lakoff observed that "'stronger' expletives are reserved for men, and the 'weaker' ones for women."[59] (To be clear: Lakoff rejected a "biological basis" for differences in men's and women's language, emphasizing that those differences are attributable to socialization—how we are "taught."[60]) Discouraging a woman from using "strong language" is, she argues, one of several means of "denying her the means of expressing herself strongly."[61] It's a lose-lose situation for female speakers, according to Lakoff, because substituting weak euphemisms for strong epithets—"Oh, fudge!" is one of her now-dated examples— "suggest[s] triviality in subject matter and uncertainty about it.[62]

How does Lakoff's snapshot of a gendered division of language hold up in the twenty-first century? According to Judith Mattson Bean and Barbara Johnston, if "the right to 'cuss' is a sign of the right to express emotion," in some contexts, women still enjoy that right less fully than men[63] The habits of self-censorship and sanction that Lakoff identifies, which researchers still observe, may explain some of the media's tendency to make a big deal over profanity when uttered by women and to downplay profanity uttered by men.

Consider coverage of the January 16, 2014, *Critics' Choice Awards*, which was broadcast live on The CW network. The next day, CNN.com's homepage included "Bullock Drops F-Bomb at Awards Show" among a dozen featured stories in its "Read This, Watch That" section. Clicking on a thumbnail photograph of Bullock led the reader to an article that begins:

Perhaps Sandra Bullock was just overwhelmed.

The "Gravity" star had a busy Thursday thanks to her Oscar nod, and by the time she took the stage at that night's Critics' Choice Movie Awards, she let an F-bomb slip during her acceptance speech for best actress in an action movie.

Bullock was trying to get out her thank-yous when a technical glitch interrupted. "What the f***?" a surprised Bullock said before joking that she's an action star.

At this point in the article, a six- or seven-second video appears, replaying in a continuous loop and showing Bullock beginning her speech ("Um, I would like to th—"). Then, a recorded voice announcing the next award interrupts Bullock, which elicits her utterance (silenced in the recording, but easily lip-read). The video was tweeted by *People Magazine*, exposing audiences beyond the original viewership to her gaffe, with the explanation "The moment that made Sandra Bullock yell, 'I am an action hero!' Technical difficulties should not happen to her. #CriticsChoice."[64]

The fourth paragraph reveals that Bullock's exclamation was not the only one of the evening to contain a profanity: "The 49-year-old wasn't the only one to go off-script that night: Bradley Cooper sneaked in the expletive during the best comedy acceptance speech, calling his [*American Hustle*] co-stars 'these f***ing actors.'" CNN found Bullock's expletive worthy of the headline and lede, a looping video, two additional paragraphs, and a mention among the four "Story Highlights" at the side of the main text. Cooper's utterance earned a single mention only halfway through the article. Discussion of these two instances of the use of expletives occupied about half of the entire article, equaling the coverage of other awards in this run-up to the Oscars.

On *US Weekly*'s website, treatment of the incident was somewhat more balanced, in that both Bullock and Cooper were mentioned in the title and both are pictured. But discussion of Bullock's expression takes up the first three paragraphs, and Cooper's only the fourth. *US Weekly* adds that Cate Blanchett also "dropped the S-bomb during her acceptance speech" when she remarked that her children "don't give a s**t what I do, and for that I'm eternally grateful."[65] Is there a hierarchy of expletives that deems the F-word more newsworthy than the S-word? Or does Blanchett's relative prestige—measured in previous awards and legitimate stage credits—earn her a near pass? In any case, both CNN and *US Weekly* lavished more attention on Bullock's utterance than on Cooper's use of the same word. It may remain

the case that "strong language" is less expected and more fraught when the speaker is female. In media coverage of these events, the capacity of the press to sanction some speech, while amplifying and commodifying it, is clear.

In contrast, it is often the case that instances of men using expletives are covered more forgivingly. In 2004, when then Vice President Dick Cheney told Senator Patrick Leahy to "go fuck himself" (or maybe it was "fuck off"—sources disagree), reports focused on rationale. CNN, for example, quoted Cheney's own defense of the utterance as "forcefully" expressive and "long overdue."[66] In sports reporting, men are also often given similarly wide berths. When CBS dwelled on footage of New England Patriots quarterback Tom Brady using profanity—inaudible but repeated and lip-readable "fucks"—during a November 3, 2014, football game, sporting news outlets focused on Brady's motivation and his unapologetic response. He was "venting his frustration" and advised anyone who didn't like it to blame the network that "chose to air the footage."[67] Similarly, when Tiger Woods uttered a profanity that went live to air on CBS during the April 2015 Masters Golf Tournament in Augusta, Georgia, commentators excused the act as one committed "in the heat of battle," even as they apologized for Woods.[68]

While coverage of utterances by Diane Keaton, Jane Fonda, Melissa Leo, Sandra Bullock, and other female celebrities tends to focus solely on *what* happened—the expletive and its renunciation, along with the public apology—coverage of similar utterances by some male public figures and sports stars tends to highlight *why* it happened ("overdue," "frustration," "heat of battle"). Female actions are recounted; male emotions are legitimated. If "the right to 'cuss' is a sign of the right to express emotion," it is clear that this right remains unequally distributed.[69]

Conclusion

So what of the "right to 'cuss,'" and expletives, deleted or otherwise? The unscripted profanity, which may or may not evade time-delay obliteration, reminds the viewer that television may be live, even if actual liveness tends to be confined to a few genres, such as sports, news, and awards shows. Sometimes such utterances have real consequences, as A. J. Clemente discovered on his first day at KFYR in Bismarck. A pair of profanities cost him his job and stalled his career in broadcasting.[70] In other cases (such as the awards show incidents involving Cher, Bono, and Nicole Richie), real consequences

included lengthy legal proceedings, not so much for the speaking performers, but rather for the networks airing the broadcasts. Those legal proceedings eventually unraveled the policy under which the fines were issued.

Despite—or, in part, as a reaction to—these costly legal battles, broadcasters in the twenty-first century have increasingly used the bleeped profanity as a sign of immediacy, suggesting to the viewer that footage is live, unscripted, and uncensored (even if this is a suggestion the viewer is unlikely to take seriously). In reality TV shows like *Hell's Kitchen* and many others, the bleeped profanity is an attempt to sell the viewer on the authenticity—the realness—of the shot. It constitutes a claim that the show is unscripted and minimally edited, whether that is actually the case or not. In scripted dramas such as *The River* and mockumentary-style comedies like *Modern Family*, scenes that use bleeped expressions mimic documentary or reality-TV footage. In each case, profanity is part of the stylistic code of liveness, "marshaled at will, feigned and knowingly exchanged with ontologically aware viewers."[71] These displacements offer deserved mockery of both institutional limits placed on expressive language and the flaunted immediacy of mock and reality forms.

Elsewhere, throughout television, scripted profanity and obligatory bleeps may be proffered as critiques of the prohibitions against it and understood as playful chiding of the powers that be (the networks' standards and practices offices, the Enforcement Bureau at the FCC, the media advocacy groups whose members are poised to hit "send" on redundant complaints about every passing potential infraction). There is a sense in which the blurted expletive has become anything but transgressive. Rather, it has become a convention as formulaic as any other, one that trivializes and commodifies transgression, turning it into a supposedly edgy branding strategy, containable within hegemonic constraints. These kinds of scenes may even devalue the transgression itself, offering critique that changes nothing: a performance of rule-breaking while abiding by rules. The joke may be lost on the PTC or the FCC, but the joke may be on those of us who revel in the profane punchline. According to Herbert Marcuse,

> Spoken to an Establishment which can well afford "obscenity," this language no longer identifies the radical, the one who does not belong. Moreover standardized obscene language is repressive desublimation. . . . The verbalization of the genital and anal sphere, which has become a ritual in left-radical speech (the "obligatory" use of "fuck," "shit") is a *debasement* of sexuality. If a radical says

"Fuck Nixon" he associates the word for highest genital gratification with the highest representative of the oppressive Establishment. . . . [T]his linguistic rebellion mars the political identity by the mere verbalization of petty bourgeois taboos.[72]

As *New York Times* columnist Dan Barry opined in a 2013 op-ed poking fun at the attempts of television channels to incorporate trendy vernacular without offending potential audiences or advertisers, is it not clear that "the mischievous use of such words by media conglomerates creates the opposite of edginess? That it is like having your grandmother repeatedly describe her gingerbread cookies as 'off da hook?'" Barry's op-ed was inspired by the show *Cook Your Ass Off*, which premiered late in 2013 on HLN (formerly Headline News, the CNN spin-off). Its title echoes that of a reality-based weight-loss competition called *Dance Your Ass Off* (2009–2010, Oxygen) that employed a formula crossing *The Biggest Loser* with *Dancing With the Stars*. Barry quotes Amy Cohn, a representative of HLN's parent company, the Time Warner-owned Turner Broadcasting, who defended the title as "playful, entertaining . . . tongue-in-cheek." Barry countered that the title is "gratuitous, childish, cheesy."[73] However gutsy, or silly, or sophomoric, however, the show didn't catch on. It was canceled after thirteen episodes.

While the networks responsible for Oxygen's *Dance Your Ass Off* and HLN's *Cook Your Ass Off* did not need to worry about complaints that might result in FCC action (the term "ass" has not been regarded as an epithet strong enough to rise to the level of "indecency," and both shows were slated for less regulated cable channels), these titles, like the nonsense phonemes in *$#*! My Dad Says* and *The B—in Apartment 23* demonstrate just how eager production companies and networks are to claim transgression as a brand strategy, so long as it can be packaged in a form that doesn't actually offend the status quo. What Marcuse once called "the verbalization of petty bourgeois taboos" has become a standard practice. Bleeped or unbleeped, live or prerecorded, legitimated or renounced, it constitutes a defanged "linguistic rebellion," a banalization of transgression, one offering few if any victories for freedom of expression, sexual or otherwise.

5

Who's Afraid of
Dick Smart?

The Body Politic, Public
Access, and the Punitive State

> If it has an audience, it's part of your
> community, even if you wish it were not.
> —Deborah Vinsel, Thurston Commu-
> nity Television, Olympia, WA

On March 31 and again on April 7 of the year 2000, the public access sta-
tion known as GRTV (Grand Rapids Television) aired a show called *Tim's
Area of Control* in a half-hour timeslot beginning at 10:30 P.M. The nonprofit
Community Media Center of Grand Rapids, Michigan, operates GRTV on
the local Comcast franchise's channel 25, which then reached about 46,000
cable subscribers.[1] The episode of *Tim's Area of Control* that aired on those
dates included a three-minute skit that the show's producer and primary per-
former, Timothy Bruce Huffman, called "Dick Smart." For the skit, Huff-
man painted a face on his penis, and set up a shot in which his penis and
testicles appeared on screen, in close-up. With the rest of his body out of

frame, he told jokes. The verbal portion of the routine was crude, rambling and not particularly funny. In much of it, Huffman heckles an imaginary audience ("What's [*sic*] the matter with you lady, you never seen a dick before?").[2] A viewer sought to complain about the program, and the skit became the center of a prolonged and unusual legal contest undertaken by the Kent County Prosecutor's Office against the performer.

Huffman was arrested and eventually convicted of criminal indecent exposure. There was no known precedent, in Michigan or any other U.S. state, for pressing such a charge against a performer whose actions were televised. Federal indecency law and the Federal Communications Commission's (FCC) policy on obscene, indecent, and profane broadcasts pertain only to broadcasting, not to cable or public-access channels.[3] (Programming determined to qualify as *obscenity*, a kind of speech that is *not* protected by the First Amendment, and at least one program depicting acts of animal cruelty, have led to criminal charges on at least a few occasions.)[4] Although public access channels like GRTV, which aired *Tim's Area of Control*, enjoy relatively light content regulation compared to broadcasting, outright obscenity is still out of bounds. But no one argued that Huffman's routine was obscene; only that he had performed an indecent act. An obscenity charge probably wouldn't have stuck, anyway, since the program "as a whole" did not pander to "the prurient interest," and like it or not, an argument could be made that the comedic aspects of the skit had some artistic value.[5] Nevertheless, court after court upheld the conviction or refused to hear the case.

Predictably, the case raised First Amendment issues regarding the relative absence of regulation pertaining to the content of cable and satellite television programming vis-à-vis the limited protection afforded to broadcast speech. But the courts largely ignored the long legacy of prior decisions that protect subscription-based media (specifically, cable TV) from the kinds of sanctions that FCC policy can apply to indecent broadcasts.[6] In fact, in many ways, arguments pressing for Huffman's conviction didn't treat his actions as televised at all. Instead, adjudication of the case rested on arguments holding that electronic media constitutes a kind of space equivalent to geographic spaces, such as public parks or streets, and thus an image seen on television is no different from seeing a person or action in person, in close proximity. The Grand Rapids prosecutor argued that laws governing conduct could pertain equally to acts committed in plain, unmediated view and to acts depicted in prerecorded television.

If electronic space and other kinds of spaces—the street, the park—are substantially equivalent, is it possible to sustain a legal apparatus that has historically treated most representations as different from "real life"? When, if ever, are representations legally equivalent to "real world" actions? What, if anything, distinguishes conduct on the screen from conduct in (relatively) unmediated circumstances?

How we parse the relationship between material-world and electronic-media experience undergirds our theories of how media affects viewers. Accordingly, in this chapter I explore concepts of electronic media not as a delivery system for speech in the form of visual and auditory representations but as a kind of space or place. Next, I establish how public-access TV differs from broadcast television; its distinct regulatory history bears directly on the case at hand. Then, I return to the strange case of *Michigan v. Huffman*. I focus on this particular case not because it marked a sea change in legal strategies to rein in the First Amendment, extend the FCC's indecency policies, or criminalize televised indecency. Truth be told, *Michigan v. Huffman* is more aberration than trendsetter. But as an aberration, the case underscores tension between the media's function as a spatially networked public sphere and the presumptive privacy of the domestic sphere, the conventional site for television and other screens. This incident and the ensuing legal actions ask us to carefully consider the relationships between bodies and screens, selves and images, and the boundaries between public and private that remodulate these relations. I argue that this case demonstrates that a regulatory regime that asserts the practical equivalence of real life and representation is one that is bound to overreach.

Spatial Effects

Television has, since its earliest days, always been almost everywhere: screens have pervaded bars, restaurants, transportation hubs, and department stores.[7] As well, TV and other media (radio, recorded music) have long been well established in hospitals, doctor's offices, beauty salons, airplanes, and myriad elsewheres.[8] Screens are (almost) everywhere, from laundromats and taxicabs—really, anywhere that people are waiting—to classrooms, live concerts, and sporting events. (Ironically, a lot of watching at big-ticket, in-person arena events involves screens that magnify and multiply views of the on-stage or on-the-field action. If Serena Williams or Beyoncé aren't close

enough to those in less than prime seats, video screens in stadiums and concert halls offer everyone a close-up.[9]) Cameras, too, have saturated our environments since at least the 1970s, tracking our movements through retail centers, city streets, school campuses, and elsewhere.[10] We have also come to carry screens, in large numbers, in the form of laptop computers, tablets, smartphones, global positioning systems (GPS), and smart watches, both in the home and in public. As Nick Couldry and Anna McCarthy write, "It is ever more difficult to tell a story of social space without also telling one of media, and vice versa."[11]

Even though the multiplicity, ubiquity, miniaturization, and mobility of media has deterritorialized screens, it has not fully erased the ways screen spaces differ from "real life" spaces. Consider Setha Low and Neil Smith, writing in *The Politics of Public Space*:

> By public space we mean the range of social locations offered by the street, the park, the media, the Internet, the shopping mall, the United Nations, national governments, and local neighborhoods. Public space includes very recognizable geographies of daily movement, which may be local, regional or global, but they also include electronic and institutional "spaces" that are every bit as palpable, if experienced quite differently, in daily life.[12]

That is, we know that TV is not a literal "window onto another world," but we engage with it as a virtual window onto images of other worlds—a not so subtle distinction.[13] If TV is not in itself an actual spatial portal, at least it performs the work of a "spatiotemporal force that establishes social relationships within and between places and between scales," as McCarthy noted.[14]

What difference does it make whether we understand electronic space and "real life" as not meaningfully distinguishable, or as distinct though thoroughly entangled? There have been concerns about the effects of screen experience on viewers as long as there have been screens; the relationship between screen life and "real life" has been debated for well over a century. Efforts to regulate broadcast speech began in the earliest phases of widespread broadcasting.[15] The social reformers and jurists who established film censorship protocols in the early twentieth century presumed strong and direct media effects, especially for the audience members they consider most vulnerable: children.[16] A hundred years later, the PTC expresses a similar goal in its mission statement: "To protect children and families from graphic

sex, violence and profanity in the media, because of their proven long-term harmful effects."[17]

Yet those studying media effects haven't always agreed with the view that effects are long-term, proven, direct, or harmful. The Motion Picture Research Council used some of the findings from research conducted in the four-year project (1929–1933) known as the Payne Fund studies to begin to enforce a strident Production Code in 1934; social scientists that conducted the studies were somewhat less alarmed.[18] The Payne studies and subsequent groundbreaking studies have found nuanced, varied, and indirect effects, and they have found little evidence of long-term, direct effects.[19] Some classic research in media effects identifies short-term but impermanent effects, or longitudinal effects but not the ones one might expect—among them, the "mean world syndrome" identified by George Gerbner, Larry Gross, and their collaborators in a study conducted in the 1970s and known as the Cultural Indicators Project, which was funded by the Lyndon B. Johnson administration's National Committee on the Causes and Preventions of Violence.[20] In more recent decades, researchers have identified more unpredictable effects and uses of media, and more critical, discerning, and resistant viewers, readers, listeners, and users.[21]

In contrast, conservative watchdog groups produce volumes of research identifying potentially harmful programming, using content analysis as a method of cataloging and quantifying instances of sexual references or representations of violence. These studies typically analyze *programming*, not audiences, and they *presume*, rather than measure, the effects. For example, a report on the sexual exploitation of girls and young women, produced by the PTC in collaboration with an organization called 4 Every Girl, concluded:

> The study showed that primetime broadcast television programs routinely include sexually exploitive dialogue and depictions of females. . . . *[I]f* past research is correct that television can shape our attitudes towards social issues, and *if* media images communicate that sexual exploitation is neither serious nor harmful, the environment is being set for sexual exploitation to be viewed as trivial and acceptable.[22]

Those are two big "ifs." The PTC may be better at describing aspects of the media environment than linking images to social phenomena or individual behaviors. Even then, these kinds of studies often fail to distinguish between

content presented satirically (*Family Guy*), tragically (*Law & Order: Special Victims Unit*), or at any other affective register. In other words, they treat all forms of nudity, all mentions of sexual behavior, as roughly equal—and invariably negative. But it is possible that a TV show could treat rape as violent and traumatizing, with sympathy for survivors, and that such a representation could be destigmatizing.[23] Are all mentions of teenage sexuality necessarily exploitive, or could they possibly be healthily realistic? Is a glimpse of a naked human body really damaging to the viewer? From the PTC's perspective, the less said about sex (and violence), the better, despite evidence found in studies of teen health and sex education that show that access to *more*, accurate, and open information about sex and its consequences reduces teen pregnancy and rates of sexually transmitted diseases.[24]

In sum, there is little agreement among scholars and among other observers about the extent or nature of media effects.[25] Perhaps the only conclusion that can be drawn from the media effects literature is that "it depends." That is, when, how, and how much media impacts our beliefs and behaviors depends on an array of circumstances: viewer predisposition, context, the availability of counter-narratives, the type of exposure and duration, and other factors so complex that they are practically individualized and difficult to measure or generalize. Nevertheless, regulatory regimes legitimate themselves by drawing on the common-sense (if unproven) presumption that since the media is consumed, it must be impactful. Much of that influence is presumed to be negative: inciting violence, debauching, and ever dumbing-down. And it is such a climate—one in which concerns about media experience presume the worst—that focuses a great deal of attention on the human body, naked or partially so, as a scourge of screen culture. That nearly naked body, in its most matter-of-fact banality, has made some of its most scandalous appearances on the channels known as "public access."

Public Access to What?

Public-access channels are anomalous in many ways: intensely localized, non-professional, and non-commercial, in stark contrast to a TV marketplace that is heavily networked, highly professionalized, hyper-commercialized, and even in its nonprofit zone, occupied largely by stations affiliated with the Public Broadcasting System (PBS), which is significantly centralized. As outlets for community-based programming that supplements cable

systems' other offerings, these channels play a unique role in the television environment as a medium supporting self- and social-determination. According to Eric Freedman, for example, a long-running program on West Hollywood Public Access called *The Paul Kent Show*, in which the host based each episode around a visit to the home of a gay man who might be a police officer or a personal trainer or (more often) a porn star, functioned "as a collective autobiography, of a community writing itself."[26] Even long after the growth of other media sources (the internet, smartphones), researchers have found still-vibrant public-access production cultures as well as audiences for whom these channels are still relevant, especially non-white and less educated audiences.[27] Importantly, those public-access producers have enjoyed not only outlets for the programming they create, but also the means to create, including training and access to equipment.

Early experiments in public access date to a 1953 project at the University of Houston and a public-access center started in 1968 by Cable TV, Inc., in Dale City, Virginia, open to members of the Dale City Junior Chamber of Commerce.[28] In 1969, the FCC's First Report and Order on community antenna television (CATV, now typically referred to simply as "cable" TV) required cable systems to provide locally originated programming, offering few specifics but opening the door to public use of cable facilities and channels.[29] Soon after, in 1971, documentary filmmakers George Stoney and Red Burns founded the Alternative Media Center at New York University's Tisch School of the Arts. The center provided programming to public-access channels on Teleprompter Inc.'s cable system in Manhattan as well as assistance to nascent access projects across the country.[30] The public access movement was off and running. Within months, both Teleprompter, serving upper Manhattan, and Sterling Manhattan Cable Company, serving Midtown and Lower Manhattan, were airing programs by the community-based organization Friends of Haiti, the artist-run Filmmaker's Cooperative, and "a Shakespeare buff from New Jersey," among many others.[31]

FCC Commissioner Nicholas Johnson, who served from 1966 to 1973, was familiar with Stoney and Burns's accomplishments, and pressed for policy to support these kinds of initiatives.[32] As a result, the FCC's Third Report and Order on cable TV, issued in 1972, mandated cable systems in the top hundred markets to allocate three channels, one each for public, educational, or governmental (PEG) use.[33] The Order also added a requirement for at least one "leased" access channel for commercial programming

by independent producers. Leased channels were intended to increase viewpoint diversity at a "reasonable" cost, and to operate on the same "nondiscriminatory, first-come, first-served basis" as other public access channels.[34] In 1976, the FCC raised the number of required access channels from three to four anywhere that a cable franchise served at least 3,500 subscribers. Some cable systems challenged this requirement, which was overturned by the Supreme Court in the case *FCC v. Midwest Video Corp.*, 440 U.S. 689, in 1979 on the grounds that by *requiring* public access channels, the FCC was treating cable systems as common carriers, which they are not.[35]

To resolve this conflict and others, Congress passed the Cable Communications Policy Act of 1984, which preserved the *possibility* of public access without making it a requirement. This new policy on public access and other matters also shifted a great deal of regulatory responsibility from federal to municipal or state governance.[36] According to Section 611 of the 1984 Act, "A franchising authority *may* establish requirements in a franchise with respect to the designation or use of channel capacity for public, education, or governmental use."[37] Wherever such channels were established, the FCC expected PEG programs to originate locally and to be original, with minimal restriction on content. In fact, the 1984 act prevented cable systems from interfering with PEG channel content, specifying that cable operators "shall not exercise any editorial control over" PEG channels.[38] Both cable operators and franchising authorities could, however, refuse channels offering programming that was "obscene or otherwise unprotected by the Constitution of the United States," and they were required to supply blocking technology upon request to viewers who wanted to avoid possibly obscene or indecent programming.[39] Otherwise, the act had little to say about PEG channels, leaving it up to franchising authorities to work out the details with cable providers.

Public access centers have produced programming that has varied widely in quality, format, and purpose, serving with remarkable success as a democratizing, refreshingly rough-around-the-edges outlet. As such, access television has been a haven for First Amendment-protected speech—the unpopular, the controversial—as well as for highly niched or hyperlocal interests, wholly amateur or ambitiously aspirational videomakers, and myriad other voices. Still, the medium's reputation may not be so noble. While much of it is focused on community-building functions, there are also examples of highly divisive programs created by hate groups or by hate-mongering individuals.[40] Public access also has "an arguably sophomoric reputation," thanks

in part to Mike Myers and Dana Carvey's parodistic *Wayne's World*, a recurring sketch on *Saturday Night Live* from 1989 to 1992, and to their 1992 feature film, both of which portrayed public access producers and their programming as indulgent and juvenile.[41]

There may be a kernel of truth in these critical assessments, yet in a truly democratic communication system, alongside the most outrageous or reactionary voices, there are bound to be some diamonds in the rough.[42] For example, *TV Party*, a public access talk show produced in New York from 1978 to 1982 and cohosted by writer Glenn O'Brien and Chris Stein, guitarist in the band Blondie, featured musicians and artists as yet unlikely to be recognized on major networks. Since 1981, the *Paper Tiger Television* collective has produced more than 300 half-hour programs of marvelously realized media criticism and social-issue documentary that aired on MNN. These two titles are a tiny sample of some of the most venerated access programs—the entire field is far too vast to survey here—but it is fair to say that such great work aired alongside programs in a range of genres, from serious talking-head interviews to raucous dance parties, from instructional videos to televangelism, and from a range of viewpoints including those of both the Far Right and Far Left. And more than a few public access programs, like the West Hollywood-based *Paul Kent Show* discussed by Freedman, have taken sexual identity and culture as their subject. *Gay USA* (launched in 1985 as *Pride and Progress*), a news program and one of many access shows produced by Lou Malletta's Gay Cable Network, employed professional journalists Andy Humm and Ann Northrup, and continues to air on MNN while also using other means of distribution, including podcasts and satellite carriage on Free Speech TV. And beginning in 1987, AIDS activism took to public access channels in *The Living with AIDS Show*, produced by Jean Carlomusto and Gregg Bordowitz as a project of Gay Men's Health Crisis; later, James Wentzy produced some 150 episodes of *AIDS Community TV*, also for MNN.

Leased access channels also attract wide-ranging constituents, including individuals and companies already active in adult entertainment industries that are looking for opportunities to promote their businesses or reach new audiences. Among them have been *Screw* magazine publisher Al Goldstein, who launched a series called *Midnight Blue* in 1976 on the cable system Group W's access channel, then known as Channel J, serving upper Manhattan, and Robin Byrd, a former adult-film actress who also got her start on leased access in 1976. After a gig as host of *The Hot Legs Show* on Man-

hattan Cable's Channel J (reaching Midtown and lower portions of the borough), in which she fielded live calls from viewers about clips from films featuring nude women, Byrd took over and renamed the program *The Robin Byrd Show*. She replaced the film clips with in-studio interviews with adult entertainment professionals, retained the call-in format, and produced live, weekly episodes for some 20 years, which were later rerun.[43]

These shows and others like them raised concerns among some in the cable industry, regulatory agencies, and Congress. Senator Jesse Helms (R-NC), who had since 1989 been leading attacks on the National Endowment for the Arts on grounds that federal funding supported sexually explicit or blasphemous works, was among the most vocal, characterizing too much access programming as "perverted and disgusting."[44] He wasn't alone. Senator Strom Thurmond (R-SC) excoriated public access as a source of "X-rated previews of hard-core homosexual films," while Senators Tim Wirth (D-CO) and Wyche Fowler (D-GA) chimed in with concerns that leased access promoted prostitution or was being otherwise "abused."[45] Accordingly, with bipartisan support, the Cable Television Consumer Protection and Competition Act of 1992, which became law on October 5, 1992, included provisions to modify portions of the 1984 Cable Act that had prevented cable operators from asserting editorial control over access programming. The 1992 act allowed cable systems to refuse programs that qualify as indecent; that is, any program that "describes or depicts sexual or excretory activities or organs in a patently offensive manner as measured by contemporary community standards," without requiring banned programming to meet stricter criteria for obscenity.[46] If a cable operator chose not to refuse this kind of programming, the 1992 act required the operator to segregate it onto a single channel and block or scramble that channel, unless subscribers requested access to it in writing; it also required that "programmers" notify cable operators if their material would qualify as indecent.[47]

These new regulations did not sit well with public access centers lacking resources to implement the new rules and reluctant to lose their status as freer speech zones. A large survey of access centers undertaken in November and December 1992—immediately after passage of the act, to understand how its indecency ban could affect their programming—revealed that many felt they would have to become more skittish about some health-related programming, especially sex education and HIV/AIDS-related programming; "political fringe opinions . . . libertarians, anarchists, rightists, leftists"; debates over reproductive rights or gay rights; and live programs, given their

"unpredictability."[48] Patricia Aufderheide, author of the study, argues that whether one likes all of the available programs or not, the 1992 act "could challenge the fundamental purpose of public access and rob it of its unique function within cable television: to permit speakers open access to the community of viewers without censorship." "Cable access," she concludes, "also performs a larger civic function. It acts as an electronic public space, where citizens can not only hear about issues of public concern but participate in the creation of that debate."[49] (This survey was conducted before the internet became widely available, spawning other outlets for user-generated content in electronic media.[50]) To impose censorious conditions would be to suppress voices "slighted by the gatekeepers of mainstream media"—and therefore, to infringe unnecessarily and unjustifiably on the First Amendment for no good reason.[51]

The Alliance for Community Media (ACM), an organization representing thousands of public access centers, contested this section of the Act, but the U.S. Court of Appeals for the D.C. Circuit affirmed its constitutionality in 1995.[52] This decision did not stand for long. Later in the same year, the U.S. District Court for the Southern District of New York, considering a case brought by Goldstein, Byrd, and Malletta, decided that Time Warner's mechanisms for singling out *Midnight Blue* and a few other programs for scrambling was not consistent with the process laid out in the 1992 act. The ruling also noted that "fear of stigmatization" was a persuasive argument against requiring viewers to write in for these programs, especially programs "targeted to gay and lesbian audiences."[53] The District Court's decision was upheld by the Supreme Court in 2000, so programs like *Midnight Blue* and *The Robin Byrd Show* could stay on the air, unscrambled—and, in a victory for privacy concerns, cable systems could not track their viewers by demanding written requests for particular channels or programs.

The Telecommunications Act of 1996 took another crack at preventing unwanted access to adult entertainment. The act contained several measures for evading or limiting potentially offensive programming, including the TV ratings system and the V-chip. But not all of the act's provisions would survive. Its Section 505 required cable operators to scramble channels "primarily dedicated to sexually-oriented programming," or, alternatively, to "time-channel" it in overnight hours when children were not expected to be watching, promulgating a kind of "safe harbor" for access channels. In protest, Playboy Entertainment Group brought suit on behalf of its channels Playboy Television and Spice, and the U.S. District Court for the District

of Delaware nullified Section 505 as excessively restrictive, a decision upheld by the Supreme Court. In essence, scrambling is overkill when channel-blocking—a reliable method of responding to viewer concerns about unwanted programming—is provided for in the act's Section 504. (Even if, as Justice Anthony Kennedy, author of the decision, quipped, "the public greeted [channel-blocking] with a collective yawn."[54]) In its decision, the Supreme Court underscored that even where there are legitimate reasons to restrict speech, the "least restrictive means" of doing so is the only con-stitutional path.

In the decision, Kennedy even called out Senator Dianne Feinstein (D-CA), cosponsor of the 1996 act, who had expressed support of the mea-sure in the congressional record that stated Section 505 would apply to Playboy and Spice, reminding her that "laws designed to suppress or restrict the expression of specific speakers contradict the basic First Amend-ment principles."[55] Further, the opinion chided legislators for trying to fix a problem for which there was little evidence: "If the number of children transfixed by even flickering pornographic television images in fact reached into the millions, we, like the District Court, would have expected to be directed to more than a handful of complaints."[56] In the end, the Supreme Court protected both the business and the First Amendment interests of the public access channel over those of the cable provider, noting that scrambling and time-channeling would constitute "penalty for its pro-gramming choice." This decision, like *Goldstein* before it, placed the onus for avoiding unwanted content on the subscriber—turn it off, watch some-thing else, or block the channel—rather than on the cable provider or other party. This was consistent with other content-regulating aspects of the Telecommunications Act of 1996, including the V-chip and ratings system, that survived legal challenges.[57] Viewers were now free to watch Playboy, Spice, *Midnight Blue*, *The Robyn Byrd Show*, or anything else they wanted to—or they could choose not to watch. But not all viewers would be con-tent with a system that puts so much responsibility in our own hands.

Michigan Law and Indecent Speech

Access channels have endured—and provoked—their share of controversy. And they have been subject to attempts to quash unpopular speech—that is, speech that someone dislikes enough to combat, regardless of how

popular it is among other viewers. In the Timothy Bruce Huffman case, punitive action was realized, and it pinpointed an individual, rather than a station or network. That was unusual. In broadcasting, a possible act of indecency is handled by the FCC as an administrative matter that, at most, triggers a fine for which a station is held responsible. In *Michigan v. Huffman*, televised indecency became a matter for the criminal courts, targeting the individual performer.

An offended viewer apparently stumbled across the "Dick Smart" skit on the *Tim's Area of Control* episode, which was rerun on GRTV in Grand Rapids, Michigan, on April 7, 2000. According to the Michigan Court of Appeals, she "lodged a complaint with GRTV."[58] *The Grand Rapids Press* reported that the viewer, who is not identified in published records, also complained about the show "to a friend who is an assistant Kent County prosecutor," who launched an investigation.[59] As a result, a search warrant was issued, and police seized a videotape of the episode from the home of Timothy Bruce Huffman, who had produced the show with his wife, Sally, for eighteen months.[60] He was charged with criminal indecent exposure, a misdemeanor punishable by up to a year in jail and a fine of up to $1,000. The law specifies that, "a person shall not knowingly make any open or indecent exposure of his or her person or of the person of another."[61] If the incident involves not only display but "fondling his or her genitals, pubic area, buttocks or, if the person is female, breasts," or if the person is determined "sexually delinquent" (understood as a repeat offender), penalties are increased; breastfeeding is entirely exempt.[62]

On January 7, 2003, a jury found Huffman guilty. He was sentenced on February 19, 2003, to one day in jail, a year of probation, a $500 fine, and court costs.[63] He appealed with the help of the Alliance for Communications Democracy and the ACLU. His case was unprecedented. The charge of indecent exposure had not previously, in any jurisdiction, been levied on a televised act. The Grand Rapids district attorney who pressed charges against Huffman was experimenting, to be sure. The FCC could not have provided balm to the offended party; it has no jurisdiction to fine or otherwise punish public access stations, producers, or performers. And barring determination of the segment as actually obscene, it did not violate GRTV's policies at that time; to qualify as obscene, the program would have to have met strict legal criteria including that the work, "taken as a whole, lack serious literary, artistic, political or scientific value."[64] Nevertheless, law enforcement used other resources to create a shadow policy through which pun-

ishment could be meted out and used as an example to warn others against airing similar material.

The circuit court in Grand Rapids upheld Huffman's conviction in November 2003, as did the Michigan Court of Appeals in May 2005. To do so, the judiciary had to navigate a series of questions pressing on the role of electronic media in daily life—questions that structured its written decision in the case. The Court of Appeals opened Section II of the decision with the question, "Does the 'Open or Indecent Exposure' Statute Apply to Television Images?" The statute prohibits "open or indecent exposure" but does not specify *where* the exposure must take place in order for it to count as a criminal act. If such laws are understood, typically, to apply to acts committed in public places, the wording does not rule out the possibility that indecent exposure could occur in the home. Nor does the statute explicitly address exposure via electronic media, let alone media viewed in the privacy of one's home. But the decision pointed out that the statute does not explicitly *dis*-include television. Reportedly, the presiding judge instructed the jury that television—specifically, cable television—constitutes "a public place," which is not exempt from the indecent-exposure prosecution, and that the telecast should be understood as "conduct, not speech, and thus not protected by the First Amendment."[65] The court decided that "the purposes of the indecent exposure statute are best fulfilled by focusing on the impact that offensive conduct might have on persons subject to an exposure." That is, the court took for granted that the impact—understood as potential harm—of a televised exposure must be at least equal to the harm done by a "live, in-person exhibition."[66] Nevertheless the court did not make clear what harm was done in the case. Nudity was taken as a social negative, regardless of context, and viewers were regarded as incapable of responding with pleasure, or critique, or indifference; they are always, in decency discourses, at risk. The court went even further, finding that TV is potentially *more* dangerous than real life: "While we agree that a televised exposure is qualitatively different than a physical exposure, we note that, in some ways, it can be more offensive and threatening."[67]

In this passage, the judiciary failed to consider that the potential for escalation to physical violence (or fear of such violence) in an in-person encounter is lacking in encounters with the screen image. The assertion that a "televised exposure" might be more "threatening" than a "physical exposure" by a "stranger in a public forum" conflates and fails to distinguish between screen experiences and "real life" experience. Nevertheless, the

fundamental question, "Does the 'Open or Indecent Exposure' Statute Apply to Television Images?" pointed to a general area of concern that is not so ludicrous: that is, our understanding of television as a public apparatus that encroaches upon the private, domestic sphere. Assistant Prosecutor Timothy McMorrow, who worked on the appeal phase, said, "this case is not about prohibiting free speech. . . . This case is all about whether he exposed himself in a public place. And a public access channel is a public place."[68]

Further, also in Section II, the court surmised that, "When a person might minimally suspect that some stranger might expose himself in a public forum, to be subjected to a televised exposure in the privacy of a home is likely a more shocking event.[69] Instead, the court might have asked, since the exposure reached the viewer via an electronic screen, Should the viewer "minimally suspect" to view material one might find indecent? In the context of PEG channels, where all but obscenity is legal speech, viewer expectations can and should allow for the possibility of indecency. But then, in that case, this case might have been closed. And it was only the beginning.

The Court of Appeals argued that not only was the televised exposure less expected in the home than in public, but also that the televised representation was "likely a more shocking event" than what might occur in close proximity to a stranger in a public place. In arguing that male frontal nudity would not only surprise but actually shock, the court seemed to assume that the viewer's experience would entail not only the unexpected but also the upsetting. (Never mind that there are other plausible reactions to such an image.) The image would not only have startled; it could have also disturbed. The court explained:

> [The] defendant's exposure, while televised, was presumably more of an immediate closeup than would occur if he had been physically present with those subject to his exposure. The Dick Smart character portrayed on TV screens was probably larger than actual size and the exposure continued for fully three minutes, much longer than would have likely been allowed on Calder Plaza [in Grand Rapids] or in some other public square."[70]

In short, to the Court of Appeals, the televised genital scene found to be "threatening" and "shocking" was simply too intolerably large and on screen for too long.

This section of the ruling overlooks the fact that TV comes with remote control and real life does not. The complainant might have changed the

channel, averted her gaze, or turned off the set rather than endure the image. There is legal precedent for regarding these options as sufficient to protect the viewer from significant harm. In 1975, the Supreme Court heard a case involving an ordinance meant to ban drive-in theaters from showing movies with nudity in order to protect passersby who might glimpse the film accidentally from nearby streets. Striking down the ordinance, the court's decision suggested that anyone coming across an offensive image in such a manner "can readily avert their eyes," without interfering in others' right to see a perfectly legal movie. In this case, *Erznoznik v. City of Jacksonville*, 422 U.S. 205, the court ruled that the ordinance was unconstitutionally broad, acknowledging that not all nudity should be understood as sexual.[71] Unfortunately, the strategy of *looking away* was lost on both the complaining Grand Rapids viewer and the Michigan Court of Appeals.

In Section III, the Court of Appeals addressed questions of venue. ("Did Sufficient Evidence of Venue Exist?")[72] Huffman's lawyers claimed that venue could not be established, and they challenged the court to prove that he had exposed himself in Grand Rapids, where charges were pressed. The court demurred, arguing that "taping did not constitute the 'exposure' for which defendant was charged under the statute"; instead, "the exposure offense occurred when defendant arranged for the tape's delivery to GRTV, in Grand Rapids, for the purpose of having it distributed by cable network into thousands of homes."[73] In other words, exposure did not take place when Huffman disrobed in front of a camera, nor when his televised image reached viewers, but rather when he dropped off the tape at the access facility. That is, venue was established at the site of Huffman's *intention* to air the contested image. This raises the question: if no one had watched the program, would it still have constituted a criminal indecent exposure? If GRTV had lost the tape or refused to air it, would Huffman still have been at risk of arrest and conviction? If so, the court has claimed for itself the task of determining indecency whether an act of exposure is witnessed or not, whether a complainant comes forward or not, and whether any harm is done or not.

Five years earlier, in *People v. Vronko* (1998), the same court had upheld conviction of a man whom a witness believed to be masturbating in his car while children passed by on their way to school. The witness did not see the man's genitals (that is, she did not witness an open exposure) but only noted that his hand appeared to be in his lap and moving "like gangbusters." The *Vronko* decision held:

The issue whether a person's exposure must actually be witnessed by another person in order to constitute the crime of indecent exposure is one of first impression in Michigan. Although the standard criminal jury instruction purports to include as an element of the crime a requirement that the defendant's exposure be witnessed by "another person" . . . the language of the statute does not explicitly require the existence of such a witness.[74]

No witness? (One might even ask, no victim?) No problem. Not in the court's eyes anyway.

The Court of Appeals also had to consider another pressing question: Section IV began by asking, "Does the Conviction Violate Defendant's First Amendment Right to Free Speech?" The conviction depended on determining that the program constituted conduct (not speech); that is, focusing on Huffman's act of exposure, not on its televised representation, which would have, according to all available precedent, been treated under the law as speech. To make this point, the court turned to prior cases involving entangled speech and non-speech acts. Quoting the 1968 draft-card burning case *United States v. O'Brien*, the Court of Appeals reiterated that, "a sufficiently important governmental interest in regulating the non-speech element can justify incidental limitations on First Amendment freedoms."[75] In other words, since Huffman's performance constituted conduct (non-speech), it was subject to the law, even though once it was transmitted, the program became speech.

There remained a catch. The Court of Appeals agreed with the Supreme Court's landmark decision in *FCC v. Pacifica* (1978) that broadcasting is subject to "limited First Amendment protection" because it is so "uniquely pervasive in the lives of all Americans" that it must be prevented from transmitting "patently offensive, indecent" material into the private sphere, the home.[76] But while broadcasting is ubiquitous and broadcasters are thus the trustees of public airwaves, subscription-based cable TV, which carries public access channels, has long been understood as an "invited guest" that no subscriber must endure if they find these channels offensive. We can, after all, stop paying the monthly bills. (Even so, some subscribers may view some portions of their subscriptions as occasionally welcome guests who have overstayed or brought unwelcome luggage.) For example, in *Community Television of Utah, Inc. v. Wilkinson* (1985), the U.S. District Court of Utah observed, "cable television is not an uninvited intruder."[77] Thanks to this ruling and others, cable TV is entitled to First Amendment protections and

immune to some of the broadcast regulations disallowing indecency that does not rise to the level of obscenity.[78] Accordingly, it is viewers' responsibility to cancel their subscription or deploy channel-blocking services if they don't like what they are paying for. In the *Huffman* decision, however, the Michigan Court of Appeals refused this established distinction between broadcasting and other delivery systems, countering that "the same reasoning [that applies to broadcasting] applies to cable television."[79]

The Court of Appeals also ignored other prior rulings, including *Denver Area Educational Telecommunications Consortium v. FCC* (1996), which struck down portions of the Cable Act of 1992 that allowed a cable operator to confine programming that it "reasonably believe[d]" to be indecent or obscene to one of its PEG channels. The Supreme Court determined in *Denver* that such "segregation" of content infringed on the First Amendment and that this part of the 1992 act could be achieved with "less restrictive means," such as the channel-blocking and V-chips mandated by the Telecommunications Act of 1996. In contrast, the Kent County prosecutors in the Huffman case argued that the public nature of public access channels—that they may be mandated by municipalities and receive public funding—distinguished them from an otherwise commercial cable environment; therefore they should be vulnerable to broadcast-like regulations.

Finally, the Court of Appeals attempted to answer the question, "Is MCL750.335c Unconstitutionally Vague and Overbroad?"[80] In 2002, just three years earlier, the same court had overturned a conviction under MCL 750.337, the law criminalizing the use of "indecent, immoral, obscene, vulgar or insulting language in the presence or hearing of any women or child," on grounds that the law was too vague and its potential for enforcement "arbitrary and discriminatory."[81] The court might have found, similarly, that MCL 750.335c, the indecent exposure statute, is not clear in regard to its application to television or any electronic medium and is not entirely invulnerable to arbitrary or discriminatory enforcement. The court found otherwise, jettisoning cable TV's status as an "invited guest," and refigured it as a menacing intrusion into the private realm. Conversely, one could say that the decision recognized the presumptively private home as irremediably looped into the public via screen culture, and therefore subject to the same paternalistic legal interventions as playgrounds and schoolyards.

Early in 2006, the Michigan Supreme Court deferred the opportunity to hear Huffman's case.[82] In October 2006, the U.S. Supreme Court also refused to hear the case, ending the string of unsuccessful appeals, foregoing

an opportunity to restate the established distinctions between broadcasting and cable TV, and letting Huffman's conviction stand.[83] A man went to jail for exposing his genitals on television on late-night local programming, during a prerecorded performance that failed to meet criteria for obscenity. Was anyone harmed by this image? Prosecutors and judiciary alike didn't seem to care in their determination to override established protections for expression in the media outlet in question. Will similar prosecutions follow? Not necessarily. In truth, the *Huffman* case has thus far proved more peculiar than influential. But that is not to say that the case was without consequence. What happened on screen had off-screen consequences, most measurably for Timothy Bruce Huffman, and perhaps, albeit less quantifiably, for other public access producers, programmers, and audiences.

Conclusion

Despite the uniqueness of the "Dick Smart" case, the Michigan Court of Appeal's decision to uphold Huffman's conviction, and the refusal of higher courts to hear further appeals, might not come as a surprise in light of the conflation of geographic space and electronic space. Legal arguments upholding the Huffman conviction relied on the theorized "palpability" of electronic networks, on the equivalence of virtuality and materiality, and on a collapse of distinctions between the representational and the real. *Huffman* reminds us of the stakes in such a claim. When representations— televisual, cinematic, photographic, or literary—are understood as conduct, not speech, speech rights may be dangerously curtailed.

In the context of the now long-running debates over decency in the media—in the courts and in Congress, between watchdog groups, the FCC, and the industry—what is the significance of the series of decisions in this case? It may be true that *Michigan v. Huffman* set only a weak precedent for treating televisual images—or representation in any medium—that are perceived as indecent as criminal acts.[84] But legal action is not only punitive; it also acts, at times, as a deterrent, a system of *de facto* censorship even where no *a priori* censorship mechanism exists. *Huffman* may be unique in some ways, but it is also part of a trend, one that bolsters an accruing chill alongside other means of intimidating or corralling unpopular speech, realigning an increasingly mediated and surveilled public with an increasingly unprotected private sphere.

One way in which an odd case like Huffman's can threaten protected speech zones such as public access involves funding. It may be only coincidence that in 2007, following resolution of the Huffman case, GRTV lost about 20 percent of its funding due to new Michigan legislation that rewrote how cable system franchises contribute to public access funding. Ted Diedrich, GRTV's station manager, recalls the 2007 budget cut as a statewide legislative move to increase municipalities' control over allocations, rather than as retribution for controversial programming. The "Dick Smart" incident, Diedrich also reported, became a "teaching moment" for the station, which incorporated into its trainings and applications a warning against "indecent exposure as defined by local, state, or federal law," to help other performers and producers avoid possible prosecution.[85]

Other public access systems may not have been so lucky, or so deft, when forced to manage their reputations following publicized incidents of obscenity, indecency, or other forms of controversy. For example, early in 2006, before the Huffman case reached the Michigan Court of Appeals, the Seattle Community Access Network (SCAN) voted to discontinue carriage of *Mike Hunt TV*, determining it was obscene; a new agreement negotiated between the city and Comcast soon after resulted in budget cuts of 25 percent at SCAN, which some observers linked to the controversy.[86] Cuts at GRTV and SCAN were not unusual. Without a doubt, investment in public access facilities has waned on a large scale, nationwide, for more than a decade. Some franchising authorities that once required cable operators to provide access facilities and channels have opted out, by not renewing contractual provisions or by omitting them from new agreements. Others have reduced or eliminated funding; still others have left access channels behind in the transition to digital broadcasting.[87] The result? An impoverished, less diverse media environment, to be sure.

Television functions as what Anna McCarthy has called a "spatiotemporal force,"[88] a mechanism enabling public communication and social interaction across spatial gaps and temporal lags. That communication and that interaction are overwhelmingly commercial, corporate, and centralized. Public access has been a rare venue for democratized mediated speech. The Michigan Court of Appeals ignored precedent to argue that cable TV—including, and maybe even especially, public access—is a public forum, legally equivalent to a street corner or park. But television is not, in a material sense, a space. Nor is *the public* a space, a sphere, or a realm. Rather, the public is a set of conditions, or a set of relationships, that makes participation

possible in the social world. According to Hannah Arendt, to be public is to enjoy "the reality that comes from being seen and heard by others … being related to and separated from them through the intermediary of a common world of things … the possibility of achieving something more permanent than life itself."[89] Those conditions and those relationships may be articulated and distributed in the language of mass media. Do the media constitute a veritable space, a scape, or an environment? I argue instead that the media are means of amplifying what is to be "seen and heard." They are technologies that mediate the exchange of ideas in the "common world of things" (now more commonly known as "the real world"). They are hardware and software that may be used to record and preserve those ideas in forms "more permanent than life itself." Nothing more, nothing less. Muddling the distinctions—conflating media and social space, and treating representations of the body and the real body as one and the same—brought us the Huffman case, the criminal conviction of a televisual image. In *Michigan v. Huffman*, the legal distinction between lived experience and representation melted, dangerously, "into air."[90]

Conclusion

The Future of Indecency and Why It Matters

Soon after the 2016 U.S. presidential election, the PTC launched a new campaign, complete with a merchandise line. The winner of the election, Donald J. Trump, had run as the Republican nominee, using the slogan "Make America Great Again."[1] On the campaign trail, he often wore a red baseball cap emblazoned with the phrase.[2] The PTC paraphrased the slogan as "Make Television Great Again," and, like the presidential campaign, slapped these words on baseball caps in red, white, and blue. Throughout December 2016, the PTC sent Christmas-themed emails to constituents soliciting donations and featuring the cap as an incentive. For $100, donors would receive a PTC-logo polo shirt and one Make Television Great Again cap; for $129, they'd receive the cap, holiday albums by Kenny G and Pat Boone, and an oxymoronically described "family friendly" World War II film produced by Roma Downey and Mark Burnett.[3] (Is *any* war film—or war itself— truly "family friendly?") One of these post-election emails outlined the organization's current priorities, which fundraising efforts would support:

1. Address outstanding Broadcast Indecency complaints.
2. Reform the TV Content Ratings System.

3. Give customers unbundled cable TV and greater consumer choice.
4. Confirm FCC Commissioner Rosenworcel to a second term.[4]

Most of these demands were not new. The first goal, resolving open indecency cases, had been a longstanding plea of the organization. Since its founding, the PTC had devoted resources to identifying potentially offensive broadcasts, complaining about them directly to the FCC, and encouraging constituents to do the same. Regarding the second goal, in April 2016, the PTC commemorated the twentieth anniversary of the TV ratings system, a mandate of the Telecommunications Act of 1996, in a report that characterized the system as a corrupt and misleading muddle.[5] The PTC and scores of like-minded organizations and scholars cosigned letters imploring the Federal Communications Commission (FCC) to repair or replace the system.[6] As for the third priority, the PTC had been among advocates of à la carte (unbundled) cable since the very start of the twenty-first century, when Senator John McCain (R-AZ) began seeking congressional support for it.

What did this self-promoting alignment of a powerful advocacy group with the new president's *cri de coeur* mean? Basically, this: the PTC is dedicated to combatting indecency on TV. Paradoxically, Trump peppered his campaign with profanity and vulgarisms. For example, a discussion of relative penis size took place during the primetime Fox News-televised debate among those vying for the Republican nomination in March 2016, when Trump responded to Marco Rubio's suggestive campaign-trail comments about the size of his rival's hands: "Look at those hands. Are they small hands? . . . If they are small, something else must be small. I guarantee you there is no problem."[7] At campaign rallies, Trump encouraged violence against protestors on several occasions. (In Las Vegas, referring to a protestor, he said, "I'd like to punch him in the face"; in Cedar Rapids, Iowa: "Knock the crap out of them, would you? . . . I will pay for the legal fees."[8]) What was a decency-focused organization doing cozying up to a president-elect associated with such crude and uncivil—and even, at times, unbroadcastable—discourse? Would the new administration respond to the PTC's demands? At this writing, it is too early to know the full history of the Trump administration's record on broadcast indecency and other regulatory issues, but there are already some indicators of the directions that policy in this area could take and how they would compare to directions taken by previous administrations.

Throughout *The Indecent Screen*, I have explored efforts to regulate indecency on television in terms of the political agendas of various stakeholders. I have focused on a roughly twenty-year period since implementation of provisions of the Telecommunications Act of 1996, which were intended to put new tools for avoiding unwanted content into viewers' hands. These new technologies included a TV ratings system instituted in 1997, the V-chip in all TV sets manufactured in 2000 or later to allow viewers to block programs with specified ratings, and a requirement that cable systems block channels at subscribers' request. I chose to focus on this period—while providing historical background on decency regulation in prior decades—because it seemed ironic, even nonsensical, that after these tools were in place, complaints about televised indecency increased rather than decreased. During this period, certain media advocacy groups worked every bit as hard, or harder, than they had previously to clean up what they characterized as offensive television, and federal regulators, for the first time, began to take punitive actions against broadcasters who were found responsible for indecency.

At the same time, the medium of television itself was changing in ways that one might have expected to quell concerns about the occasional indecent incident on TV. New digital tiers and on-demand services added channel capacity to already abundant cable bundles. Video-streaming services emerged to compete with broadcasting and cable channels as sources of reruns and new programming. Never before had there been so many ways to access television programming, and never before had there been so much of it. Audiences scattered across new channels and new delivery systems, but that didn't mean that everyone simply ignored or turned away from programming they found distasteful. Instead, some heeded rallying cries to complain about programming that offended them or programming that might have offended them had they seen it, flooding the FCC with an unprecedented hundreds of thousands of complaints during the first decade of the twenty-first century.

For the PTC and other conservative media advocacy groups, the goals were to urge the television industry (not only broadcasters) to reduce the amount of objectionable material in programming, to protect children from sexual content and profanity, and to promote traditional family values. The PTC and like-minded organizations have at times enjoined supporters to file complaints with the FCC, campaigned (unsuccessfully) for "cable choice" in the form of à la carte channels, and fought (unsuccessfully) for a primetime family hour.

In contrast, broadcast-industry trade organizations and civil liberties advocates sought fewer, rather than stronger, restrictions on broadcast speech. Their perspectives rest on an understanding of the First Amendment as being strong and applicable to all media, broadcasting included. As critics of the policy, they argue that the logic of a once-sensible set of public interest obligations imposed on broadcasters in exchange for use of public airwaves no longer applies. Instead of a broadcast environment of spectrum *scarcity*, they argued, audiences now enjoyed a multitude of ways to access TV programming and an abundance of programming in a variety of media representing a diversity of viewpoints. They charged that special restrictions on broadcasting were antiquated and unnecessary. To this end, the American Civil Liberties Union and the National Association of Broadcasters, among others, have often been critical of indecency law and have supported challenges to the FCC's indecency policy. Those in the television industry, especially broadcasters, have fought hard against a policy they claim is vaguely articulated, excessively restrictive, and arbitrarily enforced—that is, too subjective, too intrusive, and too unfair to pass constitutional tests. Broadcast networks and stations have often appealed indecency fines on those rare occasions when the FCC has imposed them, taking many of these cases to federal courts, where the constitutionality of the indecency policy has been debated and, as recently as 2012, upheld.

Beyond decency watchdogs and TV's creative communities stand elected officials and political appointees, including leading regulators at the FCC. They have taken varied stances toward indecency at times, depending on an array of factors including the priorities of the administration that appoints the commissioners. For example, President Ronald Reagan was elected in 1980 in part through his appeal to social and economic conservatives; his appointed FCC Chair Mark S. Fowler oversaw deregulation in many areas. Fowler was also in command when, on April 16, 1987, two days before his term as chair ended, the commission finalized three memos declaring several radio broadcasts indecent even though they contained none of the seven words that had, since the *Pacifica* ruling in 1978, been considered necessary for a determination of indecency.[9] The move substantially broadened the working definition of indecency. (These memos, and a public notice clarifying the new policy direction, were not officially released until April 29, by which time Dennis R. Patrick, also a Reagan appointee, had taken over as chair.)

Subsequently, the commission under Alfred Sikes (appointed by George H. W. Bush and serving as chair from August 8, 1989, to January 19, 1993), Reed E. Hundt (appointed by Bill Clinton and serving November 29, 1993, to November 3, 1997), and William E. Kennard (also appointed by Clinton, serving November 3, 1997, to January 19, 2001), issued dozens of indecency fines against radio broadcasters. However, none of these FCC chairmen oversaw cases involving TV broadcasts that resulted in monetary forfeitures.

Those fines accumulated under both Republican and Democratic administrations, and new legislation intended to minimize the impact of indecent broadcasts and prevent them entirely has come from both Republican and Democratic lawmakers. It was during the Clinton administration, for example, that Congress passed the Telecommunications Act of 1996, complete with a set of measures to control access to potentially indecent content on both TV and the internet. Later, while George W. Bush was in office, the Broadcast Decency Enforcement Act of 2005 increased fines tenfold. Both bills passed with little resistance from either side of the congressional aisle. This is not to say that bipartisan stances on broad and vague policy goals, such as protecting children from indecent content, indicate uniform approaches to policy enforcement. The 1996 Clinton-Gore initiatives— including the V-chip, ratings system, and channel-blocking—empowered what some have called the self-regulating neoliberal subject to control his or her own vast media environment. In contrast, the greatly hiked fines that went into effect a decade later appeared to satisfy an impulse to punish more harshly than in the past and to signal to concerned constituents that violators would not get off with a slap on the wrist.

Twenty-first century presidential administrations have taken more sharply contrasting approaches to the issue. Under George W. Bush, the FCC took a relatively hard line against indecency, pursuing cases and issuing toughened policy guidelines. It was during Michael K. Powell's tenure (January 22, 2001, to March 17, 2005) as FCC chair for Bush's first term and part of the second that enforcement activity against indecent television amped up. The FCC collected its very first indecency fine from a television station in 2001 from Telemundo's WKAQ in San Juan, Puerto Rico, after complaints about sexual subject matter on the variety show *No Te Duermas*. The WKAQ fine, and another against KRON in San Francisco in 2004 for fleeting nudity during a newscast, set precedent for several much more highly publicized actions involving profanity and glimpses of nudity. Kevin J. Martin (FCC

chair from March 18, 2005, to January 20, 2009) carried on Powell's generally strict stance, at least until Powell's signature indecency-policy move—the so-called Golden Globes Order of 2004, which reversed decades of regulatory tolerance for unplanned incidents involving a single utterance—was struck down by a federal appeals court in 2010. Under Powell, the FCC issued three NALs against indecent TV broadcasts, totaling over $1.26 million, as well as nine NALs involving indecent radio broadcasts.[10] Under Martin, the FCC issued three NALs involving broadcast television (two in 2006, one in 2008) and demanded over $8 million, none involving radio: by the time his term commenced, the most controversial "shock jocks" had moved to less-regulated satellite radio channels.[11] Then, action on indecency cases stalled.

In contrast to the tough-on-indecency Bush era, the Obama administration took a more moderate approach, especially while challenges to the policy moved through the courts. In 2012, however, the Obama administration asked the Supreme Court to uphold the policy.[12] The high court agreed, in *FCC et al. v. Fox Television Stations et al.* (2012), that the FCC can constitutionally take measures against broadcast indecency—but it asserted that when the FCC did so in regard to Fox's broadcasts of the *Billboard Music Awards* in 2002 and 2003 and ABC's 2003 *NYPD Blue* episode "Nude Awakening," the commission "failed to give . . . fair notice" of what the policy disallowed at the time.[13] This decision vacated declarations of indecency and related fines levied on stations airing these programs, and it did so solely on the basis of due-process considerations. That is, drawing on the Fifth Amendment, which holds that no party may "be deprived of life, liberty, or property, without due process of law," the court ordered the commission to drop cases undertaken when the Golden Globes Order was in effect.[14]

The 2012 ruling freed the FCC to once again to take action against indecent broadcasts, as long as its actions were consistent with definitions of indecency and enforcement procedures readily available to regulated broadcasters. Obama's appointed FCC chair, Julius Genachowski (June 29, 2009, to November 4, 2013), took a pragmatic approach, asking the Enforcement Bureau to clear a backlog of complaints that had not been acted on and to take punitive action on only the most "egregious" cases.[15] No indecency fines resulted during Genachowski's term.[16] Tom Wheeler (November 4, 2013, to January 20, 2017) continued along the same lines when he led the commission through the end of the Obama administration. Wheeler was chair during only one broadcast television indecency case, resulting in

the unprecedented $325,000 fine issued in 2015 against a single station—WDBJ-TV in Roanoke, Virginia—which had unintentionally included a sexually explicit image in footage accompanying a story about a former adult entertainer who had joined the local volunteer emergency-response team. It might have been a record-setting forfeiture, but it was the only one issued since 2008.

Clearly the commission's stance had shifted in the seven-year gap between fines. It was a new era in indecency regulation, following the Supreme Court's 2012 ruling, one typified by relative restraint in the vast majority of cases, less responsiveness to the complaints of conservative media advocates, and little hesitation to act emphatically in a rare case like WDBJ's newscast. The prospect of acting only on the most "egregious cases" appeared to be a commonsense compromise, but it remains one that still requires acting in the narrow gap between the constitutional rock of First Amendment principles and the regulatory hard place of broadcasting's public-interest obligations. As this book draws to a close, I consider the status of indecency as a regulated category of broadcast speech after 2016. This conclusion also goes beyond broadcasting to explore some of the uses of political speech that *if* broadcast, could qualify as indecent—and their implications for the quality of our information environment.

If indecency policy and its enforcement are subject to ever-changing political winds, how would the next administration approach the matter? What would a Trump administration bring to the decency debates? How would the Trump administration approach telecommunications policy generally? Candidate Trump promised to reduce regulatory "burdens" on industry and, once in office, quickly made deregulation a priority.[17] Presumably that would include the media and communications industries. But he didn't say very much about telecommunications policy on the campaign trail. Would the next generation of leaders at the FCC tackle indecency as zealously as those appointed by fellow Republican George W. Bush, continue Obama-era restraint in this area, or break some new ground?

Indecency in 2017 and Beyond: A New Administration Begins

On the first day of the Trump administration, Tom Wheeler, the Democratic Obama appointee who had served as FCC chairman since late 2013,

resigned. Three days after assuming office, President Trump nominated Ajit Pai, a Republican commissioner since 2012, to a second five-year term, naming him chair.[18] In June 2017, Trump renominated Jessica Rosenworcel, a Democrat initially appointed by President Barack Obama, to the commission, incidentally fulfilling one of the PTC's wishes.[19] Soon after, he named Brendan Carr, already serving as the FCC's general counsel, to the fifth commission seat, filling out a Republican majority.[20] Pai's agenda would prominently include reversing the pro-"net neutrality" 2015 Open Internet Order, which had classified internet service providers (ISPs) as common carriers regulated as public utilities.[21] In short, the 2015 order prevented broadband providers from interfering with internet traffic by blocking or reducing access to content from competitors; in December 2017, the five FCC commissioners voted three to two to repeal it.[22]

Pai also promised to champion consumer-friendly causes such as combatting certain kinds of robocalls, expanding broadband access in rural areas, and supporting video-relay services that help hearing-impaired people make telephone calls.[23] It was clear that he would also undertake vigorous deregulatory initiatives and defend the autonomy of big corporations. For example, the FCC appeared to take a *laissez-faire* approach to a proposed merger between AT&T and Time Warner.[24] (The Department of Justice, however, seemed to take a more critical view and sought to impose conditions on the merger.[25]) A similarly huge deal, Comcast's acquisition of NBC Universal was subject to months of study and multiple congressional hearings before FCC approval in 2011.[26] Pai deferred on matters of internet privacy when Trump signed congressional legislation overturning an FCC policy requiring ISPs to obtain consumers' permission before "storing and selling browsing histories," saying this was a matter for the Federal Trade Commission, not his own agency.[27] The new media regulator-in-chief also shrugged off concerns about ever-increasing media consolidation in his support for reviving the "UHF discount," which eases the formula for calculating how station-owning chains approach ownership caps.[28] The new chairman's stance on each of these issues indicated that he would favor the wishes of big media businesses over media advocates, at least those on the center and left of the political spectrum. Free Press (cofounded in 2003 by media scholar Robert W. McChesney), the National Hispanic Media Coalition, the Institute for Public Representation at Georgetown University Law Center, and other groups opposed the return of the UHF discount; Free Press joined

Common Cause and Electronic Frontier Foundation, among others, in opposition to easing restrictions on ISPs.[29]

These indicators of a deregulatory mood at the FCC under Pai didn't offer many clues to how Trump-era commissioners would act on the PTC's indecency goals. In 2015, addressing the NAB, Pai praised "over-the-top [OTT] packages designed as alternatives to cable and satellite bundles," but didn't go so far as to embrace full-fledged à la carte.[30] But he didn't really have to. The proliferation of OTT services had, in some ways, diffused the à la carte movement, since they provide a similar benefit: paying only for the channels you want. While Pai may not have yet made many public statements about the TV ratings system, he did seem prepared to act as a rhetorical enforcer-in-chief of indecency rules, telling Fox Business News that "[A]s a parent I want to make sure that my kids have a wholesome experience when they are watching programs like that," referring to *Saturday Night Live* and the 2017 *Grammy Awards* broadcast, both of which had recently garnered complaints as sources of live "F-bombs."[31] (Never mind that the *SNL* incident occurred in the safe harbor after 10:00 P.M. and that CBS successfully bleeped Adele's Grammy utterance using tape-delay equipment, so that neither incident would qualify as indecent under current policy.)

The first indecency decision issued during Pai's chairmanship was largely pragmatic. It involved a case that was over a decade old. When the offending broadcast first hit the airwaves, George W. Bush was in his second term as president; then-chairman Michael K. Powell was in his final weeks at the FCC. The program that garnered complaint was *El Vacilón por la Mañana* on WSKQ-FM, a Spanish-language station in New York owned by the company Spanish Broadcasting System (SBS). Then hosted by Luis Jiménez, who has often been compared to Howard Stern, the show has a variety format, incorporating sketch comedy and chitchat with callers. The New York chapter of the National Hispanic Media Coalition (NHMC) had expressed concerns about the program, which it characterized as indecent and maybe even obscene, as early as the year 2000.[32] In 2006, the organization, working with the Catholic Community of St. Agnes in Paterson, New Jersey, filed a petition challenging the station's license, citing both a 2001 prank in which a performer on the show claimed that the Lincoln Tunnel was flooding (FCC regulations ban hoaxes that can endanger public safety) and several 2005 programs with potentially indecent content.[33]

It was an odd case, in some ways. It was unusual, to begin with, that the NHMC was taking action against a Latino-owned and operated station. One of the organization's primary goals, throughout its history, has been to combat underrepresentation and promote diversity both on camera and behind the scenes, but its targets have generally been major networks and specific incidents of hateful speech against people of Latino/Latina descent.[34] The coalition's efforts to jeopardize WSKQ's license underscored its commitment to fight stereotyping and derogation regardless of its source. The NHMC provided the FCC with English translations of the segments in question, but SBS contested their accuracy, arguing that the petitioners had exaggerated the vulgarity of certain terms, and provided the commission with their own translation.[35] Neither was released when the case was eventually decided. Typically, NALs contain lengthy quotations from the program under consideration, including sexual references and expletives, as evidence supporting the Enforcement Bureau's reasoning. The April 2017 consent decree resolving both the indecency case and the possible hoax contained no such transcript, just a few quotes from previous documents related to the case to show how differently the NHMC and WSKQ understood the contested material. While the complainants referred to a song performed on the program as descriptive of "perverse sexual relations," WSKQ's general manager responded that the song was only "racy."[36]

The FCC's order resolving the matter dismissed the claim of a hoax-rule violation as undersubstantiated. Turning to the indecency charge, the order reads, "Based on our review of the record, we find that the broadcasts are of a nature that *could* support a forfeiture proceeding against Licensee for violations of 18 U.S.C.§ 1464, but do not implicate Licensee's basic qualifications, demonstrate a failure to serve the public interest, convenience or necessity over the station's license term of 1998–2006, or constitute serious violations."[37] The order continued: "In order to resolve the matter without further expenditure of scarce resources, the Bureau and Licensee have negotiated" a fine of $10,000.[38] It was a compromising closure to a case that had dragged on for a dozen years, allowing all involved parties and their legal teams to move on. From one angle, the station got off with a slap on the wrist. SBS could rest assured that WSKQ's license was not at risk over these incidents. (It wasn't ever clear that they really should be worried. License revocation is very rare. As the order made clear, "we are not aware of any case, where a broadcast station faced the prospect of license revocation . . . based on comparable facts."[39]) Lacking precedent, the commission was

far from willing to break new ground in this case. Still, the petitioners (the NHMC and the church that collected signatures in support of action against WSQK) could regard the order as a limited victory, in that, finally, the segments in dispute were declared indecent. It seemed like every party to the case got at least a *little* something of what they wanted, and best of all, it was over.

If "scarce resources"—in terms of administrative and legal labor to keep the case open—helped draw the WSKQ case to a close, how would such conditions shape FCC priorities going forward? In May 2017, Chairman Pai submitted a proposed FCC budget for fiscal year 2018 (October 1, 2017, to September 30, 2018) that cut fulltime staff to 1,448, down from about 1,550 in 2016, which was also a reduction, from 1,639 in 2015.[40] (Cuts at the commission have been underway steadily for two decades. Early in the Clinton administration, FCC staffing was at a high of 2,112, not surprisingly, during the development and implementation of the Telecommunications Act of 1996, and has declined in every subsequent year.[41]) If a cut of about 11.5 percent in just two years seems steep, Pai's proposed budget hit staffing for the Enforcement Bureau (EB), which handles indecency and many other kinds of cases, even harder. Over the same period, EB staff was projected to drop over 20 percent, from 238 in 2016, to 204 in 2017, to 189 in 2018.[42] The Bureau is charged in the budget proposal with handling some 23 responsibilities, from "investigating and resolving complaints" involving not only indecency but also issues ranging from the visibility of radio towers to provisions of the Children's Television Act, "mediating and settling disputes between service providers," and "serving as trial staff," among other responsibilities.[43] The proposed budget cut was one of several reasons it wasn't entirely clear why the PTC and other groups like it might expect support from the new administration for some aspects of their mission. Another reason it seemed unlikely that a Trump-era FCC would prioritize broadcast indecency was the new president's own controversial—some might say colorfully forceful, others unpresidentially offensive—use of language.

Presidential Speech: Expletives to Delete or Not to Delete

In public settings, Trump hasn't been squeamish about using profanity and engaging in name-calling. He has repeatedly been recorded using expletives, including some of the seven words that George Carlin found you can't say

on broadcast airwaves, and other epithets. For example, in 2006, from the stage at a real-estate exposition in New York City, he called then-Secretary of State Condoleezza Rice a "bitch."[44] In 2011, while exploring a possible run for the 2012 Republican nomination, Trump spoke to a gathering of Republican women in Las Vegas, using seven expletives that had to be bleeped to be quoted by broadcasters, including this tip for how to negotiate a trade deal with China: "Look, you motherfuckers, we're gonna tax you 25 percent."[45]

Trump didn't leave this kind of language behind after he announced his candidacy for the Republican nomination in 2015. During primary stump speeches in Iowa and elsewhere, he promised to "bomb the shit" out of ISIS.[46] In Portsmouth, New Hampshire, talking about bringing factory jobs back to the state and referring to companies that have moved factories offshore, Trump said, "You can tell them to go [inaudible] themselves," obviously mouthing the word "fuck" but carefully not saying it aloud.[47] Challenged by then-Fox News channel anchor Bill O'Reilly about his use of profanity, Trump admitted leaving a blank spot in the sentence but denied using the F-word: "Even I, hey Bill, even I wouldn't do that. No. I never said the word."[48] (Readers might want to locate the video and decide for themselves.)[49] A *Deadline Hollywood* reporter reported that CBS and NBC News were both bleeping and pixelating Trump's expletives (given that they are governed by the FCC's policy on indecent speech) at the cost, the reporter editorialized, of "honest journalism."[50] *Deadline Hollywood* reporter David Robb was right. The televisual convention of bleeping expletives was a form of self-censorship that diluted coverage of the raucous campaign.

Some experts on profanity suggested that Trump's "swearing" might be strategic, forging a bond with working class voters who might swear often themselves, expressing disdain for behaviors they might see as elite niceties, and earning admiration for his pull-no-punches approach.[51] But early in 2016, in Baton Rouge, he vowed, "I won't use foul language. I just won't do it. I'll never do it again actually . . . ," perhaps out of concern that this kind of language might offend evangelical voters. A columnist for *The Blaze*, a conservative news website founded by Glenn Beck, formerly of Fox News Channel, called out the candidate for using mild curses ("crap" and "dammit") later in the same speech.[52] Soon after, during a Republican presidential primary debate, CNN anchor Wolf Blitzer asked Trump about former president of Mexico Vicente Fox's remark, first on Twitter and then on a

live (unbleeped) Fox Business News show, that Mexico "is not going to pay for that fucking wall." Trump replied indignantly, "That guy used a filthy, disgusting word on television, and he should be ashamed of himself and he should apologize."[53] Either the candidate had truly renounced his old vulgar ways and expected others to do the same, or his scolding of Fox was ironic, to say the least.

Those old vulgar ways would resurface just before the election. In October 2016, *The Washington Post* released a tape that captured Trump bantering in 2005 with *Access Hollywood* host Billy Bush. During the conversation, most of which was not released at the time, Trump described his unsuccessful pursuit of a married woman ("I did try and fuck her") and his method of making sexual advances toward women he finds attractive: "Grab 'em by the pussy." (Less reported was that, during the same conversation, he addressed a man using the same vulgarity: "Look at you, you are a pussy.")[54] This time Trump had to respond, and released a video that contained an apology—as well as accusations that former president Bill Clinton was guilty of sexual misconduct more serious than his own crude chatter, and that his opponent in the presidential race, former senator and secretary of state Hillary Clinton, was partially responsible for the abuse of Clinton's victims.[55] Again, the networks' news divisions had to make difficult choices about how to cover this incident. Even CNN, a cable channel not subject to broadcast indecency law, bleeped some of Trump's utterances. "[Pussy] is a word we can't say on morning television," a CNN anchor noted.[56]

The incident didn't seem to hurt Trump's campaign. While some of his supporters representing the traditionalist Christian Right may have been uncomfortable with Trump's profane and vulgar outbursts, he had pledged in Baton Rouge to clean up his language; besides, these were past offenses, and forgiveness is a pillar of the evangelical belief system. Others didn't seem to mind. In fact, some supporters made expletives and slurs part of their *pro-*Trump rhetoric. For example, CNN commentator Sally Cohn tweeted a crowd photograph she took at a Trump rally in Pennsylvania, showing a man wearing a white T-shirt that said, in blue and red lettering, "She's a cunt, vote for Trump."[57] It wasn't an isolated incident. The *New York Times* website released a video compiling footage from in- and outside Trump's rallies, as a primer in the coarseness of political discourse at these events. The video clips, which begin with a warning—"This video includes vulgarities and racial and ethnic slurs"—show supporters wearing T-shirts emblazoned with

the words "Fuck Islam" and "Trump That Bitch"; others chant "Fuck political correctness!" and yell "Fuck that n————" when Trump mentions President Barack Obama.[58] This material could not have been shown on broadcast channels without extensive bleeping and blurring—and it is plainly repugnant.

Did broadcasters' obligation to avoid indecent language lead them to excise disturbing racist, sexist, and Islamophobic attacks by those in attendance at some of these rallies from their coverage of these events? If the broadcast networks avoided some of the most offensive material coming out of the campaign or peppered the footage they did show with bleeps and blurs, what impact might these decisions have on how viewers understood the campaign? There are no simple answers to these questions.

Print and web-based news sources often covered the incidents either without bleeping or with minimal alteration. For example, *Huffington Post* substituted "S**t" in a headline, and Time.com masked some expletives even more lightly, as "sh-t" and "mother-ckers" in the body of an article.[59] Clearly the indecency policy constrained the news environment, leading broadcasters to fully cover only those news events that lacked potentially offensive utterances. Such restrictions resulted in incomplete coverage of one of the most hotly contested political campaigns of our time. It also focused many reporters' attention on this very issue—profanity, indecent language, name-calling, offensive expletives in political speech—to the detriment of coverage of policies and plans. A self-censored newscast falls far short of what is made possible by the First Amendment's guarantee of a free press. It is not only indecency-regulated broadcasters who face editorial decisions about how to treat expletives and vulgarities in news contexts; cable news and newspapers, in both their print and digital editions, do too. In their desire to keep audiences on their screens or pages, and to keep them from turning to other news sources to fill in blanks, they must also weigh newsworthiness against the potential risks of offending viewers or readers.[60]

This is not to say that no other sitting president, candidate for public office, or legislator has cursed in front of a microphone, whether they mistakenly thought it was turned off or were aware that it was live. During the 1973–1974 investigation of the Watergate scandal that eventually resulted in President Richard Nixon's impeachment and resignation, subpoenaed audio recordings of White House conversations that Nixon had collected revealed that the president and his close associates regularly used mild and not-so-mild profanities; released transcripts of the tapes famously substi-

tuted the phrase "expletive deleted."[61] In 2004, Vice President Dick Cheney made headlines when he told Senator Patrick Leahy (D-VT) to "go fuck yourself" during a heated one-on-one conversation on the Senate floor.[62] Still, Trump's use of expletives and vulgarities is a singular case in terms of its frequency, intentionality, and publicness. And it seems to have loosened the lips of others on prominent political stages—and drawn media attention to the use of profanity by politicians.

Both Fox News and CNN reported that after Trump's election, Democrats also seemed to increase their own usage of profanity during public appearances: "This is a shitty budget," Democratic National Committee Chairman Tom Perez told an audience in Las Vegas; Senator Kirsten Gillibrand (D-NY), in a speech at New York University, used several expletives.[63] At the end of a 2017 profile of Senator Kamala Harris (D-CA), a *New York Times* reporter quotes the former prosecutor as she assails the Republican healthcare bill at a gathering in San Francisco, delicately alluding to a profanity she used:

> "I was told one should not say"—here she let fly the longest of George Carlin's "Seven Words You Can Never Say on Television"—"in these kinds of interviews," she said coyly. "So I'm not going to say it."
> In private as well, this four-syllable noun is said to be a favorite.[64]

Clearly, Harris used the same compound word that Trump aimed at global trade partners in Las Vegas in 2011.

In an editorial, the *New York Post* declared that "Trump's language crystallized popular rage at Washington politics," but ridiculed the same words in the mouths of Democrats as "gratuitous and phony."[65] Clearly, in the eyes and ears of the *Post* editorial writer, context matters, and that context includes the status and gender of the speaker, the setting, and other factors. As such, strong, even taboo, language that earns accolades in one context (whether that context is a populist presidential campaign or a premium-cable drama) is easily berated in other contexts (a speaker with whom one disagrees or a live broadcast that may be watched by children). As I showed in chapter 3, the "right to cuss" is far from evenly distributed.[66] It should be clear by now that whether controversial utterances, including but not limited to profanity or indecent speech, are lauded or assailed tells us less about their meaning and more about the political agendas of those who seek to suppress transgressive speech—whether the transgressive speaker

is an exuberant rule-flaunting celebrity, a source of frank and nonpuritanical representations of the body and sexual desire, or in another context, a professional athlete protesting social injustice.[67]

Decency Makes Strange Bedfellows: A Final Case in Point

The first indecency incident of much note to take place during Pai's term at the FCC amounted to some sound and fury, unleashing several brands of outrage and spilling a fair amount of proverbial ink. In some ways, the incident typified the kind of partisan head-butting that characterized all political discourse with some new twists. Both Trump supporters and some detractors took issue when *Late Show* host Stephen Colbert made a joke involving sexual references about the president and Russian President Vladimir Putin on May 1, 2017. Colbert's monologue was intended to respond to Trump walking out of an interview on CBS's venerable news program *Face the Nation* (1954–) after telling host John Dickerson that he finds the show "fake news" and calls it "De-Face the Nation." Colbert addressed the president directly: "You're a presi-dunce . . . a real prick-tator. . . . In fact, the only thing your mouth is good for is being Vladimir Putin's cock holster." (Some outlets reporting on the broadcast lightly masked the word that seemed to offend the most as c—k or c-ck; *Entertainment Weekly*'s website didn't transcribe that part of the monologue but included a bleeped video.)[68] The live studio audience seemed to gasp *and* laugh, whistle and cheer (and maybe even jeer), all at the same time.

The gist of the joke was not exactly new. Mainstream media outlets had previously published op-eds calling Trump Putin's "lap dog."[69] That same mild epithet—or the even milder euphemism "poodle"—had also been used to describe Tony Blair's perceived obedience to George W. Bush in supporting the 2003 invasion of Iraq.[70] If "lap dog," like "cock holster," pointed to crotch level, the canine metaphors also called up the image of a cuddly companion animal. Colbert's epithet, not so much. Instead, it was a vivid, masculinist evocation of on-your-knees oral sex, likening a penis to a pistol (why else would it need a holster?), and putting Trump in the position of an eager-to-please fellater serving a dominating Putin. Was the joke original? Not entirely. The erotics of a "bromance" between the two men had been fodder for an international array of visual artists and political cartoonists who had created images of Trump and Putin kissing and spooning.[71] Was

Colbert's line funny? Well, humor is subjective, so there's no one-size-fits-all, right or wrong answer to that question. If you don't find the ribald out of bounds, why not? When I heard the line, I chortled.

Not everyone was amused. The FCC received over 5,700 complaints about the broadcast.[72] While most complaints about indecency and profanity come from socially conservative individuals and are spurred by organizations affiliated, closely or loosely, with conservative Christianity, in this case they represented a political spectrum. Some complained about the sexual explicitness of the line. But a significant portion of complaints protested what they heard as anti-gay material. In a sample of 100 of the complaints drawn, about three-fifths referred specifically to what they perceived as homophobia in Colbert's monologue:[73]

> By using accusations of being gay as an insult, [the joke] implied that there is something wrong with being gay.
> —Urbana, Illinois

> I thought we left this kind of bigotry in the wastebin of history.
> —New York City[74]

> Many of my friends are gay and feel targeted, and I feel that this kind of vulgarity is beneath the dignity of American broadcasting.
> —Minneapolis, Minnesota

> The late show host Stephen Colbert has decided its [sic] a good time to practice rampant homophobia.
> —Fort Meade, Maryland

> I demand something be done to correct Steven Colbert's violent homophobic remarks that have no place in today's society.
> —Salt Lake City, Utah[75]

Colbert's *bona fides* as a left-leaning political satirist, first on *The Daily Show*, later on his own *The Colbert Report* (in which he played the role of a bombastic *right*-wing anchor), and finally as host of *The Late Show*, had previously been unquestioned. His 2015 attacks on opponents of marriage equality, for example, were both humorous (to this writer's funny bone, anyway) and incisively critical.[76] But two days after the controversial

monologue, Colbert apologized, admitting that if he had it to do over again, "I would change a few words that were cruder than they needed to be," but also chiding audiences to keep the role of the comic in perspective: "I have jokes; he has the [nuclear] launch codes. So, it's a fair fight."[77]

Asked about the incident during interviews on a Philadelphia radio station and the Fox Business Network, FCC Chairman Ajit Pai appeared to take a tough stance, declaring "we are going to take the facts that we find and we are going to apply the law as it's been set out by the Supreme Court and the other courts and we'll take the appropriate action."[78] Pai's comments only seemed to inflame the issue. Other media outlets announced that the FCC was "reviewing" or "investigating" Colbert, and some Trump critics warned on social media of regulatory overreach, even "censorship."[79]

In just over three weeks, the FCC's Enforcement Bureau put the incident behind all parties by closing the case. As required by the law, the EB considered the complaints but found them lacking in grounds to pursue indecency or obscenity charges against CBS stations. It was a clear case of safe-harbor immunity: *The Late Show* airs after 11:30 P.M. And since the show is taped in the afternoon and broadcast late at night, there was plenty of time to bleep and blur Colbert. The utterance may have offended some viewers, but it also, as in so many previous cases amplified by media attention, reached far more people than did the original broadcast, through postings of the segment on news sites and YouTube, which then circulated through social media, being subsequently debated, championed, and excoriated by thousands who had not seen *The Late Show* in the first place.

Reactions on all sides seemed to indicate that "decency"—or affronts to our variable standards of it—remains a hot-button issue. In the end, all the incident amounted to was a clever, if crass, insult hurled by a satirist toward a sitting president whose own sharp tongue and impulsive tweets were well known; a chance for a newly prominent head of a federal regulatory agency to posture in a manner likely to please conservative media watchdog groups; and expressions of outrage from several quarters about the possibility of derisive gay-baiting, fears of a coming crackdown, and plain old vulgarity. Traditionally, the so-called culture wars, which include the media decency debates, have seemed to be us-versus-them" battles between the irreconcilable left and right wings. In the Colbert case, the decency debates triangulated between a segment of the audience offended by what appeared to be a casually homophobic punchline, a sector opposing vulgarity of any kind

(and some of them, particularly when it was directed against Trump), and a broad spectrum of individuals and organizations that spoke out in Colbert's defense. That broad spectrum included, not surprisingly, a staff attorney for the ACLU who blogged that "the FCC has no business policing what people say on television," and leaders of the Writers Guild of America, the union representing film and TV screenwriters, who decried "any attempt by the government to stifle dissent and creativity."[80] Perhaps surprisingly, Colbert's defenders also included former governor (and former Fox News channel host) Mike Huckabee (R-AR), a Trump supporter and advocate of government deregulation. "Don't let gov't decide when speech is ok," Huckabee tweeted.[81] Strange bedfellows? Indeed.

This was not the first time that the issue of indecency had brought together political nemeses. Recall that in 2006, seven former FCC officials, both Democrats and Republicans, called for dismantlement of the indecency policy altogether.[82] More often, opposition to indecency in broadcasting has found rare political consensus, bringing together Democrats and Republicans to uphold "family values," however vaguely or narrowly construed, and to oppose "indecency." On how many other issues could we expect to see then-senators Hillary Clinton (D-NY), Rick Santorum (R-PA), and Sam Brownback (R-KS) share a stage, as they did in 2000 to denounce indecent media?[83] More strange bedfellows? Maybe. Or maybe simply another sign of the remarkable valence of the terms "decency" and "indecency." These terms are regularly deployed by politicians to curry favor with constituents. Clinton may have been doing as much, after her husband's second presidential term was racked by a sex scandal; Trump surely did so when he swore off swearing at a campaign stop in Baton Rouge. And terms like "indecency" and "decency," as well as "obscenity," "profanity," and others, are wielded to suppress speech that one dislikes despite the rights of others to speak. That was the case in the 1990s when the PTC tried to revive the Family Viewing Hour to reverse the increasing visibility of gay characters in primetime. It was also the case when, in 2005, Secretary of Education Margaret Spellings attacked an episode of the PBS children's program *Postcards from Buster*, all because a lesbian couple and their children were among families featured in the episode.

In the case of that *Buster* episode, a government official took on the role of family-values advocate, defining representable families as exclusively heterosexual and declaring other families unworthy of representation. In other

cases, we've seen decency advocates make much ado about incidents involving, among other things, banal partial nudity (in *NYPD Blue*'s "Nude Awakening"), a cautionary tale about teenage sexuality (*Without a Trace*'s "Our Sons and Daughters"), and a few broadcast words that can be heard with greater frequency in many schoolyards. We've seen calls for new ways to avoid unwanted content (such as the ratings system and V-chip of the Telecommunications Act of 1996, or family tiers); stricter policies (such as the short-lived Golden Globes Order of 2004, or attempts to apply broadcast-like indecency rules to cable TV, public access channels, or the internet); stricter penalties (such as the increased fines of the Broadcast Decency Act of 2005); and ever-increasing plentitude in programming (thanks in part to digital channels, on demand, and streaming services) that seems to provide no shortage of options for viewers seeking alternatives to programs they find offensive. None of these initiatives have brought those embroiled in decency debates to any kind of resolving truce; neither remaking television as an all decent screen, all the time, nor persuading regular complainants to desist from protesting the viewing preferences of others.

In fact, the vigor of early twentieth-century attacks by decency advocates on television in general and broadcast TV in particular led to a backlash that only made indecent language, much of it bleeped but undoubtable, ever more commonplace. The Fox network's *Family Guy* episode "PTV" (2005), with which I opened this volume, was only one of many examples—if one of the most explicit critiques and most lavishly bleeped—of the faddishness of scripted bleeps intended to tweak the noses of federal regulators and watchdog groups alike. From *Family Guy* to *Modern Family* to *Downward Dog* and more, scripted bleeps were played for laughs, perhaps so often that overuse diluted their power, turning barbed transgression into just another one of television's relentless banalities.

It may pass policy muster to pepper primetime scripts with bleeps that barely mask obvious expletives, but is it a victory in the battle for free-speech airwaves? It might pay, at this juncture, to compare a case involving speech in non-broadcast contexts. Simon Tam (also known as Simon Young), a member of the Oregon-based pop-rock band The Slants, challenged the U.S. Patent and Trademark Office's (PTO) refusal to trademark the group's name on grounds that it violated the disparagement clause of the Lanham Act, the legislation establishing the terms of trademark law in 1946. This clause authorizes the PTO to refuse or cancel trademarks that "disparage . . . persons, living or dead, institutions, beliefs, or national symbols, or bring them into

contempt or disrepute."[84] Where the PTO saw "The Slants" as being derog-
atory toward Asians and Asian-Americans, the band saw it as representing
self-empowering reclamation.[85] The eight sitting justices (recently con-
firmed Neil Gorsuch did not hear the case and therefore did not vote)
ruled unanimously in Tam's favor. Concurring opinions by justices Anthony
Kennedy and Samuel Alito sought to assure that the decision would pro-
tect all kinds of speech by not allowing complainants—or the PTO's
preemptive concerns about disparagement—to restrain speech simply
because that speech is disliked by some. Kennedy was specific: "A law that
can be directed against speech found offensive to some portion of the pub-
lic can be turned against minority and dissenting views."[86] Soon after the
decision was reached, a group of Native Americans who had successfully
petitioned the PTO to cancel the Washington Redskins' trademarks under
the disparagement clause dropped their case; the Redskins got their trade-
marks back.[87] Ray Halbritter, founder of the group Change the Mascot,
observed: "What's right is not always a legal question."[88]

He was right, of course. Just because it may be legal to use a racist slur as
the name of a professional sports team doesn't make it necessary, or, to para-
phrase an old saw, just because you can say something doesn't mean that
you should.[89] Just because the FCC doesn't have a mechanism to punish sta-
tions or networks that air programming in which gratuitous expletives are
bleeped and blurred doesn't make most of those expletives meaningful as
anything but juvenile claims of the right to offend.

FCC Chair Julius Genachowski's policy of pursuing only the most "egre-
gious" indecency cases, put in place in 2013, was surely a step in the right
direction. In some ways, it set the commission on a course of "restrained
enforcement" reminiscent of the 1978–1987 period following the landmark
Pacifica decision that contained enforcement action related to incidents
involving one or more of a list of seven words; though considered specific
words, their use had to be repeated, intentional, and prolonged to trigger
punitive action.[90] Even so, a return to *Pacifica*-era rules should be out of the
question. After all, a specific list of banned words should raise—and should
have raised then—First Amendment concerns of some magnitude. As Ruth
Bader Ginsburg argued in a statement appended to the Supreme Court's
decision in *FCC v. Fox et al.* (2012), that iteration of indecency policy was
problematic, if not flat out "wrong" in a legal sense; "time, technological
advances, and the Commission's untenable rulings" bring us to a moment
with no greater clarity.[91]

In the end, stakeholders in the decency debates would themselves act decently to abandon censorious tactics cloaked in defense of family values. We could do far worse than to recognize that television, for all of its flaws, all of its inadequacies, also takes steps in the right direction in its current, abundant forms. Never have audiences had access to so much programming, on so many platforms: there is something to please if not *every* viewer and their families, regardless of those families' composition, then at least many of them. And if not? There is always the off button and other media to choose from. We would do well to insist that these platforms are widely available, reasonably accessible, and consistent in service. We would do well to seek out programming that is meaningfully diverse in its characters and casting, stories and sources, viewpoints and values. We would serve ourselves to demand programming that is informative rather than censorious or propagandistically biased, even when facts are uncomfortable. In a media environment that unfettered, honest, and responsible, we can embrace the occasional indecent screen.

Acknowledgments

I began the project that became *The Indecent Screen* over a decade ago. It would be fair to say that it started because of a sudden wave of déjà vu. In the middle of the first decade of the twentieth century, conservative media advocates were campaigning against indecency on broadcast television, the Federal Communications Commission was receiving record-setting numbers of complaints about the odd expletive and occasional glimpse of the partially nude human body, and politicians were posturing about new initiatives to punish broadcasters for airing indecent material. This flurry of activity in the name of decency reminded me of nothing less than the volatile "culture wars" of previous decades. In the 1980s and 1990s, members of Congress, Cincinnati law enforcement, and a New York City mayor, among others, went after art they didn't like and the institutions that showed it. Complaints to the Federal Communications Commission about "shock jocks" increasingly resulted in fines levied on radio stations. And television, the quintessential domestic medium, was demonized as a threat to the nation's children, families, and homes. Interestingly, as the twentieth century drew to a close and the twenty-first century dawned, rancor directed at television only intensified, while campaigns against some of these other media settled down. Why pick on television, and why at that moment? And what did it all mean, these seemingly endless waves of attacks on these extremely popular sources of entertainment?

I began to watch as media advocates—both conservative watchdogs concerned about preserving so-called traditional family values and liberal

proponents of unfettered free speech—sparred over the appropriate limits of media regulation. I saw federal regulators enforce standing policies that were previously little used and develop new policy measures, only to have all of those policies, both new and old, challenged by broadcasters in the federal courts. Cultural conflicts that play out in corporate offices and courtrooms don't always unfold quickly. Neither did this project. It was, in many ways, fascinating to watch my subject develop over time, in fits and starts, in an instance of media history in the making.

Meanwhile, I began working through pieces of this history in conference papers and lectures. The first lecture took place in 2006 in the City University of New York's Graduate Center, where I was invited to participate in the Film Studies Certificate Program's lecture series. Not long before completing the manuscript, I gave another lecture on indecency regulation at the Annenberg School of Communication at the University of Southern California. Many thanks to Heather Hendershot and Sarah Banet-Weiser for making those calls. In the interim, I tried out new material at several Society for Cinema & Media Studies conferences and at the Dirty Sexy Policy Conference sponsored by the Media Industries Project and the Carsey-Wolf Center at the University of California, Santa Barbara. Fellow panelists and audience members alike offered valuable feedback. Thanks especially to Jason Middleton, John McMurria, Allison Perlman, Nicholas Sammond, and Thomas Streeter for their comments and questions along the way. Once these pieces became a manuscript, I am happy to say that editor Lisa Banning at Rutgers University Press embraced the project and ushered it through pre-publication processes with efficiency and confidence. Likewise, Daryl Brower shepherded *The Indecent Screen* through production smoothly. Many thanks to the entire staff of the press for their dedication to bringing projects like this one to light.

The Department of Media Culture at the College of Staten Island, City University of New York, proved once again to be a robust academic home for this project in ways large and small. Thanks to my colleagues Jillian Báez, Racquel Gates, Michael Mandiberg, Tara Mateik, Edward D. Miller, Sherry Millner, Reece Peck, Jason Simon, Valerie Tevere, Cindy Hing-Yuk Wong, Bilge Yesil, Ying Zhu, and especially David A. Gerstner, chair of the department when I finished this project. Likewise, current and former departmental staff members Emmanuel Grant, Mitchell Lovell, Janet Manfredonia, Rosemary Neuner-Fabiano, and Marilee Trulby provided appreciated technical and administrative support, as did Nicholas Biagini, as an undergraduate

research assistant. I benefited from research awards sponsored by our invaluable union, the Professional Staff Congress, and the City University of New York, known as the PSC CUNY Awards, and from CUNY's new Book Completion Award, in 2017. Thanks to that award, I was able to engage developmental editor Carolyn Bond; her gimlet eye and expert coaching taught me a tremendous amount about my writing and about writing in general. Thanks, too, to Brian Ostrander and Deborah Masi of Westchester Publishing Services, John Barnett of 4 Eyes Design, and indexer Rachel Lyon, for their help in the final stages of turning the manuscript into a book. I am also grateful to CSI Dean of Humanities and Social Sciences Nan Sussman (2012–2017), Interim Dean Gerry Milligan (2017–2018), and Provost Gary Reichard, who inspired this stage of my career with their support.

Friends and colleagues outside CUNY helped form other intellectual homes in which this project received critical boosts. A book-writing group that included Paula Chakravartty, Maggie Gray, Jinee Lokaneeta, Natasha Iskander, Christina Dunbar-Hester, C. W. Anderson, and Leonard Feldman did wonders to help me shape research into a book. Karen Cerulo, Jonathan Gray, Jennifer Holt, and Victoria Johnson offered honest assessments of this project that propelled its final stages; I value their collegiality immeasurably. Aisha Baiocchi initiated a conversation about television with me that was revelatory. Friends who offered inexhaustible encouragement—among them, Sarah Banet-Weiser, Matt Brim, Paula Chakravartty, David A. Gerstner, Ellen Seiter, Liz Snyder, and Polly Thistlethwaite—are the most decent (and occasionally indecent) bunch of friends one could hope for. Finally, I extend my gratitude to Arlene Stein: you are my home.

Notes

Introduction

1 Actually, the episode begins with a long sequence in which Peter Griffin's son Stewie, a toddler still in diapers, assassinates Osama Bin Laden. Stewie then takes his tricycle on a joyride that includes references to *Naked Gun*, *Doom*, *The Shining*, *The Wizard of Oz*, *The Sound of Music*, the *Star Wars* franchise, and *The Simpsons*, among other media texts. But the segment is unrelated to the rest of the episode, which begins, for all practical purposes, after the opening titles.

2 Even after the opening segment, the episode remains richly intertextual, thanks to cameos from Apache Chief (who first appeared on Hanna-Barbera's *Super Friends* series in 1978) and Cobra Commander (part of the *G.I. Joe: A Real American Hero* franchise ever since 1982, when the character was introduced in the Hasbro toy line and in Marvel Comics, and part of the syndicated cartoon and movie of the same name [1985–1987; 1989–1991]).

3 FCC, Enforcement Bureau, Regulation of Obscenity, Indecency and Profanity, http://transition.fcc.gov/eb/oip/. Policy statement posted July 17, 2012; accessed December 2, 2013.

4 On global media flows, see Arjun Appadurai, "Disjuncture and Difference in the Global Cultural Economy," *Theory, Culture & Society* 7 (1990): 295–310. For discussions of the imposition of U.S. speech norms elsewhere, see Paula Chakravartty, "Governance Without Politics: Civil Society, Development and the Postcolonial State," *International Journal of Communication* 1 (2007): 297–317, esp. 302. On free speech as a "rallying cry" for hegemonic politics and against dissent, see Mahmood Mamdani, "The Politics of Culture Talk in the Contemporary War on Terror," Hobhouse Memorial Public Lecture, Department of Sociology, London School of Economics (March 8, 2017), accessed September 23, 2017, http://www.lse.ac.uk/sociology/pdf/MamdanilectureMarch82007.pdf. On national sovereignty and censorship, see William Mazzarella, *Censorium: Cinema and the Open Edge of Mass Publicity* (Durham, NC: Duke University Press, 2013).

5　See Imani Perry, "Do You Really Love New York: Exposing the Troubling Relationship Between Popular Racial Imagery and Social Policy in the 21st Century," *Berkeley Journal of African-American Law & Policy* 10 (2008): 92–108.

6　Kimberlé Crenshaw, "Mapping the Margins: Intersectionality, Identity Politics, and Violence Against Women of Color," *Stanford Law Review* 43, no. 6 (1991): 1244.

7　For a cogent overview, see Allison Perlman, *Public Interests: Media Advocacy and Struggles Over U.S. Television* (New Brunswick, NJ: Rutgers University Press, 2016).

8　Megan Mullen, "The Moms 'n' Pops of CATV," in Sarah Banet-Weiser, Cynthia Chris, and Anthony Freitas, eds., *Cable Visions: Television Beyond Broadcasting* (New York: New York University Press, 2007), 27–43; Megan Mullen, *The Rise of Cable Programming in the United States: Revolution or Evolution?* (Austin: University of Texas Press, 2003).

9　*Pacifica v. FCC*, 438 U.S. 726, 748–49 (1978).

10　*Red Lion Broadcasting, Inc. v. FCC*, 385 U.S. 367 (1969).

11　William O. Douglas, writing in *United States v. Rumley*, 345 U.S. 41 (1953), which overturned the conviction of a bookseller who refused to turn over the names of his buyers during an investigation of suspected improper financial actions. An important precedent is the notion of "free trade in ideas," attributed to Oliver Wendell Holmes in his dissent appended to the decision in *Abrams v. United States*, 250 U.S. 616 (1919), which upheld the Sedition Act of 1917, which criminalized certain forms of criticism of U.S. involvement in World War I.

12　*Quincy Cable TV, Inc. v. FCC*, 768 F.2d 1434 (D.C. Cir. 1985). See also *Turner Broadcasting System Inc. v. FCC*, 512 U.S. 622 (1994); *Turner Broadcasting System Inc. v. FCC*, 52 U.S. 180 (1997), ultimately reaffirmed cable's First Amendment rights and the FCC's "must carry" rules.

13　*Community Television of Utah, Inc. v. Wilkinson*, 611 F. Supp. 1099 (D.C. Utah 1985), §ID2a.

14　Further, when Congress passed the Cable Communications Policy Act of 1984, it specified that only a "local franchising authority" (such as a city or county) could take action against a cable provider airing obscene or indecent programming. This provision also pre-empted Utah's attempt to allow the state to take action against certain kinds of programming. See Ken Levine, "Constitutional Law: Utah's Cable Decency Act: An Indecent Act," *Loyola of Los Angeles Entertainment Law Review* 7 (1987), accessed July 14, 2017, http://digitalcommons.lmu.edu/elr /vol17/iss2/9.

15　FCC fact sheet, "Obscene, Indecent and Profane Broadcasts," last updated October 25, 2016, accessed September 2, 2017, https://www.fcc.gov/consumers /guides/obscene-indecent-and-profane-broadcasts.

16　See *Nico Jacobellis v. Ohio*, 378 U.S. 184 (1964).

17　See *Miller v. California*, 413 U.S. 15 (1973), §II. The definition of obscenity in the FCC fact sheet "Obscene, Indecent and Profane Broadcasts" paraphrases *Miller*.

18　See Linda Williams, *Hard Core: Power, Pleasure, and the "Frenzy of the Visible"* (Berkeley, CA: University of California Press, 1989); Jon Lewis, *Hollywood v. Hard Core: How the Struggle Over Censorship Saved the Modern Film Industry* (New York: New York University Press, 2002); Linda Williams, ed., *Porn Studies* (Durham, NC: Duke University Press, 2004).

19 FCC fact sheet, "Obscene, Indecent and Profane Broadcasts."
20 Ibid.
21 Ibid.
22 See Melissa Mohr, *Holy Shit: A Brief History of Swearing* (New York: Oxford University Press, 2013), 10–12.
23 In 2007, in the decision that overturned the FCC's 2004 Golden Globes Order, the U.S. Court of Appeals for the Second Circuit admonished the commission for reversing its longstanding policy of not regulating "profane speech" without providing justification for the change in policy. In previous documents issued in 1976 and 1999, the FCC had argued that profane language that is not obscene or indecent is "fully protected by the First Amendment"; cited in *Fox et al. v. FCC*, 489 F.3d 444 (2d Cir. 2007), §II.
24 The medium of radio has changed, too. In the early 1990s, terrestrial radio broadcasters began simulcasting their programming via the internet, and in the United States, satellite radio took off after the launches of Sirius Satellite Radio and XM Satellite Radio in 2001 and 2002 respectively. (Sirius and XM merged in 2008.) As a subscription-based service, like cable television, satellite radio is not subject to the FCC's indecency policy for broadcast radio and TV.
25 Claude Chastegner, "The Parents' Music Resource Center: From Information to Censorship," *Popular Music* 18, no. 2 (May 1999): 179–192.
26 On the 1991 [Jesse] Helms Amendment that cut NEA funding, see Steven C. Dubin, *Arresting Images: Impolitic Art and Uncivil Actions* (New York: Routledge, 1992), 179–181, 242–244, 263–264.
27 On the role the ESRB plays in the videogame industry, see Judd Ethan Ruggill and Ken S. McAllister, "Invention, Authorship, and Massively Collaborative Media," in Cynthia Chris and David A. Gerstner, eds., *Media Authorship* (New York: Routledge, 2013), 138, 143–144.
28 See Electronic Frontier Foundation, "History of NSA Spying: Timeline" [through 2015], accessed July 25, 2017, https://www.eff.org/nsa-spying/timeline; Mark Andrejevic, "Big Data, Big Questions: The Big Data Divide," *International Journal of Communication* 8 (2014), accessed July 25, 2017, http://ijoc.org/index.php/ijoc/article/view/2161; Kimberly Kindy, "How Congress Dismantled Federal Internet Privacy Rules," *Washington Post*, May 30, 2017.
29 For an array of views on these issues, see Jack Halberstam, "You Are Triggering Me! The Neo-Liberal Rhetoric of Harm, Danger and Trauma," BullyBloggers, July 5, 2014, accessed July 25, 2017, https://bullybloggers.wordpress.com/2014/07/05/you-are-triggering-me-the-neo-liberal-rhetoric-of-harm-danger-and-trauma/; Aaron R. Hanlon, "The Myth of the 'Marketplace of Ideas' on Campus," *New Republic*, March 6, 2017; Catherine Rampell, "A Chilling Study Shows How Hostile College Students Are Toward Free Speech," *Washington Post*, September 18, 2017.
30 Although U.S. courts have found hate speech constitutional—that is, speech that derogates, expresses hatred, or threatens discrimination against a targetable, identifiable group whose members share qualities such as race, skin color, ethnicity, religion, disability, gender, sexual orientation, or national origin—many nations do have laws banning hate speech: Canada, Denmark, Germany, the Netherlands, New Zealand, Norway, Poland, and South Africa, among others. Some outlaw specific forms of hate speech; for example, France has banned Holocaust denial since 1990;

Belgium, since 1995. See Adam Liptak, "Hate Speech or Free Speech? What Much of West Bans Is Protected in U.S.," *New York Times*, June 11, 2008; Suzanne Nossel, "The Problem with Making Hate Speech Illegal," *Foreign Policy*, August 14, 2017, accessed August 22, 2017, http://foreignpolicy.com/2017/08/14/the-problem-with -making-hate-speech-illegal-trump-charlottesville-virginia-nazi-white-nationalist -supremacist/. At this writing, the European Union is considering proposals that would require social media companies to remove posts that constitute hate speech, especially videos; see Julia Fioretti, "EU States Approve Plans to Make Social Media Firms Tackle Hate Speech," Reuters.com, May 23, 2017, accessed August 22, 2017, http://www.reuters.com/article/us-eu-hatespeech-socialmedia -idUSKBN18J25C. According to some analysts, laws purported to prevent expressions of hatred are sometimes used to suppress forms of dissent; see Wafa Ben Hassine, "The Crime of Speech: How Arab Governments Use the Law to Silence Expression Online," Electronic Frontier Foundation, accessed August 22, 2017, https://www.eff.org/pages/crime-speech-how-arab-governments-use-law-silence -expression-online#.

31 Reuters, "U.S. Hate Crimes Up 20 Percent in 2016, Fueled by Election Campaign: Report," NBC News, March 14, 2017, accessed July 25, 2017, http://www.nbcnews .com/news/us-news/u-s-hate-crimes-20-percent-2016-fueled-election-campaign -n733306.

32 James Davison Hunter, *Culture Wars: The Struggle to Define America* (New York: Basic Books, 1991), 35, 51.

33 See, for example, ACLU, *FCC v. Fox Television Stations, Inc.*, Amicus Brief, August 8, 2007, accessed August 1, 2017, https://www.aclu.org/legal-document/fcc -v-fox-television-stations-inc-amicus-brief.

34 Parents Television Council, accessed August 1, 2017, http://w2.parentstv.org/Main/.

35 Family Research Council, "Vision and Mission Statements," accessed August 1, 2017, http://www.frc.org/mission-statement; American Family Association, "Our Mission," February 14, 2017, accessed August 1, 2017, http://www.afa.net/who-we -are/our-mission/.

36 See, for example, the FRC's own archive of its efforts to thwart the rights of gay, lesbian, and transgender individuals. Family Research Council, "Homosexuality," accessed August 1, 2017, http://www.frc.org/homosexuality.

37 Tony Perkins, "A TV Guide to Normalizing Homosexuality," Family Research Council, September 28, 2013, accessed August 28, 2017, http://www.frc.org/washin gtonwatchdailyradiocommentary/a-tv-guide-to-normalizing-homosexuality.

38 Quoted in David O'Brien, *Congress Shall Make No Law: The First Amendment, Unprotected Expression, and the U.S. Supreme Court* (Lanham, MD: Rowman & Littlefield, 2010), 3.

39 *Dennis v. United States*, 341 U.S. 494 (1951), quoted in O'Brien, *Congress Shall Make No Law*, 7.

40 For more on how McCarthyism impacted media and the media industries, see Thomas Doherty, *Cold War, Cool Medium: Television, McCarthyism, and American Culture* (New York: Columbia University Press, 2003), and Jeff Smith, *Film Criticism, the Cold War, and the Blacklist: Reading the Hollywood Reds* (Berkeley, CA: University of California Press, 2014).

41 O'Brien, *Congress Shall Make No Law*, 10, 92.

42 Ibid., 49–60.

43 Ibid., 37–48.

44 See *Terry Gene Bollea [Hulk Hogan] v. Gawker Media LLC*, 913 F. Supp.2d 1325 (2012), which is among the cases discussed in Jeffrey Toobin, "When Truth Is Not Enough," *New Yorker*, December 19 and 26, 2017, 96–99, 101–103, 105; see also Amy Gajda, *The First Amendment Bubble: How Privacy and Paparazzi Threaten a Free Press* (Cambridge, MA: Harvard University Press, 2015).

45 Marjorie Heins, *Not in Front of the Children: "Indecency," Censorship, and the Innocence of Youth*, 2nd ed. (New Brunswick, NJ: Rutgers University Press, 2007), 24–25.

46 Ibid., 25.

47 Ibid., 27.

48 Library of Congress, "A Century of Lawmaking for a New Nation: U.S. Congressional Documents and Debates," 1774–1875, Statutes at Large, 42nd Congress, 3d Sess., 598–599, accessed July 20, 2017, https://memory.loc.gov/cgi-bin/ampage ?collId=llsl&fileName=017/llsl017.db&recNum=0639; see also Heins, *Not in Front of the Children*, 29–34.

49 Nicola Beisel, *Imperiled Innocents: Anthony Comstock and Family Reproduction in Victorian America* (Princeton, NJ: Princeton University Press, 1997), esp. chap. 7, 158–198.

50 Judges deciding *United States v. Bennett*, 24 Fed. Cas. 1093, No. 14,571 (S.D.N.Y. 1879), and *Lew Rosen v. United States*, 161 U.S. 29 (1896), drew on the English case *Regina v. Hicklin*, L.R. 2 QB 360 (1868).

51 *United States v. One Package of Japanese Pessaries*, 86 F.2d 757 (2d Cir. 1936), overturned portions of the Comstock Act that banned shipments of contraceptive material.

52 This wasn't the first time *Ulysses* encountered legal trouble: Margaret Anderson and Jane Heap, editors of a literary magazine called *The Little Review*, which began publishing excerpts from Joyce's epic novel in 1918, were convicted of obscenity in 1921. The first edition in book form was published by Sylvia Beach's Shakespeare & Company in Paris in 1922; U.S. agents destroyed hundreds of copies. See Heins, *Not in Front of the Children*, 40–41, 45–46.

53 *Roth v. United States*, 354 U.S. 476 (1957), syllabus 3(c).

54 Frankfurter's opinion in *Butler v. Michigan*, 352 U.S. 380 (1957), is cited in O'Brien, *Congress Shall Make No Law*, 2.

55 *Miller v. California*, 413 U.S. 15 (1973), §II.

56 New York State explains legal contests over zoning with regard to adult entertainment: Department of State, Office of General Counsel, "Legal Memorandum LU03: Municipal Regulation of Adult Uses," accessed July 27, 2017, https://www .dos.ny.gov/cnsl/lu03.htm.

57 *FCC v. Pacifica*, 438 U.S. 726 (1978).

58 FCC, "In the Matter of Industry Guidance on the Commission's Case Law Interpreting 18 U.S.C. §1464 and Enforcement Policies regarding Broadcast Indecency, EB-00-IH-0089," adopted March 14, 2001, released April 6, 2001, §II. Hereafter, FCC, Industry Guidance (2001); see also *FCC et al. v. Fox Television Stations et al.*, 567 U.S. 239 (2012).

59 Heather Hendershot, *Saturday Morning Censors: Television Regulation Before the V-Chip* (Durham, NC: Duke University Press, 1998), 21.

60 Unfortunately, no scholarly volume can cover any topic comprehensively, and the one you are now reading focuses primarily on relationships among programming, programmers (networks and stations), regulators, and media advocacy groups, leaving others to examine the role played behind the scenes by the networks' standards and practices offices, known in early radio and TV as continuity acceptance offices. These network staff members vet scripts for legal concerns, including indecency, and are referred to colloquially as the "censors." For more on their history, see Geoffrey Cowan, *See No Evil: The Backstage Battle Over Sex and Violence in Television* (New York: Simon and Schuster, 1980); David Silverman, *You Can't Air That: Four Cases of Controversy and Censorship in American Television Programming* (Syracuse, NY: Syracuse University Press, 2007); and Robert Pondillo, *America's First Network TV Censor: The Work of NBC's Stockton Helffrich* (Carbondale, IL: Southern Illinois University Press, 2010). Hendershot illuminates gendered aspects of censorious labor in *Saturday Morning Censors*, esp. chap. 2, 35–59.
61 Hendershot, *Saturday Morning Censors*, 1.
62 Ibid., 21.
63 Raiford Guins, *Edited Clean Version: Technology and the Culture of Control* (Minneapolis: University of Minnesota Press, 2009), 36.
64 Ibid., 33, emphasis added.
65 While this is not the place for a reckoning of the scholarly literature on media effects, Heins's chapter on its major trends would be a useful place for any interested reader to begin. See Heins, *Not in Front of the Children*, esp. chap. 10, 228–253.
66 Pastore was also a strong advocate of the Public Broadcasting System. The 1982 NIMH report foregrounded the perspective of L. Rowell Huesmann, whose research had consistently supported theories of imitative media effects and deliberately excluded research by the likes of Seymour Feshbach, proponent of a "catharsis" theory whose studies suggested that boys used violent media as an outlet for aggressive fantasies and thus showed less aggression in real life than boys not exposed to violent media. See Heins, *Not in Front of the Children*, 235–236, 358–359n41.
67 Ibid., 228.
68 Ibid., 10.
69 Ibid., 228.
70 Ibid., 228.

Chapter 1 A Brief History of Indecency in Media

1 Barry Garron, "Channel 62 Will Cut Nudity from Movies," *Kansas City Star*, November 21, 1986, 34; Barry Garron, "Edited Movies Still Reveal More Than Some Want to See," *Kansas City Star*, May 27, 1987, 31.
2 The National Federation for Decency was renamed the American Family Association later in 1988. The member who filed the complaint is identified as Treva Burke or Burk in media accounts of the incident and its aftermath: "FCC Tells Station It May Have Violated Indecency Law," *Broadcasting*, January 18, 1988, 46; Dennis McDougal, "Station Gets Lesson in Decency," *Los Angeles Times*, February 16, 1988.
3 Barry Garron, "FCC Leaps Into Battle for Decency," *Kansas City Star*, January 14, 1988, 38.

4 FCC, New Indecency Enforcement Standards to Be Applied to All Broadcast and Amateur Radio Licensees, public notice, 2 F.C.C.R. 2726, 1987.
5 Recall that obscenity is a type of speech that is not protected by the First Amendment. Regarding obscene material that "appeals to the prurient interest . . . depicts or describes, in a patently offensive way, sexual conduct . . . and . . . taken as a whole, lacks serious literary, artistic, political, or scientific value", see *Miller v. California*, 413 U.S. 15 (1973), §II. Regarding indecent material that "contains sexual or excretory material that does not rise to the level of obscenity," see the FCC fact sheet "Obscene, Indecent and Profane Broadcasts," last updated October 25, 2016, accessed September 2, 2017, https://www.fcc.gov/consumers/guides/obscene-indecent-and-profane-broadcasts.
6 Garron, "Edited Movies," 31.
7 Sexual morality was certainly among those concerns, as was criminality, among other behaviors seen as threatening by temperance advocates, a Protestant elite concerned about growing non-Protestant immigrant populations, and those afraid of the influence of cinema on children. See Lee Grieveson, *Policing Cinema: Movies and Censorship in Early Twentieth-Century Cinema* (Berkeley, CA: University of California Press, 2004), 23–26.
8 *Mutual Film Corporation v. Industrial Commission of Ohio*, 236 U.S. 230 (1987). For a discussion of the ruling, see Garth S. Jowett, "'A Capacity for Evil': The 1915 Supreme Court *Mutual* Decision," *Historical Journal of Film, Radio and Television* 9, no. 1 (1989): 59–78.
9 See Grieveson, *Policing Cinema*, Ch. 4, 121–150.
10 On *The Unwritten Law*, see Grieveson, *Policing Cinema*, chap. 2, 37–77; on *Where Are My Children*, see Annette Kuhn, *Cinema, Censorship and Sexuality, 1909–1925* (London: Routledge, 1988), chap. 3, 28–48; on *Purity*, see Cynthia Chris, "Censoring Purity," *Camera Obscura* 79, v. 27, no. 1 (2012): 97–125.
11 Grieveson, *Policing Cinema*, 19–20.
12 See Stephen Vaughn, "The Devil's Advocate: Will H. Hays and the Campaign to Make Movies Respectable," *Indiana Magazine of History* 101, no. 2 (2005): 125–152. The early history of film censorship is elaborated in Grieveson, *Policing Cinema* and Thomas Doherty, *Pre-Code Hollywood: Sex, Immorality, and Insurrection in American Cinema* (New York: Columbia University Press, 1999).
13 *Joseph Burstyn, Inc. v. Wilson*, 343 U.S. 495 (1952).
14 Garth Jowett, "'A Significant Medium for the Communication of Ideas': The *Miracle* Decision and the Decline of Motion Picture Censorship, 1952–1968," 258–76, in Francis G. Couvares, ed., *Movie Censorship and American Culture*, 2nd ed. (Amherst: University of Massachusetts Press, 1996). See also William Bruce Johnson, *Miracles & Scarilege: Roberto Rossellini, the Church, and Film Censorship in Hollywood* (Toronto: University of Toronto Press, 2008).
15 *Freedman v. Maryland*, 380 U.S. 51 (1965).
16 See Jon Lewis, *Hollywood v. Hard Core: How the Struggle Over Censorship Saved the Modern Film Industry* (New York: New York University Press, 2002), esp. 135–191.
17 Hoover held a series of four National Radio Conferences (1922–1925) with representatives of the growing industry. For Hoover's comments on radio and censorship, see hearings on H.R. 7357 before the House Committee on the

Merchant Marine and Fisheries, 68th Cong., 1st Sess., 8 (1924); cited in *CBS, Inc. v. Democratic National Committee*, 412 U.S. 94 (1973).

18 The Radio Act of 1927, Pub. L. No. 632, February 23, 1927, 69th Congress, Section 29, accessed at American Radio History, August 10, 2017, http://www.americanradiohistory.com/Archive-FCC/Federal%20Radio%20Act%201927.pdf.

19 David Sarnoff (1936, quoted in Robert W. McChesney, *Telecommunications, Mass Media, and Democracy: The Battle for the Control of U.S. Broadcasting, 1928–1935* (New York: Oxford University Press, 1993), 240. According to McChesney, Sarnoff may have been legitimately inspired to defend the First Amendment so vigorously in light of the rise of fascism in Europe, but he may have also been motivated to question the government's authority to regulate radio generally for financial reasons (240, 245). When in 1941 the FCC ordered RCA to divest one of its two national networks (NBC Blue, which became, eventually, the foundations of ABC), the company tried hard to appeal its authority to do so.

20 "Stations Adopt Code of Ethics," *New York Times*, April 7, 1929.

21 Library of Congress, "A Century of Lawmaking for a New Nation: U.S. Congressional Documents and Debates, 1774–1875, Statutes at Large, 42nd Congress, 3d Sess.," 598–599, accessed July 20, 2017, https://memory.loc.gov/cgi-bin/ampage?collId=llsl&fileName=017/llsl017.db&recNum=0639.

22 While cases such as *United States v. Ulysses*, 5 F. Supp. 182 (1933), helped unravel portions of the draconian Comstock Act pertaining to publications, the section that banned shipments of contraceptive material was overturned when a federal appeals court dismissed charges against Dr. Hannah Stone, director of the Birth Control Clinical Research Bureau of New York founded by Margaret Sanger, in the case *United States v. One Package of Japanese Pessaries*, 86 F.2d 757 (2nd Cir. 1936).

23 Neville Miller, "Can U.S. Radio Regulate Itself? Yes!," *The Rotarian* 57, no. 1 (July 1940):18, 55–56; in the same issue, see also Paul Hutchinson, "Can Radio Regulate Itself? No!," 19, 56–58. Miller was then president of the NAB; Hutchinson, editor of *The Christian Century* magazine.

24 *The Code of the National Association of Broadcasters*, adopted by the 17th Annual Convention of the NAB, July 11, 1939, accessed April 22, 2017, https://babel.hathitrust.org/cgi/pt?id=mdp.39015041128326;view=1up;seq=1.

25 An issue of *Broadcasting*, published March 18, 1946, is cited in Victor Picard, *America's Battle for Media Democracy: The Triumph of Corporate Libertarianism and the Future of Media Reform* (New York: Cambridge University Press, 2015), 71. For an in-depth analysis of the Blue Book and public interest, see his chap. 3, 62–97.

26 Louis Chunovic, *One Foot on the Floor: The Curious Evolution of Sex on Television from* I Love Lucy *to* South Park (New York: TV Books, 2000), 26–32.

27 Lynn Spigel, *Make Room for TV: Television and the Family Ideal in Postwar America* (Chicago: University of Chicago Press, 1992), 54; Bob Pondillo, "A 'Legion of Decency' for 1950s Television?," *Television Quarterly* 33, nos. 2–3 (2001): 16–21.

28 Pondillo, "A 'Legion of Decency,'" 17.

29 National Association of Radio and Television Broadcasters—Television Board, *US Code of Practices for Television Broadcasters—Adopted: 6 December 1951,* 362, accessed April 2, 2017, http://www.tvhistory.tv/SEAL-Good-Practice.htm.

30 See Appendix 1: The Motion Picture Production Code of 1930, in Doherty, *Pre-Code Hollywood*, 347–359.

31 NARTB-TB, *Code of Practices for Television Broadcasters* (1951), 363.

32 Ibid., 362.

33 National Association of Broadcasters, *The Television Code*, 5th ed. (Washington, DC: 1959), 2.

34 NARTB-TB, *Code of Practices for Television Broadcasters* (1951), 363.

35 NAB, *The Television Code* (1959), 2, 4.

36 See Elana Levine, *Wallowing in Sex: The New Sexual Culture of 1970s American Television* (Durham, NC: Duke University Press, 2007).

37 On network censors, see Geoffrey Cowan, *See No Evil: The Backstage Battle Over Sex and Violence in Television* (New York: Simon and Schuster, 1980); David Silverman, *You Can't Air That: Four Cases of Controversy and Censorship in American Television Programming* (Syracuse, NY: Syracuse University Press, 2007); Robert Pondillo, *America's First Network TV Censor: The Work of NBC's Stockton Helffrich* (Carbondale, IL: Southern Illinois University Press, 2010); and Heather Hendershot, *Saturday Morning Censors: Television Regulation Before the V-Chip* (Durham, NC: Duke University Press, 1998).

38 Silverman, *You Can't Air That*, esp. hap. 2, 33–52.

39 See Cowan, *See No Evil*, esp. chap. 6, 116–141, for examples.

40 See Levine, *Wallowing in Sex*, esp. chap. 4, 123–68.

41 Surgeon General's Scientific Advisory Committee on Television and Social Behavior, *Television and Growing Up: The Impact of Televised Violence: Report to the Surgeon General, United States Public Health Service* (Rockville, MD: National Institute of Mental Health, 1971), accessed April 15, 2017, https://profiles.nlm.nih.gov/NN/B/C/G/X/.

42 Sylvia Lawler, "Eye on Integrity: Ex-CBS Chief Has Few Regrets Over Stance for Quality," *The Morning Call* (Allentown, PA), August 30, 1992.

43 Cowan, *See No Evil*, 19–20; see also 64–79.

44 According to Elana Levine, stations received significant numbers of complaints about *Born Innocent* (1974) and the 1975 TV movies *Sarah T: Portrait of a Teenage Alcoholic*, *Hustling*, *Someone I Touched*, and *Cage Without a Key*. See Levine, *Wallowing in Sex*, chap. 3, 76–122.

45 See Allison Perlman, *Public Interests: Media Advocacy and Struggles over U.S. Television* (New Brunswick, NJ: Rutgers University Press, 2016), 126–133.

46 Horace Newcomb and Paul M. Hirsch, "Television as a Cultural Forum," in Horace Newcomb, ed., *Television: The Critical View*, 6th ed. (New York: Oxford University Press, 2000), 565.

47 Ibid., 565.

48 David W. Rintels, "Why We Fought the Family Viewing Hour," *New York Times*, November 21, 1976. The op-ed was adapted from a speech given at an Action for Children's Television event.

49 Ibid., 1976.

50 David Black, "Inside TV's 'Family Hour' Feud," *New York Times*, December 7, 1975.

51 Norman Lear's production company Tandem was also a plaintiff in the case. See Perlman, *Public Interests*, 129; also, *WGA West, Inc. v. FCC*, 423 F. Supp. 1064

(C.D. Cal. 1976), §V Order. Judge Ferguson is better known in media circles for his role in *Sony Corp. of America v. Universal City Studios, Inc.* (1976), which established that sales of Sony's Betamax did not necessarily constitute copyright infringement when used to record TV shows for home use. An appellate court overturned the decision, a ruling the Supreme Court reversed (464 U.S. 417, 1984), resuscitating Ferguson's decision.

52 Perlman, *Public Interests*, 129; also, *WGA West, Inc. v. American Broadcasting Co.*, 609 F.2d 355 (1979).

53 Perlman, *Public Interests*, 215n22.

54 Tony Schwartz, "400 Rightist Groups in National Coalition to Start Boycott of TV Wildmon Sponsors This Week," *New York Times*, June 22, 1981; Tony Schwartz, "A Boycott of TV Advertisers Is Again Threatened," *New York Times*, January 28, 1982. See also Kathryn C. Montgomery, *Target: Prime Time: Advocacy Groups and the Struggle over Entertainment Television* (New York: Oxford University Press, 1989); Patrick M. Fahey, "Advocacy Group Boycotting of Network Television Advertisers and Its Effects on Programming Content," *University of Pennsylvania Law Review* 140 (1991): 647–709.

55 Gioia Dilberto, "Sponsors Run for Cover as TV Vigilante Donald Wildmon Decides It's Prime Time for a Boycott," *People*, July 6, 1981.

56 Walter Goodman, "Critic's Notebook: Commercial TV Gets Commercial Threats," *New York Times*, April 24, 1989.

57 UPI, "Termination of the National Broadcasters Television Code . . . ," December 15, 1982, accessed August 14, 2017, https://www.upi.com/Archives/1982/12/15/Termination-of-the-National-Association-of-Broadcasters-television-code/5771408776400/.

58 Hendershot, *Saturday Morning Censors*, 79; for more on ACT, see her chap. 3, esp. 61–81.

59 Perlman, *Public Interests*, 133–137.

60 See Larry Gross, *Up from Invisibility: Lesbians, Gay Men, and the Media in America* (New York: Columbia University Press, 2001); Stephen Tropiano, *The Prime Time Closet: A History of Gays and Lesbians on TV* (New York: Applause, 2002).

61 Perlman, *Public Interests*, 133–144.

62 See, for example, *The PTC Presents the 2001–2002 Top 10 Best and Worst Shows on Network TV*, http://www.parentstv.org/PTC/publications/reports/top10bestandworst/2002/top10worst.asp.

63 The U.S. Code is searchable at http://uscode.house.gov, accessed August 9, 2017.

64 In 1994, Congress amended Section 1464 to remove the cap on possible fines. The passage, revised in 1994, now reads: "Whoever utters any obscene, indecent, or profane language by means of radio communication shall be fined under this title or imprisoned not more than two years, or both." See U.S. Code, Title 18, Part I, chap. 71, Sect. 1464 Broadcasting Obscene Language, June 25, 1948, chap. 645, 62 Stat. 769.L. The change in wording came about in 103d Congress, Pub. L. 103-322, Violent Crime Control and Law Enforcement Act of 1994, September 13, 1994, 108 Stat. 1796.

65 See U.S. Code, Title 47, chap. 1., subchap. C, Part 73, Subpart H, Section 73.39999, Enforcement of 18 U.S.C. 1464, which went into effect August 28, 1995.

66 Ben Fong-Torres, "Garcia's 'Shit' Is Poison, FCC Rules," *Rolling Stone*, April 30, 1970.

67 "Sex Radio Fine Upheld by FCC," *Chicago Tribune*, July 8, 1973.

68 Black, "Inside TV's 'Family Hour' Feud," 1975. For more on the WUHY and WGLD cases, see also Robert L. Hilliard and Michael C. Keith, *Dirty Discourse: Sex and Indecency in Broadcasting*, 2nd ed. (Malden, MA: Blackwell, 2007), 16–19.

69 A different version of the routine appeared on Carlin's album *Class Clown* (1972) under the title "Seven Words You Can Never Say on Television."

70 *FCC v. Pacifica Foundation*, 438 U.S. 726 (1978) [No. 77–528], appendix to the opinion of the court. Hereafter, *FCC v. Pacifica* (1978).

71 In Re Pacifica Foundation 56 FCC 2d (1975), 98.

72 Ana-Ellen Marcos, "Broadcasting Seven Dirty Words: FCC v. Pacifica Foundation," *Boston College Law Review* 20, no. 5 (1979): 976–77.

73 *Pacifica Foundation v. FCC*, 181 U.S. App. D.C., 132 F.2d 9 (1977).

74 U.S. Code Title 47, Chapter 5, Subchapter III, Part I, Section 326, June 19, 1934.

75 *Pacifica Foundation v. FCC*, 181 U.S. App. D.C., 556 F.2d 9 (1977), cited in *FCC v. Pacifica* (1978), syllabus.

76 *FCC v. Pacifica* (1978), §IVC.

77 FCC Pacifica Order, 56 FCC 2d 94, 1975, at 94. Profanity, too, could remain under FCC regulation.

78 Alison Nemeth, "The FCC's Broadcast Indecency Policy on 'Fleeting Expletives' After the Supreme Court's Latest Decisions in *F.C.C. v. Fox Television Stations*: Sustainable or Also 'Fleeting?'" *CommLaw Conspectus: Journal of Communications Law and Telecommunications Policy* 2, no. 2 (2013): 401–403.

79 Quoted in U.S. Court of Appeals for the Second Circuit, *Fox Television Stations, Inc., CBS Broadcasting, Inc., WLS Television, Inc., KYKK Television, Inc., KMBC Hearst-Argyle Television, Inc., ABC, Inc., v. FCC* 06–1760, decided June 4, 2007, 7n4.

80 In 1990, KLUC in Las Vegas paid a $2,000 fine for playing "Erotic City" in 1988. In 1996, the FCC imposed a fine of $7,500 on KTFM in San Antonio (later rescinded) and a fine of $8,000 on KPTY and KBZR (in a combined ruling) in Phoenix for playing the same song.

81 *FCC Record,* Vol. 9, 87–139. Memorandum Opinion and Order, In the Matter of The Regents of the University of California, Licensee of KCSB-TV, Santa Barbara, California, adopted April 16, 1987; released April 29, 1987, 5324–5328.

82 Ibid., 5324, §6.

83 *FCC Record,* Vol. 9, 87–138. Memorandum Opinion and Order, In the Matter of Pacifica Foundation, Inc., Licensee of KPFK-FM, Los Angeles, California, adopted April 16, 1987; released April 29, 1987, 5318, 5320. Hereafter FCC, KPFK Memo (1987).

84 Dennis McDougal, "How 'Jerker' Helped Ignite Obscenity Debate," *Los Angeles Times*, August 18, 1987.

85 FCC, KPFK Memo (1987), 5321.

86 *FCC Record,* Vol. 2, No. 9, 87–138. Memorandum Opinion and Order, In the Matter of Infinity Broadcasting Corporation of Pennsylvania, Licensee of Station WYSP(FM) Philadelphia, adopted April 16, 1987; released April 29, 1987, 2706. Hereafter FCC, WYSP Memo (1987).

87 Ibid., 2706.

88 FCC, New Indecency Enforcement Standards to Be Applied to All Broadcast and Amateur Radio Licensees, Public Notice, 2 F.C.C.R. 2726 (1987).

89 Reginald Stuart, "F.C.C. Acts to Restrict Indecent Programming," *New York Times*, April 17, 1987.

90 Ibid.

91 Sydney Shaw, "Federal Communications Commission Chairman Mark Fowler Told Broadcasters Wednesday . . . ," UPI, May 2, 1984, accessed August 9, 2017, http://www.upi.com/Archives/1984/05/02/Federal-Communications -Commission-Chairman-Mark-Fowler-told-broadcasters-Wednesday /4400452318400/.

92 Stuart, "F.C.C. Acts to Restrict Indecent Programming."

93 Garron, "Edited Movies," 31.

94 McDougal, "Radio, TV Stations Fighting FCC Allegation of Indecency," *Los Angeles Times,* January 16, 1988.

95 McDougal, "TV Indecency Fine Raises New Fears in Broadcasters." The major broadcast networks (ABC, CBS, Fox, NBC, PBS and the CW) occupy most VHF channels 2 to 13, while many independent stations (and some PBS and CW affiliates) broadcast on UHF channels 14 or higher.

96 John Burgess, "FCC Fines Missouri TV Station; Penalty Is First Under 'Indecency' Rule," *Washington Post*, June 24, 1988.

97 Milagros Rivera-Sanchez, "How Far Is Too Far? The Line Between 'Offensive' and 'Indecent' Speech," *Federal Communications Law Journal* 29, no. 2 (1997): 327–366.

98 *Action for Children's Television v. FCC*, 852 F.2d 1332 (D.C. Cir. 1988), ¶8. For an in-depth examination of the U.S. Court of Appeals, D.C. Circuit's role in shaping policy in this areas, see Jeremy H. Lipschultz, "The Influence of the United States Court of Appeals for the District of Columbia Circuit on Broadcast Indecency Policy," *Jeffrey S. Moorad Sports Law Journal* 3, no. 1 (1996), accessed at http:// digitalcommons.law.villanova.edu/mslj/vol3/iss1/4.

99 Infinity Broadcasting Corporation of Pennsylvania (WYSP(FM)), reconsideration order, 3 FCC Rcd 930, 64 R.R.2d 211 (1987).

100 On Helms's influence on arts funding, see Courtney Randolph Nea, "Content Restrictions and National Endowment for the Arts Funding: An Analysis from the Artist's Perspective," *William & Mary Bill of Rights Journal* 2, no. 1 (1983): 165–184. For more on Helms's role in enacting the failed 24-hour ban, see John Crigler and William J. Byrnes, "Decency Redux: The Curious History of the New FCC Broadcast Indecency Policy," *Catholic University Law Review* 38, no. 2 (Winter 1989): 329–363.

101 The law was overturned by the U.S Court of Appeals for the District of Columbia; see Edmund L. Andrews, "F.C.C.'s 'Indecency' Ban Is Upset by Appeals Court," *New York Times*, May 18, 1991.

102 H.R. 2977-102nd Congress: Public Telecommunications Act of 1992, accessed May 12, 2017, https://www.govtrack.us/congress/bills/102/hr2977.

103 *Action for Children's Television v. FCC*, 11 F.3d 170 (D.C. Cir. 1993), quoted in Ronald J. Ostrow, "Court Voids Ban on Indecent Programming," *Los Angeles Times*, November 24, 1993.

104 FCC to Grant Broadcasting System II, Inc. [correspondence], *FCC Record* 12, no. 15 (June 16–June 27, 1997): 8277–8281.
105 Ibid., 8278.
106 FCC, WYSP Memo (1987), 2705.

Chapter 2 Targeting TV in the Twenty-First Century

1 FCC, In the Matter of WDBJ Television, Inc., Notice of Apparent Liability for Forfeiture, EB-IHD 21-14-00016819/EB-12-IH-1363, released March 20, 2015, accessed March 16, 2017, https://apps.fcc.gov/edocs_public/attachmatch/FCC-15 -32A1.pdf.
2 NAB, "NAB Statement in Response to Proposed FCC Indecency Fine Against Schurz Communications" [press release], March 23, 2015, accessed March 16, 2017, http://www.nab.org/documents/newsroom/pressRelease.asp?id=3621; PTC, "PTC Statement on FCC Broadcast Indecency Ruling" [press release], March 23, 2015, accessed March 16, 2017, http://w2.parentstv.org/Main/News/Detail.aspx ?docID=3242.
3 Ted Johnson, "Broadcasters Protest FCC Indecency Fine to Roanoke TV Station," *Variety*, July 28, 2015.
4 That ruling was in *FCC v. Fox* et al., 567 U.S.—(2012). See John Eggerton, "WDBJ Fights FCC Indecency Fine," *Broadcasting & Cable*, July 1, 2015.
5 FCC, New Indecency Enforcement Standards to Be Applied to All Broadcast and Amateur Radio Licensees, Public Notice, 2 F.C.C.R. 2726 1987. A similar definition, slightly paraphrased, is found at FCC, Obscenity, Indecency & Profanity— FAQ, n.d., accessed September 21, 2017, https://www.fcc.gov/reports-research /guides/obscenity-indecency-profanity-faq.
6 The FCC had issued fines in two previous cases of broadcast indecency but canceled both fines. John Burgess and Jeffrey Goldberg, "FCC Fines Missouri TV Station; Penalty Is First Under 'Indecency' Rule," *Washington Post*, June 24, 1988; FCC to Grant Broadcasting System II, Inc. [correspondence], *FCC Record* 12, no. 15 (June 16–June 27, 1997): 8277–8281.
7 Notice of Apparent Liability for Forfeiture In the Matter of Telemundo of Puerto Rico License Corp./Licensee of Station WKAQ-TV San Juan, Puerto Rico, EB-00-IH-00140, §III. Released March 30, 2001, https://transition.fcc.gov/eb /Orders/2001/da01792.html, accessed June 30, 2015.
8 Michael Strocko, "Just a Concern for Good Manners: The Second Circuit Strikes Down the FCC's Broadcast Indecency Regime," *University of Miami Business Law Review* 17, no. 1 (2008): 174, accessed July 23, 2017, http://repository.law.miami.edu /umblr/vol17/iss1/5.
9 NAL—WKAQ-TV (2001), §II.
10 Ibid., *n*2.
11 FCC, In the Matter of Industry Guidance on the Commission's Case Law Interpreting 18 U.S.C. §1464 and Enforcement Policies regarding Broadcast Indecency, EB-00-IH-0089, adopted March 14, 2001, released April 6, 2001, §II. Hereafter, FCC, Industry Guidance (2001).
12 Ibid., §II.
13 Ibid., §II.

14 Ibid., §III.I.A.

15 Ibid., §II.

16 Notice of Apparent Liability for Forfeiture/In the Matter of Young Broadcasting of San Francisco, Inc., EB-02-IH-0786, released January 27, 2004, https://transition .fcc.gov/eb/Orders/2004/FCC-04-16A1.html, ¶12.

17 *Peter Branton v. FCC*, 993 F.2d 906 (D.C. Cir. 1993), cited in FCC, Industry Guidance (2001), *n17*. In this case, a complainant (Branton) sought for the FCC to find that a 1989 broadcast of National Public Radio's newscast *All Things Considered* was indecent, because it aired a tape in which John Gotti, alleged leader of a criminal syndicate, used the word "fuck" or its variants ten times. The commission's decision found the segment newsworthy, even if it did contain indecent language.

18 Notice of Apparent Liability for Forfeiture/In the Matter of Young Broadcasting of San Francisco, Inc., EB-02-IH-0786, released January 27, 2004, https://transition .fcc.gov/eb/Orders/2004/FCC-04-16A1.html; also, Separate Statement of Commissioner Kevin J. Martin, https://transition.fcc.gov/eb/Orders/2004/FCC -04-16A4.html, both accessed July 1, 2015.

19 FCC, Memorandum Opinion and Order, In the Matter of Complaints Against Various Broadcast Licensees Regarding Their Airing of The "Golden Globe Awards," File No. EB-03-IH-0110, adopted October 3, 2003, released October 3, 2003.

20 FCC, Memorandum Opinion and Order, In the Matter of Complaints Against Various Broadcast Licensees Regarding Their Airing of the "Golden Globe Awards" program, EB-03-1H-0110, adopted March 3, 2004, released March 18, 2004, 4*n*23. Hereafter, Golden Globes Order (2004).

21 Quoted in Pierre N. Leval, dissenting, *Fox et al. v. FCC* (2007), 53*n*18.

22 Jeff Jarvis, a media consultant and director of the Tow-Knight Center for Entrepreneurial Journalism at the City University of New York School of Journalism, obtained copies of the complaints against *Married by America* under a Freedom of Information Act request. Expecting 159, he received only 90, many of which were duplicates originating from only 23 senders. Just two of the complaints were original; the rest were identical form letters. See Jeff Jarvis, "A BuzzMachine Exclusive! The Shocking Truth About the FCC: Censorship by the Tyranny of the Few," *BuzzMachine* [blog], November 15, 2004, http://buzzmachine.com /2004/11/15/.

23 A spokesperson for Veterans of Foreign Wars took issue with Kid Rock wearing an American flag during his segment. See "VFW Slams Kid Rock for Flag Poncho," *St. Petersburg Times,*, February 2, 2004.

24 Shannon L. Holland, "The 'Offending' Breast of Janet Jackson: Public Discourse Surrounding the Jackson/Timberlake Performance at Super Bowl XXXVIII," *Women's Studies in Communication* 32, no. 2 (Spring 2009): 130.

25 See *CBS Corporation; CBS Broadcasting Inc.; CBS Television Stations, Inc.; CBS Stations Group of Texas L.P.; and KUTV Holdings, Inc. v. FCC*, U.S. Court of Appeals for the Third Circuit, No. 06-3575. Argued September 11, 2007; published July 21, 2008, pages 5, 7–8. Hereafter, *CBS et al. v. FCC* (2008).

26 "TiVo: Jackson Stunt Most Replayed Moment Ever," CNN, February 3, 2004, accessed April 20, 2017, http://www.cnn.com/2004/TECH/ptech/02/03 /television.tivo.reut/.

27 "Google Taps Into Search Patterns," BBC News, December 22, 2005, accessed April 20, 2017, http://news.bbc.co.uk/2/hi/technology/4551936.stm.

28 Jonathan D. Salant, "FCC to Investigate Jackson's Display at Super Bowl," *Washington Post*, February 2, 2004.

29 At the time, the five commissioners were Chair Powell, Kevin J. Martin, and Katherine Q. Abernathy, who constituted the Republican majority, as well as Democrats Jonathan S. Adelstein and Michael J. Copps, who in this instance formed a bipartisan consensus.

30 Golden Globes Order (2004), 5*n*27.

31 Associate Press, "Howard Stern, Bono Cited for Indecency," NBCNews.com, March 18, 2004, accessed May 6, 2017, http://www.nbcnews.com/id/4558191/ns /business-us_business/t/howard-stern-bono-cited-indecency/#.WQ5CpWUXe7Z.

32 Complaints Regarding Various Television Broadcasts Between February 2, 2002 and March 8, 2005 (Omnibus Order), 21 F.C.C.R. 2664 (2006), §III.B.

33 *Fox et al. v. FCC* (2007): 31.

34 Ira Teinowitz, "Fox Hit with $1.2 Million Indecency Fine," *Advertising Age*, October 13, 2004; Cynthia Littleton, "Fox Fine Scaled Back," *Variety*, February 25, 2008, 4, 18.

35 See Stephen Labaton, "Indecency on the Air, Evolution Atop the F.C.C.," *The New York Times*, December 23, 2004.

36 *CBS et al. v. FCC* (2008).

37 Ibid., summary at §V.

38 Frank Ahrens, "FCC Chief Hopes to Raise Cost of Airing Indecency," *Washington Post*, January 15, 2004; Frank Ahrens, "Legislation Increasing Indecency Fines Dropped," *Washington Post*, October 8, 2004.

39 Bill McConnell, "FCC Ups Indecency Fines," *Broadcasting & Cable*, June 18, 2004.

40 "Bush Signs Law Increasing Fines for Indecent Broadcasts," *USA Today*, June 16, 2006.

41 FCC, 2013 Inflation Adjustment Order, 28 FCC Rcd, 10787*n*16, cited in FCC, NAL in the Matter of WDBJ Television, Inc., adopted March 20, 2015, released March 23, 2015, FCC 15-32, p 3034, ¶25 and *n*86.

42 FCC 04-279, Memorandum Opinion and Order, In the Matter of Complaints by Parents Television Council Against Various Broadcast Licensees Regarding Their Airing of Allegedly Indecent Material, adopted December 8, 2004, released January 24, 2005, File No. EB-03-IH-0357 et al.

43 FCC 04-280, Memorandum Opinion and Order, In the Matter of Complaints by Parents Television Council Against Various Broadcast Licensees Regarding Their Airing of Allegedly Indecent Material, adopted December 8, 2004, released January 24, 2005, File No. EB-03-IH-0362 et al.

44 ABC then had 225 affiliates. Associated Press, "66 ABC Affiliates Didn't Show 'Ryan,'" *Today*, August 4, 2004, accessed August 19, 2018, https://www.today.com /popculture/66-abc-affiliates-didnt-show-ryan-wbna6455962.

45 FCC, In the Matter of Complaints Against Various Television Licensees Regarding Their Broadcast on November 11, 2004, of the ABC Television Network's Presentation of the Film "Saving Private Ryan," Memorandum and Order, EB-04-IH-0589, adopted February 3, 2005, released February 28, 2005, §III, ¶13, ¶10, ¶14. Hereafter "Saving Private Ryan" Memo (2005).

46 FCC, Memorandum Opinion and Order In the Matter of WPBN/WTOM License Subsidiary, Inc., adopted January 11, 2000, released January 14, 2000.

47 "Saving Private Ryan" Memo (2005), §II, ¶3.

48 *FCC Record*, Vol. 9, 87–138. Memorandum Opinion and Order, In the Matter of Pacifica Foundation, Inc., Licensee of KPFK-FM, Los Angeles, California, adopted April 16, 1987; released April 29, 1987; 5318–19, 5321–22n1, n4.

49 Ibid., 5321.

50 Jennifer Holt, "NYPD Blue: Content Regulation," in Ethan Thompson and Jason Mittell, eds., *How to Watch Television*, (New York: New York University Press, 2013), 271–280, esp. 273.

51 Holt likens the shot to Dustin Hoffman's famous view of Anne Bancroft, his flirtatious future mother-in-law, in *The Graduate*. In that scene, Bancroft's stockinged leg stretches horizontally across the lower portion of the frame, bisecting Hoffman's body at about crotch level. But it is compositionally closer to movie posters for the James Bond film *For Your Eyes Only* (1981), Mike Leigh's *Naked* (1993), and many others in which a woman's legs form an inverted V, within which a male figure appears at some distance and thus relatively miniaturized. Ibid., 275.

52 Ibid., 275.

53 FCC, In the Matter of Complaints Against Various Television Licensees Concerning Their February 25, 2003 Broadcast of the Program "NYPD Blue": Notice of Apparent Liability for Forfeiture, released January 25, 2008, Washington, DC. File Nos. EB-03-IH-0122 and EB-03-IH-0353, ¶1–2.

54 Ibid., ¶11.

55 Ibid., ¶9.

56 Ibid., ¶12, ¶10.

57 Ibid., ¶5.

58 Ibid., ¶8, ¶15.

59 Ibid., ¶16.

60 Ibid., ¶4.

61 Laura Mulvey, "Visual Pleasure and Narrative Cinema," in *Visual and Other Pleasures* (Bloomington, IN: Indiana University Press, 1989), 16. Originally published in *Screen* 16, no. 3 (Autumn 1975): 6–18.

62 Memorandum Opinion and Order In Re Complaints by Parents Television Council Against Various Broadcast Licensees Regarding Their Airing of Allegedly Indecent Material, EB-03-IH-0362 et al., adopted December 8, 2004, released January 24, 2005, §II.6.r, §II.9.

63 Bruce Golding, "Appeals Court Tosses 'Indecency' Fines Over 'NYPD Blue' Nudity," *New York Post*, January 4, 2011; *Fox Television Stations v. FCC*, 2. Previously, the Second Circuit had found the indecency policy "arbitrary and capricious" under the Administrative Procedure Act; see *Fox et al. v. FCC* (2d Cir. 2007). This ruling (like its later finding of unconstitutionality) was overturned by the Supreme Court; see *Fox Television Stations, Inc., v. FCC*, 29 S.Ct. 1800, 1819 (2009).

64 *Mutual Film Corporation v. Industrial Commission of Ohio*, 236 U.S. 230 (1987); also, Garth S. Jowett, "'A Capacity for Evil': The 1915 Supreme Court *Mutual* Decision," *Historical Journal of Film, Radio and Television* 9, no. 1 (1989): 59–78.

65 A couple participating in the contest was arrested for public lewdness at St. Patrick's Cathedral in New York City. Paul Mercurio, an *Opie and Anthony* producer reporting on the couple's activity, was also charged. More than 500 complaints

reached the FCC. Marianne Garvey, "Couple Arrested for Having Sex in New York City Cathedral," Fox News, August 16, 2002, accessed August 11, 2017, http://www.foxnews.com/story/2002/08/16/couple-arrested-for-having-sex-in-new-york-city-cathedral.html.

66 FCC, In the Matter of Viacom Inc., Infinity Radio Inc. et al., Order and Consent Degree, adopted November 9, 2004, released November 23, 2004.

67 John Eggerton, "PTC Complains About CBS 'Orgy,'" *Broadcasting & Cable*, January 13, 2005.

68 FCC 04-268, Notice of Apparent Liability for Forfeiture, In the Matter of Complaints Against Various Television Licensees Concerning Their December 31, 2004 Broadcast of the Program "Without a Trace," EB-05-IH-0035, adopted February 21, 2006, released March 15, 2006, ¶18. The FCC canceled eight of the fines a month later because those stations were located in parts of Indiana and Tennessee that observe Eastern, not Central time, and had aired the episode after 10:00 P.M.; see Bloomberg News, "FCC Trims Record Fine Against CBS," *Los Angeles Times*, March 31, 2006.

69 Reuters, "FCC Out of Context with *Trace* Indecency Fine," March 20, 2006, archived at TV.com, http://www.tv.com/news/fcc-out-of-context-with-trace-indecency-fine-3746/, accessed June 12, 2017. The nonprofit public-interest law firm Media Access Project operated from 1972 to 2012, focusing on issues including media concentration and net neutrality.

70 Email correspondence, Jon Minkoff, Information and Data Officer, Enforcement Bureau, FCC, June 28, 2017.

71 Mark Fowler, Jerald Fritz, Henry Geller, Newton N. Minow, James M. Quello, Glen O. Robinson, and Kenneth G. Robinson, Jr.; Brief for *Amici Curiae* Former FCC Commissioners and Officials in Support of Petitioners, No. 06-1760(L), in U.S Court of Appeals for the Second Circuit, *Fox Television Stations, Inc., et al. v. Federal Communications Commission*, filed September 16, 2006. Hereafter Fowler et al., Brief for *Amici Curiae* (2006).

72 Dennis Wharton, "FCC's Wharton Blasts Quello's Stern Warning," *Variety*, March 20, 1994, accessed August 17, 2017, http://variety.com/1994/biz/news/fcc-s-barrett-blasts-quello-s-stern-warning-119388/; Douglas Martin, "James H. Quello, Ex-member of the F.C.C, Dies at 95," *New York Times*, February 3, 2010.

73 Heins, *Not in Front of the Children*, 100–101; Andrew Duncan, " FCC Crackdown on Profanity, Indecency Marks Shift in Policy, Robinson Says," University of Virginia School of Law, News & Media, November 16, 2006, accessed August 17, 2017, http://variety.com/1994/biz/news/fcc-s-barrett-blasts-quello-s-stern-warning-119388/.

74 Fowler et al., Brief for *Amici Curiae* (2006), 3.

75 John Eggerton, "Minow, Fowler: Strip FCC of Indecency-Enforcement Authority," *Broadcasting & Cable*, August 8, 2008; Mark Fowler, Jerald Fritz, Henry Geller, Glen O. Robinson, Kenneth G. Robinson, Jr., Newton N. Minow, and Timothy K. Lewis, Brief for *Amici Curiae* Former FCC Commissioners and Officials in Support of Petitioners, No. 10-1293, in U.S. Court of Appeals for the Second Circuit on Remand from the Supreme Court of the United States, *Fox Television Stations, Inc., et al. v. Federal Communications Commission*, filed November 9, 2011.

76 *Fox et al. v. FCC*, 489 F.3d 444 (2d Cir. 2007), 2.

77 *FCC v. Pacifica* (1978), §IVC.

78 *Fox et al. v. FCC* (2007), 29.

79 *Fox Television Stations v. FCC*, 129 S. Ct. 1800, 1819 (2009), pp 24, 31.

80 *Fox Television Stations, Inc., CBS Broadcasting, Inc., WLS Television, Inc., KTRK Television, Inc., KMBC Hearst-Argyle Television, Inc., ABC Inc. v. FCC*, Docket Nos. 061760-ag, 06-2750-ag, 065358-ag, decided July 13, 2010, 18, 23, 27. Hereafter *Fox et al. v. FCC* (2010).

81 KCSM was fined $15,000. See FCC, Notice of Apparent Liability and Memorandum Opinion and Order, in the Matter of Complaints regarding Various Television Broadcasts Between February 2, 2002 and March 8, 2005, adopted February 21, 2006, released March 15, 2006.

82 *Fox et al. v. FCC* (2010), §III.

83 Ibid., 32.

84 Email correspondence, Jon Minkoff, Information and Data Officer, Enforcement Bureau, FCC, May 4, 2017; see also FCC Customer Complaint Center, accessed May 30, 2017, https://consumercomplaints.fcc.gov/hc/en-us; dropdown menu options for complaints against radio and TV include "indecency."

85 John Eggerton, "Government Files Reply Brief in Indecency Challenge," *Broadcasting & Cable*, December 6, 2011.

86 The scarcity principle is based on the finite electromagnetic spectrum (the airwaves) over which broadcasters transmit their signals. John Eggerton, "MAP to Supremes: Pacifica Can Stand and FCC Indecency Enforcement Regime Still Fall," *Broadcasting & Cable*, November 3, 2011.

87 Nina Totenberg, "High Court Hears Arguments in FCC Indecency Case," National Public Radio, January 10, 2012. See http://www.npr.org/2012/01/10/144984607/high-court-hears-arguments-in-fcc-case, accessed March 4, 2012. Also FCC in the Matter of WPBN/WTOM, Memorandum and Order FCC 00-10, released January 14, 2000.

88 *FCC v. Fox* et al., 567 U.S.—(2012), 16–17.

89 Ibid., 12.

90 Holt, "NYPD Blue," 278.

91 *FCC v. Fox* et al. (2012), 18.

92 Ruth Bader Ginsburg, concurring in judgment, *FCC v. Fox* et al. (2012).

93 FCC, Public Notice: FCC Reduces Backlog of Broadcast Indecency Complaints by 70% (More Than One Million Complaints); Seeks Comment on Adopting Egregious Cases Policy, GN Docket No. 13-86, April 1, 2013.

94 Ibid.

95 Since 2011, Powell has been president and CEO of the National Cable & Telecommunications Association, the pay-TV and broadband service's trade and lobbying organization. See Marin Cogan, "In the Beginning, There Was a Nipple," *ESPN: The Magazine*, January 28, 2014, accessed August 19, 2017, http://www.espn.com/espn/feature/story/_/id/10333439/wardrobe-malfunction-beginning-there-was-nipple.

96 Katy Bachman, "Comments to FCC Overwhelmingly Support Strict Broadcast Indecency Rules," *Adweek*, August 2, 2013.

97 In 2014, over 99 percent of comments supported net neutrality; see Elise Hu, "3.7 Million Comments Later, Here's Where Net Neutrality Stands," *All Tech Considered*, NPR, September 17, 2014, accessed August 18, 2017, http://www.npr.org/sections/alltechconsidered/2014/09/17/349243335/3-7-million-comments-later

-heres-where-net-neutrality-stands. Also, Mike Snider, "Record 9 Million Comments Flood FCC on Net Neutrality," *USA Today*, July 19, 2017.

98 "Help Put a Stop to Anti-LGBT Attacks on the Spanish-Language Program 'Jose Luis Sin Censura,'" GLAAD (2011–2012), accessed August 18, 2017, https://www.glaad.org/jlsc.

99 FCC, In Re Liberman Broadcasting, Inc., Order and Consent Decree, November 14, 2013.

100 FCC, In the Matter of WDBJ Television, Inc., Notice of Apparent Liability for Forfeiture, EB-IHD-14-00016819/EB-12-IH-1363, released March 20, 2015, accessed March 16, 2017, https://apps.fcc.gov/edocs_public/attachmatch/FCC-15-32A1.pdf, ¶18, ¶19.

101 FCC, 2006 Indecency Omnibus Order, 21 FCC Rcd at 2716–17, ¶215–18, cited in NAL, WDBJ (2015), *n*57.

102 Jack N. Goodman and Robert Corn-Revere, Opposition to FCC Notice of Apparent Liability, In the Matter of WDBJ Television, Inc., EB-IHD-14-00016819 and EB-12-IH-1363.

103 Ibid., 9–10, 13.

104 Ibid., 31.

105 Email correspondence, Robert Corn-Reeve, June 14, 2017.

106 How lucrative are such mergers? The value of individual stations varies from market to market, but the amount of cash—and the number of stations—exchanging hands during the second decade of the twenty-first century is staggering. Schurz Communications sold fifteen stations to Gray Television for a reported $442.5 million, or an average of $29.5 million per station. Price Colman, "Gray: Strong Stations, Smart Operations," *TV NewsCheck*, January 19, 2016, accessed August 12, 2017, http://www.tvnewscheck.com/article/91617/gray-strong-stations-smart-operations. See also Michael J. de la Merced and Cecilia Kang, "TV Stations Rush to Seize on Relaxed F.C.C. Rules," *New York Times*, May 1, 2017.

107 See Parents Television Council, News & Reviews, Latest News, accessed June 17, 2017, at http://w2.parentstv.org/main/News/Latest.aspx. During the first half of 2017, the PTC was issuing press releases more or less weekly, many of which urged cancelation of offending shows, suggested boycotts against sponsors of offending shows, or demanded FCC investigations of particular broadcasts.

Chapter 3 Television: More or Less?

1 The *King of the Hill* episode is "Enrique-cilable Differences," first aired February 20, 2005.

2 FCC, Enforcement Bureau, "Obscenity, Indecency & Profanity (FAQ)," n.d., accessed September 29, 2017, https://www.fcc.gov/reports-research/guides/obscenity-indecency-profanity-faq; FCC, Enforcement Bureau, "TV Ratings & Channel Blocking," last reviewed/updated January 14, 2010, accessed September 29, 2017, https://transition.fcc.gov/eb/oip/RateBlock.html.

3 Raiford Guins, *Edited Clean Version: Technology and the Culture of Control* (Minneapolis: University of Minnesota Press, 2009), 33–34.

4 In 2010, Nielsen found that "the average American home now has 2.93 TV sets per household . . . the number of people per TV home holds steady at 2.5." See "U.S. Homes Add Even More TV Sets in 2010," The Nielsen Company Newswire,

April 28, 2010, accessed August 9, 2014, http://www.nielsen.com/us/en/insights /news/2010/u-s-homes-add-even-more-tv-sets-in-2010.html. By this time, many other screens—videogaming consoles, internet-connected computers, tablets, and smartphones—were also capable of streaming TV programming.

5 See, for example, Consumer Advisory Committee, "Further Recommendation Regarding 2006 Quadrennial Regulatory Review of the Commission's Media Ownership Rules," n.d., accessed August 9, 2015, https://apps.fcc.gov/edocs_public /attachmatch/DOC-289942A1.pdf. This document defines each type of diversity.

6 See, for example, Robert McChesney, *The Problem of the Media: U.S. Communication Politics in the Twenty-First Century* (New York: Monthly Review Press, 2004); or Ben H. Bagdikian, *The New Media Monopoly*, 20th ed. (Boston: Beacon, 2004).

7 From 1994 to 2003, investment by cable systems such as Time Warner and Cablevision in cable channels dropped from about 54 percent to about 30 percent, but the decline did not signal the entry of new owners into the market. Instead, over the same period, the broadcast networks (ABC, CBS, Fox, NBC, UPN, The WB) increased their investments in cable channels from just under 16 percent to over 63 percent. Then, as now, these markets are deeply entangled. See Cynthia Chris, "Can You Repeat That? Patterns of Media Ownership and the 'Repurposing' Trend," *The Communication Review* 9 (2006): 63–84.

8 Mara Einstein, *Media Diversity: Economics, Ownership, and the FCC* (Mahwah, NJ: Lawrence Erlbaum, 2004), vii.

9 Joe Nocera, "Giving Nepotism a Good Name," *The New York Times*, July 7, 2007.

10 Lynn Spigel, *Make Room for TV: Television and the Family Ideal in Postwar America* (Chicago: University of Chicago Press, 1992), 37.

11 Ibid., 39.

12 Ibid., 51, 54, 57.

13 Ibid., 54.

14 Bob Pondillo, "A 'Legion of Decency' for 1950s Television?," *Television Quarterly* 33, nos. 2–3 (2001): 16–21.

15 Anne Gray's study of how families negotiated, delegated, and controlled access to remote controls and VCRs in the 1980s shows that the Kramdens' experience was not only fictional and comedic but rife in real life and emblematic of power imbalances within families. See her *Video Playtime: The Gendering of a Leisure Technology* (New York: Routledge, 1992).

16 Spigel, *Make Room for TV*, 65–72.

17 Leo Bogart, *The Age of Television: A Study of Viewing Habits and the Impact of Television on American Life* (New York: Frederick Ungar, 1956), 101, cited in Spigel, *Make Room for TV*, 44.

18 *The Beulah Show* (1950–1952, on ABC); *Amos 'n' Andy* (1951–1953), CBS's controversial adaptation of the popular radio serial; and *The Nat King Cole Show* (1956–1957, NBC) constitute the precious few series featuring African American performers during television's first decade. Marlon Riggs' documentary *Color Adjustment* is a key survey of these programs, demeaning stereotypes, and associated controversies (distributed by California Newsreel, 1991).

19 On the male-dominated audiences for sports on TV in bars, see Anna McCarthy, *Ambient Television: Visual Culture and Public Space* (Durham, NC: Duke University Press, 2001), 29–62.

20 John McMurria, *Republic on the Wire: Cable Television, Pluralism, and the Politics of New Technologies* (New Brunswick, NJ; Rutgers University Press, 2017), 35–36.

21 Sylvester "Pat" Weaver, former president of NBC, was among founders of STV. See McMurria, *Republic on the Wire,* esp. chap. 3, 95–97.

22 Congress made sure that the FCC did not allow pay-TV services to seriously compete with broadcasters through the 1960s, perhaps to protect relationships between elected officials and local stations, who stood to lose viewers, and therefore advertising revenue, if consumer choice expanded. See John McMurria, "A Taste of Class; Pay-TV and the Commodification of Television in Postwar America," in Sarah Banet-Weiser, Cynthia Chris, and Anthony Freitas, eds., *Cable Visions: Television Beyond Broadcasting* (New York: New York University Press, 2007), 46.

23 Jon Lewis, *Hollywood v. Hard Core: How the Struggle Over Censorship Saved the Modern Film Industry* (New York: New York University Press, 2002), 105–27.

24 Megan Mullen discusses pioneering cable "firsts" in Tuckerman, Arkansas; Astoria, Oregon; and Mahanoy City, Lanford, and Pottsville, Pennsylvania, in "The Moms 'n' Pops of CATV," in Banet-Weiser, Chris, and Freitas, *Cable Visions,* 24–43. In each of these locations, community-access antenna-television (CATV) systems were operational by 1951.

25 United States General Accounting Office, Report to the Chairman, Committee on Commerce, Science, and Transportation, U.S. Senate: Telecommunications: Issues Related to Competition and Subscriber Rates in the Cable Television Industry, GAO-04-8 (Washington, DC: October 2003): 7. Congress renamed the GAO in 2004 as the Government Accountability Office, keeping the same acronym. Henceforth cited as GAO-04-08, Issues Related to Competition and Subscriber Rates.

26 Patrick R. Parsons and Robert M. Frieden, *The Cable and Satellite Television Industries* (Boston: Allyn and Bacon, 1998), 122.

27 FCC, *Annual Assessment of the Status of Competition in the Market for the Delivery of Video Programming: First Report,* CS Docket No. 94-48, released September 28, 1994, 7549–7550, ¶220, 224. Published within *FCC Record* 9, no. 25 (1994), 7442–7637.

28 FCC, *Annual Assessment of the Status of Competition in the Market for the Delivery of Video Programming: Twelfth Annual Report,* MB Docket No. 05-255, released March 3, 2006, 4–5, ¶8, 14.

29 Ibid., ¶21–22.

30 FCC, *Annual Assessment of the Status of Competition in the Market for the Delivery of Video Programming: Fifteenth Report,* MB Docket No. 12-203, released July 22, 2013, 46, ¶100. A footnote is a little more specific: "Comcast offers 300 channels and Time Warner Cable offers over 400 channels." See FCC, *Annual Assessment: Fifteenth Report,* 46n311.

31 Ibid., 4, ¶3–4.

32 GAO-04-8, Issues Related to Competition and Subscriber Rates in the Cable Television Industry.

33 FCC Media Bureau, Further Report on the Packaging and Sale of Video Programming Services to the Public (February 9, 2006), 4n5. Hereafter, Further Report 2006.

34 Alex Mindlin, "Despite Choices on TV, the Favorites Reign," *New York Times,* March 26, 2007.

35 See Chris, "Can You Repeat That?," esp. 74–78. An invaluable source on the subject of reruns is Derek Kompare, *Rerun Nation: How Repeats Invented American Television* (New York: Routledge, 2004).

36 There are several individuals who hold patents for components of the V-chip system. See Black Inventors and Scientists Museums, Inc., "Joseph N. Jackson: Inventor of the Programmable Television Receiver," http://theblackinventionsmuseum.org/BISMuseums/Joseph_N_Jackson.html, accessed September 9, 2016; Lawrie Mifflin, "Questions Linger as F.C.C. Prepares V-Chip Standards," *New York Times*, March 12, 1998; George Leopold, "Patent Dispute Threatens to Delay V-Chip," *EE Times*, February 12, 1999, http://www.eetimes.com/document.asp?doc_id=1138656.

37 Frank Ahrens, "Senator Bids to Extend Indecency Rules to Cable," *Washington Post*, March 2, 2005; Bill Keveney, "Lieberman Offers Glimpse of V-chip, TV Views," *Hartford Courant*, March 5, 1996.

38 Guins, *Edited Clean Version*, 46–47.

39 Eriq Gardner, "Republican Party Platform Urges More TV Obscenity Prosecutions," *Hollywood Reporter*, August 28, 2012.

40 See Michael Phillips, "'Love Is Strange' MPAA Rating Controversy," *Chicago Tribune*, August 28, 2014, which points out that this film, about gay senior citizens who experience unexpected consequences after marrying, received an R-rating for a few uses of the "F-word," while other films with more profanity—and many with a great deal of violence—were rated PG-13. Kirby Dick's documentary about the MPAA system, *This Film Is Not Yet Rated* (2006), concluded that films featuring gay characters are consistently given much more strict ratings, even when other factors—degree of sexual explicitness, language—are the same.

41 This current set of film ratings follows several adjustments made to the system, which originally included only G (general audiences), M (mature audiences), R (minimum age 16,unless chaperoned by a parent or guardian), and X (minimum age 18). In 1970, M became GP, which changed to PG in 1972. The MPAA added the PG-13 rating in 1984 and replaced X with NC-17 in 1990. Ratings are based on instances of "strong language," nudity, sexuality, violence, smoking, drug use, disturbing images, mature themes, and other factors; see *Classification Ratings and Rules*, revised January 1, 2010 (Sherman Oaks, CA: Motion Picture Association of America and Washington, DC: National Association of Theatre Owners), esp. 5–8.

42 The Federal Trade Commission has pressured the National Association of Theatre Owners to enforce age restrictions, but participation in the ratings system is voluntary, and theater employees may lack authority. See Pamela McClintock, "FTC Report: Theaters Making 'Marked Improvement' in Enforcing Movie Ratings," *The Hollywood Reporter*, March 25, 2013, and Jacob Gershman, "Do Theaters Have to Enforce Movie Ratings?," *Wall Street Journal*, law blog, October 25, 2013, accessed August 30, 2014, http://blogs.wsj.com/law/2013/10/25/do-theaters-have-to-enforce-movie-ratings/.

43 The TV Parental Guidelines, "Understanding the TV Ratings," accessed August 25, 2014, http://www.tvguidelines.org/ratings.htm.

44 Ted Hearn, "NCTA Update Congress on Media Literacy," *Multichannel News*, November 22, 2004.

45 An FCC report assessing the 1996 act's effectiveness in stymying children's access to violent media concluded that "the V-chip is of limited effectiveness," given how few households put it to use, according to surveys conducted by the Kaiser Family Foundation (KFF) and other pollsters. See FCC, *Violent Television Programming and Its Impact on Children*, M.B. Docket No. 04-261, April 25, 2007, page 14, ¶29. A few years later, KFF reported continuing parental befuddlement, stating, "Only 11% know that the rating FV has anything to do with violence . . . just 2% know that 'D' indicates suggestive dialogue." See Victoria Riseout and the Jenry J. Kaiser Family Foundation, *Parents, Children & Media: A Kaiser Family Foundation Survey* (Publication #7638, Menlo Park, CA, June 2007).

46 L. Brent Bozell III, "The V-Chip Is No Magic Bullet," *Washington Times*, April 19, 2005; reprinted in *Catholic Exchange*, April 25, 2005, accessed August 13, 2017, https://catholicexchange.com/v-chip-is-no-magic-pill.

47 Ibid.

48 Erica Ogg, "Parents Group Derides V-Chip Ads," *CNET*, July 27, 2006, accessed August 13, 2017, https://www.cnet.com/news/parents-group-derides-v-chip-ads/.

49 "Re: Evaluation of the Existing Television Content Rating System," letter to Chairman Tom Wheeler et al., Federal Communications Commission, from Tim Winter, president, Parents Television Council et al., May 9, 2016, accessed September 4, 2016, http://w2.parentstv.org/blog/index.php/2016/05/09/coalition-calls-on-fcc-to-reform-tv-ratings/.

50 "Re: Television Content Ratings System," letter, to Chairman Tom Wheeler et al., Federal Communications Commission, from Douglas A. Gentile, Ph.D., Iowa State University et al., April 26, 2016, accessed December 21, 2017, http://w2.parentstv.org/MediaFiles/PDF/Letters/Academia_RatingsLetter.pdf. Studies cited in the letter include, among many others, Lowell R. Huesmann, Jessica Moise-Titus, Cheryl-Lynn Podolski, and Leonard D. Eron's "Longitudinal Relations Between Children's Exposure to TV Violence and Their Aggressive and Violent Behavior in Young Adulthood: 1977–1992," *Developmental Psychology* 39, no. 2 (2003): 201–221; and Aletha C. Huston, Edward Donnerstein, Halford Fairchild, Norma D. Feshbach, Phyllis A. Katz, John P. Murray, Eli A. Rubenstein, and Diana M. Zuckerman, *Big World, Small Screen: The Role of Television in American Society* (Lincoln, NE: University of Nebraska Press, 1992).

51 Shalom M. Fisch and Rosemarie T. Truglio, *"G" Is for Growing: Thirty Years of Research on Children and Sesame Street* (Mahwah, NJ: Lawrence Erlbaum, 2001) and Daniel R. Anderson, Althea C. Huston, K. L. Schmitt, Deborah L. Linebarger, and John C. Wright, "Early Television Viewing and Adolescent Behavior," *Monographs of the Society for Research in Child Development* 66, no. 1; both cited in the "Re: Television Content Ratings System" letter, Gentile et al., 2016.

52 Ted Hearn, "Barton: Cable Indecency Law Coming," *Multichannel News*, May 18, 2004; Steve McClellan, "Barton Predicts Cable, Satellite Indecency Rules," *Broadcasting & Cable*, April 19, 2004; John Eggerton, "Hill Bill Targets Violence," *Broadcasting & Cable*, March 15, 2015.

53 Ted Hearn, "Copps Favors Cable-Indecency Regs," *Broadcasting & Cable*, April 21, 2004.

54 John Eggerton, "NAB Chairman Blasts Indecency Crackdown," *Broadcasting & Cable*, February 3, 2005.

55 Ted Hearn, "Powell: Cable Smut Regulations Unconstitutional," *Multichannel News*, March 3, 2005.

56 Ted Hearn, "CRS Study Pans Cable Indecency Rules," *Multichannel News*, December 7, 2005; Ted Hearn, "How Bad Will It Get at the FCC: Cable Lawyers and Lobbyists Question FCC Chairman Kevin Martin's Attempt to Force New Regulations on Cable TV Operators," *Multichannel News*, November 12, 2007.

57 Hearn, "Powell."

58 John Eggerton, "Pay TV Tiering Bill Introduced," *Broadcasting & Cable*, April 29, 2005. See also text of S. 946 (109th): Kid Friendly TV Programming Act of 2005, introduced April 28, 2005, to the Committee on Commerce, Science, and Transportation, https://www.govtrack.us/congress/bills/109/s946/text.

59 John Eggerton and John M. Higgins, "Cable Ops Offer Family Tiers, Says McSlarrow," *Broadcasting & Cable*, December 12, 2005.

60 R. Thomas Umstead, "Time Warner Spells Out Family Tier," *Multichannel News*, December 15, 2005.

61 Anne Becker, "Comcast Announces Family Tier," *Broadcasting & Cable*, December 22, 2005.

62 ESPN costs cable providers far more than any other channel: according to the research firm SNL Kagan, in 2014, it cost $6.04 per subscriber per month, more than four times the cost of the second most expensive channel (TNT, at $1.48). Four of the ten costliest nationally distributed channels are sports-oriented (ESPN, the NFL Network, ESPN2, and FOX Sports 1). See Rani Molla, "How Much Cable Subscribers Pay per Channel," *Wall Street Journal*, August 5, 2014, blogs.wsj .com/numbers/how-much-cable-subscribers-pay-per-channel-1626/, accessed January 25, 2015.

63 Consider the forest as a source of threat in *Little Red Riding Hood* and *Hansel and Gretel*. In *The Wizard of Oz* (1939), Dorothy finds the forest "dark and creepy," and the Scarecrow warns, "it'll get darker before it gets lighter."

64 Guins, *Edited Clean Version*, 35–36.

65 Time Warner Cable, Family Choice, accessed August 21, 2014, http://165.237.62.28 /East/learn/programming/family/familychoice.html.

66 TWC, FAQs, accessed September 27, 2014, http://www.timewarnercable.com/en /residential-home/support/faqs/faqs-tv/programmin/familychoi/why-did-time -warner-cable-crea.html; http://www.timewarnercable.com/en/residential-home /support/faqs/faqs-tv/programmin/familychoi/can-i-order-family-choice-on-o.html.

67 SkyAngel Faith & Family Television, "About Us: Robert W. Johnson," accessed August 21, 2014, http://www.skyangel.com/About/CompanyInfo/Overview /default_14.aspx.

68 Christian marketing, media, and branding campaigns are explored in Heather Hendershot, *Shaking the World for Jesus: Media and Conservative Evangelical Culture* (Chicago: University of Chicago Press, 2004); Mara Einstein, *Brands of Faith: Marketing Religion in a Commercial Age* (New York: Routledge, 2007); and Sarah Banet-Weiser, *Authentic™: The Politics of Ambivalence in a Brand Culture* (New York: New York University Press, 2012), esp. chap. 5, "Branding Religion: I'm Like Totally Saved," 165–210.

69 Telecommunications companies providing cable TV, phone and internet service consistently rank at or near the bottom of the American Consumer Satisfaction Index. In 2015, the industry ranked dead-last among 43 industries included in the

survey. See Rebecca R. Ruiz, "Customer Satisfaction with TV, Internet and Phone Service at 7-Year Low, Study Finds," *New York Times*, June 2, 2015, http://bits.blogs .nytimes.com; also, Doug Aamoth, "Everybody Hates Time Warner Cable and Comcast," Time.com, May 20, 2014.

70 Geraldine Fabrikant, "Media; Need ESPN But Not MTV? Some Push for That Option," *The New York Times*, May 31, 2009.

71 John Eggerton, "Bigwigs Want Skinny on Buffet Cable," *Broadcasting & Cable,* May 19, 2004; Ted Hearn, "FCC Opens a la Carte Inquiry Sought by House, *Multichannel News,* May 25, 2004. Later, Senator McCain's motives for championing the issue came under scrutiny when it became clear that pro à la carte Cablevision was a big donor to The Reform Institute, a think tank associated with McCain. See "McCain Group Got Big Cable Donation," *New York Times*, March 7, 2005.

72 GAO-04-08, Issues Related to Competition and Subscriber Rates, 1–2, 30.

73 Ibid., 6. In quotes and titles, I preserve the source's spelling of the term *à la carte*, which may omit the accent grave.

74 Ted Hearn, "Conservative Groups Pushing a la Carte," *Multichannel News*, April 29, 2004; Eggerton, "Bigwigs Want Skinny on Buffet Cable."

75 John Eggerton, "Black Caucus Opposes a la Carte," *Broadeasting & Cable*, May 19, 2004.

76 Consumers Union/CFA, 1.

77 Ibid., 1.

78 Ibid., 19–20.

79 Ibid., 1, 2, 25.

80 FCC Media Bureau, Report on the Packaging and Sale of Video Programming Services to the Public, to U.S. House of Representatives Committee on Energy and Commerce, November 18, 2004, 6. Hereafter, Media Bureau Report, 2004.

81 Ibid., 6.

82 Ibid., 6.

83 Ted Hearn, "PTC, McCain Slam à la Carte Report," *Multichannel News*, November 22, 2004.

84 Ted Hearn, "Groups Revive à la Carte Campaign," *Multichannel News*, July 20, 2005.

85 Michael Farrell, "Dolan with Martin on a la Carte," *Multichannel News*, December 1, 2005.

86 P. J. Bednarski, John M. Higgins, and Mike Grebb, "Martin Touts A-La-Carte Pricing for Cable," *Broadcasting & Cable*, November 29, 2005.

87 Ted Hearn, "Martin's New FCC Study Favors a la Carte," *Multichannel News*, November 29, 2005.

88 The revised FCC report also stated that subscribers might save as little as 1 percent and as much as 13 percent per month. Further Report on the Packaging and Sale of Video Programming Services to the Public (February 9, 2006), 4.

89 Ted Hearn, "Martin Pitches a la Carte to Pitch Industry," *Multichannel Newswire*, January 18, 2007.

90 John Eggerton, "NAACP Opposes A La Carte," *Broadcasting & Cable*, March 15, 2007; John Eggerton, "Minority Programmers Fight À La Carte," *Broadcasting & Cable*, March 28, 2007.

91 Comcast asked the U.S. Court of Appeals to get involved when its request to waive a set-top box rule was denied, after the FCC had granted a waiver to Cablevision,

which had been more amenable to à la carte. (The contested rule required cable systems to make their systems compatible with boxes from any and all competitors). The lawsuit didn't get far, but it was one of several signs telling just how querulous relations between the FCC and the industry had become. Erin Marie Daly, "Comcast Suffers Blow in Set Top Box Appeal," Law360.com, May 16, 2008; see *Comcast Corp. v. FCC* 07-1445, U.S. Court of Appeals for the District of Columbia Circuit.

92 "Deception and Distrust: The Federal Communications Commission Under Chairman Kevin J. Martin." A majority Staff Report Prepared for the Use of the Committee on Energy and Commerce, U.S. House of Representatives, 110th Congress, December 2008, 1.

93 Ibid., 9.

94 "A la Carte Gets Bashed at FCC Hearing," *TV Technology*, July 30, 2004, accessed January 26, 2015, http://www.tvtechnology.com/news/0086/a-la-carte-gets-bashed-at-fcc-hearing/195314.

95 Tom Lowry, "Will the Fox and Time Warner Cable Spat Rekindle the A La Carte Debate?," Bloomberg Business Week Archives, December 30, 2009, accessed January 25, 2015, http://www.businessweek.com/stories/2009-12-30/will-the-fox-and-time-warner-cable-spat-rekindle-the-a-la-carte-debate.

96 Yinka Adegoke, "In a Switch, Cable Operators Want to Go 'a la Carte,'" Reuters, September 27, 2011, accessed January 25, 2015, http://www.reuters.com/article/2011/09/27/cable-idUSS1E78K05L20110927.

97 At the start of 2014, industry analysts at SNL Kagan reported that 5 percent of households were cord-cutters. See Gautham Nagesh, "Online Video Could get a Boost from Proposed Laws," *Wall Street Journal*, wsj.com, January 7, 2014.

98 Andrew Wallenstein, "A La Carte TV Will Never Be," *Variety* 319, no. 5 (April 23, 2013): 25.

99 A study by the investment and assets-management firm Needham suggested a worse-case scenario resulting from à la carte, in which only some twenty channels would remain financially viable. An executive from the advertising media buyer Group M saw things differently: under à la carte, he speculated, smaller channels would reach fewer homes but draw the same number of viewers; as a result, their value to advertisers wouldn't change a bit. See Jeanine Poggi, "What 'a la Carte' Would Mean for Advertisers," *Advertising Age*, September 23, 2013; also Sam Thielman, "A la Carte Is the Worst Idea Anyone Ever Had," *Adweek*, August 14, 2013.

100 Cynthia Littleton, "HBO to Launch Standalone Over-the-Top Service in U.S. Next Year," *Variety*, October 15, 2014.

101 Jeanine Poggi, "CBS Starts Offering Its Signal Over the Web as Over-the-Top Gate Opens," *Ad Age*, October 16, 2014.

102 Emily Stone, "Nickelodeon to Offer a Streaming Service as Viacom Steps Up Digital Efforts," *The New York Times*, January 30, 2015.

103 Time Warner Cable began using "TV Everywhere" to describe its new capabilities that offered customers access to channels on multiple internet-connected devices in 2009; although it remains associated with the brand, it also functions as a generic term.

104 For discussions of neoliberal citizenship vis-à-vis media use, see Laurie Ouellette, "Take Responsibility for Yourself: Judge Judy and the Neoliberal Citizen," in Susan

Murray and Laurie Ouellette, eds., *Reality TV: Remaking Television Culture* (New York: New York University, 2004), 223–242; John McMurria, "Desperate Citizens and Good Samaritans: Neoliberalism and Makeover Reality TV," *Television and New Media* 9, no. 4 (July 2008): 305–332; also, Guins, *Edited Clean Version*, esp. 36.

105 The Supreme Court struck down portions of the CDA pertaining to indecency and the internet in *Reno v. ACLU*, 521 U.S. 844 (1997). The CDA constituted Title V of the Telecommunications Act of 1996.

Chapter 4 Bleeps and Other Obscenities

1 Michael Walsh, "Fired TV Anchor A. J. Clemente Explains his F-bomb Blunder on 'Today' Show," *Daily News* (New York), April 24, 2013, accessed January 7, 2014, http:// newww.nydailyws.com/news/national/fired-tv-anchor-explains-f-bomb -blunder-article-1.1326078#commentpostform.

2 "U.S. Local TV Market Rankings/Ranked by Number of TV Households per Designated Market Area (DMA)/As of September 1, 2012," Sports TV Jobs, Resources, accessed January 7, 2014, http://www.sportstvjobs.com/resources /local-tv-market-sizes-dma.html.

3 "Station Facing Backlash After Firing Anchor for Cursing on Air on First Day," CBS Seattle News, April 23, 2013, accessed January 7, 2013, http://seattle.cbslocal. com/2013/04/23/station-facing-backlash-after-firing-anchor-for-cursing-on-air-on-first-day/. See also Merrill Knox, "A. J. Clemente Says His Media Classes Are 'Sold Out,'" TVSPY, January 31, 2014, accessed March 15, 2014, http://www .mediabistro.com/tvspy/a-j-clemente-says-his-media-classes-are-sold-out_b114439.

4 Clay Jenkinson, "The Errant F-word Is the Least of Our Challenges," *The Bismarck Tribune*, May 5, 2013, accessed January 7, 2013, http://bismarcktribune.com/news /columnists/clay-jenkinson/the-errant-f-word-is-the-least-of-our-challenges/article _77a2019e-b287-11e2-8f73-001a4bcf887a.html.

5 John Mitchell, "North Dakota Anchorman Fired for On-Air Profanity," *Entertainment Weekly* Popwatch, April 23, 2013, accessed January 7, 2013, http://popwatch .ew.com/2013/04/23/north-dakota-anchor-fired-profanity/.

6 Jenkinson, "The Errant F-word."

7 The Parents Television Council's mission is "To protect children and families from graphic sex, violence and profanity in the media, because of their proven long-term harmful effects. . . . To provide a safe and sound entertainment media environment for children and families across America." See The PTC Mission, Parents Television Council, accessed June 24, 2015, http://w2.parentstv.org/main/About/mission. aspx.

8 See Christopher M. Fairman, *Fuck: Word Taboo and Protecting Our First Amendment Liberties* (Naperville, IL: Sphinx, 2009).

9 It is also very likely that the race and ethnicity of the speaker factor into contextual considerations of potentially indecent incidents, consciously or unconsciously, but so few of the cases that have resulted in formal declarations of broadcast indecency by the FCC have involved non-white performers that I am hesitant to generalize on this point. This may only be evidence of a persistent paucity of people of color in central mass-media roles and the niching of black audiences to less regulated cable channels. I do address cases in which race or ethnicity are factors, either in regard to how the FCC adjudicates (see discussions of the WKAQ case in chapter 1 and the

WSKQ case in the conclusion) or how the media covers these incidents (see discussion of Janet Jackson's performance at the 2004 Super Bowl halftime show in chapter 2).

10 David Antin, "Video: The Distinctive Features of the Medium," in *Video Art* (Philadelphia: Institute of Contemporary Art, University of Pennsylvania, 1975); also, Robert Vianello, "The Power Politics of 'Live' Television," *Journal of Film and Video* 37, no. 3 (Summer 1985), 26.

11 Antin, "Video," 61.

12 See Cynthia Chris, "Can You Repeat That? Patterns of Media Ownership and the 'Repurposing' Trend," *The Communication Review* 9 (2006): 63–84, esp. 76–77; also, Derek Kompare, *Rerun Nation: How Repeats Invented American Television* (New York: Routledge, 2004).

13 Antin, "Video," 60.

14 Ibid., 61.

15 Associated Press, "'Saturday Night Live' Will Be Live on West Coast," *Mercury News* (San Jose, CA), March 16, 2017, accessed October 1, 2017, http://www.mercurynews.com/2017/03/16/saturday-night-live-to-air-live-to-all-not-taped-for-some/. The shift to nationwide live broadcasts, with two time zones now showing *SNL* in primetime, presents new challenges for the show, as airing in the safe harbor after 10:00 P.M. previously protected performers' occasional expletives from indecency fines.

16 "SNL Going LIVE During Family Hours," *PTC Weekly Wrap* (email newsletter), September 29, 2017.

17 For an interview with Weir that includes footage from the broadcast, see "The Day of Desperation—January 22, 1991," YouTube, uploaded by tens across, December 1, 2010, accessed August 7, 2014. For more on ACT UP's Day of Desperation, see the DIVA TV Program Synopsis, http://www.actupny.org/diva/synDesperation.html, accessed August 7, 2014.

18 Cavan Sieczkowski, "'Jaws' Music Cuts Off 'Life of Pi' Visual Effects Team Oscar Speech," *Huff Post Entertainment*, February 24, 2013, accessed August 7, 2014, http://www.huffingtonpost.com/2013/02/24/jaws-oscars-life-of-pi-_n_2756380.html; Rae Annfera, "When Winning an Oscar Means Bankruptcy: VFX Artists Protest the Academy Awards," Co.Create, February 25, 2013, accessed August 17, 2013, http://www.fastcocreate.com/1682488/when-winning-an-oscar-means-bankruptcy-vfx-artists-protest-the-academy-awards#1; "Visual Effects Artists Angry as Bill Westenhofer's 'Life of Pi' Oscar Speech Gets Cut Short, *AceShowbiz*, February 26, 2013, accessed July 8, 2014, http://www.aceshowbiz.com/news/view/00058240.html.

19 John Ellis, *Visible Fictions: Cinema Television Video* (New York: Routledge & Kegan Paul, 1982), 132. Emphasis added. For another take on television's "immediacy," see Rhona J. Berenstein, "Acting Live: TV Performance, Intimacy, and Immediacy (1945–1955)" in James Friedman, ed., *Reality Squared: Television Discourse on the Real* (New Brunswick, NJ: Rutgers University Press, 2002), 26.

20 Jane Feuer, "The Concept of Live Television: Ontology as Ideology," in E. Ann Kaplan, ed., *Regarding Television* (Los Angeles: American Film Institute and Frederick, MD: University Publications of America, 1983), 14.

21 Feuer paraphrases Stephen Heath and Gillian Skirrow, "Television: A World in Action," *Screen* 18, no. 2 (Summer 1977): 7–59, in "The Concept of Live Television," 14.

22 Feuer, "The Concept of Live Television," 15.

23 John Thornton Caldwell, *Televisuality: Style, Crisis, and Authority in American Television* (New Brunswick, NJ: Rutgers University Press, 1995), 27.

24 Caldwell, *Televisuality*, 27–31, 367n80.

25 Mimi White, "The Attractions of Television: Reconsidering Liveness," in Nick Couldrey and Anna McCarthy, eds., *MediaSpace: Place, Scale and Culture in a Media Age* (New York: Routledge, 2004), 76.

26 Ibid., 85.

27 See Brian Stetler, "If a Quiz Show Succeeds, NBC Gets the Grand Prize," *New York Times*, September 7, 2013, C1, C5.

28 Michael O'Connell, "'Million Second' Misfire: NBC Spins Quiz Show's Ratings Debacle," *Hollywood Reporter*, September 18, 2013.

29 Jeremy Enger, "The Hills Are a Prop, and the Show Is Live," *New York Times*, December 1, 2013; and David Hinckley, "TV Is Live with 'The Sound of Music,' Starring Carrie Underwood and Stephen Moyer," *Daily News* (NY), December 1, 2013.

30 *Gimme a Break* ("Cat Story," 1985), *ER* ("Ambush," 1997), *West Wing* ("The Debate," 2005), *Will & Grace* ("Alive and Schticking," 2005), and *30 Rock* ("Live Show," 2010, and "Live from Studio 6H," 2012) all offered live episodes. Most were performed live twice: first for Eastern and Central time zones, and three hours later for Mountain and Pacific zones. After *Roc* aired a live episode ("The Hand That Rocs the Cradle," 1992) during its first season, Fox decided to produce the entire second season (1992–1993) live—for the East Coast, anyway. Like *Saturday Night Live* (1975–), *Roc* recorded the live broadcast for western feeds. For an example of the critical support that comes out around live broadcasts, see Dave Itzhoff, "Tina Fey on the '30 Rock' Live Episode and the Show's Future," *New York Times*, ArtsBeat: The Culture at Large, April 24, 2012.

31 "Nielsen Estimates 116.4 Million TV Homes in the U.S. for the 2015–16 TV Season," August 28, 2015, accessed March 31, 2016, http://www.nielsen.com/us/en /insights/news/2015/nielsen-estimates-116-4-million-tv-homes-in-the-us-for-the-2015-16-tv-season.html; Nellie Andreeva, "Starz Rises to No. 2 Pay Cable Network in Subscribers," *Deadline Hollywood*, March 26, 2015, accessed March 31, 2016, http://deadline.com/2015/03/starz-no-2-pay-cable-network-subscribers -q4-2014-1201399405/.

32 Federal Communications Commission, Memorandum Opinion and Order, in the Matter of Complaints Against Various Broadcast Licensees Regarding Their Airing of the "Golden Globe Awards" program, File No. EB-03-1H-0110, adopted March 3, 2004, released March 18, 2004, accessed June 26, 2015, https://www.fcc .gov/eb/Orders/2004/FCC-04-43A1.html. Subsequently referred to as the Golden Globes Order.

33 Associated Press, "66 ABC Affiliates Didn't Show 'Ryan,'" *Today*, November 10, 2004, accessed August 22, 2018, https://www.today.com/popculture/66-abc -affiliates-didnt-show-ryan-wbna6455962.

34 Notices of Apparent Liability and Memorandum Opinion and Order, In the Manner of Complaints Regarding Various Television Broadcasts Between February 2, 2002, and March 8, 2005, adopted February 21, 2006, released March 15, 2006, ¶72, accessed September 30, 2017, https://transition.fcc.gov/eb /Orders/2006/FCC-06-17A1.html. Hereafter, Omnibus Order 2006.

35 Ibid., ¶73.

36 Ibid., ¶82.

37 Ibid., ¶86.

38 Four prior rulings advising "restraint" in regard to "single, non-literal" expletives are cited in *Fox et al. v. FCC*, 7.

39 In re Complaints Against Various Broadcast Licenses Regarding the Airing of the "Golden Globe Awards" Program, 19 FCCR 4575 (2004), 5, ¶9; 6, ¶11. Hereafter, Golden Globes Order (2004).

40 *Fox Television Stations, Inc., CBS Broadcasting Inc., WLY Television, Inc., KTRK Television, Inc., KNBC Heart-Argyle Television, Inc., ABC Inc. v. Federal Communications Commission*, United States Court of Appeals for the Second Circuit, Docket Nos. 06-10-ag, 06-2750-ag, 06-5358-ag, decided July 13, 2010, page 4*n*23. Hereafter *Fox et al. v. FCC* (2010). See also Melissa Mohr, *Holy Shit: A Brief History of Swearing* (New York: Oxford University Press, 2013), 7, 215–217, for a discussion of the multiple uses and meanings of the work "fuck," including as an intensifier; her examples date as far back as 1790.

41 Golden Globes Order (2004), 8, ¶8.

42 *Fox et al. v. FCC* (2010), 26, 28.

43 "Diane Keaton Drops F-Bomb on 'Good Morning America,'" Fox News, January 16, 2008, accessed March 15, 2014, http://www.foxnews.com/story/2008/01/16/diane-keaton-drops-f-bomb-on-good-morning-america/. Video clips from the scene were distributed by TMZ.com, The Huffington Post website, on YouTube (see FTVLive.com: "Diane Keaton drops the F-Bomb on GMA," accessed March 15, 2014, http://www.youtube.com/watch?v=OnIu5CZNfDw,), and elsewhere.

44 Bill Hutchinson, "Jane Fonda Apologizes for Off-Color Slang on 'Today' Show," February 14, 2008, accessed October 25, 2013, http://www.nydailynews.com/entertainment/gossip/jane-fonda-apologizes-off-color-slang-today-show-article-1.306752#ixzz2il2PoIGI; Parents' Television Council, "NBC Assaults Families with Offensive Language on Today Show," February 14, 2008, accessed October 25, 2013, http://www.parentstv.org/ptc/news/release/2008/0214.asp.

45 The possibility of control-room staff failing to "dump" a profanity within the (usual) seven-second window is reminiscent of a scene in *Network* (1976), in which anchorman Howard Beale (Peter Finch) says, on-air, that he will kill himself during a future broadcast. Control-room staff, idly chatting, completely miss the announcement.

46 Corinne Heller, "OTRC: Melissa Leo Apologizes for 'F-Bomb' at Oscars," *ABC7 Eyewitness News*, Los Angeles, n.d., accessed August 7, 2014, http://abc7.com /archive/7984417/.

47 This device—a stationary camera trained on a seated contestant, out of earshot of other competitors—is a convention of this type of reality TV show. On MTV's *The Real World* (1992–), it is known as the "confessional." On *Big Brother* (2000–), based on the show of the same name created by John de Mol for Dutch TV in 1997), the space is known as the "diary room." Both terms infer that what is said to the camera is private, but of course it is not.

48 The "Sailor Mouth" episode (September 21, 2001) of *Spongebob Squarepants* (1999–present) aired on Nickelodeon, and therefore, technically, was not subject to the same rules as programs originating on broadcast networks; but its use of the

bleeped profanity is equally noteworthy, since it occurred in a zone that is typically profanity-averse: children's TV.

49 On *Action*'s use of bleeped "obscenities and epithets," see Louis Chunovic, *One Foot on the Floor: The Curious Evolution of Sex on Television from* I Love Lucy *to* South Park (New York: TV Books, 2000), 160–161.

50 These aren't isolated cases. The scripted bleep can be found in episodes of Fox's *The Simpsons* ("Bart's Inner Child," 1993, and "Judge Me Tender," 2010); NBC's *Parks and Recreation* ("The Stakeout," 2009) and *30 Rock* ("Standards and Practices," 2012); and ABC's *The Goldbergs* ("Circle of Dreams," 2013), among others. On ABC's *Downward Dog*, an episode ("Loyalty," May 30, 2017) bleeped and pixelated the mouths of both a human and a CGI-assisted canine when they uttered scripted "fucks"—twice for Nan (Alison Tolman) and just once for Martin the dog, when he referred to Nan's boss, who refused to throw a coveted tennis ball, as a "[bleep]-ing ball tease."

51 Archie Bland, "Grumpy Old Man to Star in First Twitcom," *The Independent*, November 13, 2009, http://www.independent.co.uk/news/media/tv-radio/grumpy-old-man-to-star-in-first-twitcom-1819933.html. See also Brian Stelter, "First Came the Tweets, and Then the Sitcom," *New York Times*, May 18, 2010, http://www.nytimes.com/2010/05/19/arts/television/19shatner.html.

52 Jason Halpern got a second chance to develop a sitcom around a character based on his father. *Surviving Jack*, with Christopher Meloni in the father role, lasted for only eight episodes on Fox in 2014. A reviewer called its humor, relative to the original Twitter feed, "neutered." See Joshua Kline, "TV Review: Sh*t His Dad Doesn't Say," *Tulsa Voice*, April 2014, accessed June 17, 2015, http://www.thetulsavoice.com/April-2014/Sht-his-dad-doesnt-say/.

53 See Virginia Heffernan, "Epithet Morphs From Bad Girl to Weak Boy," *The New York Times*, March 22, 2005. See also Sheryl Kleinman, Matthew B. Ezzell, and A. Corey Frost, "Reclaiming Critical Analysis: The Social Harms of 'Bitch,'" *Sociological Analysis* 3, no. 1 (Summer 2009): 47–68, esp. 52–53. Kleinman, Ezzell, and Frost argue that all of the multiplying uses of "bitch" refer back to its misogynistic meaning, which dates to at least the 1400s, and that efforts to reclaim the term only "reinforce" antifeminist agendas.

54 Sigmund Freud, *Jokes and Their Relation to the Unconscious* [1905] trans., ed. James Strachey (New York: W. W. Norton, 1989), 164.

55 Herbert Marcuse, *An Essay on Liberation* (Boston: Beacon Press, 1969), 35.

56 Ibid., 35*n*8.

57 Herbert Marcuse, "Art and Revolution," in *Counter-Revolution and Revolt* (Boston: Beacon Press, 1972), 80.

58 For a preview of one study of women and strong language, see Janice Williams, "Who Curses More? Women Love Saying the F-Word as Foul-Mouthed Females Are on the Rise," *International Business Times*, November 8, 2016, accessed October 1, 2017, http://www.ibtimes.com/who-curses-more-women-love-saying-f-word-foul-mouthed-females-are-rise-2443444.

59 Robin Tolmach Lakoff, "Language and Woman's Place," *Language and Society* 2, no. 1 (April 1973): 50. See also Lakoff, *Language and Woman's Place: Text and Commentaries*, rev. exp. edition, ed. Mary Bucholtz (New York: Oxford University Press, 2004).

60 Lakoff, "Language and Woman's Place," 46, 51, 57.

61 Ibid., 48.

62 Ibid., 48, 50.

63 Judith Mattson Bean and Barbara Johnston, "Gender, Identity, and 'Strong Language' in a Professional Woman's Talk," in Lakoff, *Language and Woman's Place*, 242.

64 The CW is a joint venture of CBS Corporation and Warner Bros., a division of Time Warner. CNN's parent company is Turner Broadcasting System, which is another division of Time Warner. *People* is owned by Time Inc., which in early 2014, at the time of Bullock's *Critics' Choice Awards* appearance, was also a division of Time Warner. Later that year, Time Warner spun off Time Inc.'s magazine publishing interests into a separate, publicly traded company. Coverage of Bullock, in this instance, rippled synergistically throughout the conglomerate's properties.

65 See Nicole Eggenberger, "Sandra Bullock, Bradley Cooper Drop F-Bombs at Critics' Choice Movie Awards," *US Weekly*, January 17, 2014, http://www.us magazine.com/entertainment/news/sandra-bullock-bradley-cooper-drop-f -bombs-at-critics-choice-movie-awards-2014171.

66 "Cheney Says He Felt Better After Cursing at Leahy," CNN.com, June 26, 2004, accessed June 17, 2015, http://www.cnn.com/2004/ALLPOLITICS/06/25 /cheney.leahy/.

67 Matt Brigidi, "FCC Can't Stop Tom Brady from Cursing," SB Nation, December 16, 2014, accessed June 15, 2015, http://www.sbnation.com/ nfl/2014/12/16/7404227/tom-brady-cursing-fcc-complaint; Michael David Smith, "Tom Brady's Words Draw FCC Complaints," NBC Sports, December 16, 2014, accessed June 15, 2015, http://profootballtalk.nbcsports. com/2014/12/16/tom-bradys-bad-words-draw-fcc-complaints/; "Tom Brady's Cursing Draws Indecency Beefs," *The Smoking Gun*, December 16, 2014, accessed June 16, 2015, http://www.thesmokinggun.com/documents/Tom-Brady-FCC -complaints-687543.

68 From 2011 to 2015, the FCC received 22 complaints about profanity during live broadcasts of golf tournaments, 15 of which involved Woods. See Sam Weinman, "Tiger Woods Dropped an F-Bomb on Live TV, and It Was Quite Awkward," The Loop (blog), *Golf Digest*, April 11, 2015, accessed June 17, 2015, http://www .golfdigest.com/blogs/the-loop/2015/04/tiger-woods-dropped-an-f-bomb.html; Alan Bastable and Pete Madden, "Tiger Woods' Off-Color Language Prompts FCC Complaints," Golf.com, May 19, 2015, http://www.golf.com/tour-and-news /tiger-woods-cursing-draws-fcc-complaints, accessed June 17, 2015; Nick Schwartz, "Read the Complaints Viewers Filed to the FCC Over Tiger Woods Swearing on Television," *USA Today*, May 19, 2015, accessed June 17, 2015, http://ftw.usatoday. com/2015/05/tiger-woods-swearing-fcc-complaint.

69 Bean and Johnston, "Gender, Identity, and 'Strong Language,'" 242.

70 Eventually, Clemente found his way back into the profession, and by 2016 and 2017 he had frequent bylines on the news website operated by WRDE-TV, an NBC affiliate serving Delmarva Peninsula in Delaware.

71 Caldwell, *Televisuality*, 367n80.

72 Marcuse, "Art and Revolution," 80–81.

73 Dan Barry, "One Cooking Show You Shouldn't Try at Home," *New York Times*, December 1, 2013, Week in Review, 3.

Chapter 5 Who's Afraid of Dick Smart?

1 See *People of the State of Michigan v. Timothy Bruce Huffman*, Court of Appeals of Michigan, No. 252315. Submitted February 9, 2005; decided May 10, 2005; published July 26, 2005, 2. Hereafter *Michigan v. Huffman* (2005).

2 The entire monologue is transcribed in *Michigan v. Huffman* (2005), 2. The jokes belong to the familiar genre that is found in a milder form in the Borscht Belt, typified by the late Henny Youngman's "Take my wife—please" one-liners, even if Huffman's routine lies closer to the misogynistic and homophobic rants of the likes of Andrew "Dice" Clay. These same kinds of jokes were fodder for analysis in Freud's *Jokes and Their Relation to the Unconscious* (1905). They were featured in the joke-filled drawings and paintings seen in Richard Prince's 2007 retrospective "Spiritual America" at the Guggenheim Museum as well as in his collaboration with Marc Jacobs for Louis Vuitton on a line of joke-bearing handbags. Huffman's "Dick Smart" routine was crude and not particularly funny, but its verbal content is of a type that is absolutely pervasive in culture, both high and low.

3 U.S. Code Title 18, Part I, Chapter 71, Section 1464: Broadcasting Obscene Language (1948, revised 1994); Federal Communications Commission, Consumer Help Center, TV: "Obscene, Indecent and Profane Broadcasts," accessed July 2, 2015, https://consumercomplaints.fcc.gov/hc/en-us/articles/202731600-Obscene-Indecent-and-Profane-Broadcasts.

4 Lou Perfidio was arrested for obscenity related to his show *The Great Satan at Large* (1991) on Tucson Community Cable but seems to have avoided charges by fleeing the state; see Linda R. Linder, *Public Access Television: America's Electronic Soapbox* (Westport, CT: Praeger, 1999), 44. Producer Terrel Denise Johnson and host Gareth Rees received 200 hours of community service and a year of probation on obscenity charges after showing *Midnight Snack*, a short demonstrating safer-sex techniques, created by New York-based Gay Men's Health Crisis, on their Austin Community Television show *InfoSex*, despite a defense that argued that the video was educational; see Reporters Committee for Freedom of the Press, "Court Upholds Conviction of Cable Team Charged with Obscenity," November 6, 1995. In 1996, Eric Voelker was charged with animal cruelty, having decapitated, skinned, and grilled three iguanas on camera for his Manhattan Neighborhood Network (MNN) public access show *Sick & Wrong*. He was convicted and fined; see Jennifer S. Rosa, "Chapters 118 and 208 of the Laws of 1999: The New York State Legislature Develops a Pseudo Animal Rights Agenda," *St. John's Law Review* 74, no. 1 (Winter 2012): 286–301.

5 See criteria for meeting the definition of obscenity (also discussed in this volume's introduction), in *Miller v. California*, 413 U.S. 15 (1973), §II. The definition of obscenity in the FCC fact sheet "Obscene, Indecent and Profane Broadcasts" paraphrases *Miller*.

6 See, for example, *Red Lion Broadcasting Co., Inc. v. FCC*, 385 U.S. 367 (1969).

7 See Anna McCarthy, *Ambient Television: Visual Culture and Public Space* (Durham, NC: Duke University Press, 2001).

8 Joy Van Fuqua, *Prescription TV: Therapeutic Discourse in the Hospital and at Home* (Durham, NC: Duke University Press, 2012); Susan Ossman, "Media, Bodies and Spaces of Ethnography: Beauty Salons in Casablanca, Cairo and Paris," 114–125, and Nitin Govil, "Something Spatial in the Air: In-Flight Entertainment and the

Topographies of Modern Air Travel," 233–254, both in Nick Couldrey and Anna McCarthy, eds., *MediaSpace: Place, Scale and Culture in a Media Age*, (New York: Routledge, 2004).

9 On the expansion of screen culture at sports venues, see Nick McCarvel, "Djokovic, Others Say No to ESPN Mid-Match Interviews, But Idea Could Catch On," *USA Today*, September 8, 2015, accessed June 23, 2016, http://www.usatoday.com/story /sports/tennis/2015/09/08/novak-djokovic-espn-us-open-interviews/71902212; also, Ken Belson, "New Dimensions in Scoreboard Watching," *New York Times*, July 19, 2014, accessed June 23, 2016, http://www.nytimes.com/2014/07/20/ sports/football/daktronics-plays-outsize-role-as-giant-sports-video-displays- proliferate.html; regarding live music performances, Christopher Borrelli, "Video Screens Sharpen Concert Debate," *Chicago Tribune*, July 5, 2011, accessed June 23, 2016, http://articles.chicagotribune.com/2011-07-05/entertainment/ct-ent-0705 -focus-video-screens-20110705_1_new-screen-concert-u2.

10 See Bilge Yesil, *Video Surveillance: Power and Privacy in Everyday Life* (El Paso, TX: LFB, 2009).

11 Nick Couldrey and Anna McCarthy, "Introduction: Orientations: Mapping MediaSpace," in Couldrey and McCarthy, *MediaSpace*, 1.

12 Neil Smith and Setha Low, "Introduction: The Imperative of Public Space," in Setha Low and Neil Smith, eds., *The Politics of Public Space* (New York: Routledge, 2006), 3.

13 See Lynn Spigel, *Make Room for TV: Television and the Family Ideal in Postwar America* (Chicago: University of Chicago Press, 1992), 138–140; also discussed in McCarthy, *Ambient Television*, 15.

14 McCarthy, *Ambient Television*, 15.

15 Consider, for example, contests over the extent to which radio-broadcast speech would be locally sourced, discussed in Bill Kirkpatrick, "Localism in American Media Policy 1920–1934: Reconsidering a 'Bedrock Concept,'" *The Radio Journal—International Studies in Broadcast and Audio Media* 4, nos. 1–3 (2006): 87–110.

16 Joseph McKenna, quoted in Garth Jowett, "'A Capacity for Evil': The 1915 Supreme Court *Mutual* Decision," *Historical Journal of Film, Radio and Television* 9, no. 1 (1989): 68.

17 Parents Television Council, The PTC Mission, accessed June 30, 2015, http://w2 .parentstv.org/main/About/mission.aspx. The PTC is not the only organization with such a mission. The National Center on Sexual Exploitation (known as Morality in Media until 2015), maintains the FCC Watch on Decency project, which urges the FCC to enforce the policy on obscenity, indecency, and profanity, and urges members of the public to complain to the FCC about specific broadcasts: accessed June 30, 2015, http://endsexualexploitation.org/fcc/.

18 See Henry James Forman, *Our Movie Made Children* (New York: MacMillan, 1933), https://archive.org/stream/moviemadechildre00formrich /moviemadechildre00formrich_djvu.txt. See also Mark Lynn Anderson, "Taking Liberties: The Payne Film Studies and the Creation of the Media Expert," in Lee Grieveson and Haddee Wasson, eds., *Inventing Film Studies* (Durham, NC: Duke University Press, 2008), 38–65.

19 The literature on variation in media effects is vast. Among the earliest to outline the role of psychological and social factors in determining the range of possible

reactions to media experience was Hadley Cantril, *The Invasion from Mars: A Study in the Psychology of Panic* (Princeton, NJ: Princeton University Press, 1940). See also one of the foundational texts of "uses and gratifications" theory, Herta Herzog, "What Do We Really Know About Daytime Serial Listeners," in Paul Lazarsfeld and Frank Stanton, eds., *Radio Research 1942–3* (New York: Duell Sloane and Pearce, 1944), 3–33. Albert Bandura's "Bobo Doll" experiments in social learning suggested that children who observed others engaged in violent play added violent actions to their own play repertoires, but not so much if these actions were punished. See D. Ross Bandura and S.A. Ross, "Transmission of Aggression Through the Imitation of Aggressive Models," *Journal of Abnormal and Social Psychology* 63 (1961): 575–582.

20 George Gerbner, Larry Gross, Nancy Signorielli, and Michael Morgan offered a theory of indirect media effects, observing that heavy viewers of violent media don't become violent themselves but do overestimate the amount of violent crime in their own neighborhoods and their chances of being victimized themselves; that is, TV doesn't cause more violence, but does influence our perceptions, resulting in "mean world syndrome." See Gerbner et al., *Television's Mean World: Violence Profile* no. 14–15 (September 1986), accessed August 19, 2016, http://web.asc.upenn.edu /gerbner/Asset.aspx?assetID=408.

21 For excellent studies that demonstrate that media effects are not uniform or direct, see Henry Jenkins, *Textual Poachers: Television Fans and Participatory Culture* (New York: Routledge, 1992); David Morley and Charlotte Brunsdon, *The* Nationwide *Television Studies* (New York: Routledge, 1999); Ellen Seiter, *The Internet Playground: Children's Access, Entertainment, and Mis-Education* (New York: Peter Lang, 2005); and Mary L. Gray, *Out in Country: Youth, Media and Queer Visibility in Rural America* (New York: New York University Press, 2009).

22 Parents Television Council and 4 Every Girl, *TV's Newest Target: Teen Sexual Exploitation: The Prevalence and Trivialization of Teen Sexual Exploitation on Primetime TV*, July 2013, 14 (emphasis added), http://w2.parentstv.org/main/Media Files/PDF/Studies/sexploitation_report_20130709.pdf.

23 For a brief discussion of "catharsis theory" and *Law & Order: SVU* viewers who find the series healing rather than harmful, see Cynthia Chris, "Queasy Questions About Media Effects," *Contexts* 12. no. 3 (Summer 2013): 60–62. See also Seymour Feshbach and Robert D. Singer, *Television and Aggression* (San Francisco: Jossey-Bass, 1971).

24 For a survey of studies on this topic, see Planned Parenthood Federation of America, *Reducing Teen Pregnancy* (July 2013), accessed August 20, 2016, https:// www.plannedparenthood.org/files/6813/9611/7632/Reducing_Teen_Pregnancy .pdf. The report rightly notes that media representations of sexual behavior often elide mention of "sexual precautions and the consequences of sexual behavior," 4.

25 The most comprehensive may be textbooks such as Jennings Bryant, Susan Thompson and Brice W. Finklea's *Fundamentals of Media Effects*, 2nd ed. (Long Grove, IL: Waveland, 2013) or Raymond W. Preiss, Barbara Mae Gayle, Nancy Burrell, Mike Allen, and Jennings Bryant, eds., *Mass Media Effects Research: Advances Through Meta-Analysis* (New York: Routledge, 2011).

26 Eric Freedman, "Public Access/Private Confession: Home Video as (Queer) Community Television," *Television & New Media* 1, no. 2 (May 2000): 187.

27 Wenhong Chen, Marcus Funk, Joseph D. Straubhaar, and Jeremiah Spence, "Still
 Relevant? An Audience Analysis of Public and Government Access Channels,"
 Journal of Broadcasting & Electronic Media 57, no. 3 (2013), 278–279.
28 Chen et al., "Still Relevant?," 264; Kevin Howley, "Manhattan Neighborhood
 Network: Community Access Television and the Public Sphere in the 1990s,"
 Historical Journal of Film, Radio and Television 25, no. 1 (March 2006): 135n7.
29 FCC, First Report and Order [on CATV], 20 FCC 2d 201 (1969).
30 Howley, "Manhattan Neighborhood Network," 122–123.
31 Charles R. Morris, John David, Tomas Freebairn, Wendy Gould, David Othmer,
 Mary Schroonmaker, Lake Wise, *Public Access Channels: The New York Experience:
 A Report for the Fund for the City of New York* (New York: The Center for the
 Analysis of Public Issues, March 1972), 9–10.
32 Johnson was also familiar with video-using activist collectives including the
 Raindance Foundation, which was founded in 1969; cofounder Michael Sham-
 berg's volume *Guerrilla TV* (New York: Holt Rinehart and Winston, 1971). See
 Howley, "Manhattan Neighborhood Network," 123; Halleck, *Hand-Held Visions*,
 7–8.
33 Cable Television Report and Order, 36 FCC 2d 143, 1972.
34 See Fred H. Cate, Donna N. Lampert, and Frank W. Lloyd, *Cable Television Leased
 Access* (Washington, DC: The Annenberg Washington Program, Communications
 Policy Studies, Northwestern University, 1991), §II.A. The Cable Act of 1984
 increased the number of required leased access channels to 10 percent of systems
 with 36 to 54 activated channels and 15 percent of systems with over 55 channels; see
 Cate et al., *Cable Television Leased Access*, §II.C; also, Federal Communications
 Commission, Policy Division: "Leased Access," accessed June 29, 2016, https://
 www.fcc.gov/general/leased-access.
35 *FCC v. Midwest Video Corp.*, 440 U.S. 689 (1979). "Common carriers" are defined
 and governed under federal law in the U.S. Code, Title 47, Chapter 5, Subchapter I,
 Section 153, and Subchapter II, Part I, Section 201. In 2015, the FCC classified ISPs
 as common carriers under the leadership of Chair Tom Wheeler. His successor Ajit
 Pai made repeal a top priority and the commission voted 3 to 2 to reverse the
 Obama-era decision on December 14, 2017. See Jon Brodkin, "To Kill Net
 Neutrality Rules, FCC Says Broadband Isn't 'Telecommunications,'" *Ars Technica*,
 June 1, 2017, accessed August 15, 2017, https://arstechnica.com/information
 -technology/2017/06/to-kill-net-neutrality-rules-fcc-says-broadband-isnt
 -telecommunications/; Cecilia Kang, "What's Next After the Repeal of Net
 Neutrality," *New York Times*, December 15, 2017.
36 As well, the 1984 Cable Act prevented municipalities or other franchising agents
 from regulating cable rates but allowed them to increase franchise fees. How the act
 took shape through negotiations between the National Cable Television Associa-
 tion and localities represented by the National League of Cities is surveyed in
 Wenmouth Williams, Jr., and Kathleen Mahoney, "Perceived Impact of the Cable
 Act of 1984," *Journal of Broadcasting & Electronic Media* 31, no. 2 (Spring 1987):
 193–205.
37 Cable Communications Policy Act of 1984, Pub. L. 98–549, October 30, 1984,
 Section 611(a). Hereafter, Cable Act of 1984. Emphasis added.
38 Cable Act of 1984, Section 611(e). For an overview of this history, see Jason
 Roberts, "Public Access: Fortifying the Electronic Soapbox," *Federal Communica-*

tions Law Journal 47, no. 1 (1994). The same hands-off rule also applied to commercial cable channels; see Cable Act of 1984, Section 612(c)(2).

39 Ibid., Sec. 624(d)(1) and (d)(2)(A); also, Sec. 639, which establishes penalties of up to $10,000 or two years imprisonment for transmitting cable programming that is "obscene or otherwise unprotected by the Constitution."

40 MNN was founded when the borough's franchise agreement with prior providers expired and new agreements were established with Time Warner and other providers. Howley, "Manhattan Neighborhood Network," 123.

41 Chen et al., "Still Relevant?," 64. *Wayne's World* (1992) was directed by Penelope Spheeris, and a 1993 sequel was directed by Stephen Surjik.

42 DeeDee Halleck, *Held-Held Visions: The Impossible Possibilities of Community Media* (New York: Fordham University Press, 2002), 7–8, 97–110.

43 David Richards, "And Now for the Late Night Nudes," *Washington Post*, March 27, 1997.

44 Christopher D. Ritchie, "Confronting Indecent Cable Television Programming: Balancing the Interests of Children and the Exercise of Free Speech in Denver Area Educational Telecommunications Consortium, Inc. v. FCC," *Nove Law Review* 21, no. 2 (1997): 749.

45 *Alliance for Community Media, Alliance for Communications Democracy, People for the American Way v. FCC; Denver Area Educational Telecommunications Consortium, Inc. and ACLU v. FCC*; U.S. Court of Appeals, D.C. Circuit (1995).

46 Cable Television Consumer Protection and Competition Act of 1992 (hereafter Cable Act of 1992), Section 10(a), cited in *Al Goldstein and Media Ranch, Inc., Plaintiffs, v. Manhattan Cable Television, Inc., The City of New York, William Squadron, Defendants*, 916 F. Supp. 262 (S.D.N.Y. 1995), 263. Hereafter *Goldstein v. Manhattan Cable Television*. The definition of indecency in the 1992 Act is very similar to the FCC's general definition of indecency: that which "depicts or describes sexual or excretory organs or activities in terms patently offensive as measured by contemporary community standards for the broadcast medium." See FCC, "Obscenity, Indecency & Profanity" FAQ, accessed August 18, 2016, https://www.fcc.gov/reports-research/guides/obscenity-indecency-profanity -faq.

47 Sections 10(a) and 10(b) of the Cable Act of 1992 are summarized in *Goldstein v. Manhattan Cable Television*, 263.

48 Patricia Aufderheide, "Underground Cable: A Survey of Public Access Programming," *Afterimage* 22, no. 1 (Summer 1994): 5. One of the interviewees in this study was Deborah Vinsel, director of Thurston Community Television in Olympia, WA, who is quoted in the epigraph to this chapter.

49 Ibid., 5.

50 User-generated content is not always progressive or inclusive. Online forums have become havens for a vast array of controversial speech, including the "alternative" or "Alt-Right" movement pushing a white supremacist and nationalistic agenda in the United States, using websites that allow users to remain anonymous (like 4chan), commercial Alt-Right web-based publishers (like Breitbart), and sections of social media forums (like Reddit).

51 Aufderheide, "Undergound Cable," 5.

52 *ACM v. FCC*, 56 F3d 105, 117.

53 *Goldstein v. Manhattan Cable Television*, 265.

54 Kennedy cited a survey indicating that during the 14-month period from March 1996 to May 1997, "fewer than 0.5% of cable subscribers requested full blocking," suggesting that there was little demand for even the least restrictive method of "content-based speech regulation." *United States, et al., Appellants v. Playboy Entertainment Group, Inc.*, No. 98-1682, May 22, 2000, Section III.

55 Ibid., Section II.

56 Ibid., Section III.

57 Title V of the Telecommunications Act of 1996, known as the Communications Decency Act, criminalized transmission of not only obscene but also "indecent" material to anyone under 18. In *Reno v. American Civil Liberties Union*, 521 U.S. 844 (1997), with U.S. Attorney General Janet Reno representing governmental interests to preserve Title V, the Supreme Court found this portion of the act unconstitutional, excessively vague, and likely to excessively impinge the free-speech rights of adults. The "spectrum scarcity" rationale for regulating indecency in broadcasting, the court found, should not apply to the radically *un*-scarce internet.

58 *Michigan v. Huffman* (2005), 2.

59 Doug Guthrie, "Defense Lawyer Calls Exposure Conviction 'Rigged,'" *Grand Rapids Press,* January 8, 2003, D1.

60 *Michigan v. Huffman* (2005), 1, states that the "Dick Smart" sketch was part of the "sixty-eighth episode of the show" and that it aired twice, both times between 10:30 and 11:00 P.M.

61 The Michigan Penal Code, Act 328 of 1931, Section 750.335a: Indecent exposure; violation; penalty; mother's breastfeeding or expressing milk exempt, subsection (1), http://www.legislature.mi.gov, accessed August 16, 2017. A breastfeeding and milk-expressing exemption has been in place since only 2014.

62 Ibid., subsections (2b), (2c).

63 "Timothy Bruce Huffman Convicted of Exposing Himself," *Broadcasting & Cable*, June 21, 2004. See also John Eggerton, "'Indecent Exposure via Cable' Appealed," *Broadcasting & Cable*, March 7, 2005. Huffman served out a portion of the jail sentence after violating the terms of his parole.

64 FCC, "Obscene, Indecent and Profane Broadcasts," last updated/reviewed, September 13, 2017, accessed October 2, 2017, https://www.fcc.gov/consumers/guides/obscene-indecent-and-profane-broadcasts.

65 John Eggerton, "First Amendment End Run," *Broadcasting & Cable*, June 20, 2004.

66 *Michigan v. Huffman* (2005), 3.

67 Ibid., 3–4.

68 Shah, "Access to Indecency." Thanks to Timothy McMorrow, now retired from the Prosecuting Attorney's office of Kent County, Michigan, for corresponding with me by email about this aspect of the case, June 13 and 26, 2015.

69 *Michigan v. Huffman* (2005), 3–4.

70 Ibid., 4.

71 *Erznoznik v. City of Jacksonville*, 422 U.S. 205 (1975).

72 *Michigan v. Huffman* (2005), 14.

73 Ibid., 4.

74 *Michigan v. Vronko*, 228 Mich. App. 649 (1998).

75 *United States v. O'Brien*, 391 U.S. 367 (1968), cited in *Michigan v. Huffman* (2005), 5.

76 *FCC v. Pacifica Foundation*, 437 U.S. 726, 748; 98 S Ct 3026, Section C (1978).

77 *Community Television of Utah, Inc. v. Wilkinson*, 611 F. Supp. 1099 (1985).
78 See also *Quincy Cable TV, Inc. v. FCC*, 768 F.2d 1434 (D.C. Cir. 1985), and *Preferred Communications, Inc. v. City of Los Angeles*, 476 U.S. 488 (1986).
79 *Michigan v. Huffman* (2005), 8.
80 Ibid., 8.
81 On August 15, 1998, Timothy Joseph Boomer let loose a string of loud profanities after falling into a cold river. Michael Smith, who served as a witness in the case, was canoeing nearby with his family. Kenneth Socia, a deputy from the Arenac County Sherriff's Department, arrested Boomer under Section 750.337 of the Michigan Penal Code, which prohibited the use of "indecent, immoral, obscene, vulgar or insulting language in the presence or hearing of any woman or children." See The Michigan Penal Code, Act 328 of 1931, Section 750.337: Woman and Children; improper language in presence, at http://www.legislature.mi.gov, accessed June 26, 2015. On June 11, 1999, an Arenac County jury convicted Boomer of a misdemeanor. On March 29, 2002, the Michigan Court of Appeals reversed Boomer's conviction under the Due Process Clause of the Fourteenth Amendment, finding that the law lacked provisions for "fair notice of what conduct is prohibited, and it encourages arbitrary and discriminatory enforcement." *People v. Boomer*, Docket No. 225747, 655 N.W.2d 255 (2002), 250 Mich. App. 534, Court of Appeals of Michigan, July 11, 2002. The Michigan Legislature repealed Section 750.337, effective March 14, 2016.
82 *People of the State of Michigan, Plaintiff-Appellee, v. Timothy Bruce Huffman, Defendant-Appellant*, 708 N.W.2d 95 (2006), Docket No. 129052, Supreme Court of Michigan, January 12, 2006.
83 *Timothy B. Huffman v. Michigan*, Supreme Court of the United States, Docket No. 05-1449. Petition for Writ of Certiorari denied October 2, 2006.
84 See John Eggerton, "Cable Speech in Jeopardy," *Broadcasting & Cable*, June 21, 2004, accessed at http://www.broadcastingcable.com.
85 Personal email correspondence from Ted Diedrich to the author, March 31, 2016.
86 See Kerry Murakami, "Public Access TV Tightens Obscenity Rules," *Seattle Post-Intelligencer*, January 19, 2006, accessed March 2, 2008, http://seattlepi.nwsource.com/local/256243_cable19.html; also Cydney Gillia, "Cable Axis: Challenging Times for SCAN TV under Proposed Franchise Agreement," March 2, 2006, accessed March 2, 2008, RealChangeNews.org, http://www.realchangenews.org/2006/2006_03_01/cableaxis.html.
87 Charles B. Goldfarb, *Public, Educational, and Governmental (PEG) Access Cable Television Channels: Issues for Congress* (Washington, DC: Congressional Research Service, October 7, 2011), 2, 5–6, 16–21.
88 McCarthy, *Ambient TV*, 15.
89 Hannah Arendt, "The Public and the Private Realm," in *The Human Condition* (Chicago: University of Chicago Press, 1958), 58.
90 "The bourgeoisie, wherever it has got the upper hand, has put an end to all feudal, patriarchal, idyllic relations. It . . . has left remaining no other nexus between man and man than naked self-interest, than callous "cash payment" . . . for exploitation, veiled by religious and political illusions, it has substituted naked, shameless, direct, brutal exploitation. . . . Constant revolutionizing of production, uninterrupted disturbance of all social conditions, everlasting uncertainty and agitation distinguish the bourgeois epoch from all earlier ones. . . . All that is solid melts into air, all that is

holy is profaned, and man is at last compelled to face with sober senses, his real conditions of life, and his relations with his kind." See Karl Marx and Frederick Engels, *The Communist Manifesto* (1848) (Oxford, UK: Oxford University Press, 1992), 5–6.

Conclusion

1 The slogan revived Ronald Reagan's 1980 campaign "Let's Make America Great Again."

2 The Louisiana-based company that makes apparel sporting the phrase claims to have sold a million of these baseball caps directly to consumers on Trump's official website. See John McCormick, "The Woman Behind Trump's Empire of Swag," *Bloomberg Businessweek*, June 23, 2017, accessed July 2, 2017, https://www .bloomberg.com/news/articles/2017-06-23/the-woman-behind-trump-s-empire-of -swag. Even though the campaign trademarked the phrase (see Heather Long, "Donald Trump Trademarks 'Make America Great Again,'" CNN, October 8, 2015, accessed July 2, 2017, http://money.cnn.com/2015/10/08/investing/donald-trump-make-america-great-again-trademark/index.html), vendors from Amazon.com to Wal-Mart sell cheaper knock-offs, many made in China.

3 Parents Television Council (PTC), "[Name of recipient], Let's Make Television Great Again!," email, December 6, 2016; PTC, "Make Television Great Again: Special Christmas Offer," email, December 7, 2016; PTC, "Make Television Great Again: Christmas Special," email, December 13, 2016. The Burnett-Romey production *Little Boy* may have seemed like a strange choice: the MPAA rated it PG-13—that is, friendly only to families without kids 12 and under. It entails a youngster's prayers for the end of the war, which appear to be answered by the bombing of Hiroshima, which caused the immediate deaths of tens of thousands of people and the later deaths of many more who suffered from radiation sickness and other injuries. Each and every one was a member of a family.

4 PTC, "Priorities for the First 100 Days," email, November 18, 2016.

5 Christopher Gildemeister, *Protecting Children or Protecting Hollywood? A Twenty-Year Examination of the Effectiveness of the TV Content Ratings System* (Los Angeles: Parents Television Council, 2016), accessed October 2, 2017, http://w2.parentstv.org/MediaFiles/PDF/Studies/2016RRStudy.pdf.

6 See "Re: Television Content Ratings System", to Chairman Tom Wheeler et al., Federal Communications Commission, from Douglas A. Gentile, Ph.D., Iowa State University et al., April 26, 2016, accessed July 4, 2017, http://w2.parentstv.org /MediaFiles/PDF/Letters/Academia_RatingsLetter.pdf; also the letter "Re: Evaluation of the Existing Television Content Rating System" to Chairman Tom Wheeler et al., Federal Communications Commission, from Tim Winter, President, Parents Television Council et al., May 9, 2016, accessed July 4, 2017, http://w2.parentstv.org/blog/index.php/2016/05/09/coalition-calls-on-fcc-to-reform-tv-ratings/. These petitions to the FCC are discussed in chapter 2.

7 Emily Shapiro, "The History Behind the Donald Trump 'Small Hands' Insult," ABC News, March 4, 2016, accessed July 1, 2017, http://abcnews.go.com/Politics /history-donald-trump-small-hands-insult/story?id=37395515.

8 Michael Finnegan and Noah Bierman, "Trump's Endorsement of Violence Reaches New Level," *Los Angeles Times*, March 13, 2016, accessed July 1, 2017, http:// www.latimes.com/politics/la-na-trump-campaign-protests-20160313-story.html.

9 *FCC Record,* Vol. 9, 87–139. Memorandum Opinion and Order, In the Matter of
The Regents of the University of California, Licensee of KCSB-TV, Santa Barbara,
California, adopted April 16, 1987, released April 29, 1987, 5324–5328. *FCC Record,*
Vol. 9, 87–138. Memorandum Opinion and Order, In the Matter of Pacifica
Foundation, Inc., Licensee of KPFK-FM, Los Angeles, California, adopted
April 16, 1987, released April 29, 1987, 5318, 5320. *FCC Record,* Vol. 2, No. 9, 87–138.
Memorandum Opinion and Order, In the Matter of Infinity Broadcasting
Corporation of Pennsylvania, Licensee of Station WYSP(FM), Philadephia,
adopted April 16, 1987, released April 29, 1987, 2706. See also FCC, New Indecency
Enforcement Standards to Be Applied to All Broadcast and Amateur Radio
Licensees, Public Notice, 2 F.C.C.R. 2726 1987.

10 The NALs issued under Powell were as follows: Complaints Against Various
Licensees Concerning Their Broadcast of the Fox Television Program "Married
by America" on April 7, 2003, adopted October 5, 2004, released October 12,
2004, accessed September 14, 2017, https://transition.fcc.gov/eb/Orders/2004
/FCC-04-242A1.html; Complaints Against Various Television Licensees
Concerning Their February 1, 2004, Broadcast of the Super Bowl XXXVIII
Halftime Show, on April 7, 2003, adopted August 31, 2004, released September-
ber 22, 2004, accessed September 14, 2017, https://transition.fcc.gov/eb/Orders
/2004/FCC-04-209A1.html; Young Broadcasting of San Francisco, Inc.,
Licensee, Station KRON-TV, adopted January 23, 2004, released January 27,
2004, accessed September 14, 2017, https://transition.fcc.gov/eb/Orders/2004
/FCC-04-16A1.html. For radio station NALs issued under Powell, see FCC,
Enforcement Board, "Obscene, Profane & Indecent Broadcasts: Notices of
Apparent Liability," last updated April 7, 2015, accessed September 14, 2017,
https://transition.fcc.gov/eb/broadcast/NAL.html.

11 The NALs issued under Martin were as follows: Complaints Against Various
Television Broadcasts Between February 2, 2002 and March 8, 2005, adopted
February 2, 2006, released March 15, 2006, accessed September 14, 2017, https://
transition.fcc.gov/eb/Orders/2006/FCC-06-17A1.html; Complaints Against
Various Television Licensees Concerning Their December 31, 2004, Broadcast of
the Program "Without a Trace," adopted March 28, 2006, released March 28, 2006,
accessed September 14, 2017, https://transition.fcc.gov/eb/Orders/2006/DA-06
-675A1.html; Complaints Against Various Television Licensees Concerning Their
February 25, 2003, Broadcast of the Program "NYPD Blue," adopted and released
January 25, 2008, accessed September 14, 2017, https://transition.fcc.gov/eb
/Orders/2008/FCC-08-25A1.html.

12 Nina Totenberg, "High Court Hears Arguments in FCC Indecency Case," *All
Things Considered,* January 10, 2012, http://www.npr.org/2012/01/10/144984607
/high-court-hears-arguments-in-fcc-case.

13 *FCC et al. v. Fox Television Stations et al.,* 2012.

14 The Supreme Court refused to comment on the policy in terms of the First
Amendment; the Fourteenth Amendment also contains a Due Process Clause,
applying the concept to the States.

15 Michael Copps served as acting chair, January 22 to June 28, 2009. FCC, Public
Notice: FCC Reduces Backlog of Broadcast Indecency Complaints by 70% (More
Than One Million Complaints); Seeks Comment on Adopting Egregious Case
Policy, GN Docket No. 13-86, April 1, 2013.

16 Genachowski was chair when the Enforcement Bureau issued an NAL requiring a forfeiture of $25,000 from the Fox network for refusing to cooperate with the commission during an investigation of an episode of Seth McFarlane's animated series *American Dad* ("Don't Look a Smith Horse in the Mouth," January 3, 2010). The NAL stopped short of declaring the episode indecent. The FCC had received 100,000 complaints about a scene in which the character Stan Smith masturbates a racehorse.

17 Trump's Executive Order 13771 requires the elimination of two existing regulations for every new one implemented, in all areas, from finance to the environment. Susan Dudley, "A New Direction for Regulation in President Trump's First 100 Days," *Forbes*, April 26, 2017, accessed September 22, 2017, https://www.forbes.com /sites/susandudley/2017/04/26/a-new-direction-for-regulation-in-president -trumps-first-100-days/#1671311e5f26.

18 Todd Shields, "Trump Renominates Net Neutrality Foe Ajit Pai to FCC, Source Says," *Bloomberg*, March 7, 2017, accessed July 1, 2017, https://www.bloomberg.com /news/articles/2017-03-07/net-neutrality-foe-ajit-pai-said-renominated-by-trump -to-fcc.

19 When Rosenworcel's first term expired on June 30, 2015, Obama sought reappoint-ment. (According to agency rules, she could continue to serve until the end of the congressional term on January 3, 2017). Some conservatives were opposed, and the Senate did not take up her re-confirmation while Obama was still in office. See Alden Abbott, "Reconfirming Jessica Rosenworcel as an FCC Commissioner Would Undermine Internet Freedom," The Heritage Foundation, December 15, 2016, accessed July 4, 2017, http://www.heritage.org/economic-and-property-rights/commentary/reconfirming-jessica-rosenworcel-fcc-commissioner-would.

20 James Doubek, "Trump Picks Republican Lawyer for FCC Commission Seat," National Public Radio, June 29, 2017, accessed July 2, 2017, http://www.npr.org /sections/thetwo-way/2017/06/29/534828696/trump-picks-republican-lawyer -for-fcc-commissioner-seat.

21 Cecilia Kang, "Trump's F.C.C. Pick Quickly Targets Net Neutrality Rules," *New York Times*, February 5, 2017, accessed July 6, 2017, https://www.nytimes.com/2017 /02/05/technology/trumps-fcc-quickly-targets-net-neutrality-rules.html?mcubz =2.

22 Brian Fung, "The FCC Just Voted to Repeal Its Net Neutrality Rules, in a Sweeping Act of Deregulation," *Washington Post*, December 14, 2017.

23 Ajit Pai, "Springing Forward for the Public Interest: The FCC's March Agenda" (blog,) *Medium*, March 2, 2017, accessed July 2, 2017, https://medium.com/@ AjitPaiFCC/springing-forward-for-the-public-interest-the-fccs-march-agenda -337b8ef582bc; https://www.fcc.gov/about/leadership/ajit-pai.

24 Reuters, "Don't Expect the FCC to Review AT&T's Bid for Time Warner," *Fortune*, February 27, 2017, accessed September 22, 2017, http://fortune. com/2017/02/27/att-time-warner-fcc-review/.

25 Tim Wu, "Why Blocking the AT&T-Time Warner Merger Might Be Right," *New York Times*, November 9, 2017.

26 Tim Arango, "G.E. Makes It Official: NBC Will Go to Comcast," *New York Times*, December 3, 2009, accessed July 6, 2017, http://www.nytimes.com/2009/12/04 /business/media/04nbc.html; Katy Bachman, "Comcast-NBCU Bid Gets

Fourth Hearing," *Hollywood Reporter*, March 11, 2010, accessed July 3, 2017, http://www.hollywoodreporter.com/news/comcast-nbcu-bid-gets-fourth-21541.

27 Kimberly Kindy, "How Congress Dismantled Federal Internet Privacy Rules," *Washington Post*, May 30, 2017, accessed July 4, 2017, https://www.washingtonpost .com/politics/how-congress-dismantled-federal-internet-privacy-rules/2017/05/29 /7ad06e14-2f5b-11e7-8674-437ddb6e813e_story.html?utm_term=.28803bbd14d8; Eric Fung, "Trump Has Singed Repeal of FCC Privacy Rules. Here's What Happens Next," *Washington Post*, April 4, 2017, https://www.washingtonpost.com /news/the-switch/wp/2017/04/04/trump-has-signed-repeal-of-the-fcc-privacy -rules-heres-what-happens-next/?utm_term=.9b23714d662d.

28 Beginning in 1985, the FCC valued the markets reached by UHF stations (those broadcasting on channel 14 or higher) as only 50 percent that of VHF stations (channels 2 to 13). In 2016, the commission dropped the discount, since the transition from analog to digital broadcasting had reduced the power differential between VHF and UHF stations. See Ted Johnson, "Sinclair Merger Faces Roadblock as Court Puts Hold on FCC Station Ownership Rule," *Variety*, June 1, 2017, accessed July 4, 2017, http://variety.com/2017/biz/news/ fcc-uhf-d,scount-appellate-court-sinclair-tribune-1202451298/.

29 David Lieberman, "President Trump Signs Law Scrapping Broadband Privacy Rule—Update," Deadline Hollywood, April 3, 2017, accessed July 4, 2017, http:// deadline.com/2017/04/lawmakers-face-intense-lobbying-internet-privacy- vote-1202053678/; Free Press, "Groups Petition FCC to Delay Reinstating Obsolete Loophole That Would Usher in a New Era of Media Consolidation" (press release), May 11, 2017, accessed July 4, 2017, https://www.freepress.net/press -release/108070/groups-petition-fcc-delay-reinstating-obsolete-loophole.

30 FCC, Electronic Document Management System, "Remarks of FCC Commis- sioner Ajit Pai at the National Association of Broadcasters Show, Las Vegas, Nevada, April 13, 2015," accessed July 5, 2017, https://apps.fcc.gov/edocs_public /attachmatch/DOC-332987A1.pdf.

31 John Eggerton, "FCC's Pai on Broadcast TV: Keep It Clean," *Broadcasting & Cable*, February 16, 2017, accessed July 1, 2017, http://www.broadcastingcable.com /news/washington/fccs-pai-broadcast-tv-keep-it-clean/163412.

32 Rafael Mieses, "El Shock," *The Bronx Journal*, February 1, 2000, accessed June 28, 2017, http://www.lehman.cuny.edu/lehman/depts/depts/langlit/tbj/feb00/local .htm.

33 FCC, Order in re Applications of WSKQ Licensing Inc., adopted April 4, 2017, released April 5, 2017; [attached] Consent Decree, 2*n*2; see also NHMC, About Us, History, 2001, accessed June 28, 2017, http://www.nhmc.org/about-us/history/.

34 For example, NHMC was among those protesting a slur used in a 1999 episode of NBC's *Will & Grace*, and it called for a boycott of Howard Stern's show after he made derogatory remarks about the Tejano singer Selena immediately following her murder. See Dana Calvo, "NBC Puts 'Tamale' Back in 'Will & Grace,'" *Athens [GA] Banner-Herald*, December 18, 1999, accessed July 4, 2017, http:// onlineathens.com/stories/121899/ent_1218990028.shtml#.WVUrR2UXe7Y; Jerry Crowe, "Latinos To Stern: Apology Is Not Accepted," *Los Angeles Times*, April 11, 1995, accessed July 4, 2017, http://articles.latimes.com/1995-04-11/entertainment /ca-53295_1_howard-stern.

35 "WSKQ Indecency Fine Is First Under Pai," *Inside Radio*, April 6, 2017, accessed June 28, 2017, http://www.insideradio.com/free/wskq-indecency-fine-is-first-under-pai/article_50b16ff4-1a91-11e7-844a-c7a18d7dc81d.html.

36 FCC, Order in re Applications of WSKQ Licensing Inc., adopted April 4, 2017, released April 5, 2017; [attached] Consent Decree, 2*n*2. By the Acting Chief of the FCC Media Bureau, Michelle M. Carey.

37 Ibid., 2, ¶4.

38 Ibid., 2, ¶4.

39 Ibid., 2, ¶4.

40 Eriq Gardner, "FCC Budget Showcases Rapidly Shrinking Media Regulatory Agency," *Hollywood Reporter*, May 23, 2017. Gardner summarizes staffing estimates in the budget proposal.

41 Federal Communications Commission Fiscal Year 2018, Budget Estimates to Congress (May 2017), 14, accessed June 29, 2017, https://www.fcc.gov/document/fy-2018-fcc-budget.

42 Ibid., 10.

43 Ibid., 64–65.

44 Ivan Pereira and Bill Hutchinson, "The Donald Fires Off on Rummy, Rice," *Daily News* (NY), November 20, 2006, accessed July 3, 2017, http://www.nydailynews.com/archives/news/donald-fires-rummy-rice-article-1.577939.

45 Delen Goldberg, "Donald Trump: U.S. Leadership 'Weak, Pathetic and Incompetent,'" *Las Vegas Sun*, April 28, 2011, accessed July 4, 2017, https://lasvegassun.com/news/2011/apr/28/trump-us-leadership/; to see how ABC News covered the speech, see "Donald Trump to China on Imports: Listen You Motherf*ckers, We're Gonna Tax You 25 Percent!," YouTube, posted by SayNOtoRACISTS, April 29, 2011, https://www.youtube.com/watch?v=zO0j96dv4uI.

46 Reuters, "Trump Re-enacts Carson's Alleged Stabbing, Says He'll Bomb the S**t Out of ISIS," *HuffPost*, November 12, 2015, accessed July 3, 2017, http://www.huffingtonpost.com/entry/donald-trump-bomb-isis_us_56454ccee4b08cda348844bf.

47 Andy Cush, "Donald Trump Didn't Say 'Fuck' at a New Hampshire Rally, He Said 'F&@%,'" *Gawker*, February 11, 2016, accessed July 5, 2017, http://gawker.com/donald-trump-didnt-say-fuck-at-a-new-hampshire-rally-1758549325.

48 David Robb, "News Network Should Stop Bleeping the Shit Out of Trump's Speeches," *Deadline Hollywood*, March 10, 2016, accessed July 5, 2017, http://deadline.com/2016/03/donald-trump-profanity-network-censorship-fcc-1201717741/.

49 Clips of Trump speaking in New Hampshire (and using profanity elsewhere) can be found in YouTube posts including "Trump and the F Bomb," posted by Left Out Loud, February 26, 2016, accessed September 22, 2017, https://www.youtube.com/watch?v=b920jK4hvbs.

50 Robb, "News Networks Should Stop Bleeping."

51 Melissa Mohr, "Why Donald Trump Is Smart to Swear," *Time*, June 28, 2016, accessed July 3, 2017, http://time.com/4380189/donald-trump-swearing/; Michael Adams, "Donald Trump Swears . . . A Lot. What's His Potty Mouth Really Saying?," *Slate*, August 9, 2016, accessed July 4, 2017, http://www.slate.com/blogs/lexicon_valley/2016/08/09/trump_s_swearing_signifies_a_hatred_of_political_correctness.html.

52 Richard Rainey, "Donald Trump Rallies in Baton Rouge, Swears Off Swearing," *Times-Picayune* (New Orleans), February 11, 2016, accessed July 1, 2017, http://www.nola.com/politics/index.ssf/2016/02/donald_trump_rallies_in_baton.html; Mike Opelka, "Donald Trump Swears He'll Never Swear Again . . . 30 Minutes Later He Breaks His Vow," *The Blaze*, February 12, 2016, accessed July 1, 2017, http://www.theblaze.com/news/2016/02/12/donald-trump-swears-hell-never-swear-again-30-minutes-later-he-breaks-his-vow/; Mark Hensch, "Trump on Foul Language: 'I'll Never Do It Again,'" *The Hill*, February 12, 2016, accessed July 1, 2017, http://thehill.com/blogs/ballot-box/presidential-races/269235-trump-on-foul-language-ill-never-do-it-again.

53 Jessica Durando, "Former President Vicente Fox: Mexico 'Not Going to Pay for That (Expletive) Wall,'" *USA Today*, January 25, 2017, accessed July 1, 2017, https://www.usatoday.com/story/news/world/2017/01/25/former-president-mexico-not-going-pay-expletive-wall/97055844/; David Wright, "Vicente Fox Says It Again—This Time on Live TV," CNN.com, February 26, 2016, accessed July 1, 2017, http://www.cnn.com/2016/02/26/politics/vicente-fox-donald-trump-wall-expletive/index.html; https://www.youtube.com/watch?v=b920jK4hvbs.

54 Transcript: Donald Trump's Taped Comments About Women," *New York Times*, October 8, 2017, accessed July 1, 2017, https://www.nytimes.com/2016/10/08/us/donald-trump-tape-transcript.html?mcubz=2.

55 Gabrielle Bluestone, "Donald Trump Releases Video Apologizing for the Pussy Grabbing," *Jezebel: The Slot*, October 8, 2016, accessed July 4, 2017, https://theslot.jezebel.com/donald-trump-appears-to-pledge-not-to-grab-women-by-the-1787560694.

56 Robb, "News Networks Should Stop Bleeping."

57 Sally Holmes, "Let's Take Just a Second to Talk About This Trump Supporter's Truly Vile T-Shirt," *Elle*, October 11, 2016, accessed July 4, 2017, http://www.elle.com/culture/career-politics/news/a39926/trump-supporter-disgusting-hillary-shirt/.

58 Ashley Parker, Nick Corasaniti, and Erica Berenstein, "Voices From Donald Trump's Rallies, Uncensored," *New York Times*, August 3, 2016, accessed July 5, 2017, https://www.nytimes.com/2016/08/04/us/politics/donald-trump-supporters.html?_r=0; Erica Berenstein, Nick Corasaniti, and Ashley Parker, "Unfiltered Voices From Donald Trump's Crowds," *New York Times: Times Video*, August 3, 2016, access July 5, 2017, https://www.nytimes.com/video/us/politics/100000004533191/unfiltered-voices-from-donald-trumps-crowds.html?action=click&contentCollection=us&module=lede®ion=caption&pgtype=article.

59 Mohr, "Why Donald Trump Is Smart to Swear."

60 A business reporter examined how CNN, the *Los Angeles Times*, the *Washington Post*, and her own paper chose to cover Anthony Scaramucci's "vulgar" and "obscenity-laced" interview with *The New Yorker* during his brief term as White House communications director. See Sydney Ember, "Scaramucci's Vulgar Rant Spurs Newsroom Debate: Asterisks or No Asterisks?" *New York Times*, July 28, 2017.

61 "A Brief History of Presidential Profanity," *Rolling Stone*, December 10, 2012, accessed September 22, 2017, http://www.rollingstone.com/politics/lists/a-brief-history-of-presidential-profanity-20121210/john-f-kennedy-19691231.

62 Julian Borger, "Cheney Vents F-Fury at Senator," *Guardian*, June 25, 2004, accessed July 7, 2017, https://www.theguardian.com/world/2004/jun/26/usa.dickcheney;

Juli Weiner, "Dick Cheney Could Not Be Prouder of That Time He Told Pat Leahy to 'Go Fuck Himself'' on the Senate Floor," *Vanity Fair*, April 23, 2010, accessed July 7, 2017, http://www.vanityfair.com/news/2010/04/dick-cheney-could -not-be-prouder-of-that-time-he-told-pat-leahy-to-go-fuck-himself-on-the-senate -floor.

63 Dan Merica, "Sh*t Talking Is Democrats' New Strategy," CNN.com, April 24, 2017, accessed July 7, 2017, http://www.cnn.com/2017/04/24/politics/tom-perez- swearing-trump/index.html; "Make Profanity Great Again? Cursing Is Becoming a Staple of Dems' Rhetoric," *Fox News Insider*, April 25, 2017, accessed July 7, 2017, http://insider.foxnews.com/2017/04/25/democrats-cursing-swearing-oppose- donald-trump; "Democrats Raise Eyebrows With Foul-Mouthed Rhetoric," *Fox News Insider*, June 12, 2017, accessed July 7, 2017, http://insider.foxnews. com/2017/06/12/democrats-foul-mouthed-message-cursing-election -gillibrand-perez.

64 Matt Flegenheimer, "As Democrats Drift, The Expectations Rise for Rookie Senator," *New York Times*, July 7, 2017, A12. The event was recorded for the podcast *Pod Save America*.

65 Post Editorial Board, "Democrats' Pathetic Bid to Swear Their Way into Voters' Hearts," *New York Post*, June 12, 2017, accessed July 7, 2017, http://nypost. com/2017/06/12/democrats-pathetic-bid-to-swear-their-way-into-voters-hearts/.

66 Judith Mattson Bean and Barbara Johnstone, "Gender, Identity, and 'Strong Language' in a Professional Woman's Talk," in Robin Tolmach Lakoff, *Language and Woman's Place: Text and Commentaries*, rev. exp. edition, ed. Mary Bucholtz (New York: Oxford University Press, 2004), 242.

67 I refer to some National Football League players' decision to kneel rather than stand during the national anthem before games starting in 2016, in protest of police killings of young black men and to President Trump's verbal and tweeted attacks on these players. See Eric Reid, "Why Colin Kaepernick and I Decided to Take a Knee," *New York Times*, September 25, 2017; also, Anna Dubenko, "Right and Left React to the N.F.L. Protests and Trump's Statements," *New York Times*, September 25, 2017. In *West Virginia Board of Education v. Barnette*, 319 U.S. 624 (1943), the Supreme Court ruled that no one can be forced to assume any particular posture when the anthem is played.

68 Mariah Cooper, "Stephen Colbert's Trump-Putin Joke Received More Than 5,000 Complaints," *Los Angeles Blade*, May 23, 2017, accessed September 22, 2017, http://www.losangelesblade.com/2017/05/23/stephen-colberts-trump-putin-joke- received-5000-complaints/; Andy Swift, "Colbert Blasts 'Presi-dunce' Trump in Scathing *Late Show* Monologue," *TV Line*, May 1, 2017, accessed July 4, 2017, http://tvline.com/2017/05/01/stephen-colbert-donald-trump-monologue-watch- late-show-video/; Oliver Gettell, "Stephen Colbert Unloads on Trump: 'You're the presi-dunce,'" *Entertainment Weekly*, May 1, 2017, accessed September 22, 2017, http://ew.com/tv/2017/05/01/stephen-colbert-insults-trump-presidunce -pricktator/.

69 Jennifer Rubin, "Trump Proves He's a Putin Lapdog," *Washington Post*, July 21, 2016, accessed July 1, 2017, https://www.washingtonpost.com/blogs/right-turn/wp /2016/07/21/trump-proves-hes-a-putin-lapdog/?utm_term=.011b46250a6b; Nicholas Kristof, "Donald Trump: The Russian Poodle," *New York Times*, Decem-

ber 17, 2016, accessed July 1, 2017, https://www.nytimes.com/2016/12/17/opinion
/sunday/donald-trump-the-russian-poodle.html.

70 "50% See Blair as Bush's LapDog," *Guardian*, November 14, 2002, accessed July 1,
2017, https://www.theguardian.com/politics/2002/nov/14/foreignpolicy.uk1;
Edward Luce, "Was Blair Bush's Poodle?," *Financial Times*, May 10, 2007, accessed
July 1, 2017, https://www.ft.com/content/1b706386-fe22-11db-bdc7-000b5df10621
?mhq5j=e3.

71 Adam Taylor, "The Putin-Trump Kiss Being Shared Around the World," *Washington Post*, May 15, 2016, accessed July 2, 2017, https://www.washingtonpost.com
/news/worldviews/wp/2016/05/13/the-putin-trump-kiss-being-shared-around-the
-world/?utm_term=.5ca3b0846da8; Caitlin Yilek, "Image of Putin Caressing a
Pregnant Trump Appears on New York Building," *Washington Examiner*, February 14, 2017, accessed July 2, 2017, http://www.washingtonexaminer.com/image-of-putin-caressing-a-pregnant-trump-appears-on-new-york-building/article/
2614840#!.

72 Margaret Harding McGill, "Colbert Joke Prompts Thousands of FCC Complaints
from All Political Stripes," *Politico*, May 19, 2017, accessed June 30, 2017, http://
www.politico.com/story/2017/05/19/stephen-colbert-joke-fcc-complaints-238609.

73 Sample of 100 complaints sent to the FCC on May 2 or May 3, 2017, obtained by
Politico via a Freedom of Information Act (FOiA) request, received July 6, 2017, by
email from Politico; also available via link to PoliticoPro in Harding McGill,
"Colbert Joke."

74 Ibid.

75 Sample complaints, available via link to PoliticoPro in Harding McGill, "Colbert
Joke."

76 Melissa Locker, "Watch Stephen Colbert Shut Down Same-Sex Marriage
Haters," *Vanity Fair*, June 27, 2015, accessed June 30, 2017, http://www.vanityfair.com
/hollywood/2015/06/watch-stephen-colbert-shut-down-same-sex-marriage-haters;
Emma Margolin, "Stephen Colbert Quizzes Ted Cruz on Gay Marriage, Constitution," NBC News, September 22, 2016, https://www.nbcnews.com/politics/2016
-election/colbert-quizzes-ted-cruz-gay-marriage-constitution-n431451.

77 David Sims, "Stephen Colbert's 'Apology,'" *The Atlantic*, May 4, 2017, accessed
June 30, 2017, https://www.theatlantic.com/entertainment/archive/2017/05
/stephen-colberts-apology/525375/.

78 David Itzkoff, "F.C.C. Will Review Complaints About Colbert Joke, Chairman
Says," *New York Times*, May 5, 2017, http://www.foxbusiness.com/features/2017/05/04/fcc-chair-on-colberts-trump-bash-will-apply-obscenity-law-if-needed.html.

79 Aric Jenkins, "The FCC Is Reviewing Stephen Colbert's Trump Joke. But What
Can It Actually Do?," *Fortune*, May 6, 2017, accessed June 30, 2017, http://fortune.
com/2017/05/06/stephen-colbert-donald-trump-fcc/; Jenkins links to a lengthy
thread started by a freelance journalist: Lauren Duca, "This is what government
censorship looks like," Twitter, May 5, 2017, accessed July 4, 2017, https://twitter
.com/laurenduca/status/860612919708536832. See also Elizabeth Wagmeister,
"Stephen Colbert Speaks Out on FCC Controversy—With More Trump
Bashing," *Variety*, May 17, 2017, accessed June 30, 2017, http://variety.com/2017/tv
/news/stephen-colbert-fcc-controversy-donald-trump-cbs-upfront-1202431094/.

80 Brian Hauss, "You Can't Say That on Television (Colbert Edition)" [blog], ACLU, May 9, 2017, accessed September 23, 2017, https://www.aclu.org/blog/free-speech /you-cant-say-television-colbert-edition; Dominic Patten, "WGA 'Appalled' Over FCC Review of Stephen Colbert's Crude Trump Tirade," *Deadline Hollywood*, May 8, 2017, accessed September 23, 2017, http://deadline.com/2017/05/ stephen-colbert-wga-fcc-donald-trump-joke-1202086693/.

81 John Bowden, "Huckabee Defends Colbert from Calls for FCC Punishment," *The Hill*, May 6, 2017, accessed September 23, 2017, http://thehill.com/blogs/blog-brief ing-room/332191-huckabee-rejects-calls-for-fcc-to-punish-colbert-over-trump-joke.

82 Mark Fowler, Jerald Fritz, Henry Geller, Newton N. Minow, James M. Quello, Glen O. Robinson, and Kenneth G. Robinson, Jr.; Brief for *Amici Curiae* Former FCC Commissioners and Officials in Support of Petitioners, No. 06-1760(L), in U.S Court of Appeals for the Second Circuit, *Fox Television Stations, Inc., et al. v. Federal Communications Commission*, filed September 16, 2006.

83 James Poniewozik, "The Decency Police," *Time*, March 20, 2005.

84 U.S. Code Title 15, Chapter 22, Subchapter I, §1052(a), Trademarks Registrable on Principal Register; Concurrent Registration, July 5, 1946, accessed at Cornell Law School, Legal Information Institute, July 5, 2017, https://www.law.cornell.edu /uscode/text/15/1052.

85 Katy Steinmetz, "'The Slants' Suit: Asian American Band Goes to Court Over Name," *Time*, October 23, 2013, accessed July 5, 2017, http://entertainment.time. com/2013/10/23/the-slants-suit-asian-american-band-goes-to-court-over-name/.

86 Matt Ford, "The Supreme Court Offers a Warning on Free Speech," *The Atlantic*, June 19, 2017, accessed July 5, 2017, https://www.theatlantic.com/politics/archive /2017/06/supreme-court-first-amendment/530865/.

87 U.S. Patent and Trademark Board, Trademark Trial and Appeal Board, Amanda Blackhorse et al. v. Pro-Football, Inc., Cancelation No. 92046185, June 18, 2014, http://ttabvue.uspto.gov/ttabvue/v?pno=92046185&pty=CAN&eno=199.

88 Quoted in Kat Chow, "What's Next for the Founder of The Slants, and the Fight Over Racial Slurs," *Code Switch* Podcast, NPR, July 6, 2017, accessed September 25, 2017, http://www.npr.org/sections/codeswitch/2017/07/06/535055061/whats -next-for-the-founder-of-the-slants-and-the-fight-over-racial-slurs.

89 The phrase "just because you can doesn't mean that you should" may derive at least in part from a biblical verse: "All things are lawful for me, but all things are not helpful," in *The Bible*, New King James Version (Edinburgh: Thomas Nelson, 1979), 1 Corinthians 6:12, accessed December 19, 2017, https://www.biblestudytools.com /nkjv/1-corinthians/6.html.

90 The U.S. Court of Appeals for the Second Circuit's decision in *Fox et al. v. FCC* (2009) is one of many sources describing the post-*Pacifica* era as "restrained."

91 Ruth Bader Ginsburg, concurring in judgment, *FCC v. Fox* et al. (2012).

Index

Sawyer, Diane, 121–122
SCAN, 153
Scaramucci, Anthony, 225n60
scarcity principle, 6, 76, 158, 198n86
Schenck v. United States (1919), 18
Schindler's List, 68
Schurz Communications, 80–81, 199n106
Schwartzman, Andrew Jay, 53, 72–73
scripted programming, profanity in,
 123–128, 132, 210–211n48, 211n50
Section 1464 of U.S. Code, 46–48, 65,
 190n64
Sedition Act (1917), 182n11
Seidler, David, 123
Seinfeld, 124–125
sexual revolution, 38–39
$#*! My Dad Says, 126, 133
"shock jocks," 11, 50, 52–53, 160, 177
Shocktime U.S.A., 51
Sick & Wrong, 213n4
Signorielli, Nancy, 215n20
Sikes, Alfred, 159
Simpsons, The, 43–44, 73
Sims, Thetus Willrette, 32
Sims Act (1912), 32
SkyAngel, 100–101
Slants, The, 174–175
SLAPS test, 22
Sling TV, 106
Smith, Michael, 219n81
Smith, Neil, 137
Smothers Brothers Comedy Hour, The, 38
Socia, Kenneth, 219n81
Solomon, David, 66
*Sony Corp. of America v. Universal City
 Studios, Inc.* (1976), 189–190n51
Sound of Music remake, 117
space, electronic media as kind of, 136–139,
 152, 153–154
speech, freedom of. *See* First Amendment
Spellings, Margaret, 108–110, 173
Spigel, Lynn, 85
Spongebob Squarepants, 210n48
Stanley v. Georgia (1969), 21
Steinberg, Hank, 72–73
Stevens, John Paul, 48, 75
Stevens, Ted, 92, 98
Stewart, Potter, 9

Stone, Hannah, 188n22
streaming subscriptions, 13, 105–106,
 107–108, 163
Subscription Television, Inc. (STV), 88
suburbanization, 85
subversive speech, 17–18
Super Bowl halftime show, 63–65, 78
Surviving Jack, 211n52

Tam, Simon, 174–175
Taylor, Arthur, 40
Telecommunications Act (1996): Commu-
 nications Decency Act, 15, 108, 218n57;
 effectiveness of, 203n45; parental controls
 under, 91–92, 93, 96, 108; passing of, 159;
 and public-access channels, 144–145;
 television following, 11–14
Telemundo, 26, 59, 159
television: absence of people of color on,
 87, 200n18; Code of Television
 Standards, 36–38, 42–43; effects of,
 138–139, 214–215n19, 215n20; and family
 hour, 39–45, 55–56; following Telecom-
 munications Act of 1996, 11–14; as kind
 of space, 136–139, 152, 153–154;
 ownership statistics on, 199–200n4;
 regulation code and its precedents,
 32–39; special status of, 6–9; ubiquity
 of, 137. *See also* history of indecency in
 media; television choices
Television and Behavior report, 25
Television and Growing Up report, 25
television choices, 82–85, 108–110; and à la
 carte model, 101–108, 163, 204n62,
 205n71, 206n99; and cable television,
 89–91; and family-friendly tiers, 97–101;
 and family unity, 85–88; and parental
 controls, 91–97; proliferation of, 12, 83,
 89–91, 157
Television Consumer Freedom Act, 106
Thurmond, Strom, 143
Timberlake, Justin, 63–65, 78
Time Warner Cable: and à la carte model,
 107; and family-friendly tiers, 98, 99–100;
 and "TV Everywhere," 90, 107, 206n103
Tim's Area of Control, 134–135, 146, 153,
 213n2
Title 18, Part 1 of U.S. Code, 46–48

About the Author

CYNTHIA CHRIS is an associate professor and chair of the Department of Media Culture at the College of Staten Island, City University of New York, and is affiliated with the Program in Women's and Gender Studies at the CUNY Graduate Center. She is the author of *Watching Wildlife*, coeditor of *Cable Visions: Television Beyond Broadcasting* and *Media Authorship*, and former co-editor of the journal *WSQ* (2014–2016). She has contributed to the journals *Antennae: The Journal of Nature in Visual Culture*, *Art Journal*, *Contexts*, *Camera Obscura: Feminism, Culture, and Media Studies*, *Communication Review*, *Feminist Media Studies*, and *Television and New Media*, as well as the edited volumes *The Craft of Media Criticism*, *Keywords in Media Studies*, *Animal Life and the Moving Image*, and *Animals and the Human Imagination*.